150 Best House Ideas

150 Best House Ideas

COLLINS DESIGN

An Imprint of HarperCollins*Publishers*

HarperCollins books may be purchased for educational, business, or sales promotional use.
For information, please write: Special Markets Department, HarperCollins*Publishers*,
10 East 53rd Street, New York, NY 10022.

First published in 2005 by:
Collins Design,
An Imprint of HarperCollins*Publishers*
10 East 53rd Street
New York, NY 10022
Tel.: (212) 207-7000
Fax: (212) 207-7654
collinsdesign@harpercollins.com
www.harpercollins.com

Distributed throughout the world by:
HarperCollins*Publishers*
10 East 53rd Street
New York, NY 10022
Fax: (212) 207-7654

Executive editor:
Paco Asensio

Editorial coordination:
Ana Cañizares

Art director:
Mireia Casanovas Soley

Graphic design and layout:
Emma Termes and Cris Tarradas Dulcet

Library of Congress Control Number: 2005925394

ISBN: 978-0-06-078000-5

Printed by: Anman Industries Gràfiques del Vallès, www.anman.com

D.L: B-35.965-2005

Fifth Printing, 2008

150 Best House Ideas

COLLINS | DESIGN

An Imprint of HarperCollins*Publishers*

HarperCollins books may be purchased for educational, business, or sales promotional use.
For information, please write: Special Markets Department, HarperCollins*Publishers*,
10 East 53rd Street, New York, NY 10022.

First published in 2005 by:
Collins Design,
An Imprint of HarperCollins*Publishers*
10 East 53rd Street
New York, NY 10022
Tel.: (212) 207-7000
Fax: (212) 207-7654
collinsdesign@harpercollins.com
www.harpercollins.com

Distributed throughout the world by:
HarperCollins*Publishers*
10 East 53rd Street
New York, NY 10022
Fax: (212) 207-7654

Executive editor:
Paco Asensio

Editorial coordination:
Ana Cañizares

Art director:
Mireia Casanovas Soley

Graphic design and layout:
Emma Termes and Cris Tarradas Dulcet

Library of Congress Control Number: 2005925394

ISBN: 978-0-06-078000-5

Printed by: Anman Industries Gràfiques del Vallès, www.anman.com

D.L: B-35.965-2005

Fifth Printing, 2008

Contents

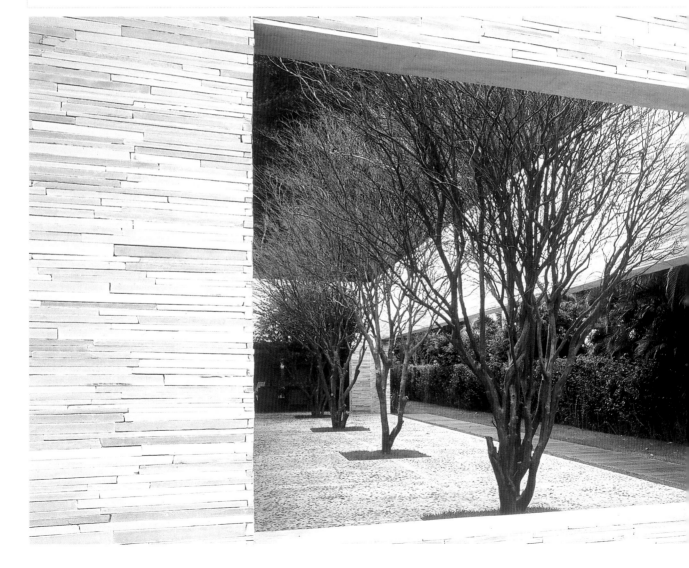

Introduction

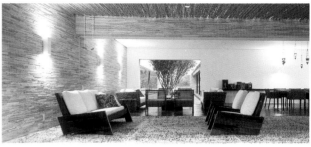

The world of architecture and interior design is constantly growing and continuously generates a broad array of groundbreaking and innovative designs. These designs are becoming increasingly accessible to the general public, rather than being exclusively reserved to closed architectural circles. This is especially true when it comes to residential design, where people looking to build their own houses or update their existing ones can find an endless source of inspiration in the houses being designed today by contemporary architects.

150 Best House Ideas aims to provide the average house owner with an inspirational handbook of ideas exemplified by some of the most recently completed single-family homes around the world. Some projects involve a more complex intervention, while others employ simple techniques that result in highly efficient and esthetic designs. Still others explore the numerous possibilities of building green in order to reduce the intake of energy and respect the surrounding environment. Regardless of the scale or scope of the projects presented, homeowners can pick and choose ideas according to their own tastes and adapt them to their individual budgets to create a personalized design. Classified according to the different environments in which single-family homes may be situated, this book offers an extensive collection of contemporary houses designed by renowned architects that provide the architect, homeowner, or avid reader with a wealth of ideas for maximizing the potential of a new residence and making the most of its location.

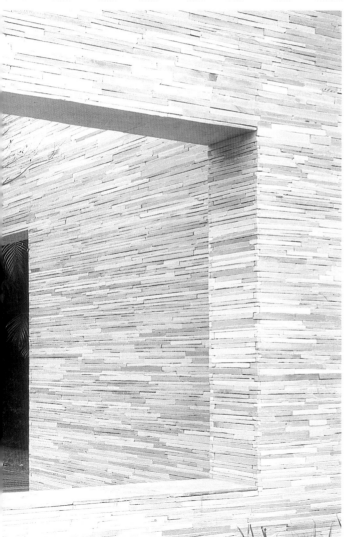

City & Suburban

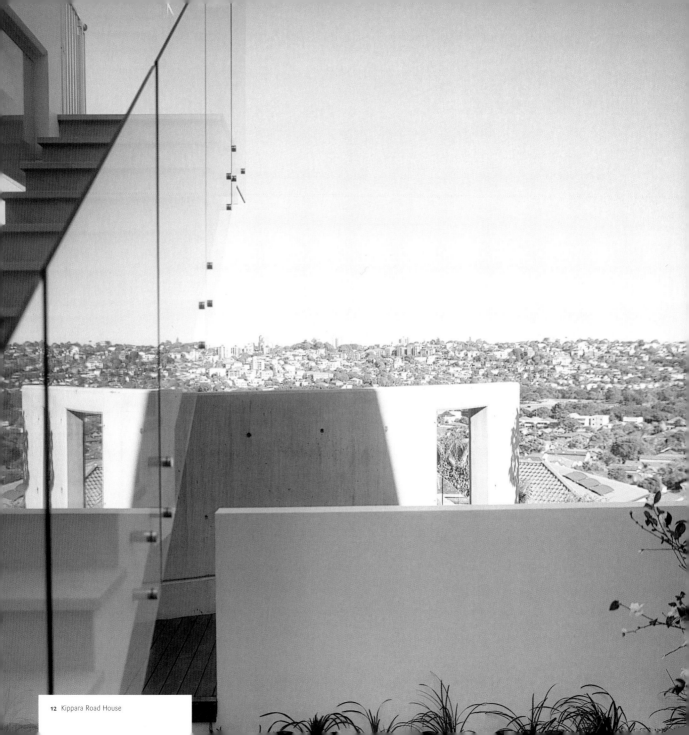

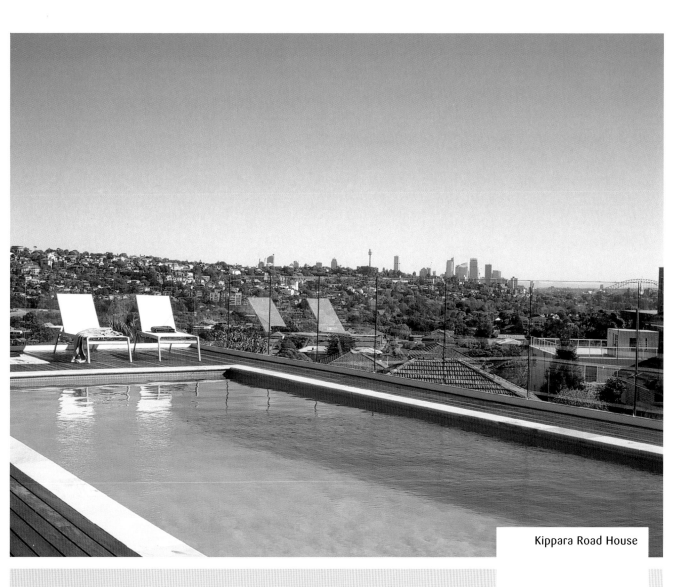

Kippara Road House

Situated on a steep site in Sydney's eastern suburbs, this house enjoys a 180-degree panoramic view stretching from Sydney Harbor to the northwest and down the coastline to the south. The house is designed around a central core consisting of a curved concrete wall that starts at ground level and rises up through the three levels.

Architect: CSA Architects
Location: Sydney, Australia
Date of construction: 2004
Photography: Richard Powers

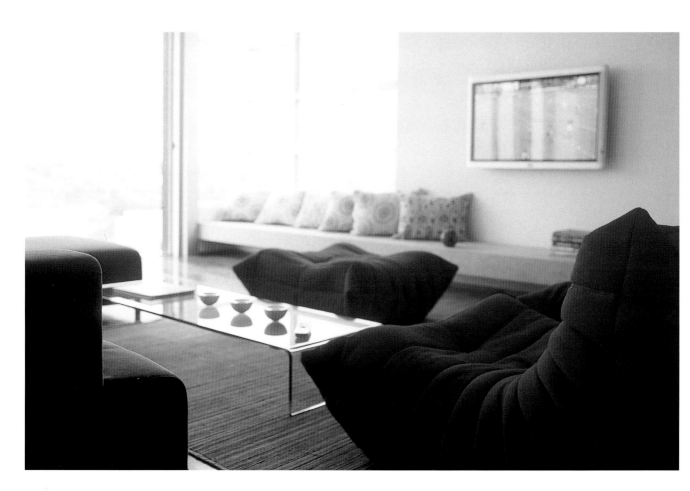

A long window seat serves
as an extra seating area
with pillows, and doubles as
a shelf for decorative
objects and books.

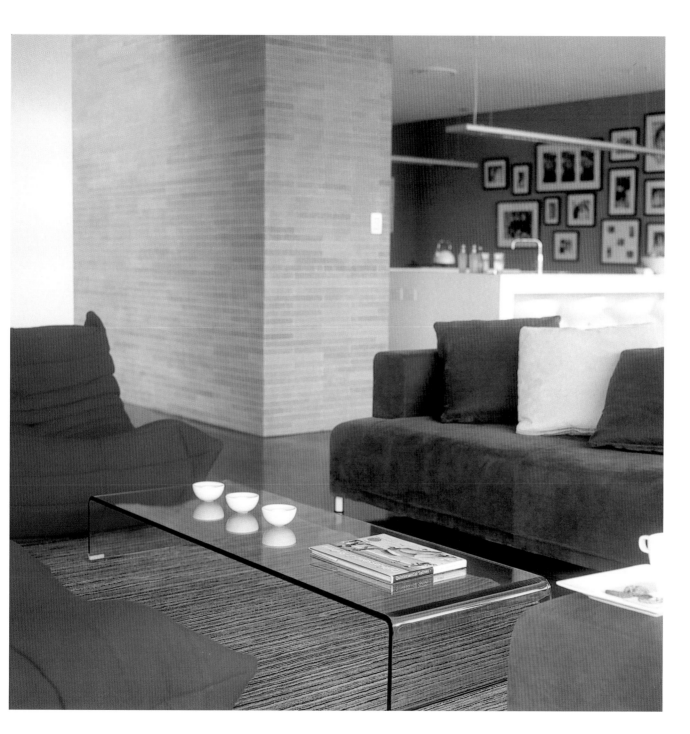

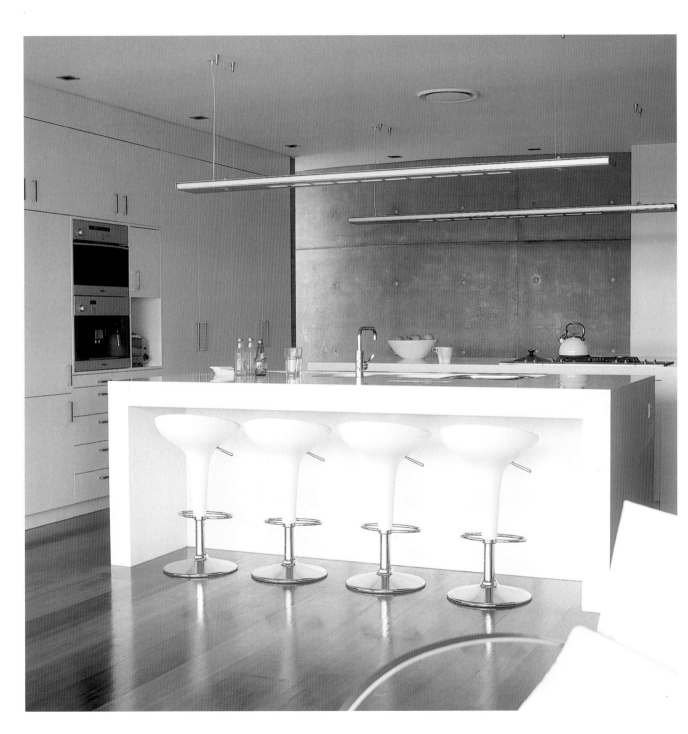

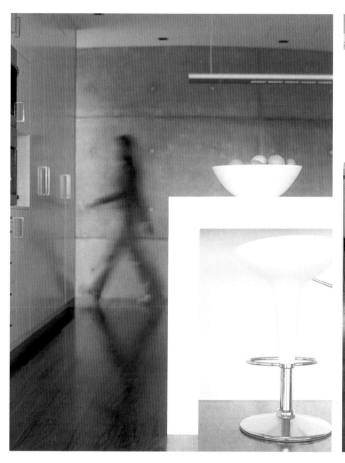

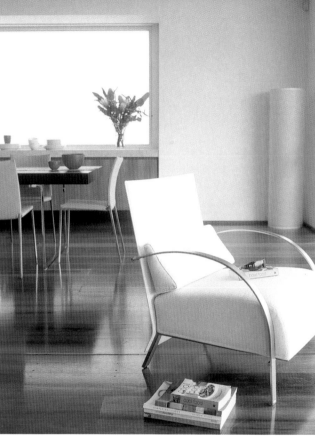

To contrast with the concrete, 200-mm-wide wooden floorboards were used to cover the floors of the main level, while rugs were added for extra warmth.

Lower Ground Floor

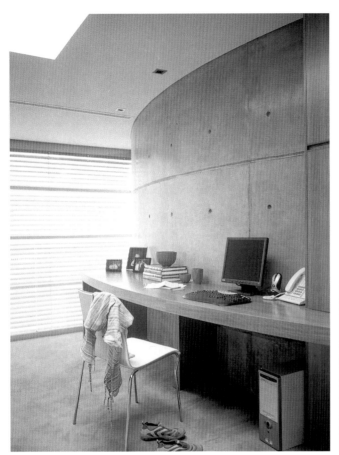

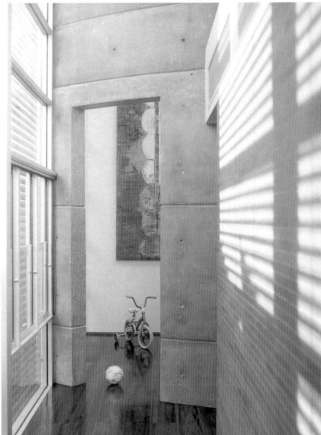

The curved concrete wall provides a
feeling of continuity that links the
different areas of the home and
offsets the polished surfaces in many
rooms of the house.

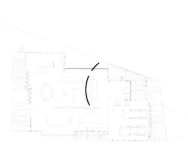

Ground Floor

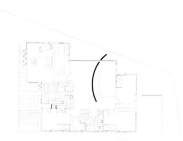

First Floor

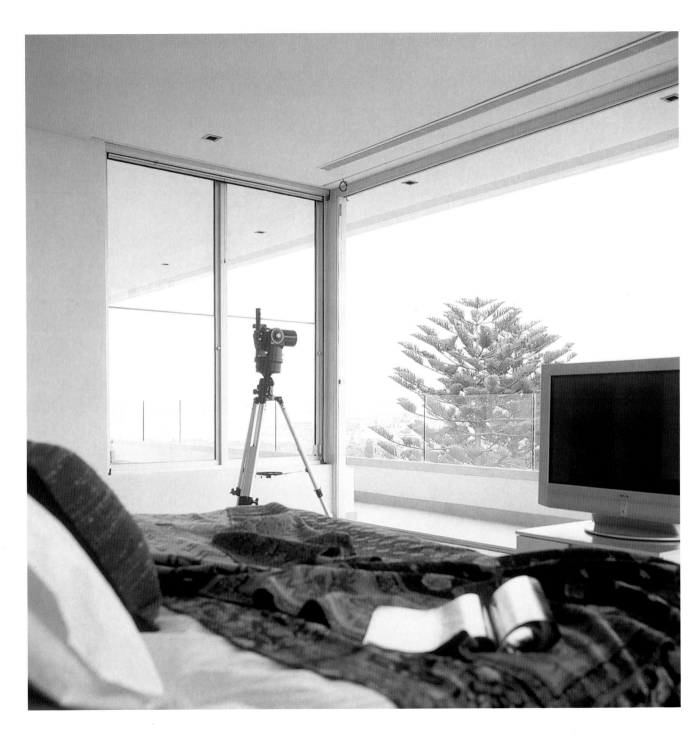

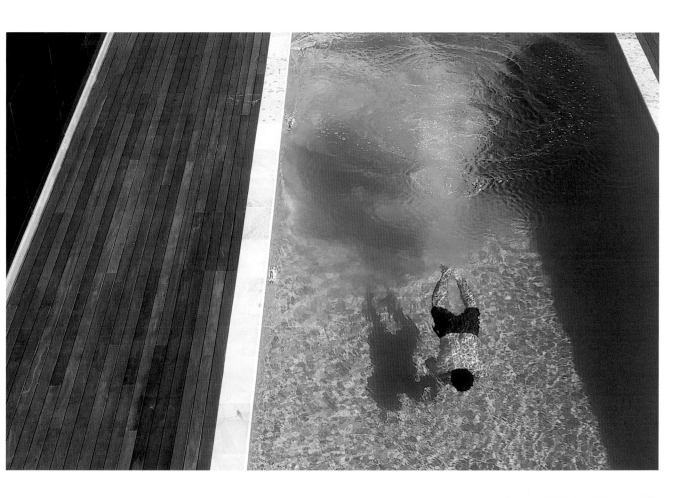

Because of to the steep site, the pool was raised obove the ground-floor level and connected with the main balcony through external stairs, as a way of linking the pool to the main living areas.

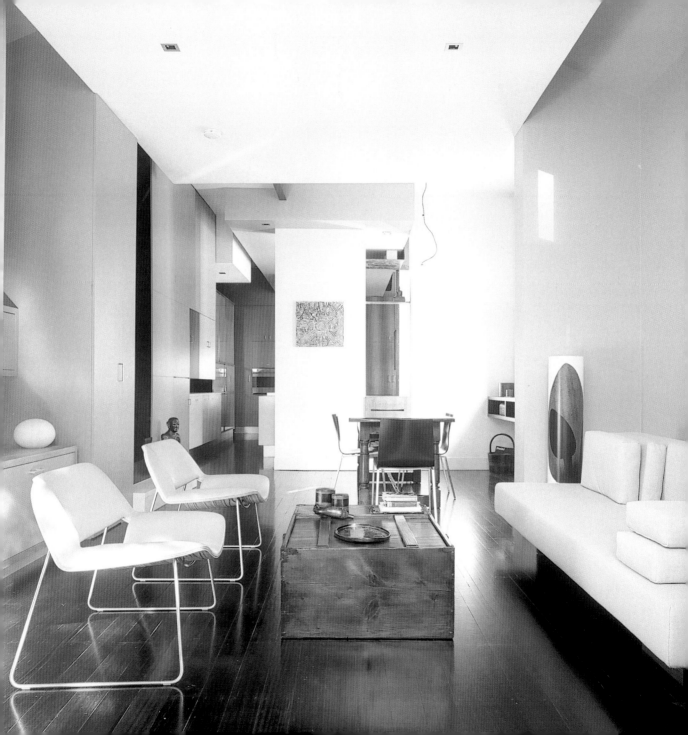

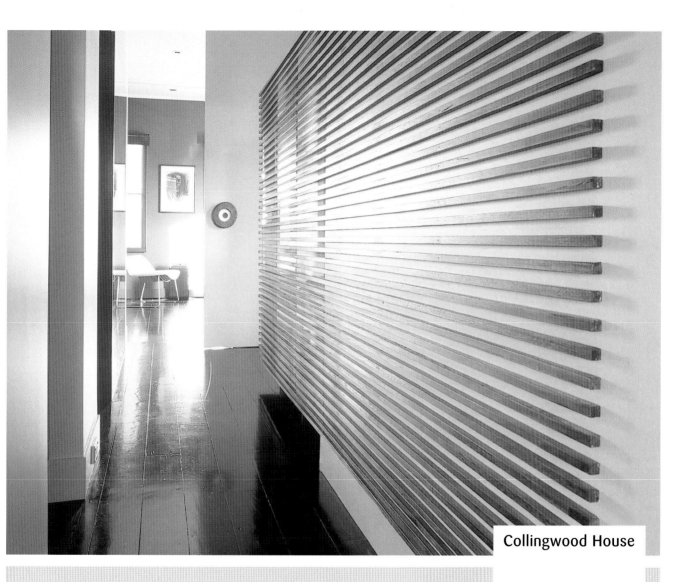

Collingwood House

This property, a former corner hotel dating back to the late nineteenth century, was transformed into a contemporary home for a young couple. The architects focused primarily on breaking down the antiquated Victorian notions of spatial hierarchy to create more open, fluid living areas.

Architect: Multiplicity
Location: Melbourne, Australia
Date of construction: 2004
Photography: Shania Shegedyn

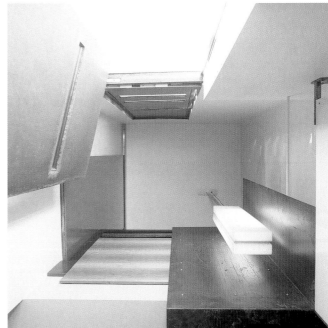

After reconfiguring the floor plan, an existing window at floor level was cut down to the ground to create a new entrance door made of rusted and black steel.

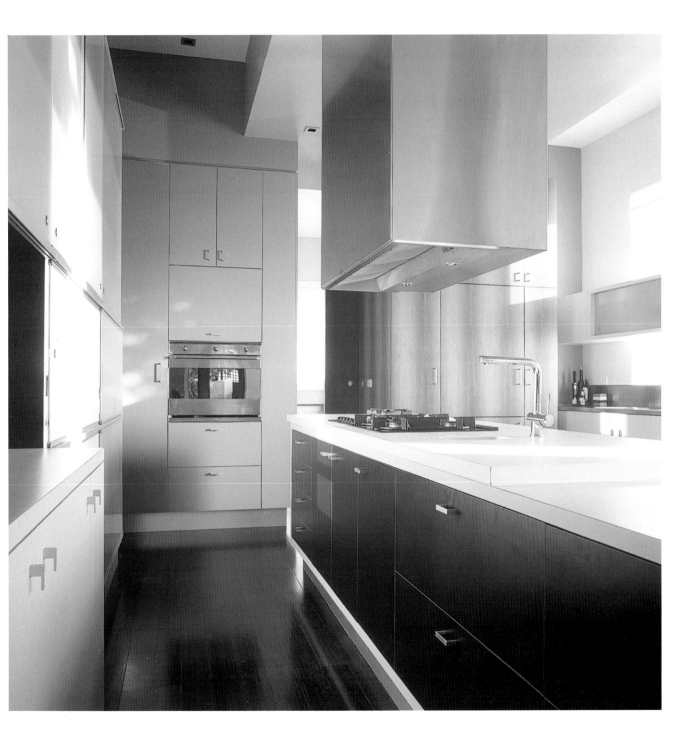

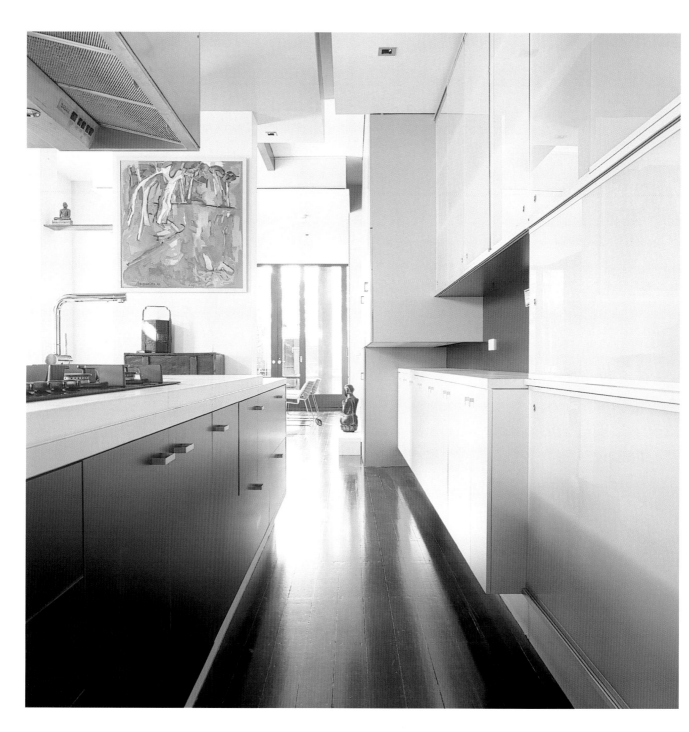

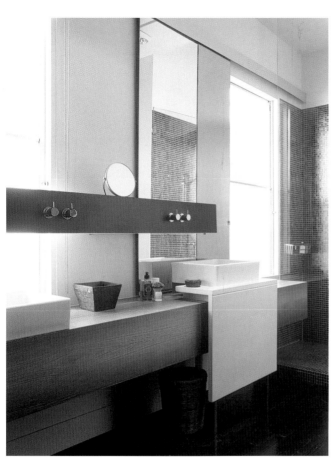

Orientation is key: the main bathroom takes advantage of two original windows to the west in order to obtain intense qualities of light.

Ground Floor

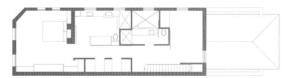

First Floor

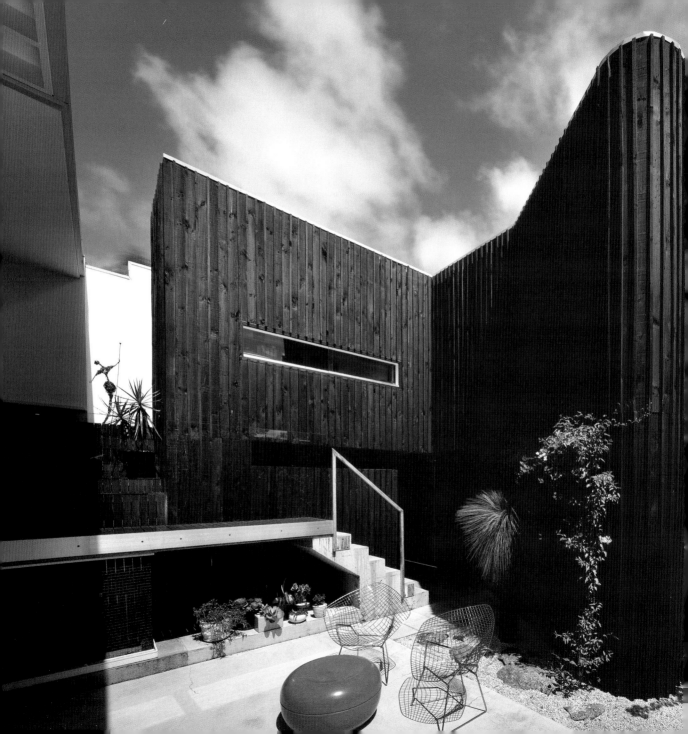

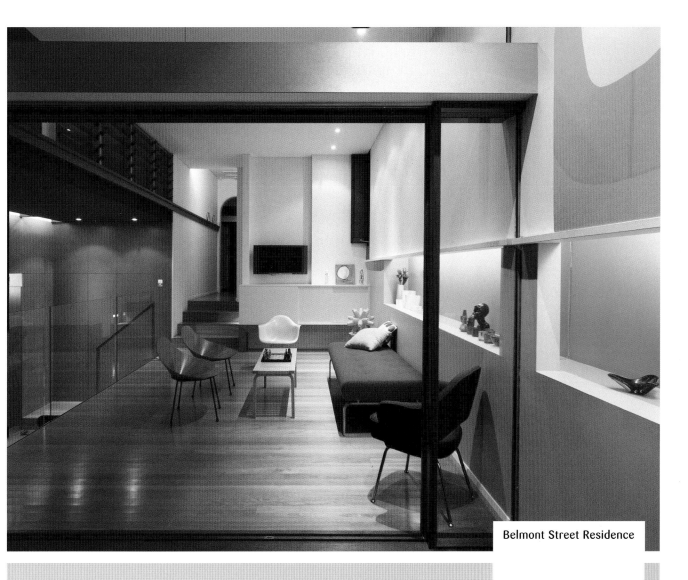

Belmont Street Residence

A new extension to an existing house provides an intimate courtyard and a series of platforms for living, dining, and entertaining that interact on different levels with the main courtyard space. Bold architectural elements and a liberal use of color create a dialogue of interconnecting spaces.

Architect: David Boyle
Location: Alexandria, Australia
Date of construction: 2004
Photography: Murray Fredericks

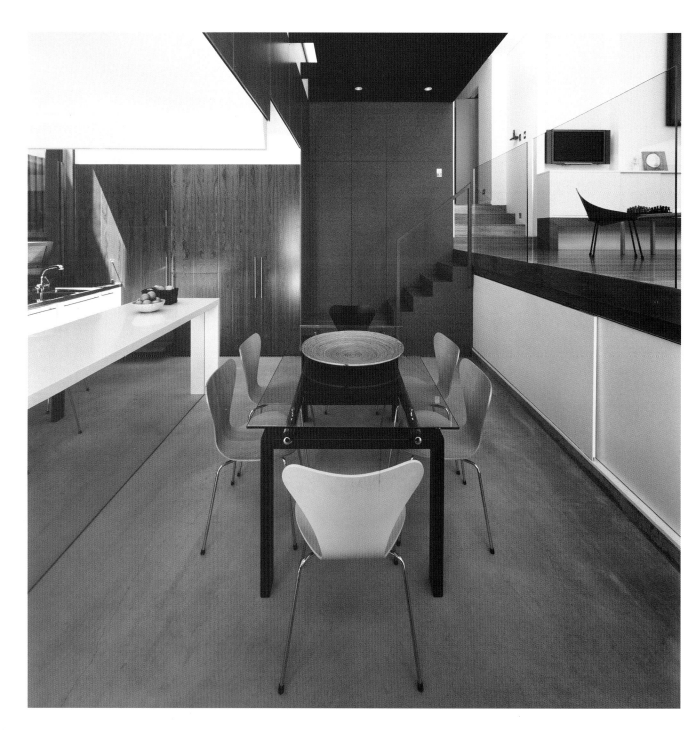

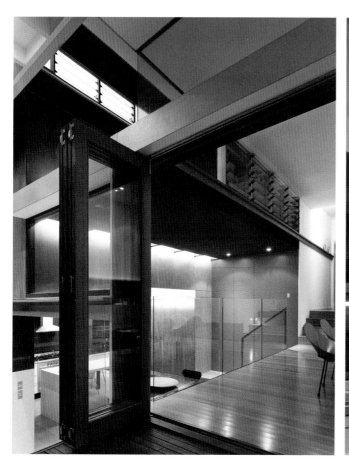

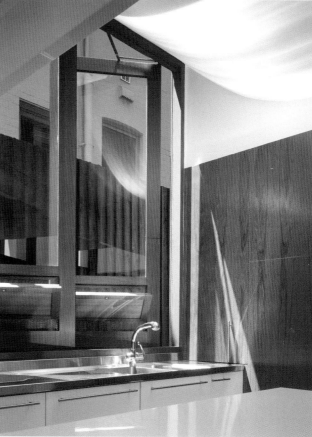

Lower Ground Floor

A U-shaped building footprint that partially encloses the rear courtyard was developed to control the visual and environmental climate of the extension.

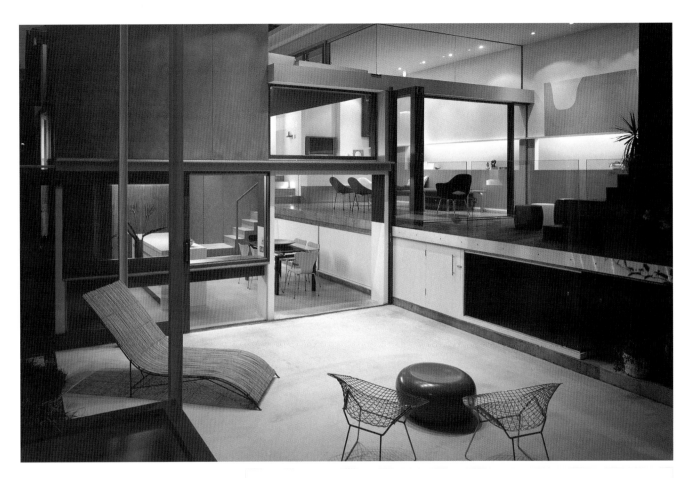

The stepped floor levels of the new work take advantage of the sloping site and ensure a direct relationship with the exterior.

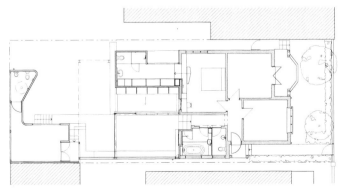

Upper Ground Floor

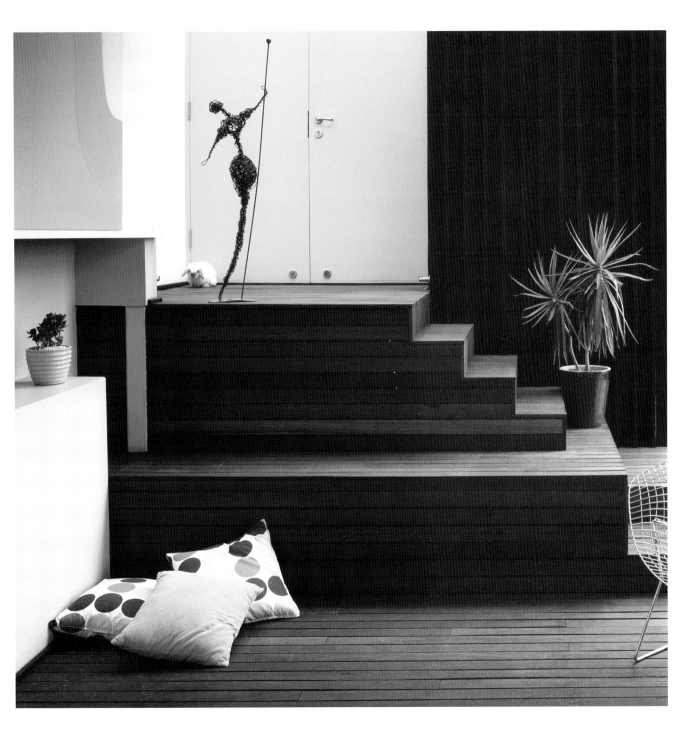

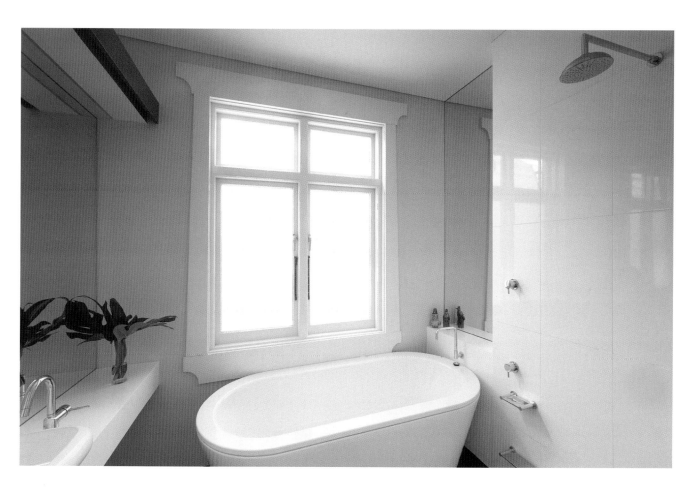

Glazing was maximized in order to minimize the reliance on artificial light during the day. The glazing is sufficiently protected with overhanging eaves or roofs to allow solar penetration in winter months and protection from unwanted heat during the summer.

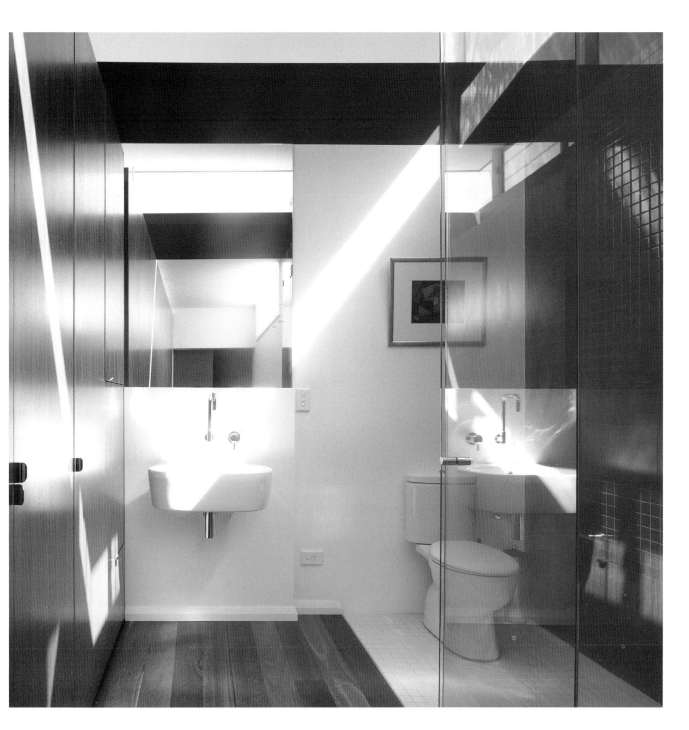

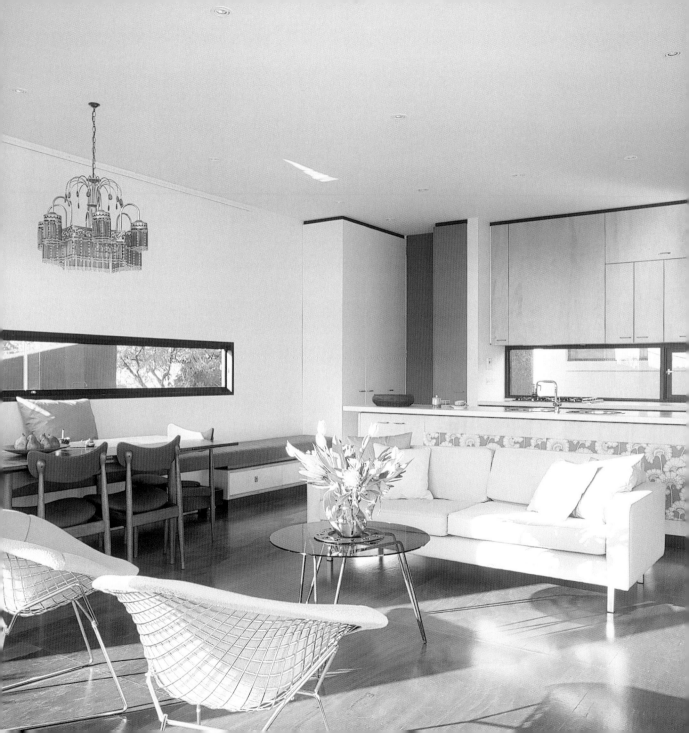

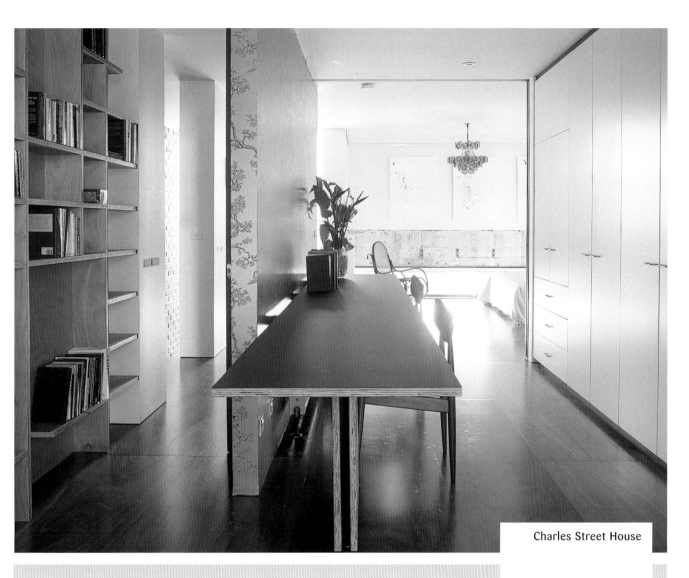

Charles Street House

Conceived for a lawyer/artist and an art curator, this new home was constructed within the partial shell of an old industrial building in Fitzroy. A rich palette of materials and a subtle mixture of styles generates an attractively unique, comfortable, and light-filled home.

Architect: Six Degrees
Location: Melbourne, Australia
Date of construction: 2004
Photography: Shania Shegedyn

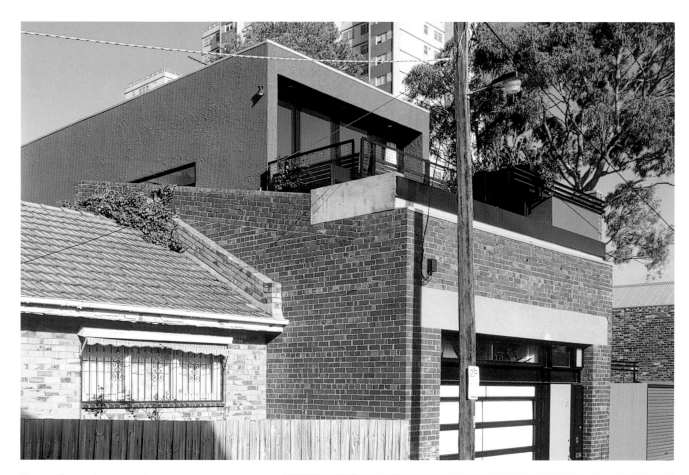

The ground floor contains a garage and studio, and the first floor houses the bedrooms, study, and walk-in closet. The kitchen and living area are situated on the top floor, with a roof deck garden above that looks out toward the inner-city Fitzroy area.

Ground Floor

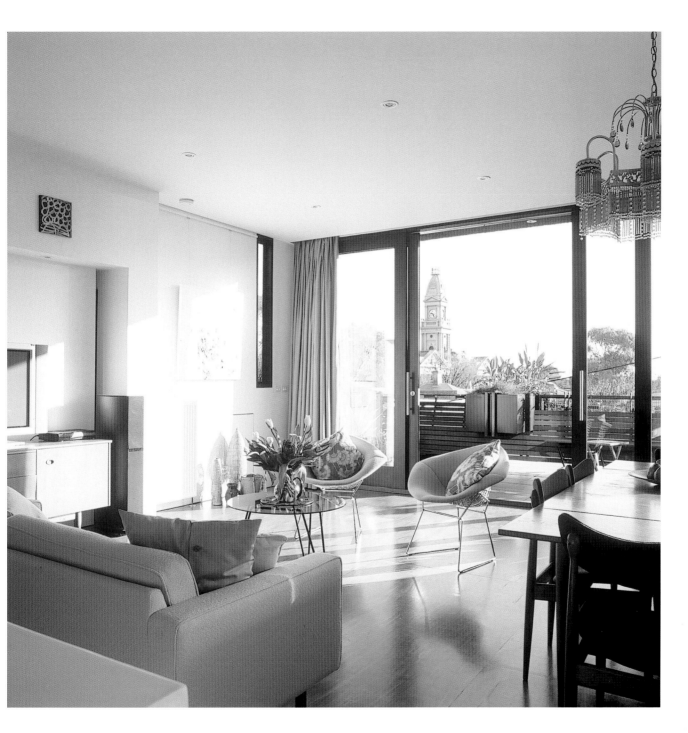

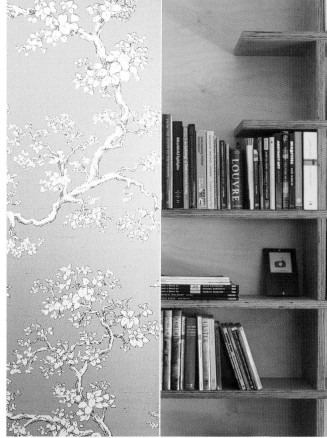

Instead of painting, try wallpaper or fabric on walls: These designs by Florence Broadhurst give the interior a warm and elegant look.

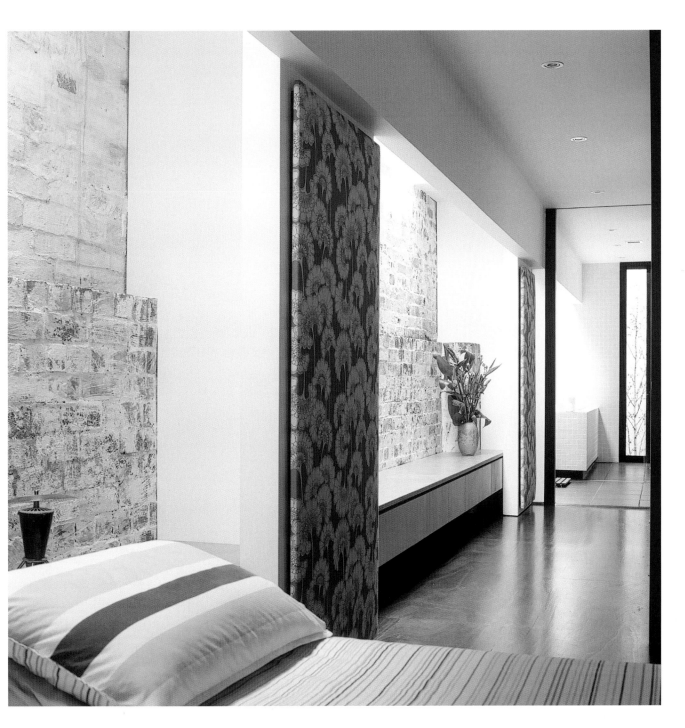

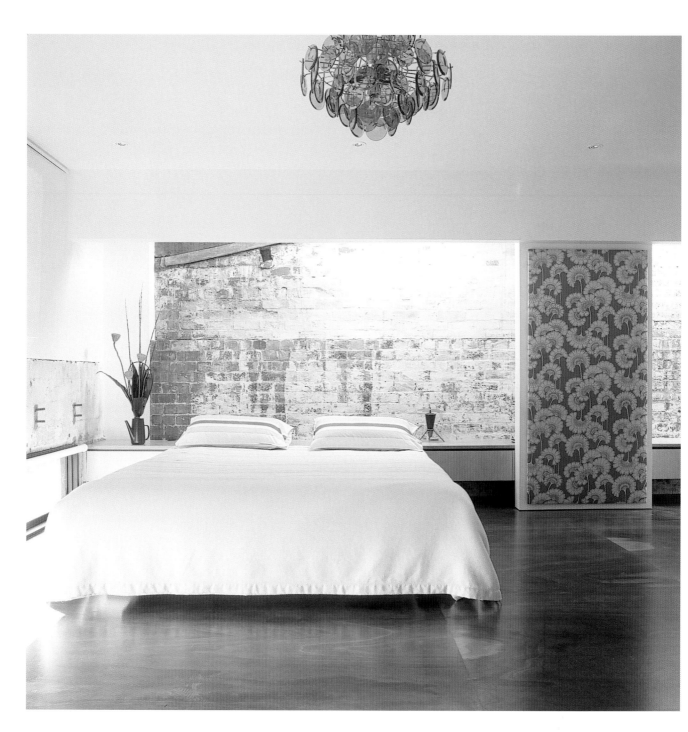

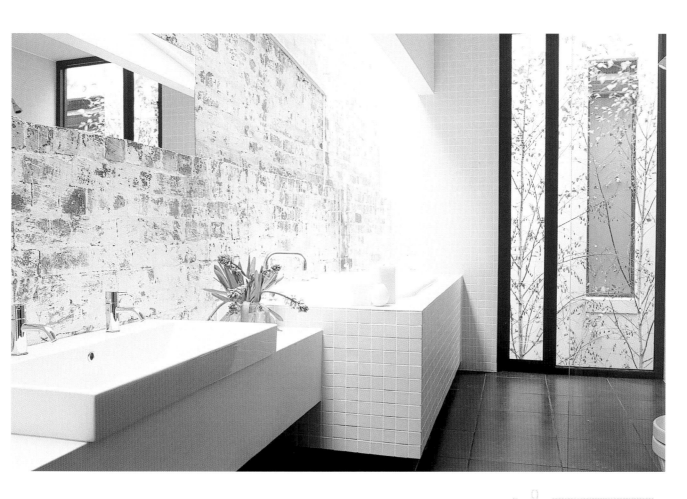

9

Combining smooth, linear
elements with rough, worn
materials can create an
attractive balance in any
interior, and also has the
advantage of being easily
maintained.

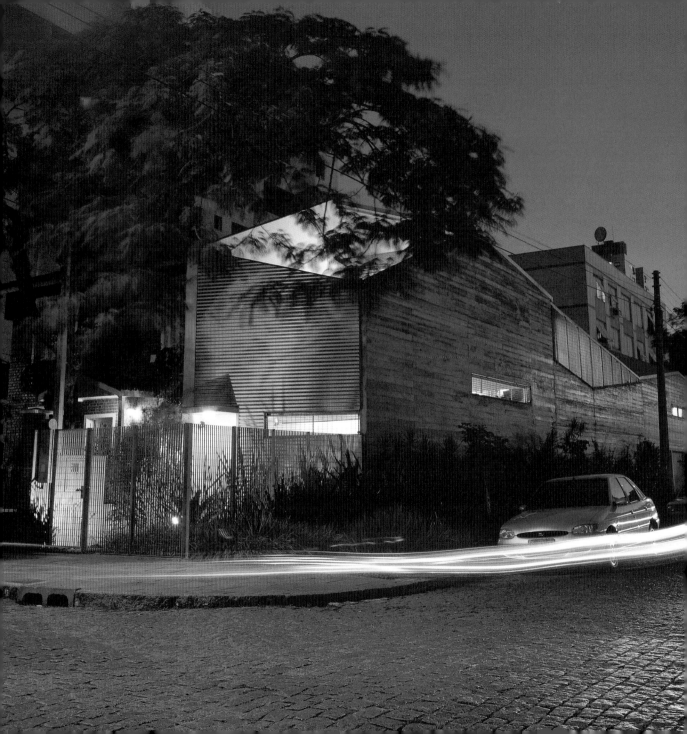

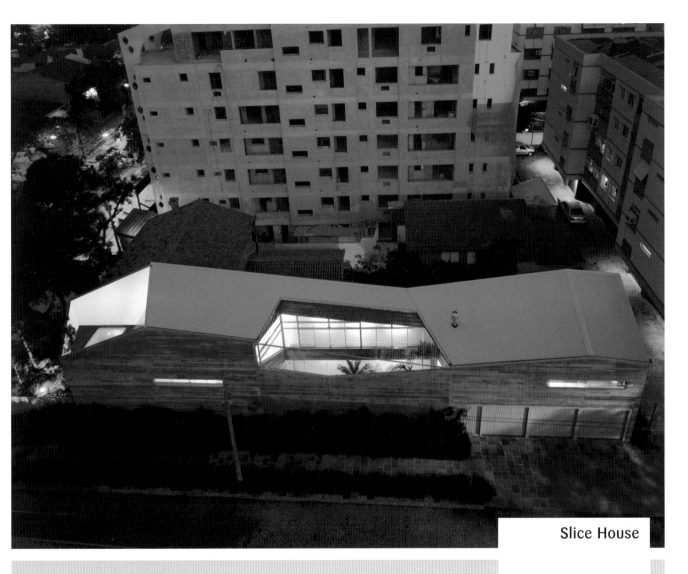

Slice House

Architect: Proctor:Rihl
Location: Porto Alegre, Brazil
Date of construction: 2004
Photography: Marcelo Nunes,
Sue Barr

This house was conceived as a "slice" built on urban lot left unused after the opening of a new road. The project makes a series of references to modern Brazilian architecture as well as adding a new element through its complex, prismatic geometry, which generates a series of spatial illusions in the interior.

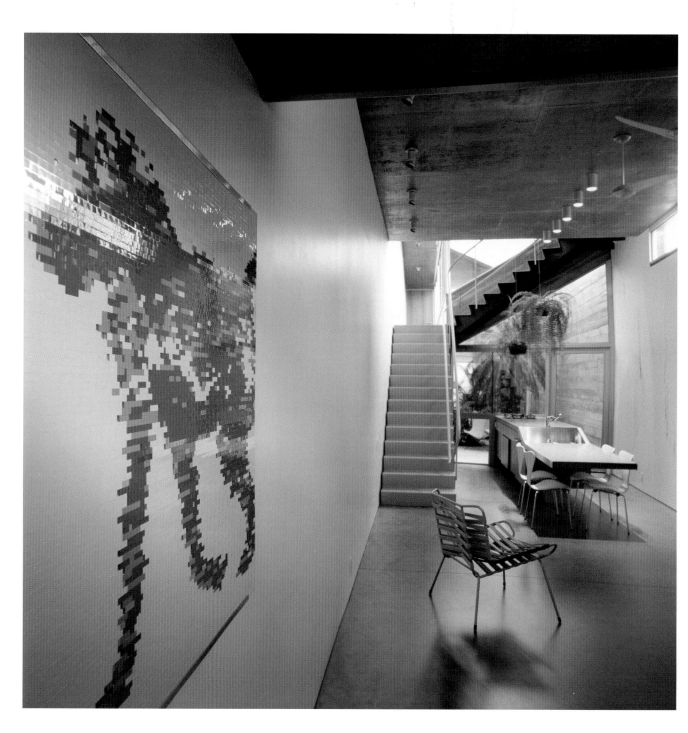

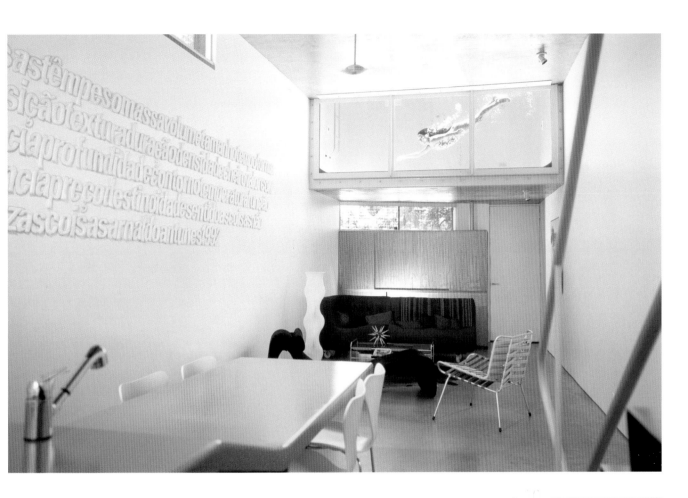

The swimming pool structure was integrated into the living area to serve as a daylight filter that creates rippled water effects during the day and as an oversized light fixture at night.

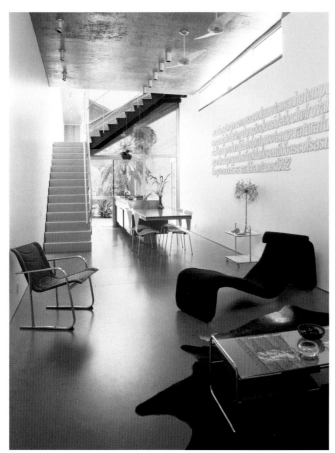

A courtyard incorporated into the center of the building generates a microclimate inside the house that allows it to remain completely open during the summer.

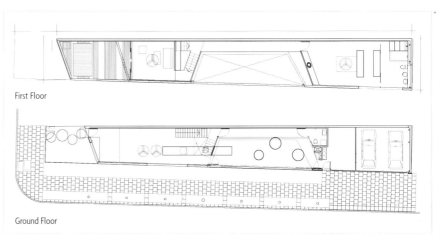

First Floor

Ground Floor

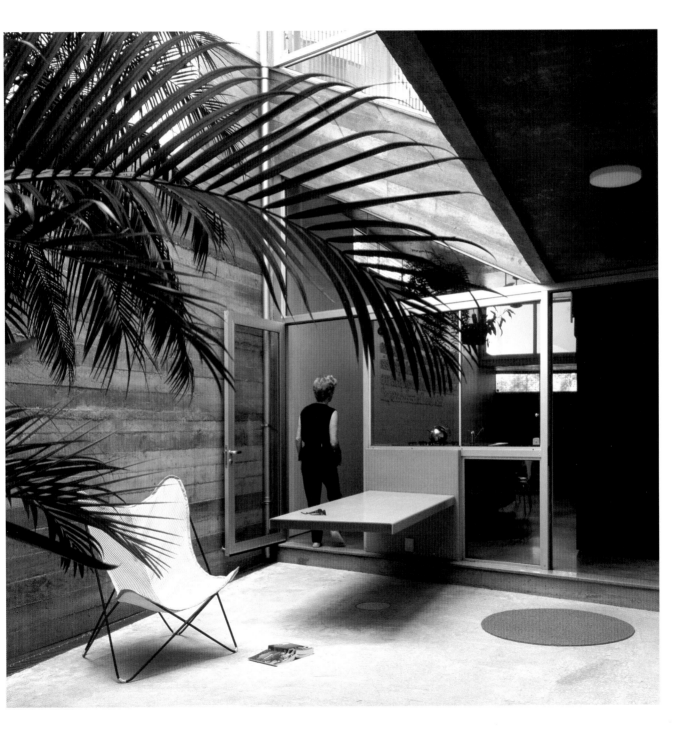

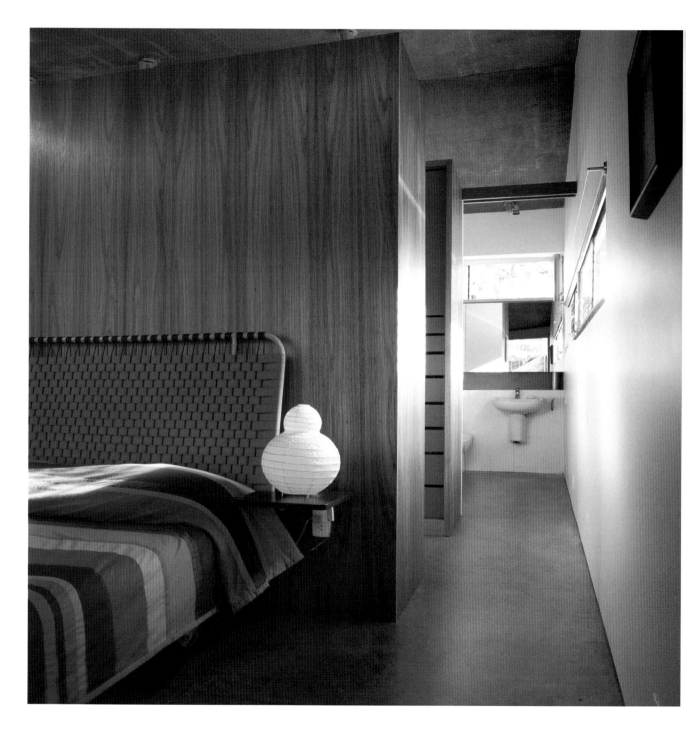

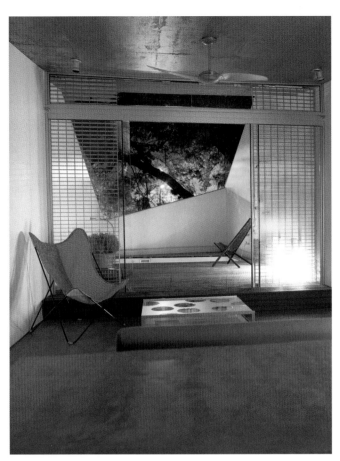

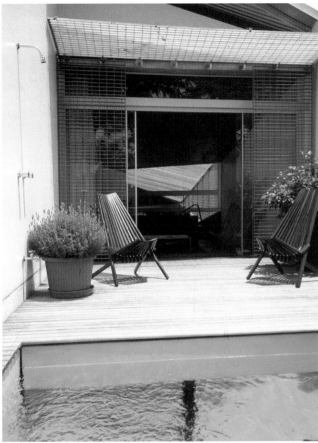

Spatial distortions, sloping angles, and innovative perspectives mark the overall design.

Section

Elevation

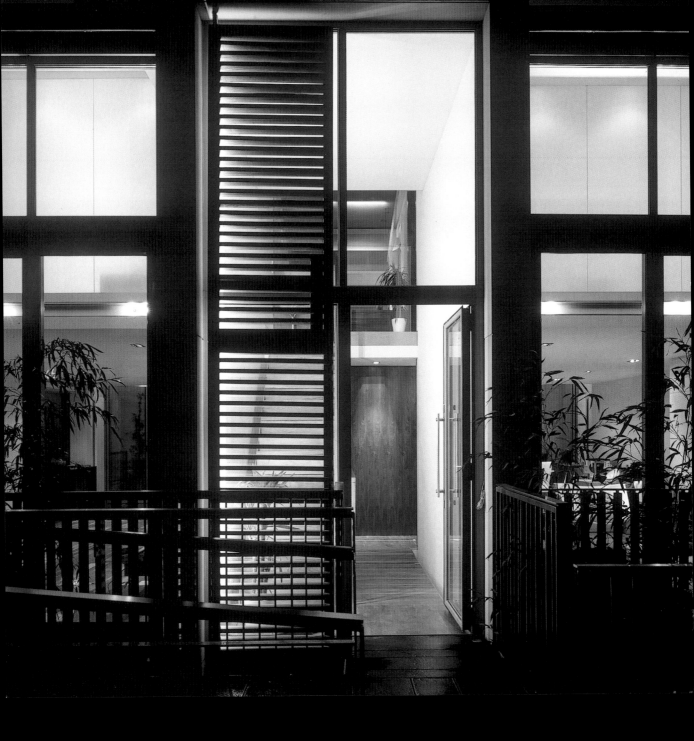

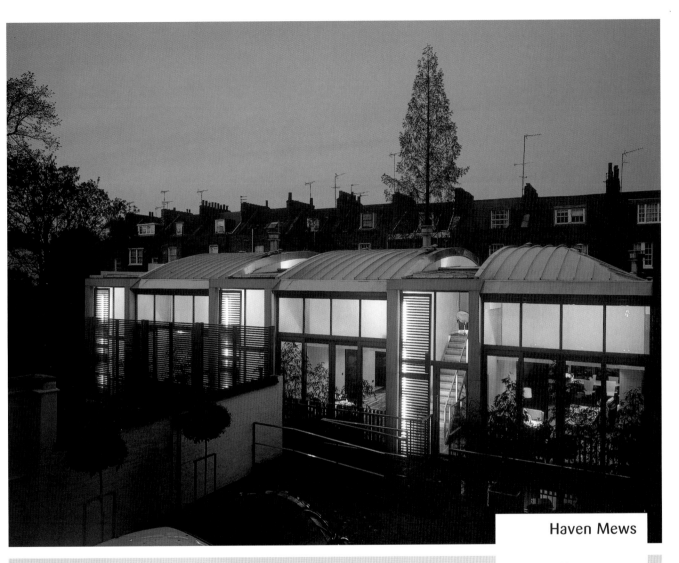

Haven Mews

Concealed from the street, these exclusive mews were designed with the objective of obtaining the penetration of natural light deep into the houses, using a combination of natural materials and establishing an interplay between indoor and outdoor spaces that encourages a sense of height and space.

Architect: Buckley Gray Yeoman
Location: London, United Kingdom
Date of construction: 2004
Photography: Chris Gascoigne/VIEW

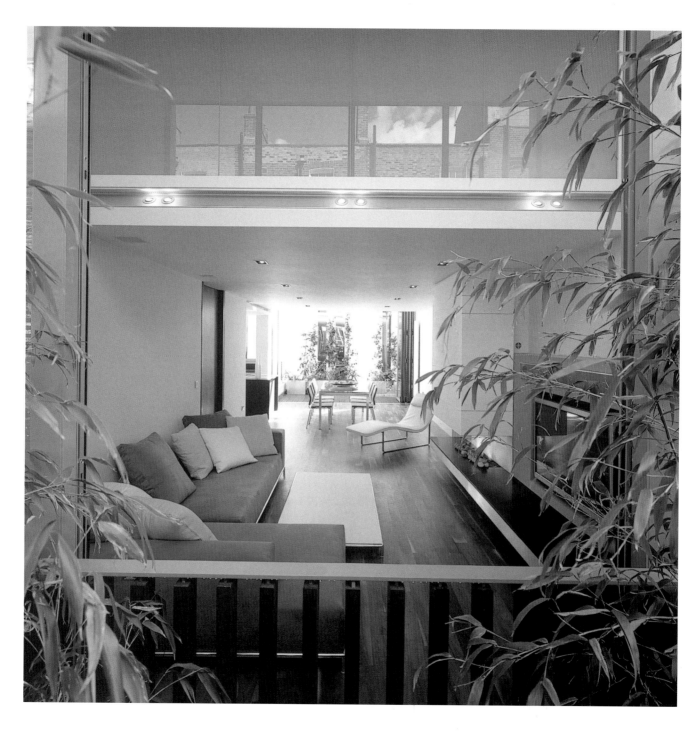

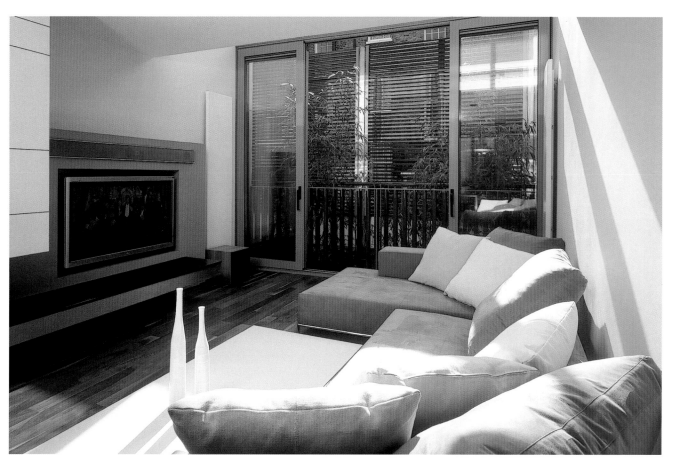

A series of internal and external rooms with aluminum-framed windows at the front and rear elevations were designed to pull light into the buildings.

Ground Floor

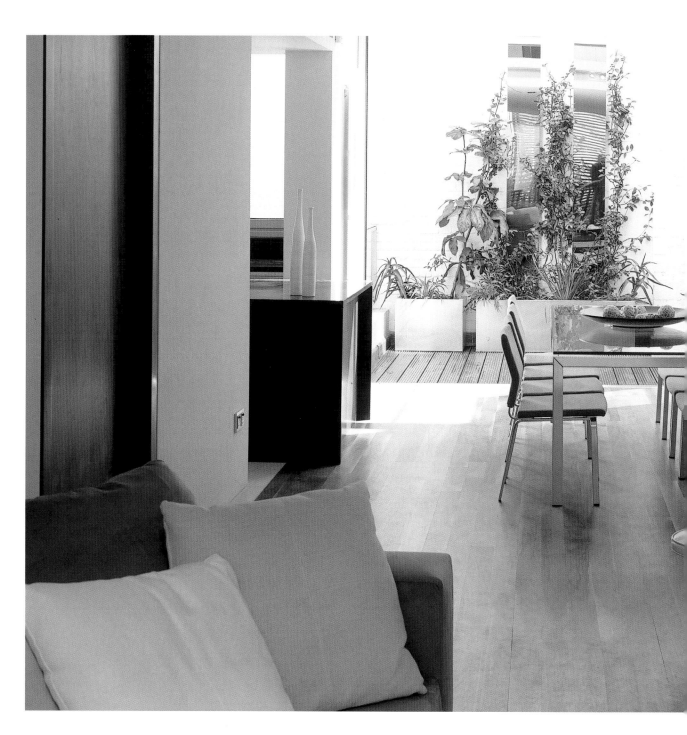

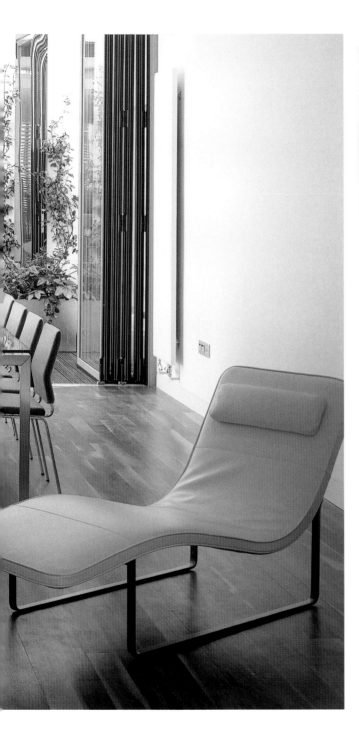

Split levels create a combination of single- and double-height rooms, encouraging a sense of vertical space and establishing site lines and interaction between the different levels of the three story dwellings. External landscaped areas adjoin every floor.

First Floor

A sense of clarity is created by the clean lines delineating the glass, limestone and iroko louvering of the ordered façade, which reflects the materials used throughout the interior.

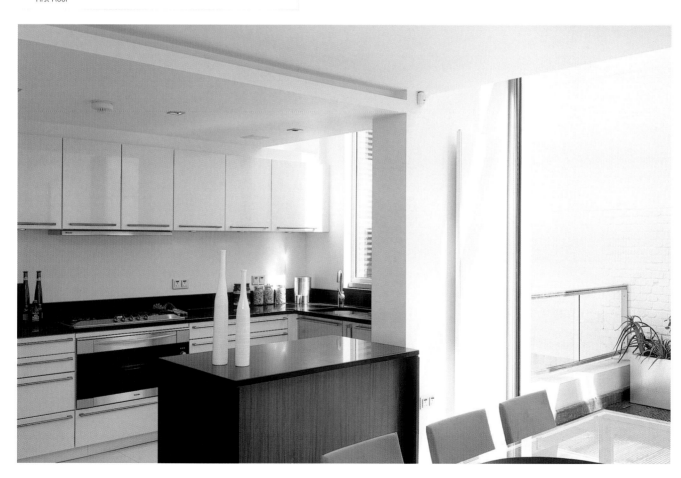

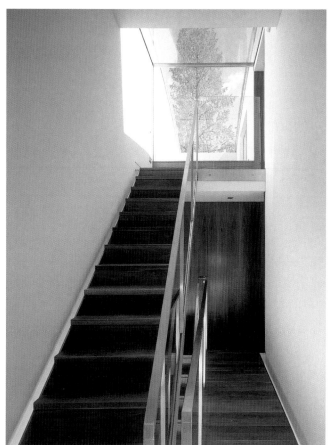

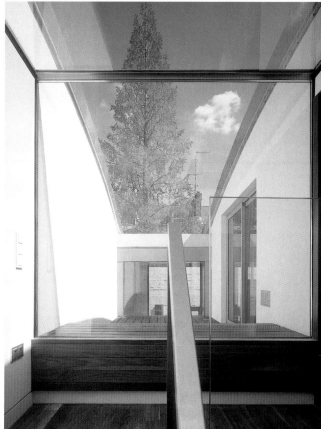

Reached by a bridge walkway, the glazed entrances open into a double-height, top-lit space with a view onto the roof terrace above.

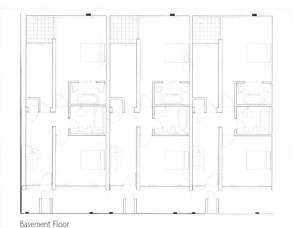

Basement Floor

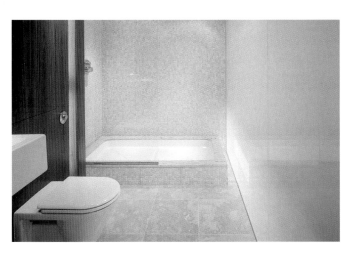

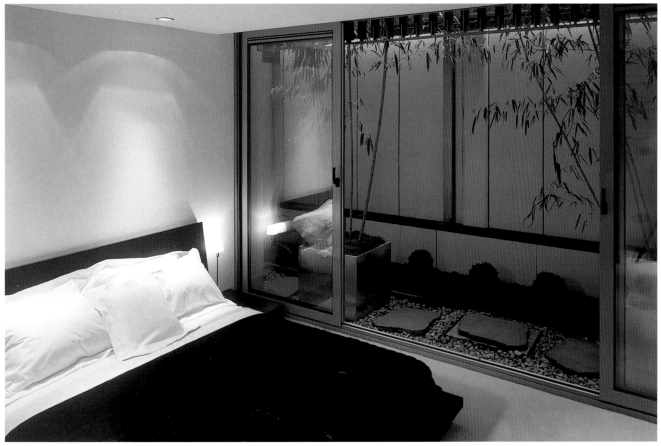

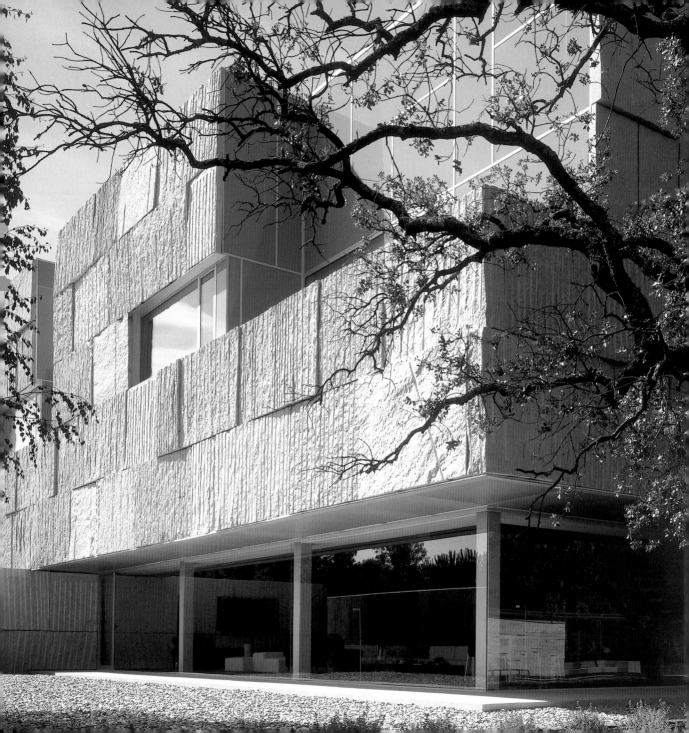

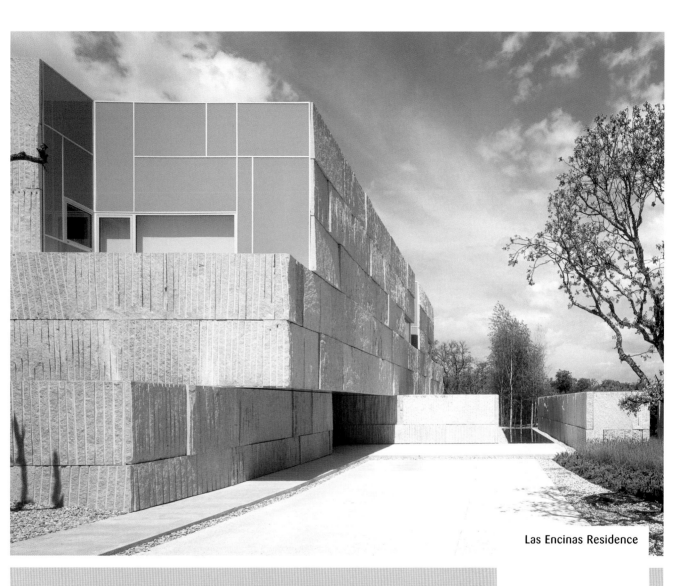

Las Encinas Residence

A generously sized lot accommodates this two-story suburban Madrid house, which takes the shape and appearance of a solid block of granite, intermittently interrupted by sheets of glass that reveal its residential interior.

Architect: Vicens + Ramos
Location: Madrid, Spain
Date of construction: 2003
Photography: Eugeni Pons

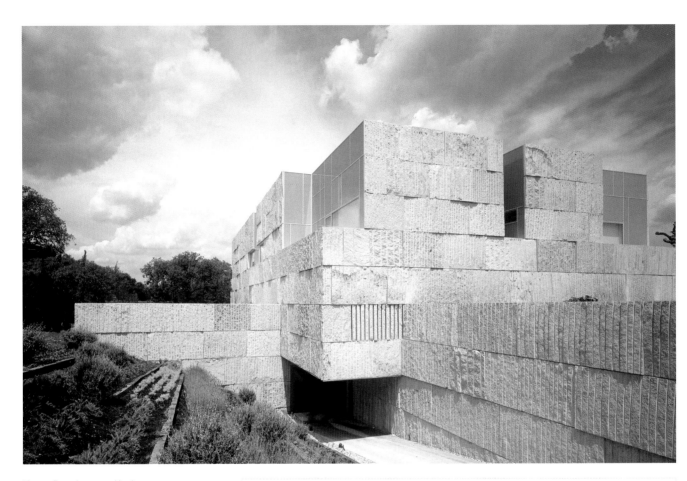

The two floors above ground level are supported by a basement floor that consists of a garage, a sunken patio, and a vertical passageway that leads to the upper levels.

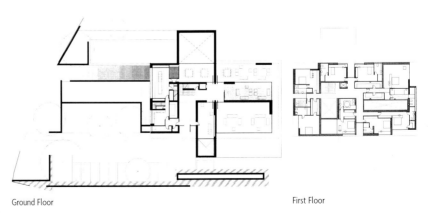

Ground Floor

First Floor

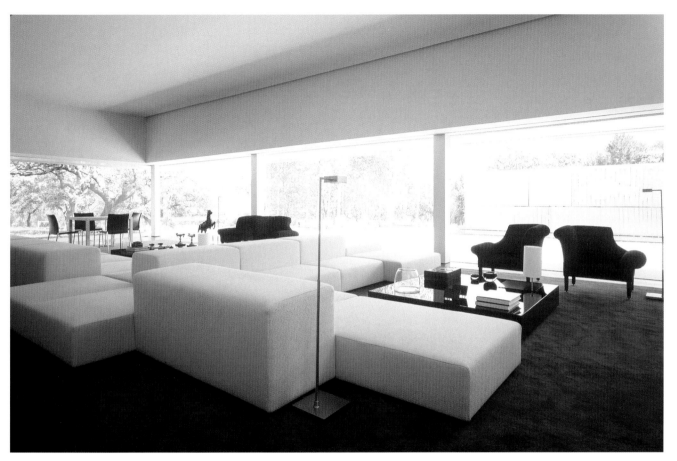

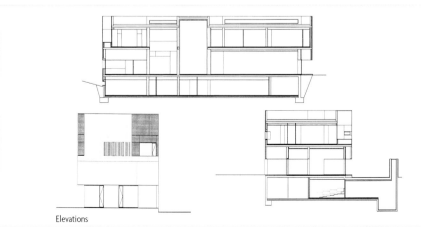

Elevations

In contrast to most contemporary homes, this house favors the use of carpet over bare floors: Using a solid, rich color with a minimalist décor can yield a very modern environment.

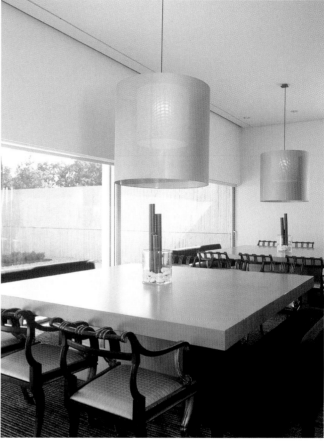

Mixing contemporary elements
with antique can create a fresh
and unique interior design.

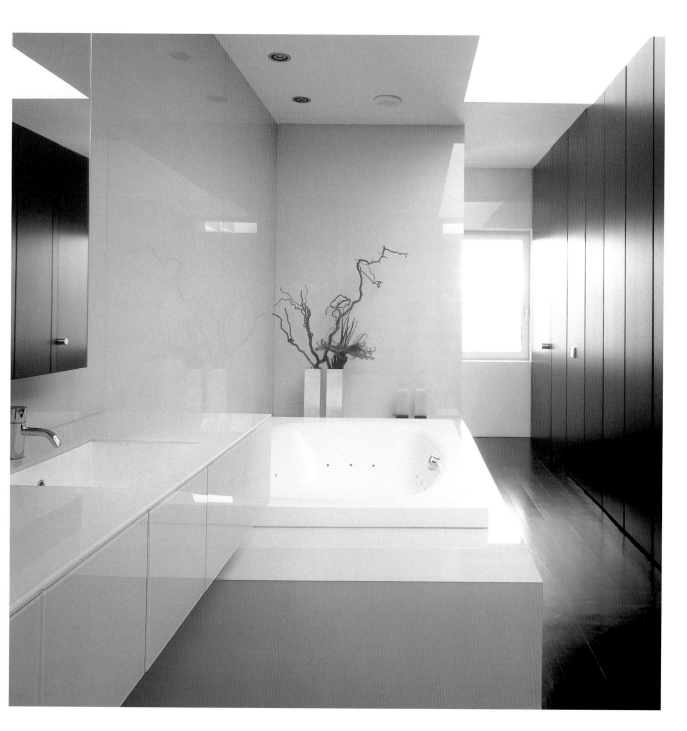

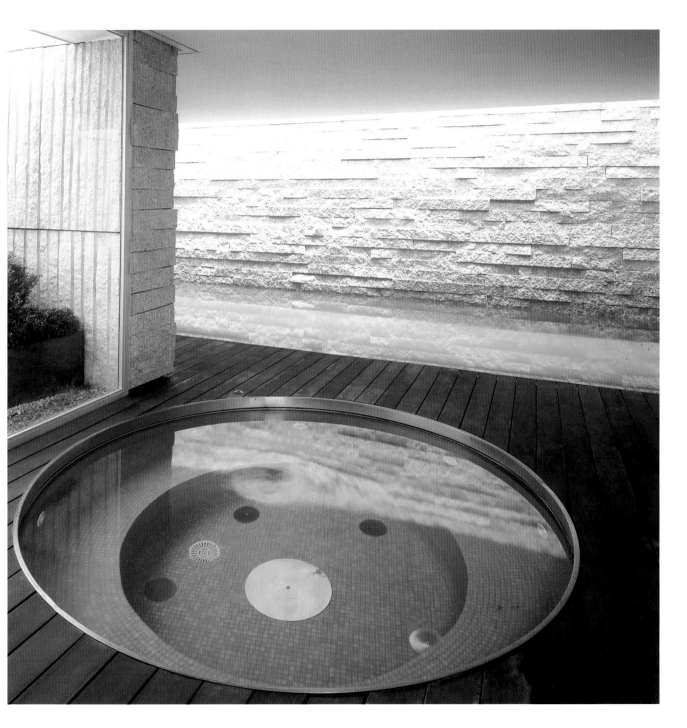

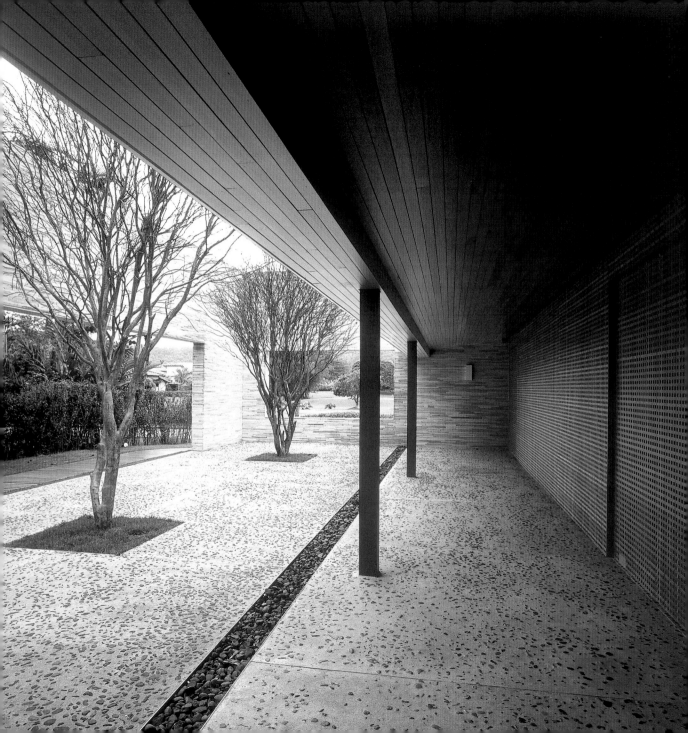

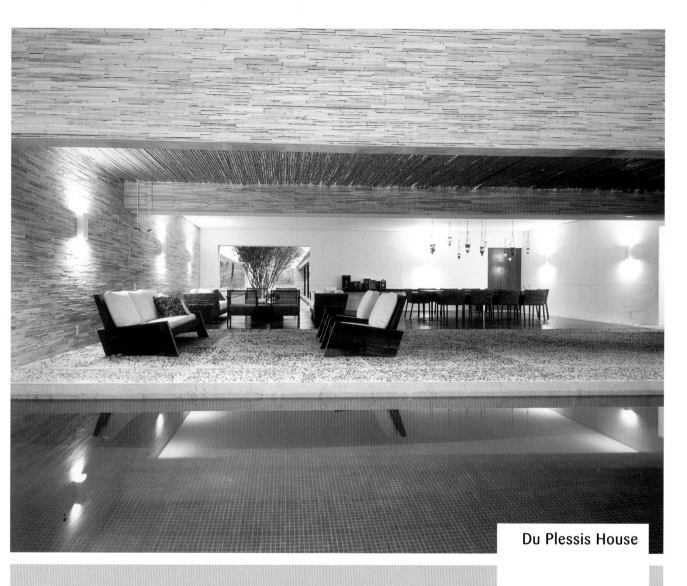

Architect: Marcio Kogan
Location: São Paulo, Brazil
Date of construction: 2003
Photography: Arnaldo Pappalardo

Set in a typically tropical property of São Paulo, this house exhibits a dual yet complementary aspect that combines an austere, contemporary structure with a landscaped patio that expresses a clearly traditional style.

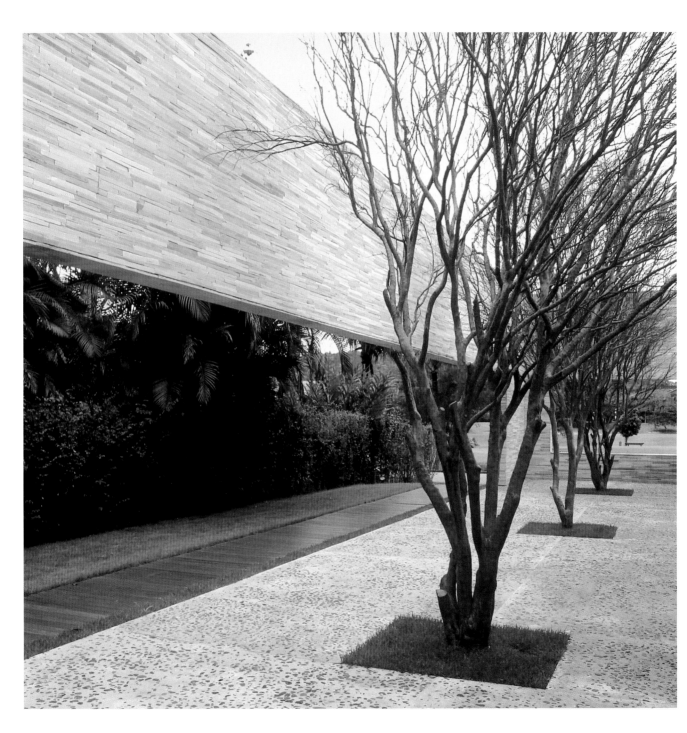

The exterior of the house is faced with mineira stone, a material typical of the region.

Elevation

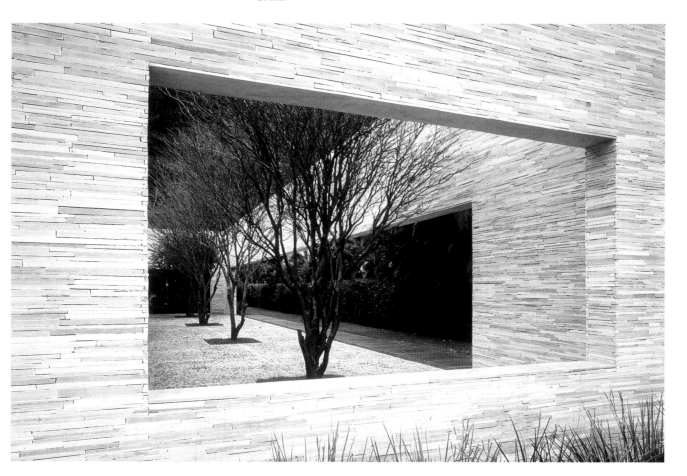

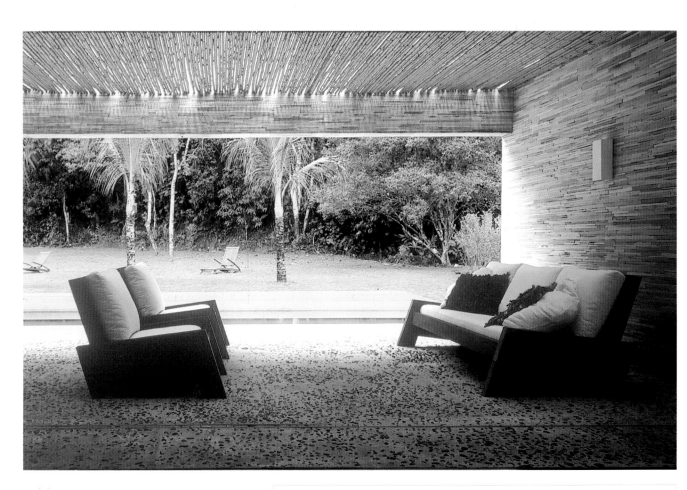

16

Cement, natural stone, and bamboo combine to produce a feeling of warmth in the interior and reflect the local materials of the area.

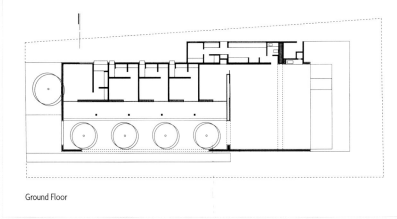

Ground Floor

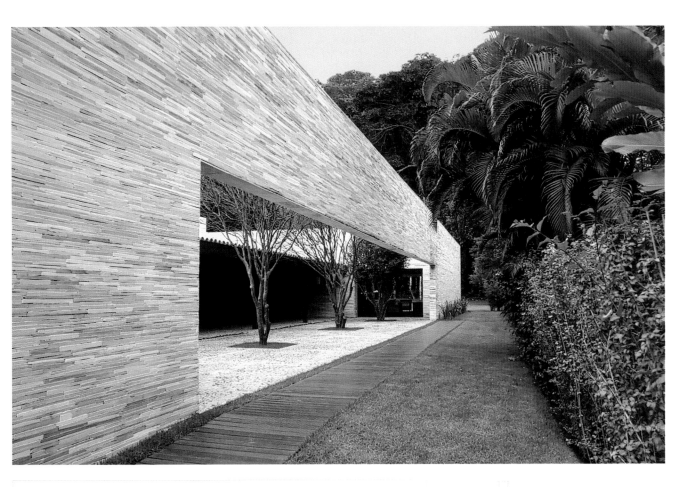

The portico structure adds an air of intimacy to the exterior patio, simultaneously integrating it with the interior spaces.

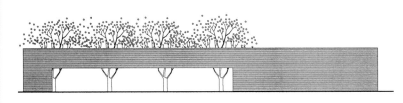

Elevations

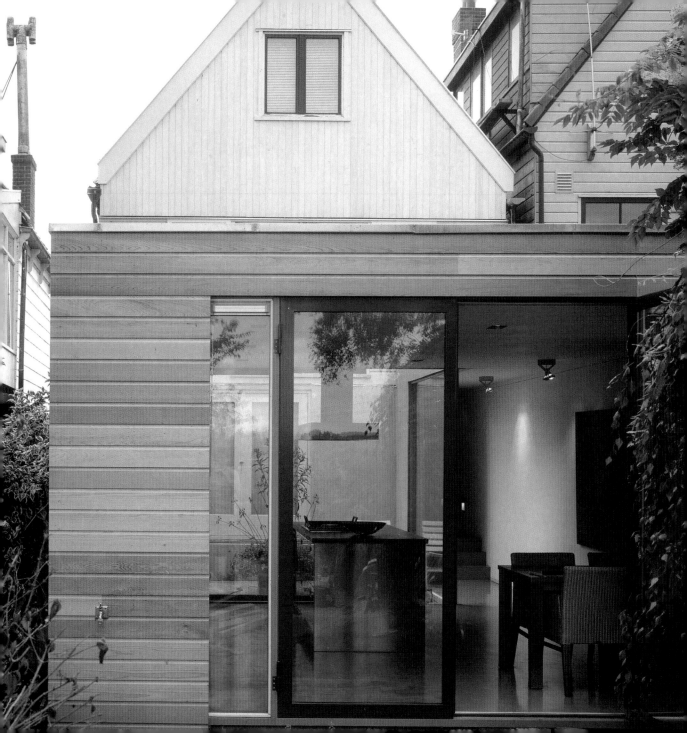

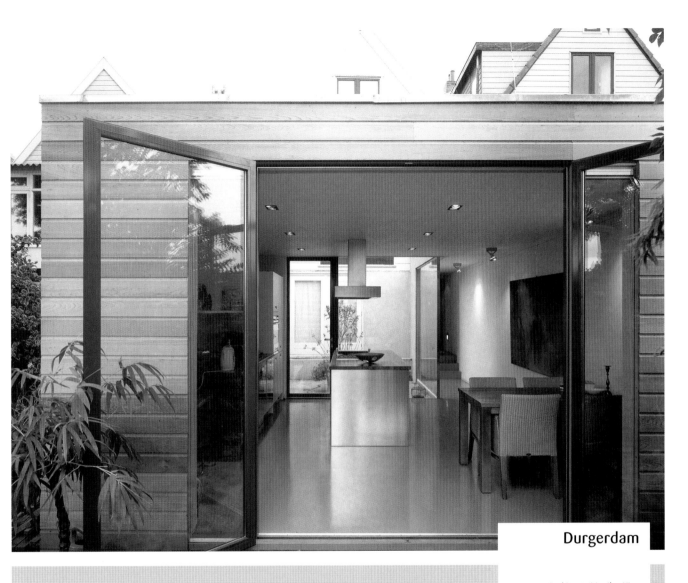

This project consists of a typical dike house located along the Durgerdam dike in Amsterdam. The addition of a new kitchen and dining area as a separate structure from the house creates a dynamic relationship between both spaces, which are linked by a small patio. The new addition features contemporary finishes such as stainless steel and glass combined with wood.

Architect: Moriko Kira
Location: Amsterdam, Netherlands
Date of construction: 2003
Photography: Luuk Kramer

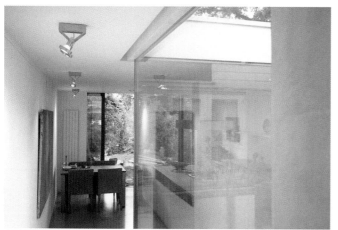

By linking the new structure to the main house with a single staircase, the architects managed to create an intermediate patio that allows natural light to flow through either side of the kitchen. The transition in the landscape from the front to the rear of the house is enhanced by the addition, which creates a sequence of spatial events.

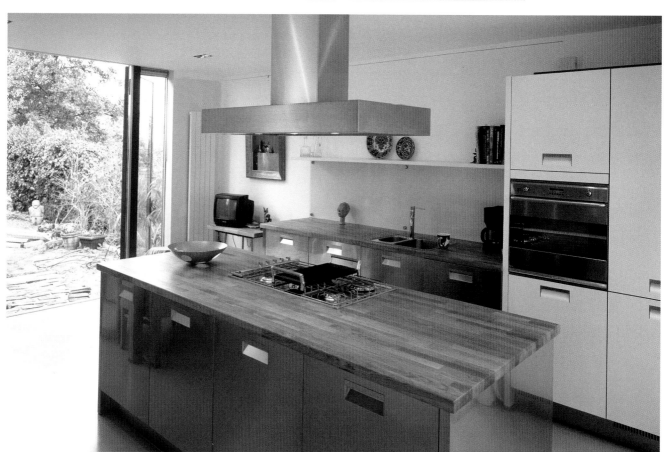

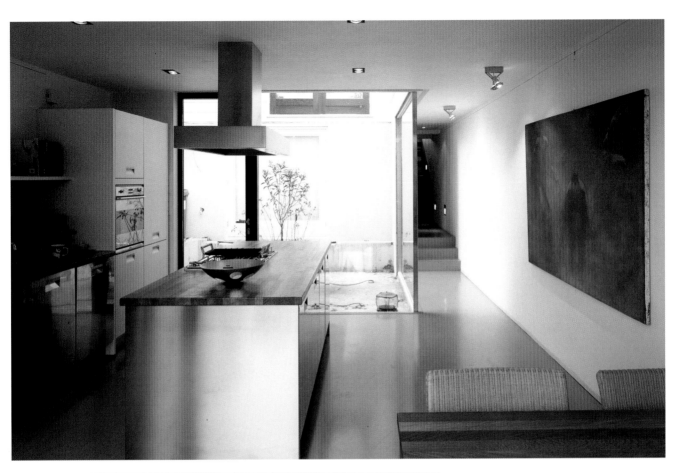

The bathroom, bedroom, patio, and new live-in kitchen are characterized by their varying relationships with the surrounding landscape.

tuin

3
2
1

Ground Floor

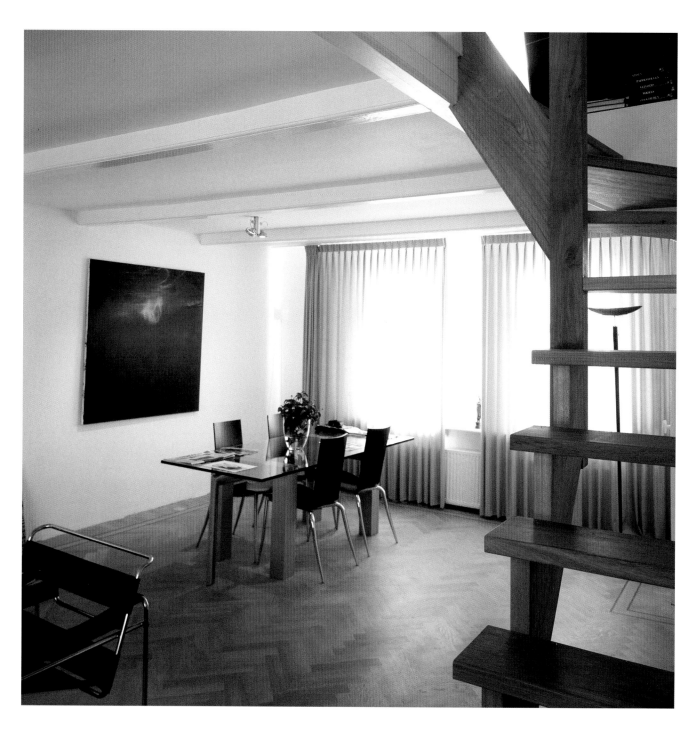

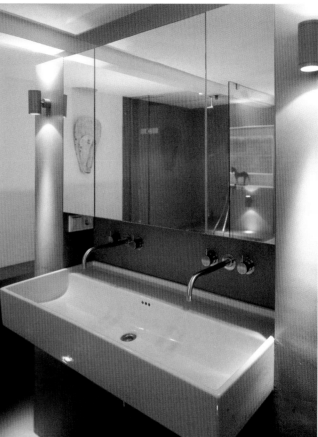

Sections

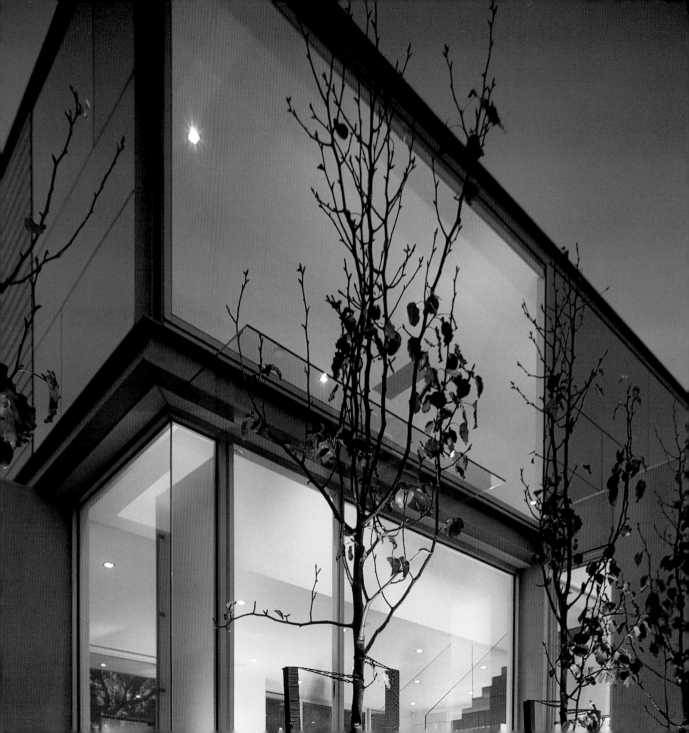

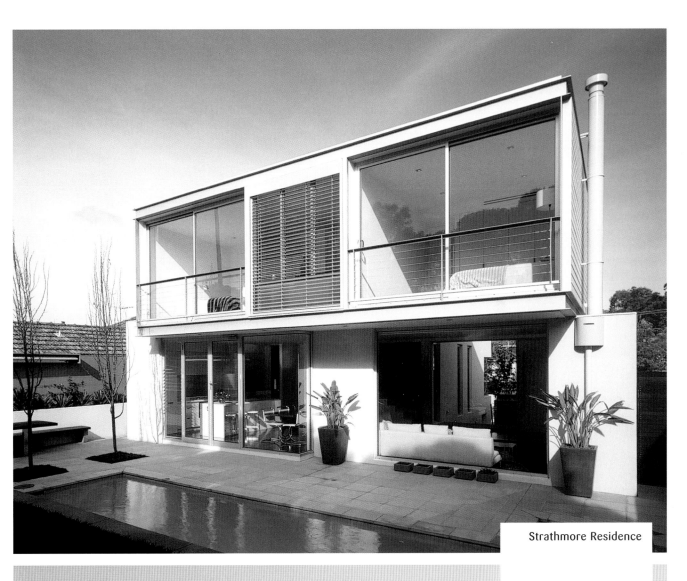

Strathmore Residence

An existing brick residence built in the early 1970s was reconstructed almost in its entirety through a subtle manipulation of the cube and by redefining the original order of the home. The aim was to create as much living space as possible while maximizing natural light throughout the residence.

Architect: BBP Architects
Location: Victoria, Australia
Date of construction: 2004
Photography: Cristopher Ott

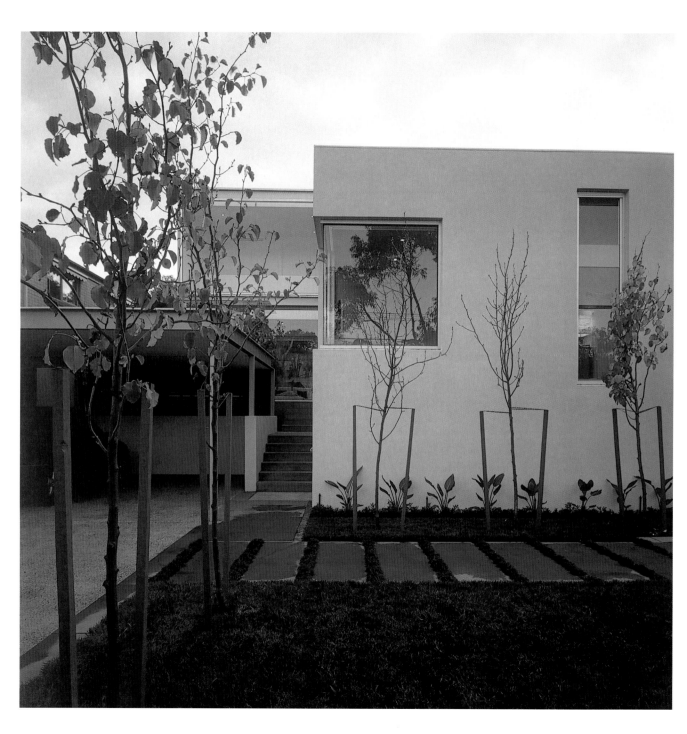

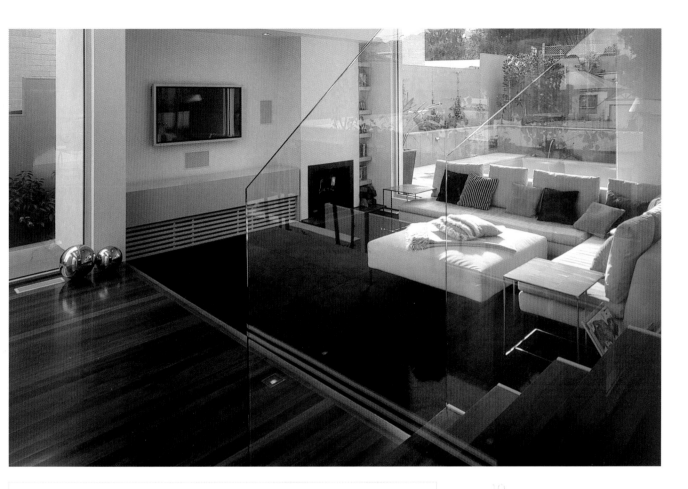

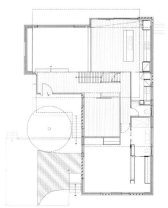

Ground Floor

The use of minimalist materials such as glass, steel, and metal cladding provides transparency and a modernist esthetic throughout.

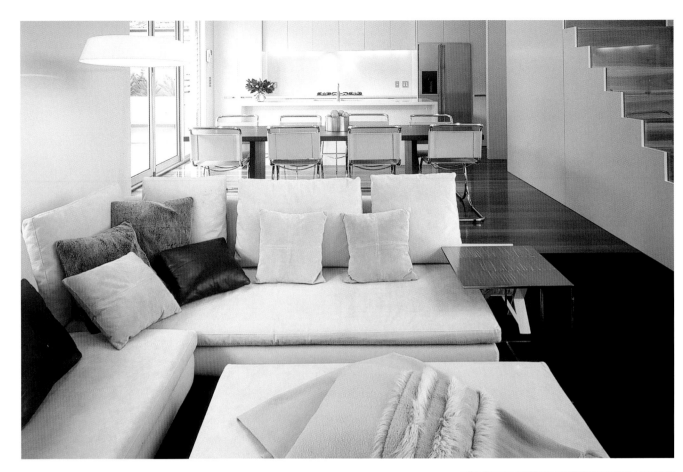

The ground floor incorporates an open-plan family, kitchen, and dining area, and a study and master bedroom. The dining area enjoys direct access to the landscaped patio.

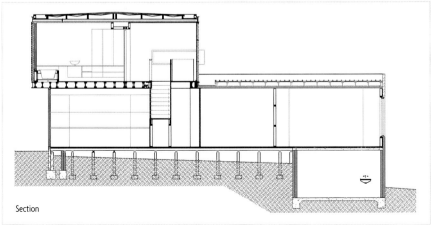

Section

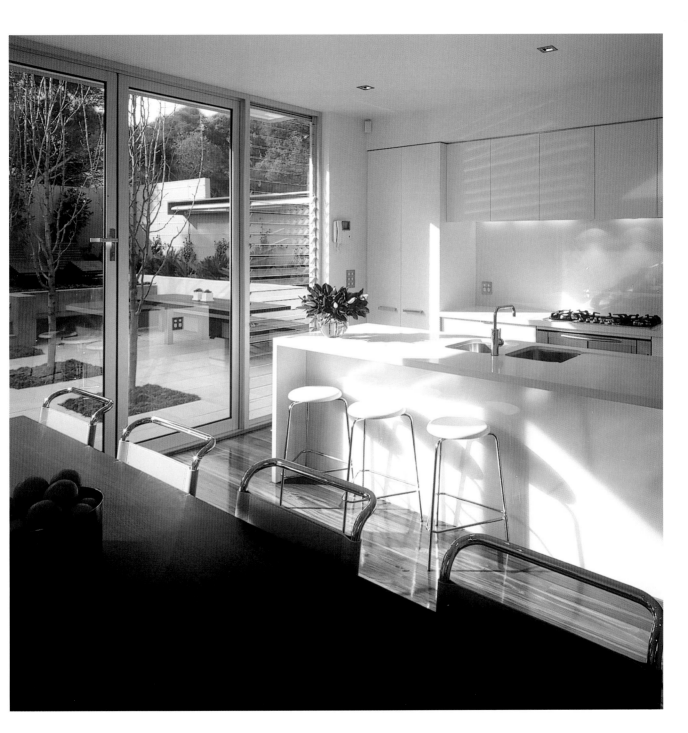

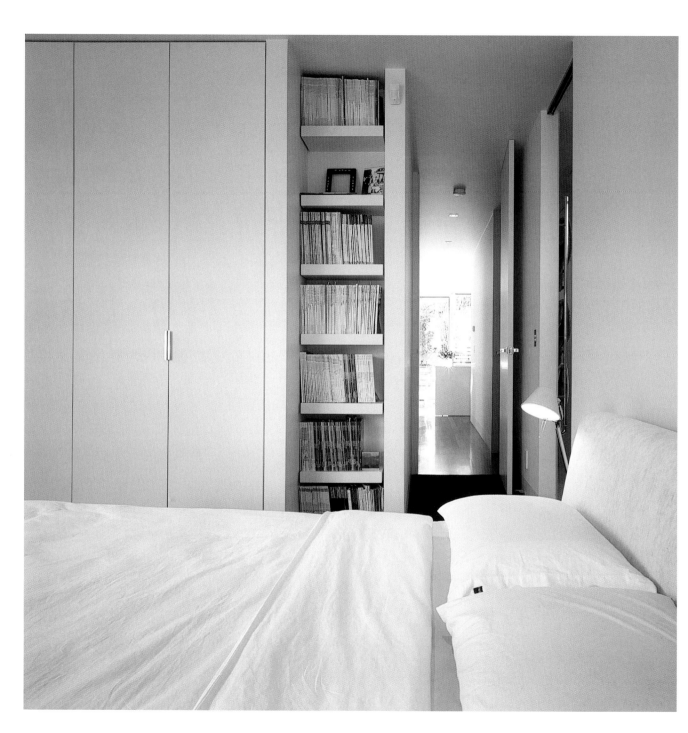

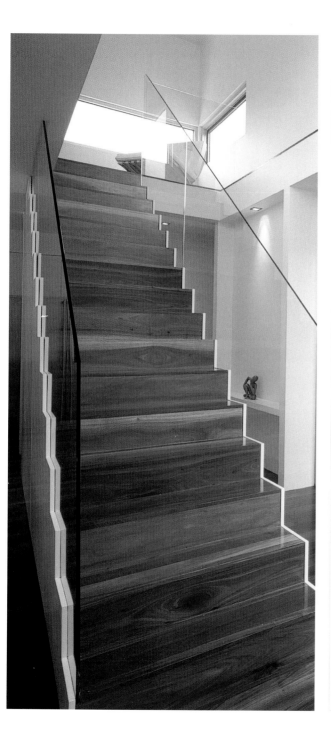

Thanks to the glass handrails and abundance of windows, the staircase does not visually obstruct the main space.

First Floor

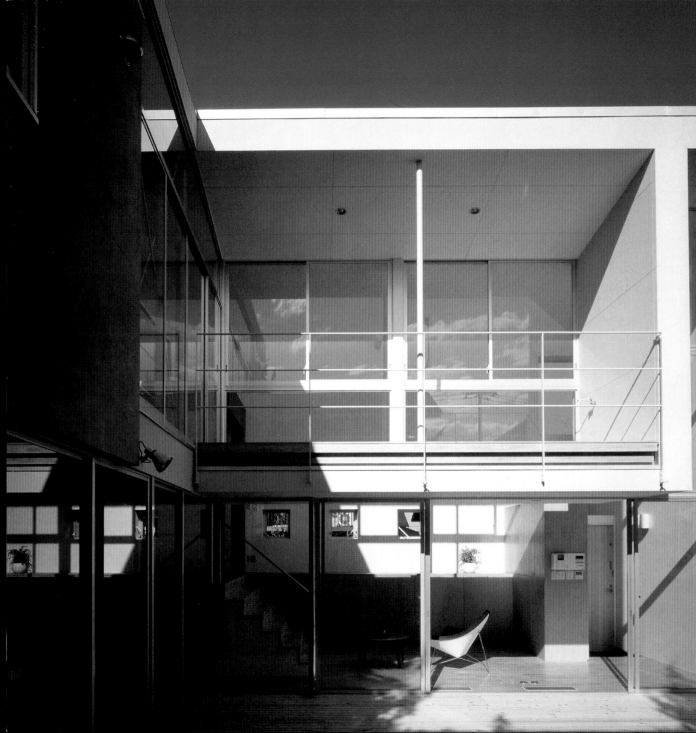

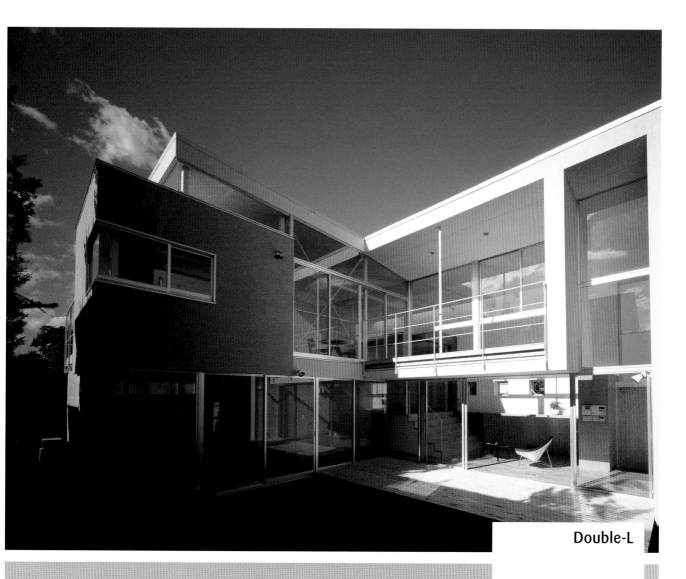

Double-L

Located in Yokohama, one of Tokyo's rapidly growing suburbs, this project bases its approach on a review of the conditions of the site and the creation of a series of functions relating to each other and to the exterior. Its L-shaped configuration allows for a versatile and open-plan interior.

Architect: Noriyuki Tajima/
tele-design
Location: Yokohama, Japan
Date of construction: 2002
Photography: Tatsuya Naoki

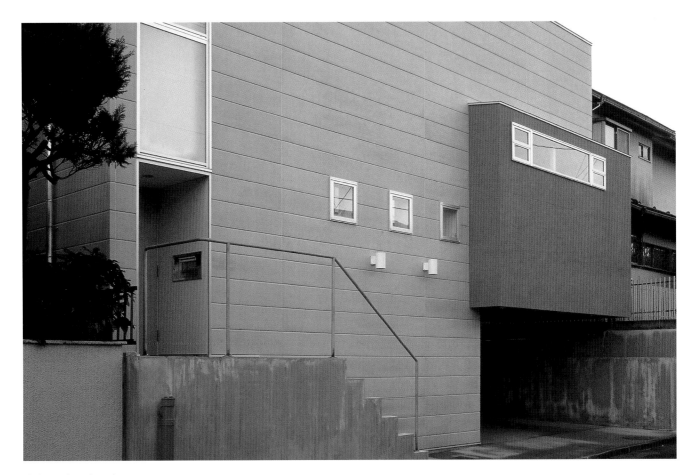

The house is focused inward to
ensure privacy and so that the
enclosed, austere exterior reflects
the surrounding structures.

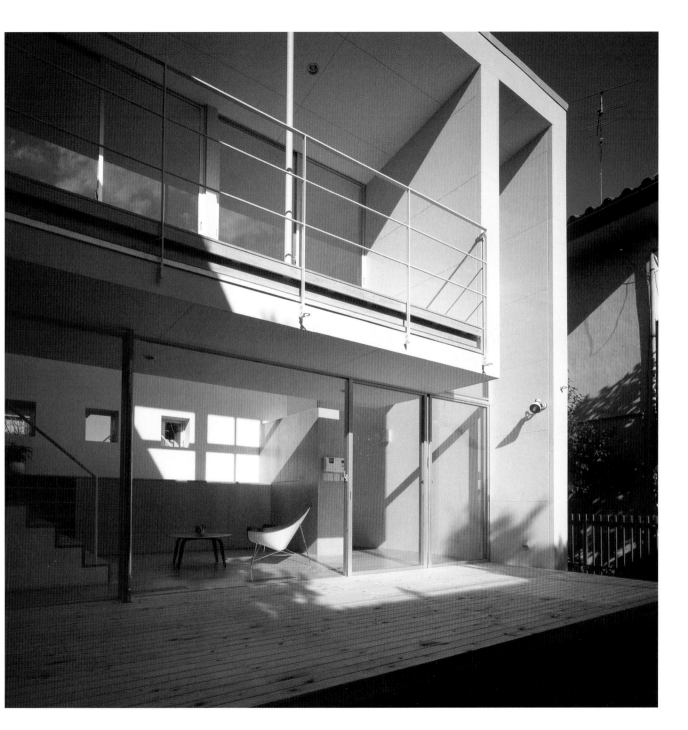

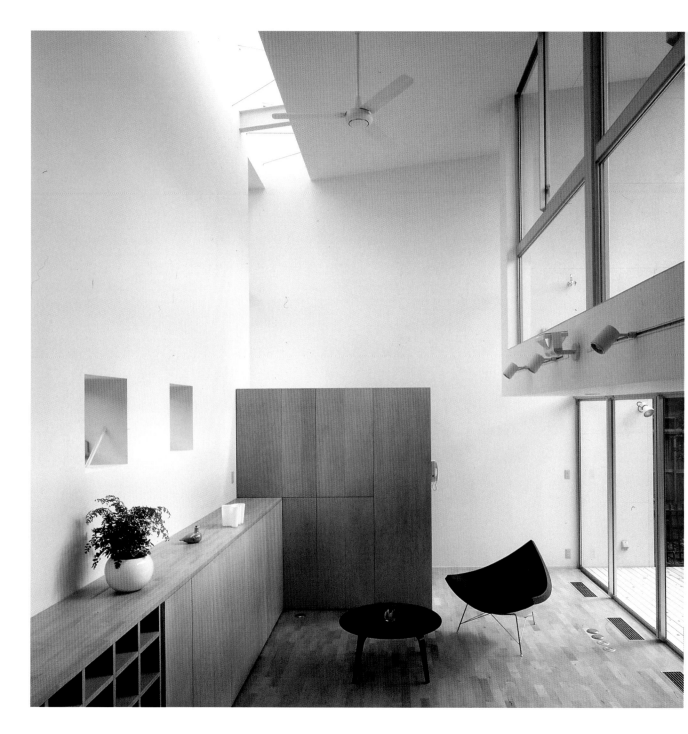

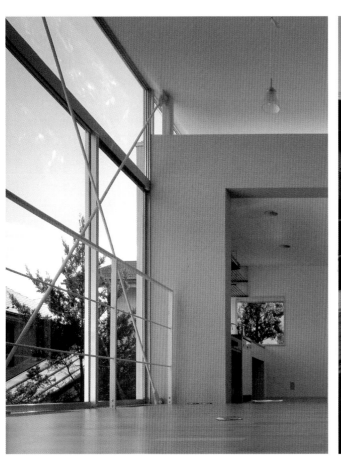

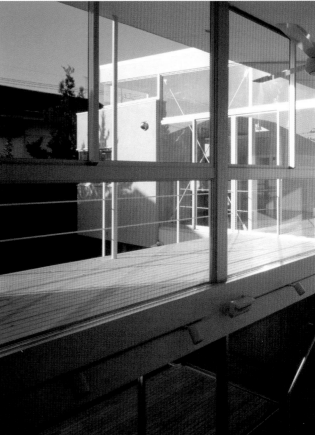

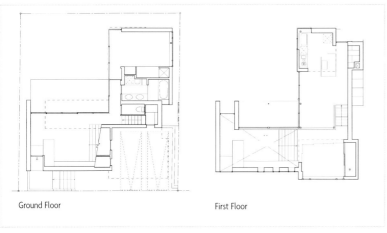

Ground Floor

First Floor

High ceilings can be further emphasized by portico structures that may also serve to make the space more intimate or to delineate different zones.

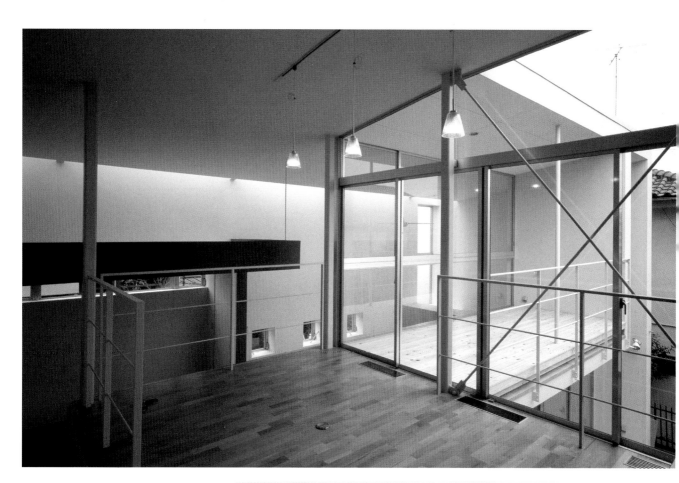

The L-shape of the house allowed for the creation of multiple terraces that look onto the patio and play off of each other enabling each room to be used for various purposes.

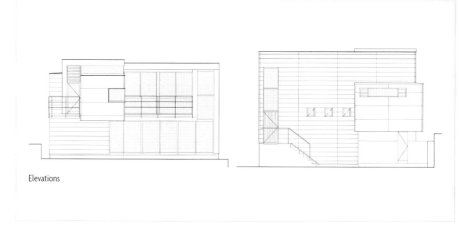

Elevations

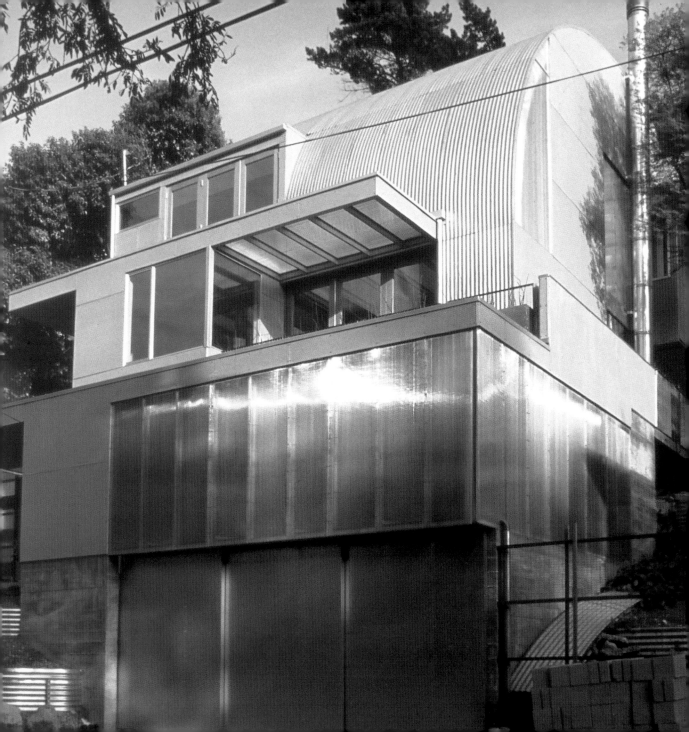

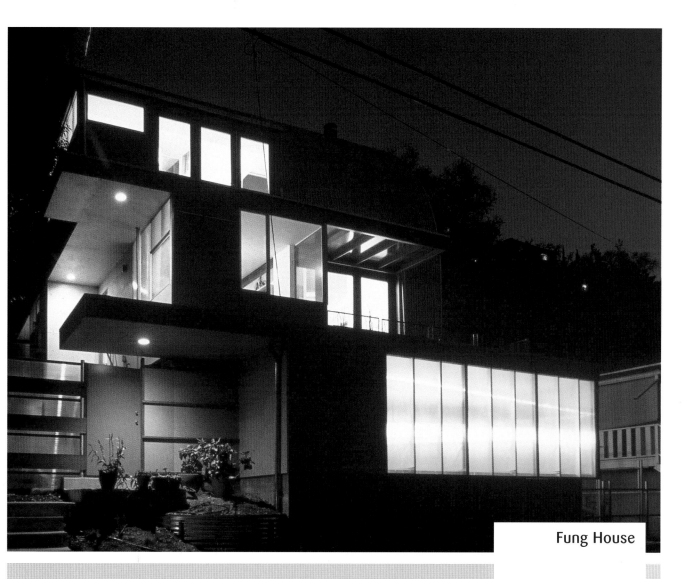

Fung House

This house in Mt. Washington, a hilly area near the center of Los Angeles was, constructed around a concrete and steel modular framework and conceived as a flexible and expandable environment that would evolve according to the owners' future requirements.

Architect: Fung+Blatt Architects
Location: Los Angeles, CA,
United States
Date of construction: 2003
Photography: Deborah Bird

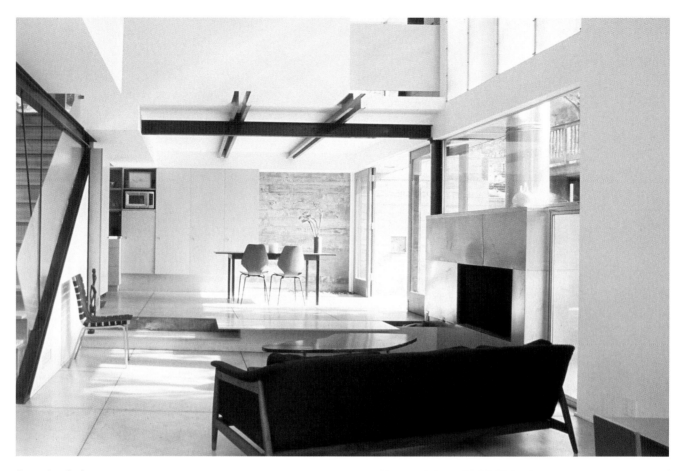

Constructing only what was necessary, the designers treated outdoor areas as extensions of the interior space. The traffic areas fulfill a double function, and the garage and attic were designed to house other functions in the future.

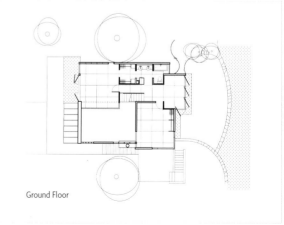

Ground Floor

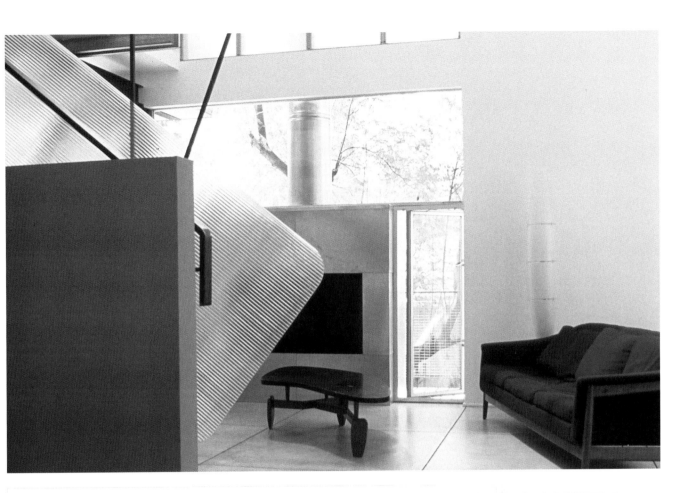

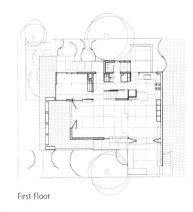

First Floor

Second Floor

By making full use of the possible extensions toward the outdoors and reducing the unused space to a minimum, a modestly sized functional building was achieved.

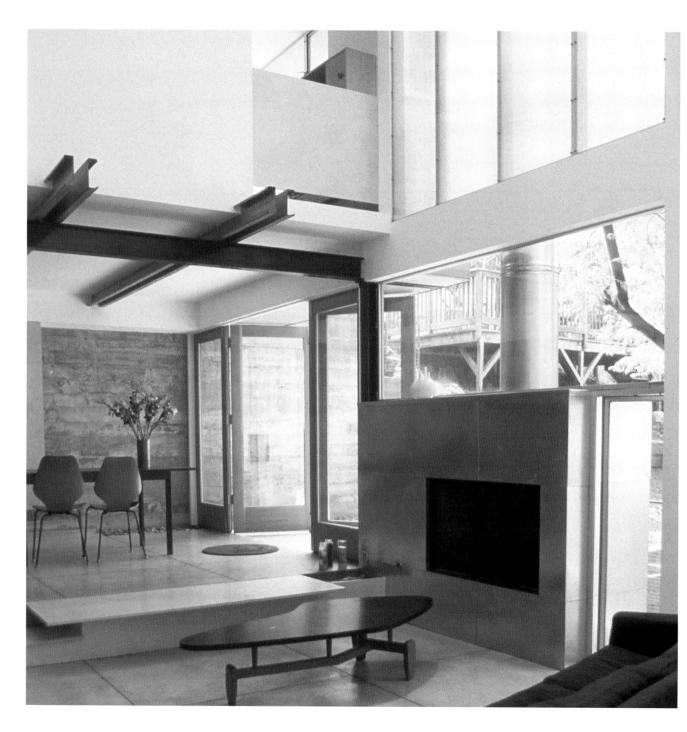

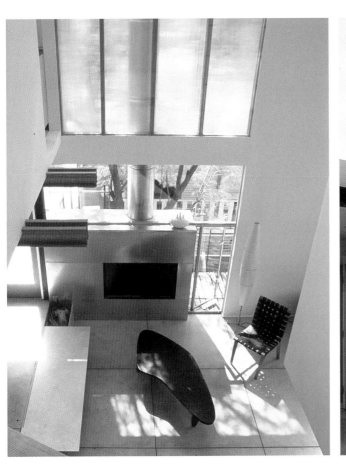

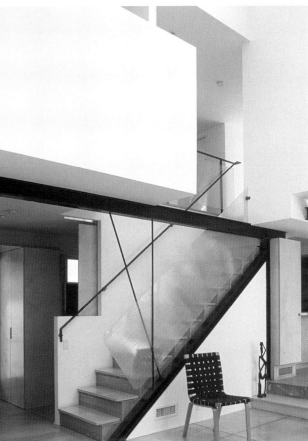

An emphasis on color and contrast can be used to distinguish the different areas of a home.

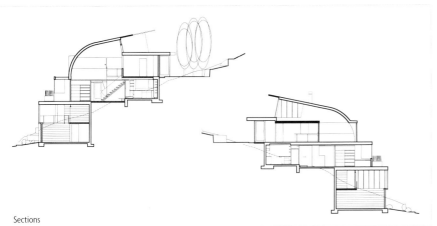

Sections

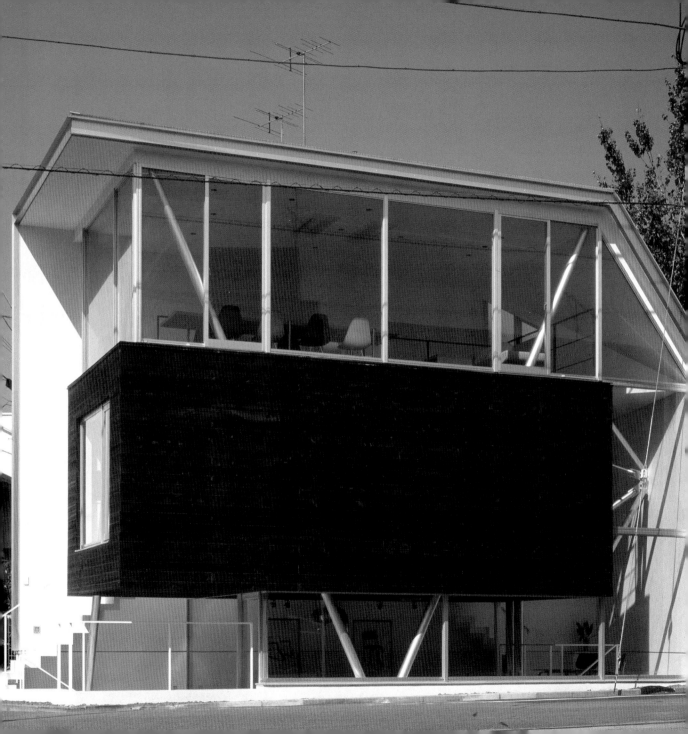

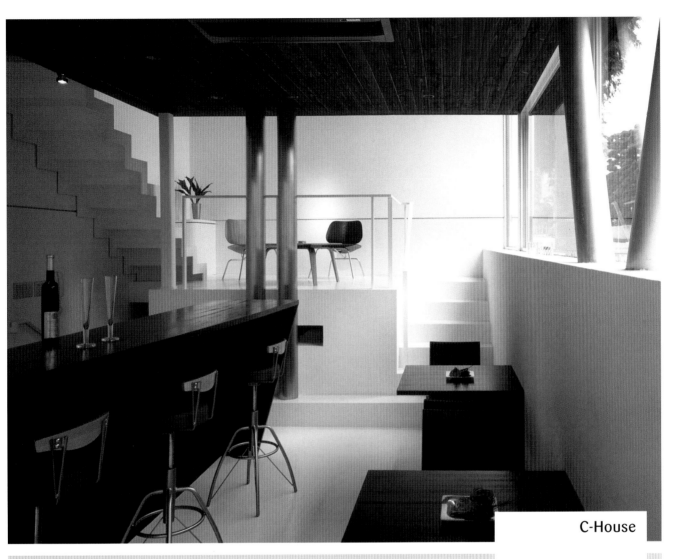

C-House

The C-House is a small yet complex urban building that is used as a residential studio and as a commercial café, both of which belong to the same client. Situated on the outskirts of Tokyo, the objective of the design plan was to minimize the traffic noise and introduce as much daylight as possible into the residence.

Architect: Toshimitsu Kuno,
Nobuki Nomura/tele-design
Location: Tokyo, Japan
Date of construction: 2002
Photography: Tatsuya Naoki,
Tamotsu Matsumoto

Combining the functions of a residence and commercial space is a genuine reflection of Tokyo's contemporary urban lifestyle.

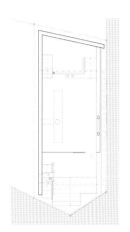

Ground Floor

First Floor

Second Floor

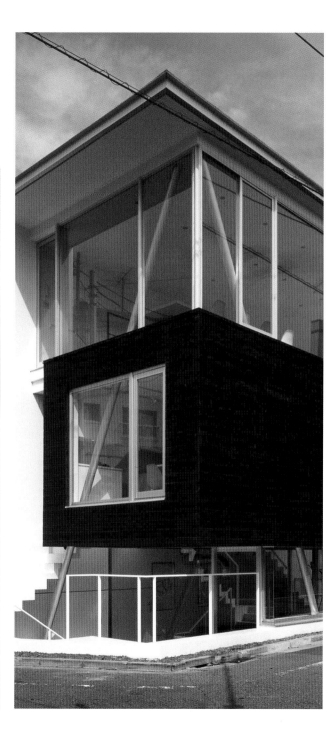

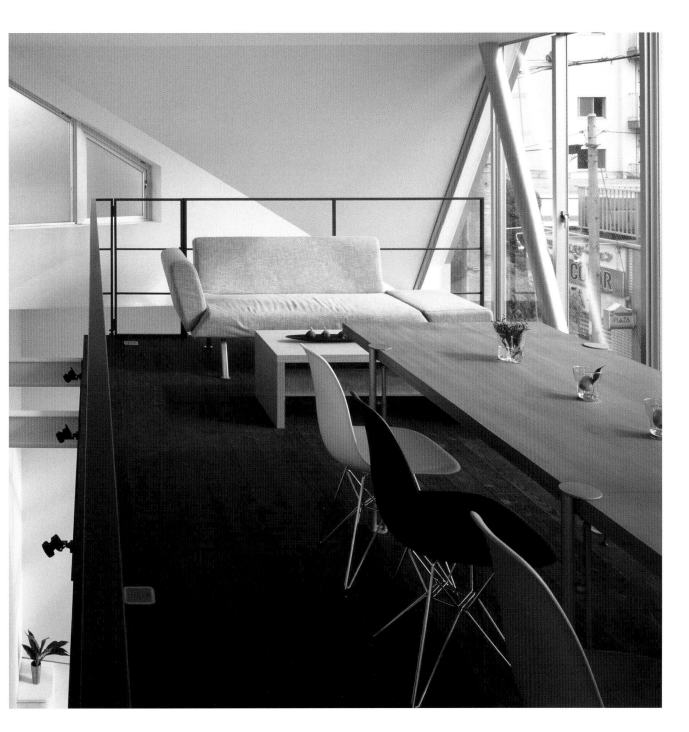

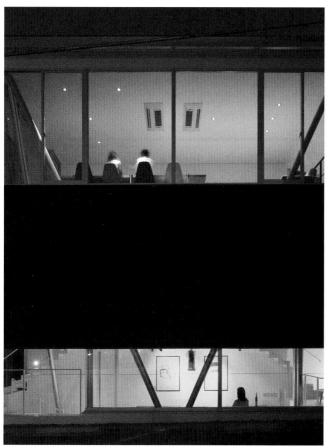
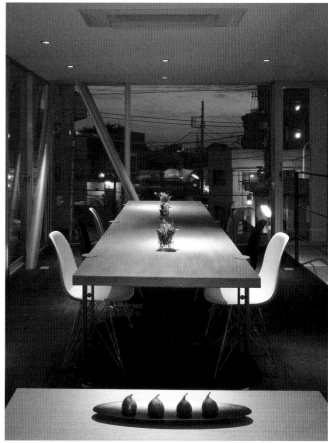

The opaque space that houses
the private functions of
the residence ensures greater
privacy to those who live
there. Light is introduced
through lateral openings.

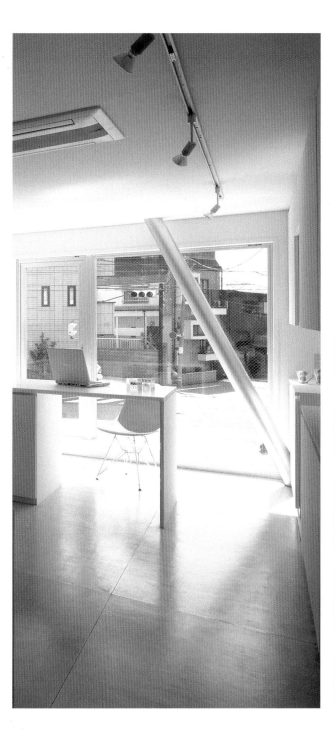

Steel braces were used to anchor the structure and link the levels of the building, also providing a striking visual attribute from the exterior.

Longitudinal Section

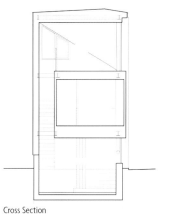

Cross Section

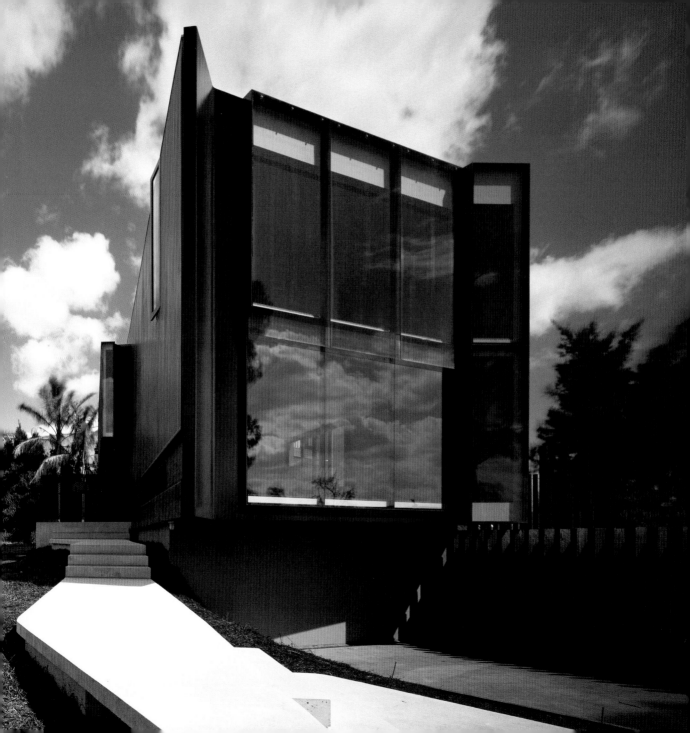

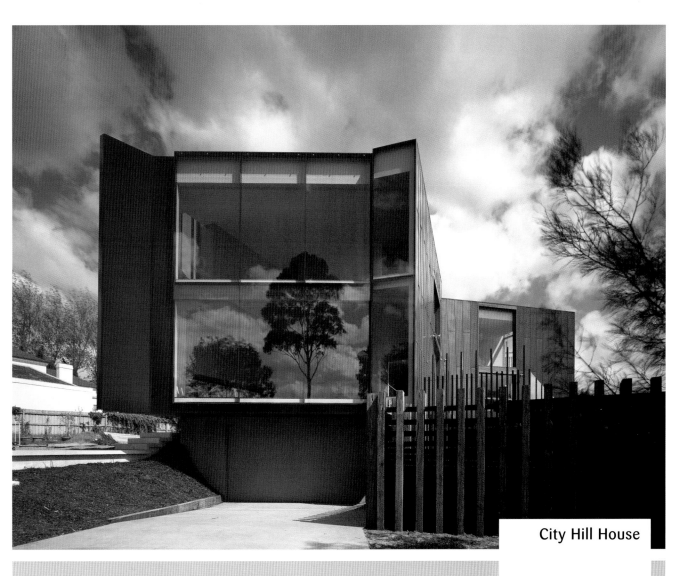

City Hill House

This project was planned by the architects as an in-depth exploration of the different ways of experiencing views, both those obtained from the house and those of the house itself. The large structure is wrapped in copper bands to create alternating views and form an unusual composition and internal layout.

Architect: John Wardle Architects
Location: Melbourne, Australia
Date of construction: 2003
Photography: Trevor Mein

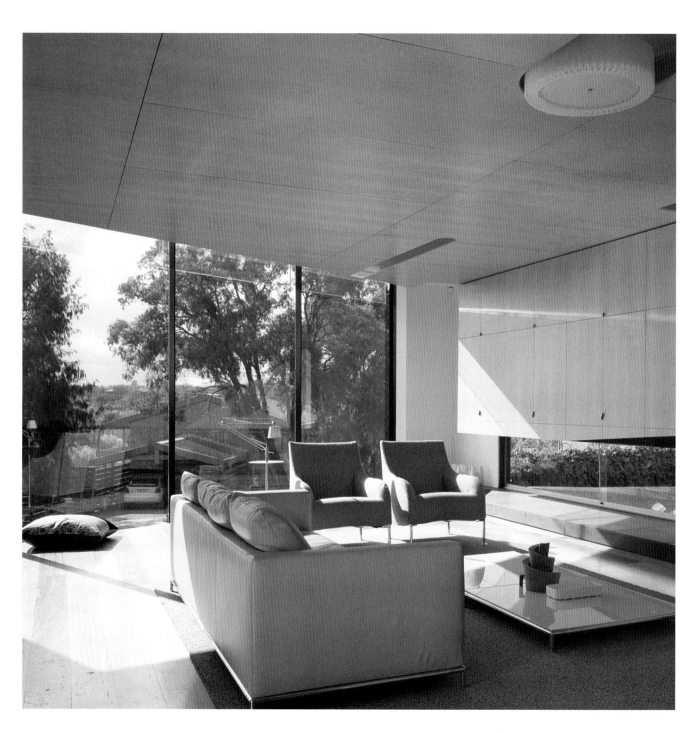

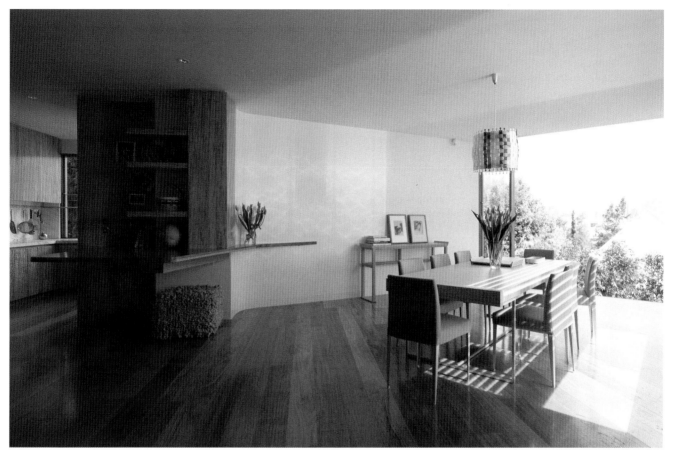

Ground Floor

First Floor

The kitchen and dining room are situated in the rear of the house, which enjoys a view of the city of Melbourne. At the other end, the living room looks out toward the nearby suburbs.

Subtle details in the layout
create different kinds of
relationships between the
various rooms and levels
of the house.

Sketch

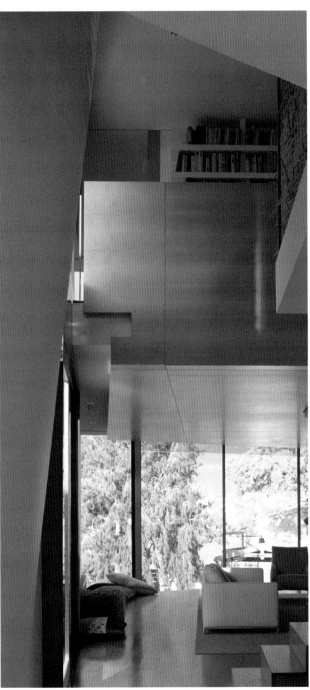

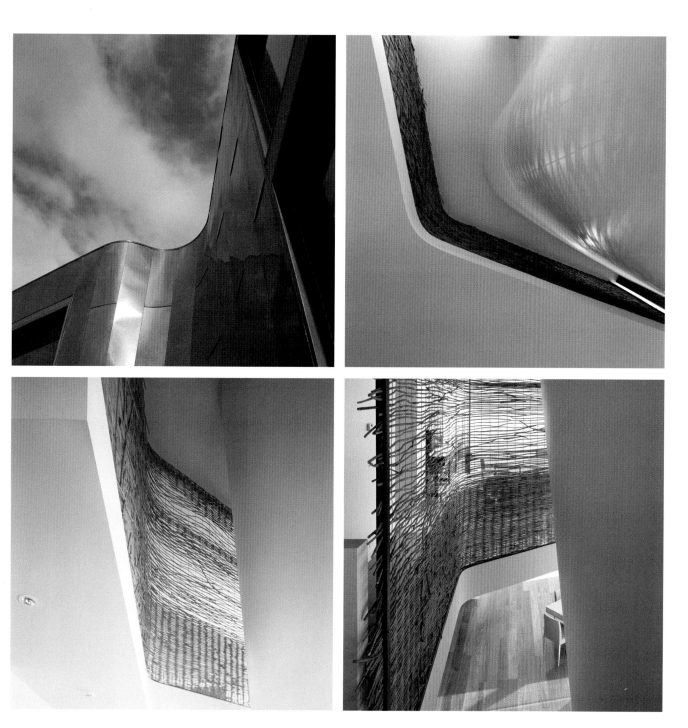

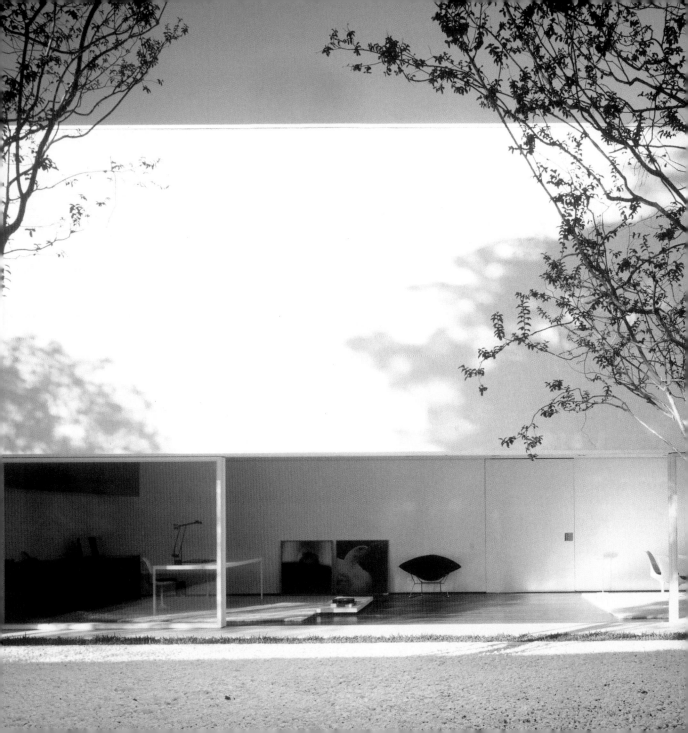

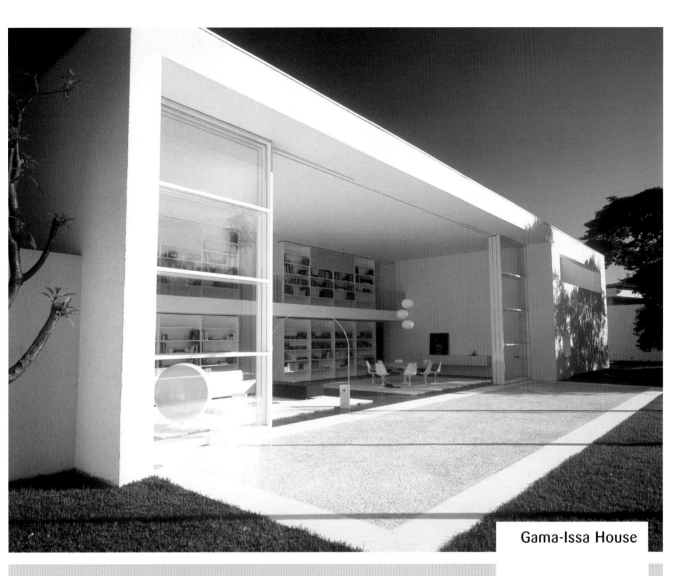

Gama-Issa House

This house, located in the Alto de Pinheiros area of São Paulo, takes the form of a large, white perimeter wall that wraps around the property, isolating it from its context and creating inward views of the house itself. Large-scale windows, marble stairways, and sophisticated spaces characterize this project.

Architect: Marcio Kogan
Location: São Paulo, Brazil
Date of construction: 2001
Photography: Arnaldo
Pappalardo

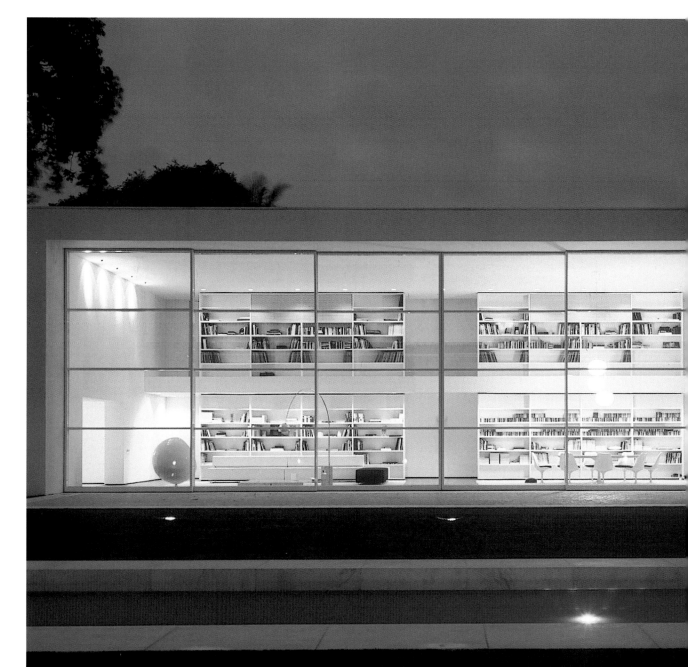

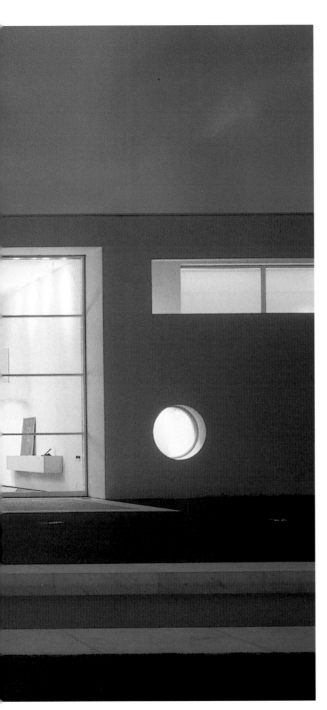

An entire back wall can be used as a library space; in this case the high ceilings allowed the insertion of a mezzanine walkway to access the upper shelves.

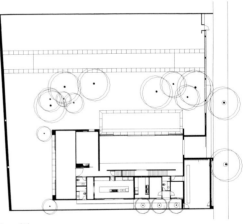

Ground Floor

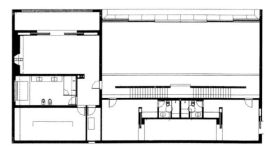

First Floor

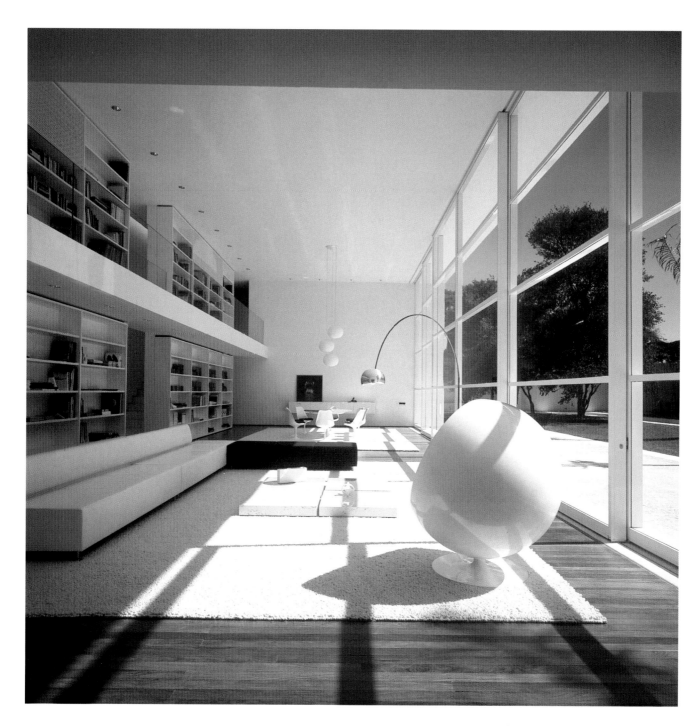

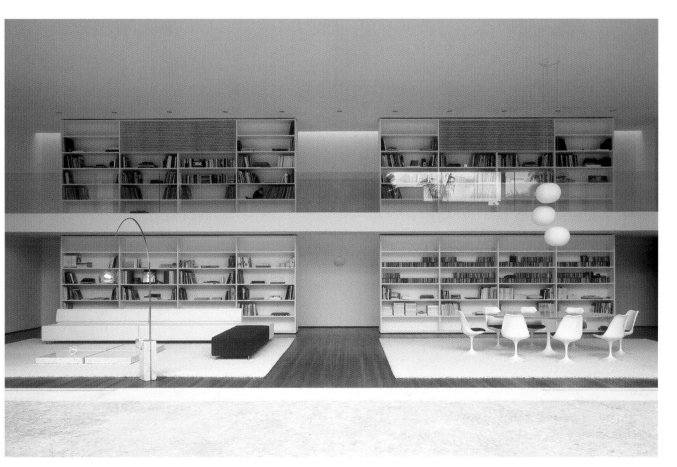

Slabs of marble laid on the floor were used to configure a table for the living room, while retro space-age furnishings, mainly in white, give the space a futuristic feel.

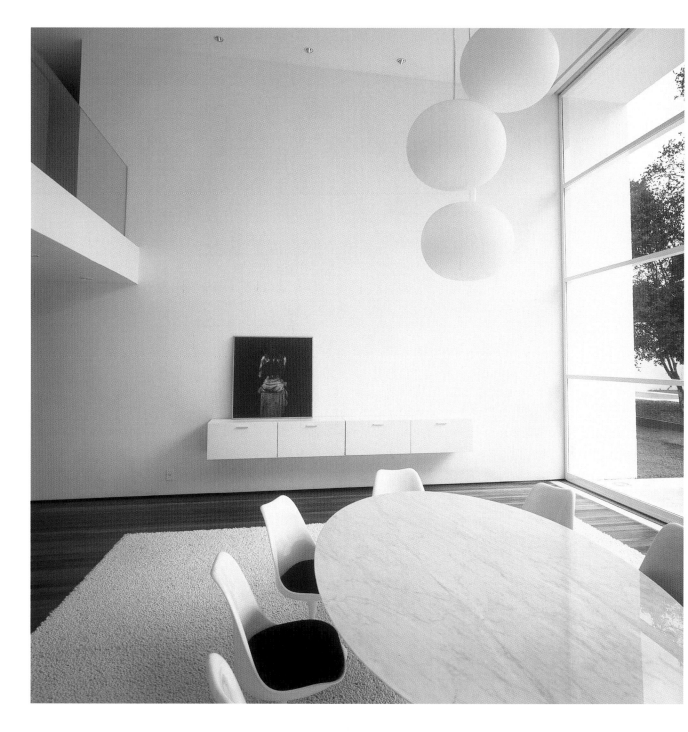

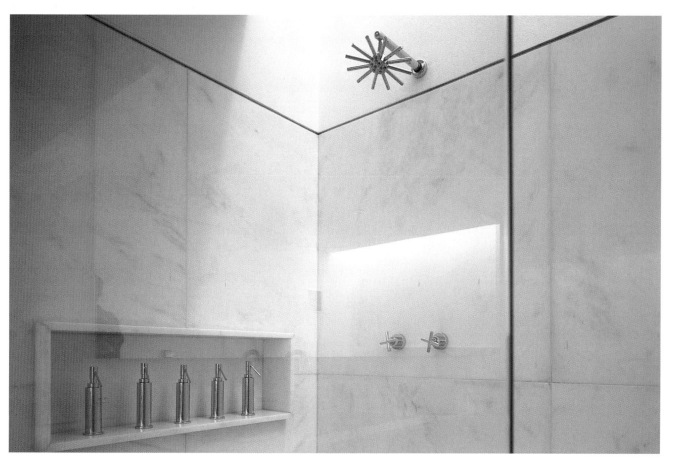

The bathroom was fashioned entirely out
of marble and fitted with an original
showerhead and built-in marble shelf.

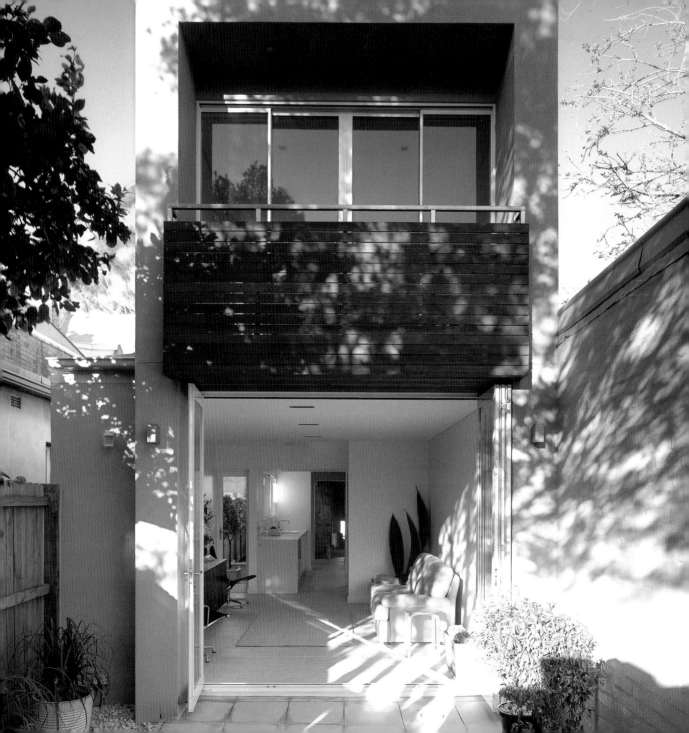

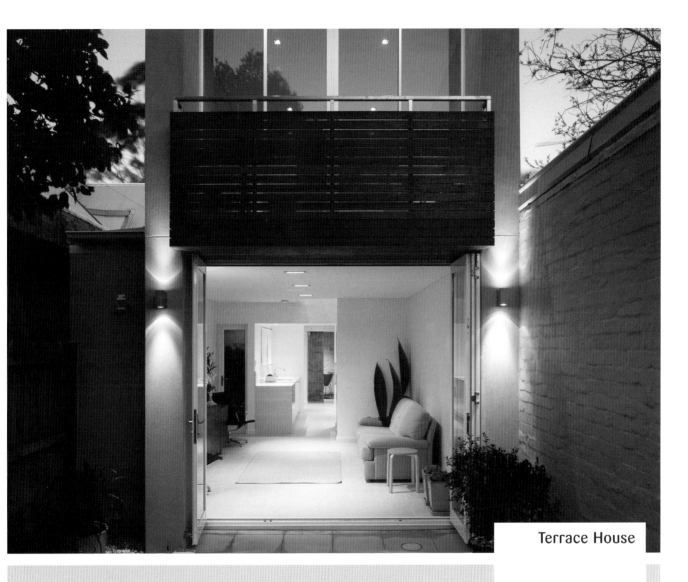

Terrace House

This terrace house forms part of the heritage listed as Glenrock Terrace, the oldest surviving terrace in the Waverley area and considered to be one of the best examples of a stone terrace in Sydney. A new addition, linked to the original part of the house, was given a modern quality that emphasizes the use of contemporary materials and the entry of light.

Architect: Cullen Feng
Location: Sydney, Australia
Date of construction: 2004
Photography: Murray Fredericks

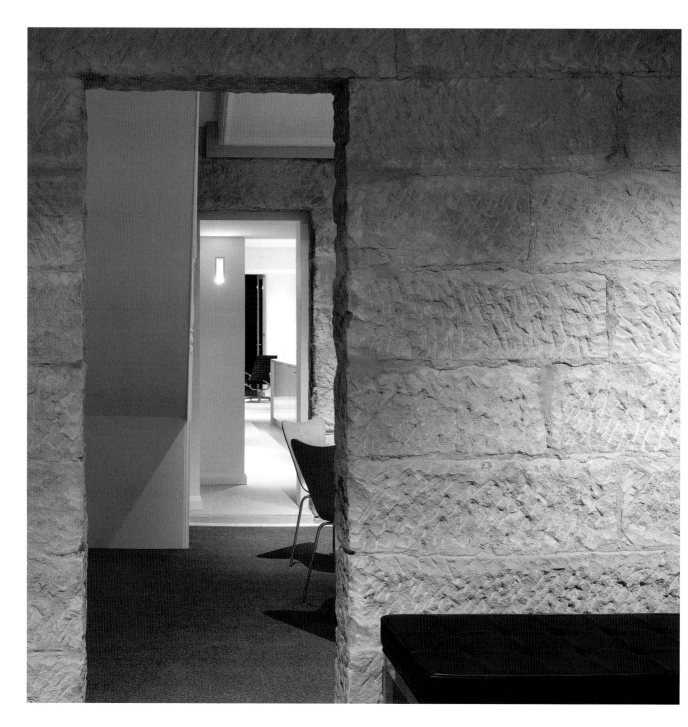

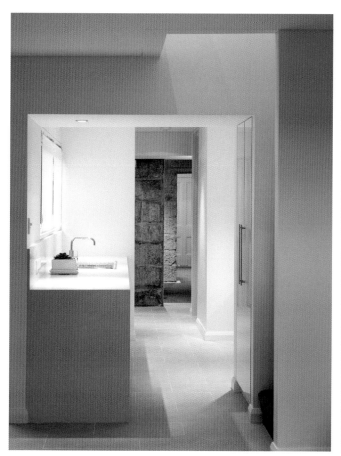

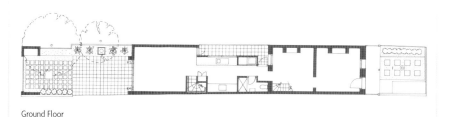

Ground Floor

In the existing part of the house, the wall treatments were stripped to reveal the original coarse sandstone blocks, which were cleaned and then sealed with a protective layer. The exposed sandstone lends an added texture to the house and heightens the contrast between old and new.

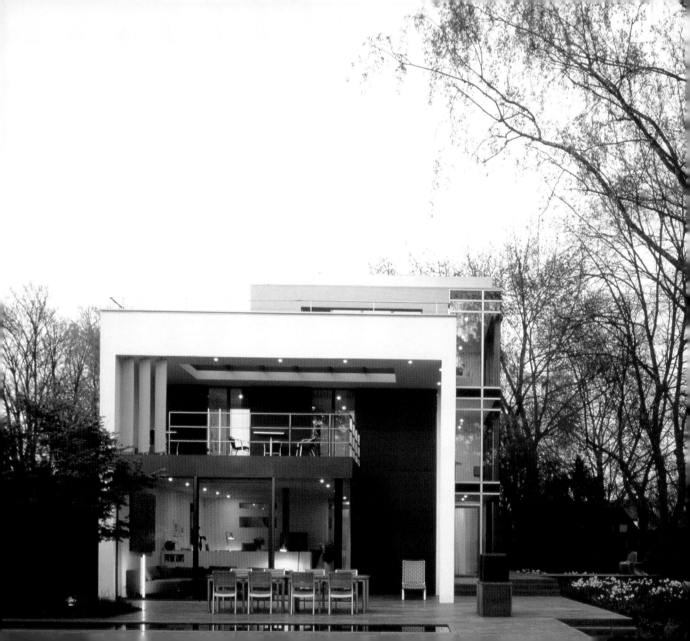

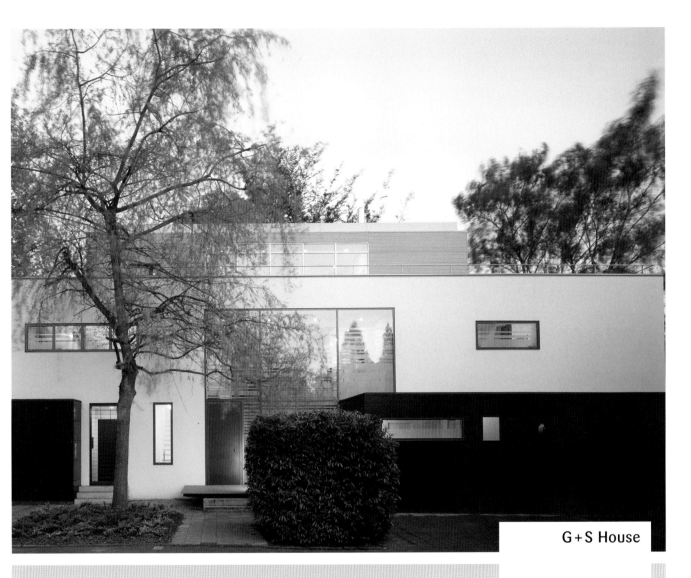

G + S House

Partially positioned above a foundation wall of a 1950s building, this house incorporates a new structure made of glass and steel set deep into the cube-like construction. By matching the colors and materials found in the adjoining buildings, the new addition is fully integrated with the existing context.

Architect: Gatermann + Schossig
Location: Cologne, Germany
Date of construction: 2000
Photography: Robertino Nikolic

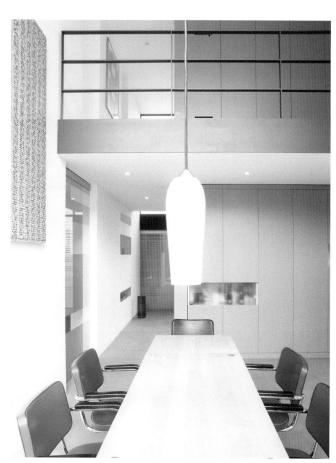

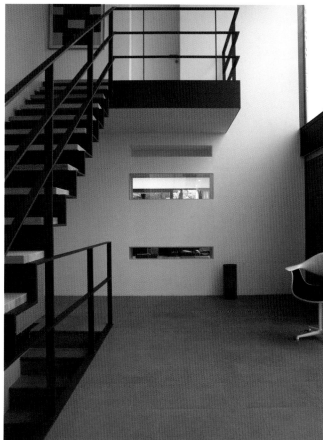

The two-story space in the entrance and dining area creates a feeling of spaciousness, even though the ceiling heights are elsewhere normal.

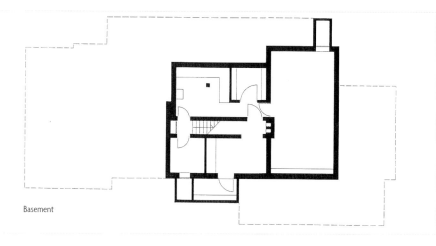

Basement

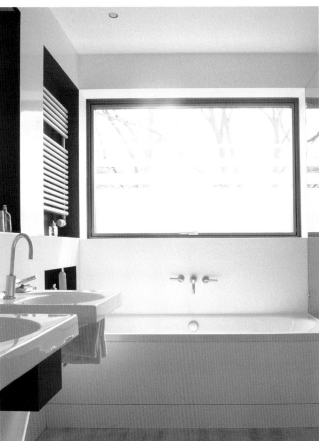

The aim of the project was to create a building with low-emission facilities that would guarantee the efficient use of primary energy and drinking water.

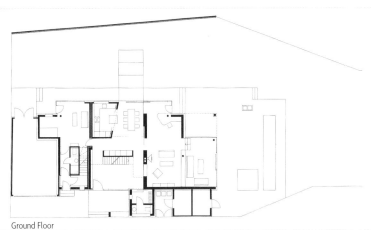

Ground Floor

A high-efficiency gas condensing
boiler is used for heating and
hot water, supported by a thermal
solar collector plant designed
to use surplus energy for interior
heating.

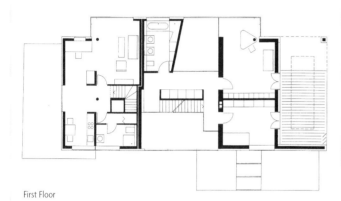

First Floor

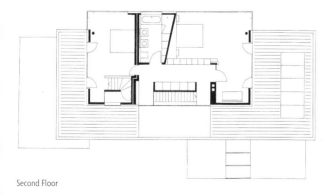

Second Floor

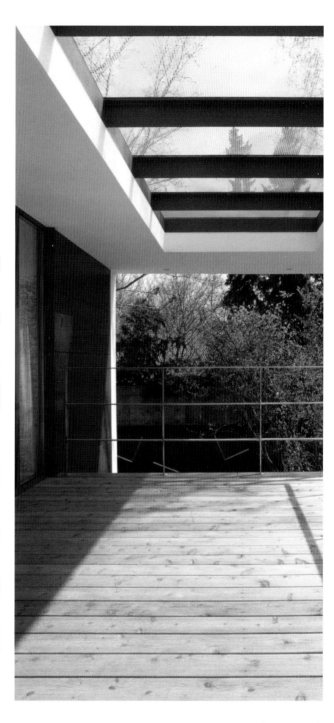

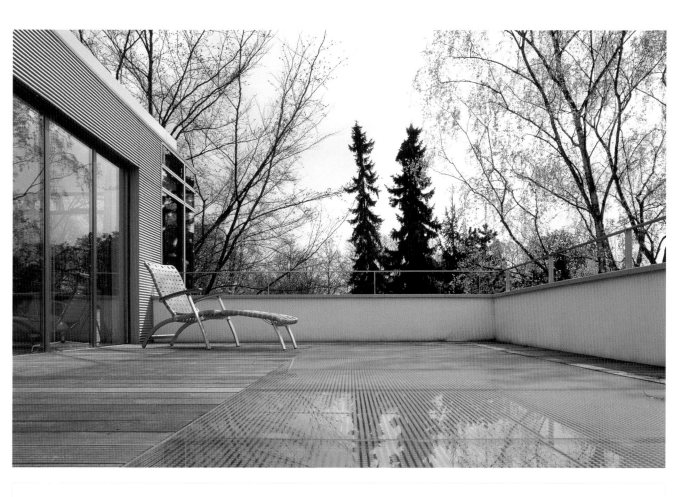

Sections

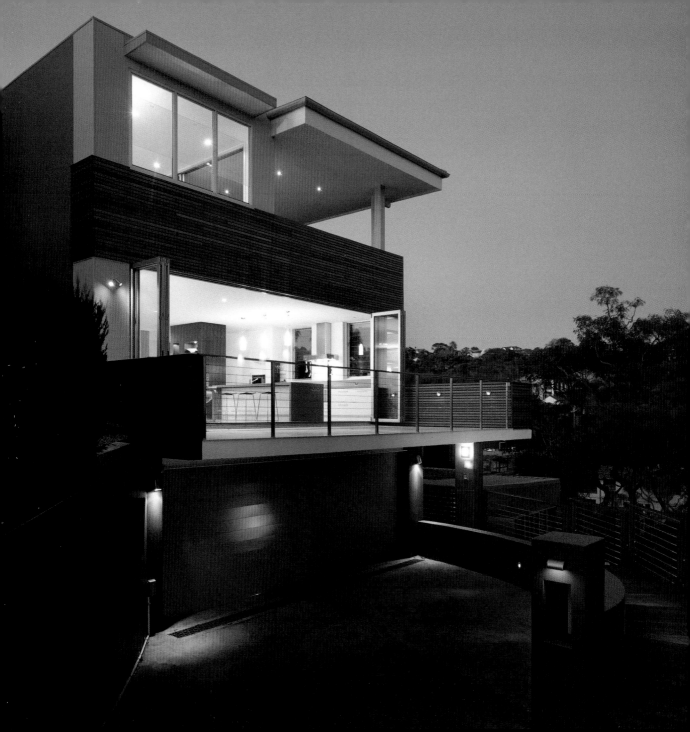

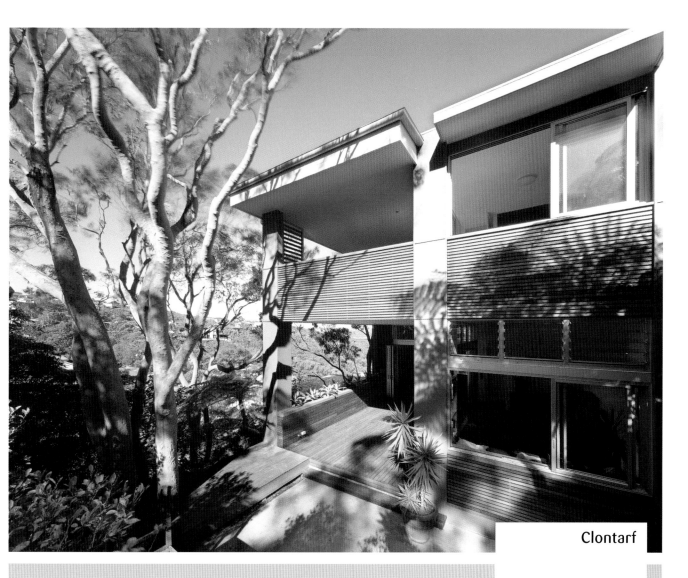

Clontarf

The challenge of this project lay in reconciling the new house's solar orientation and its views, which, within this site, were situated at opposite ends. The architectural solution consists of double-height spaces, glazed walls, and large outdoor spaces carved into the house that bring light into the interior.

Architect: Molnar Freeman
Architects
Location: Sydney, Australia
Date of construction: 2004
Photography: Murray Fredericks

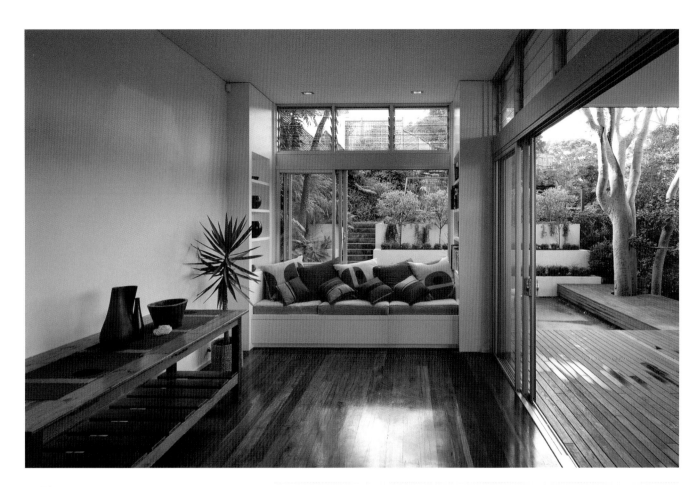

The creation of covered outdoor rooms, often ignored in residential design, can provide houses with tremendously useful and comfortable spaces, especially in places with temperate climates.

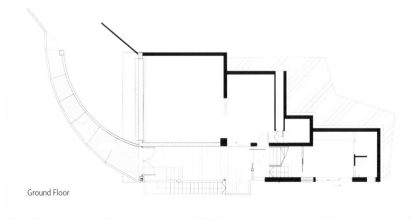

Ground Floor

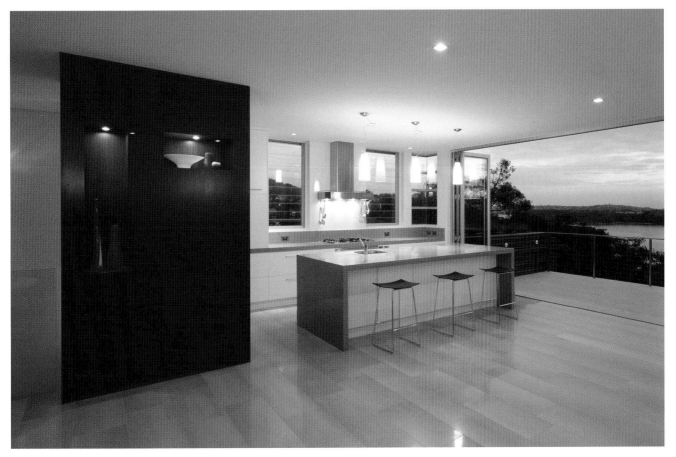

A combined living, kitchen, and dining zone laid with limestone pavers is the only area that spans the full width of the house.

First Floor

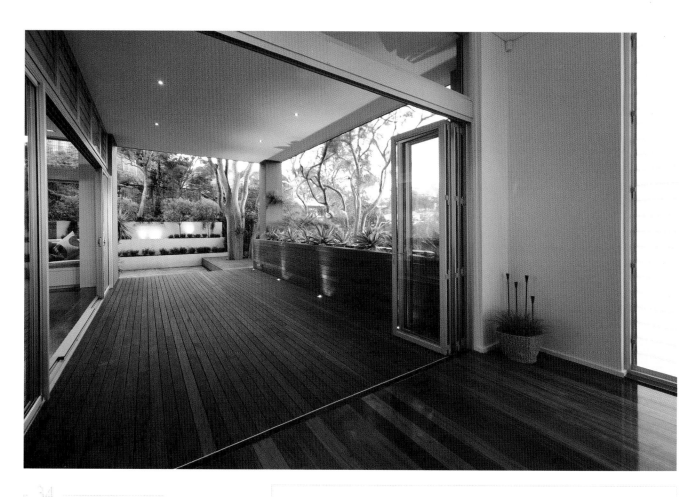

34

During the winter, the owners can use the northern space where the low-angled sun penetrates, while in summer the southern terrace opens up to the harbor.

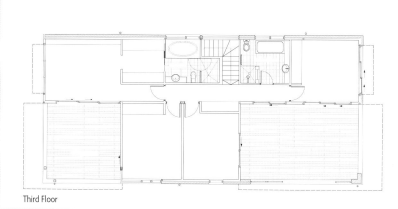

Third Floor

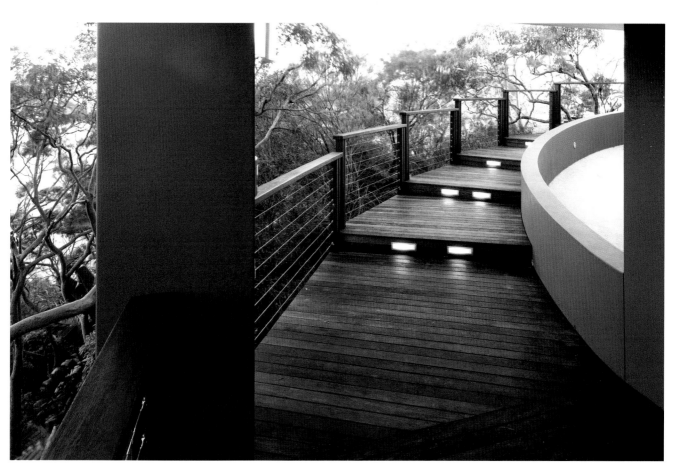

Considering the relatively small size of
the site, this house provides a variety
of outdoor living options that suit a
contemporary lifestyle.

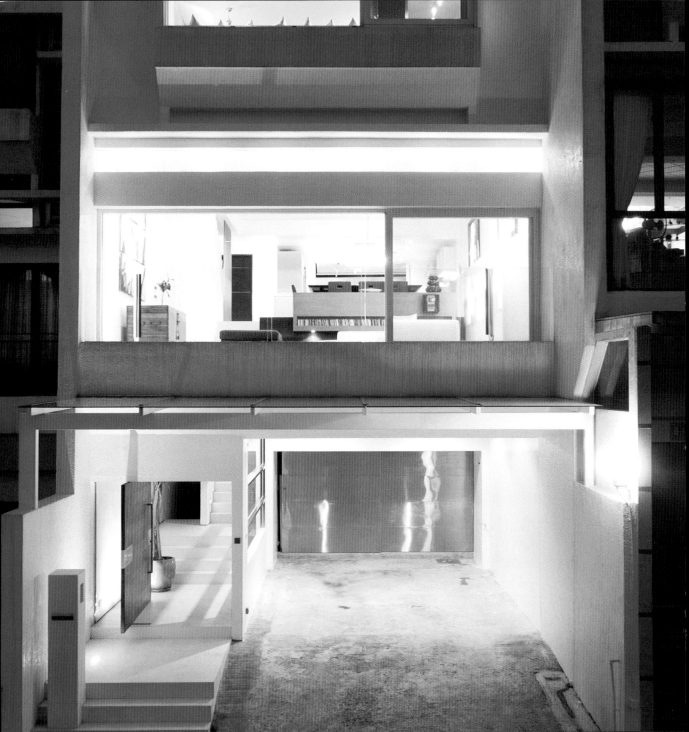

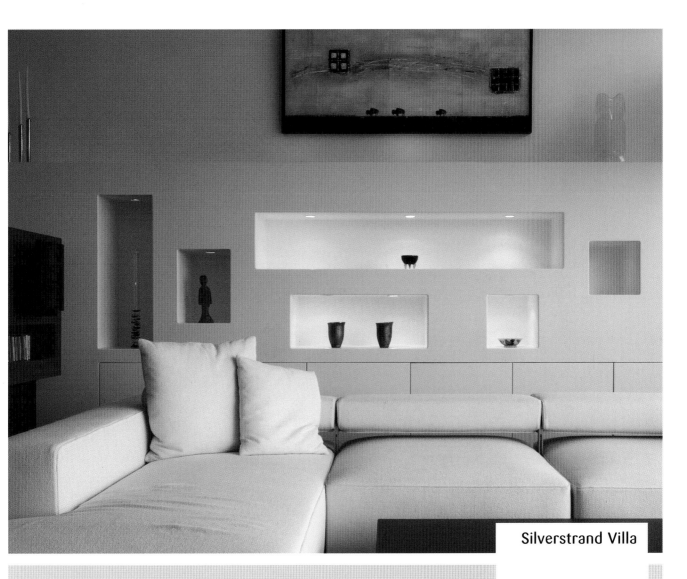

Silverstrand Villa

A comprehensive renovation involving the redistribution of interior spaces transformed this three-story home into a more practical, open, and comfortable space. The vertical distribution organizes the public zones on the lower levels and the private areas on the top floor.

Architect: Original Vision
Location: Hong Kong, China
Date of construction: 2004
Photography: John Butlin of Arcfoto Photography

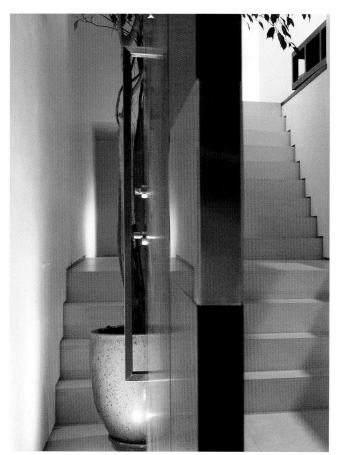
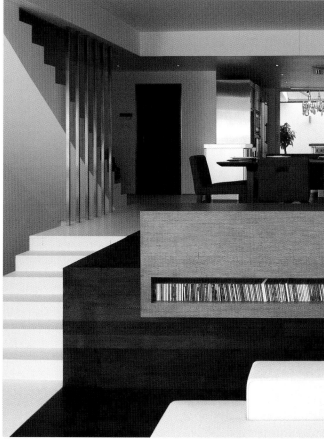

35

The entrance was transformed
with an oversized door and
window wall that looks onto
an open parking area. On the
first floor, an access stair was
introduced, leading to an open
study area.

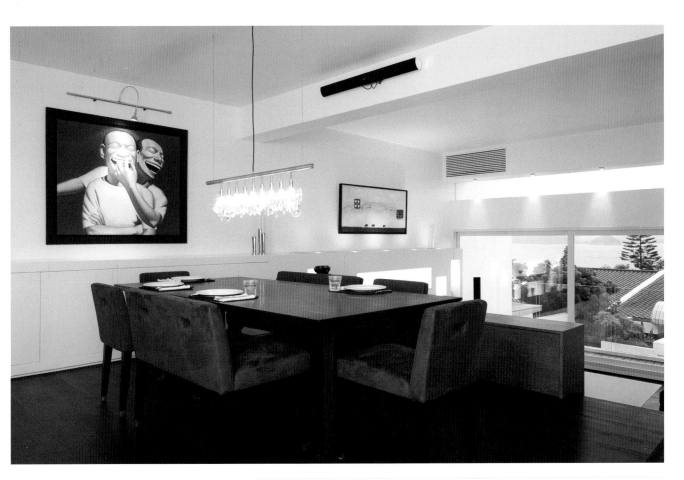

The dining area cascades into the living room, which in turn culminates in a wide balcony with a view of the sea.

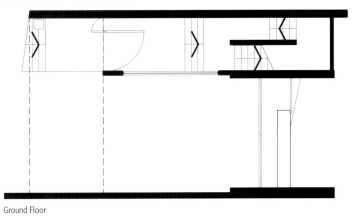

Ground Floor

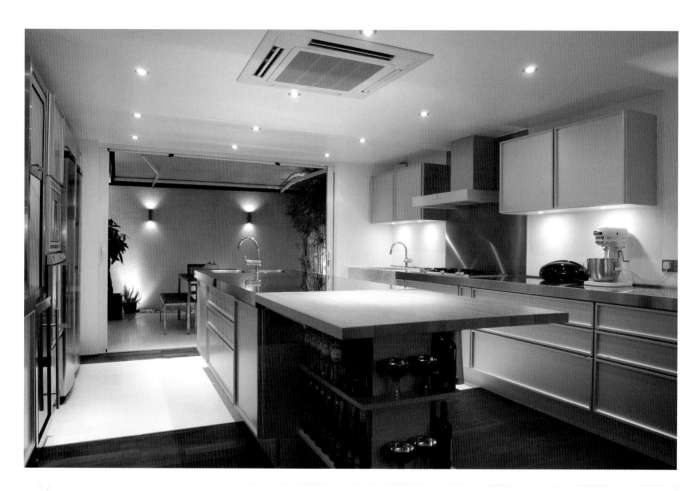

The consistency of materials and detailing enhance the feeling of space and continuity within the home.

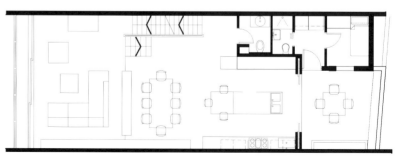

First Floor

The bedrooms are incorporated into the second floor, while an open space at roof level serves as the family's private retreat.

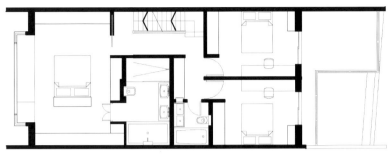

Third Floor

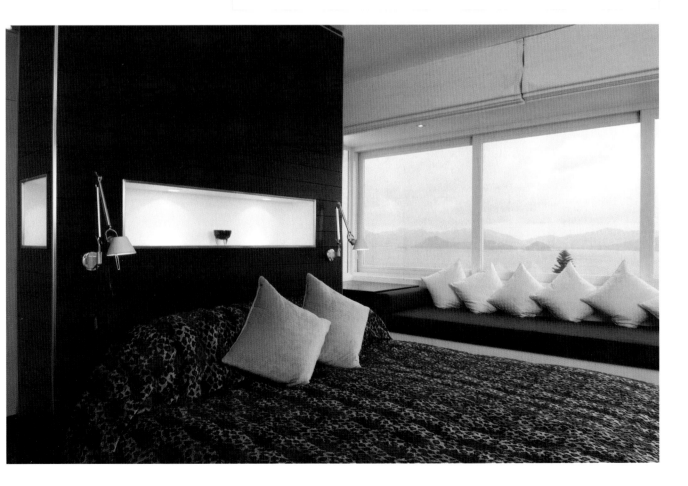

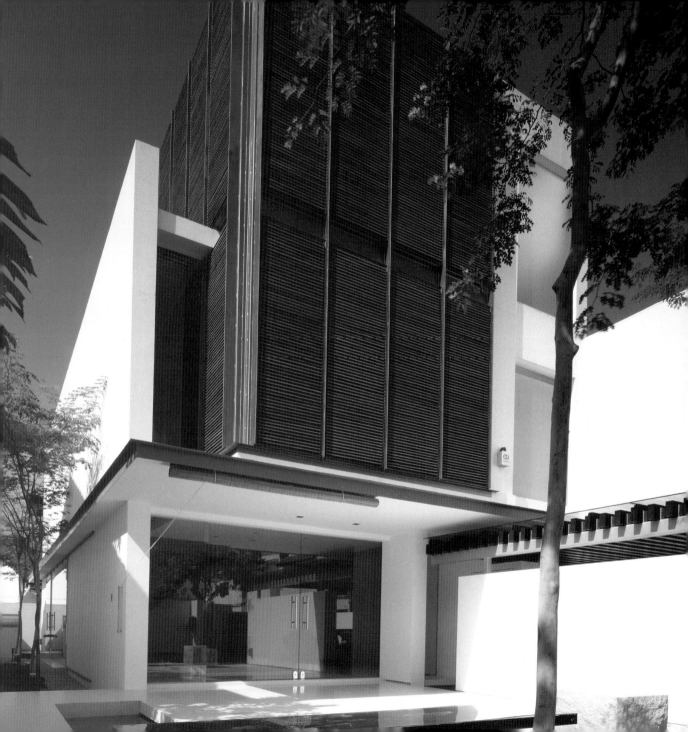

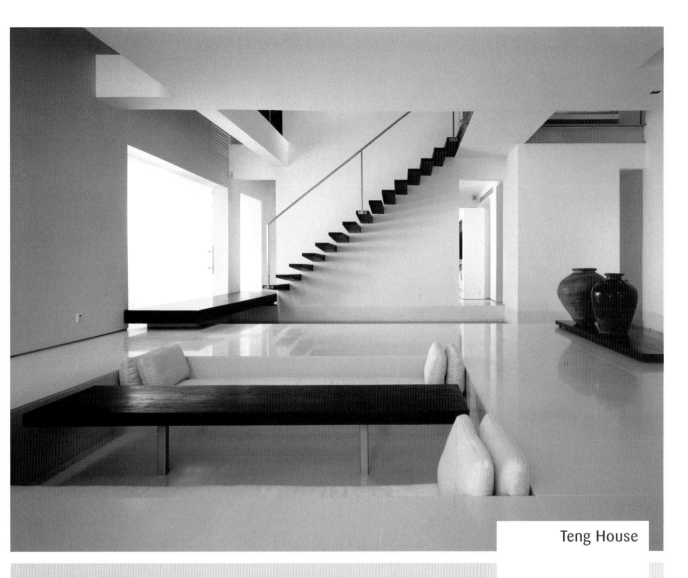

Teng House

Having no external views to exploit, this narrow, three-story box, divided from an adjoining house by a party wall, was focused inwards and fitted with a vertical light shaft that inundantes the central space with light and upward views of the various levels.

Architect: SCDA Architects
Location: Singapore, Singapore
Date of construction: 2000
Photography: Peter Mealin/Jacob Termansen

The structure is stacked in two
three-story-high blocks separated by
a vertical light shaft. Steel and glass
bridges span the gap at the second-
and third-story level, linking the rear
and front of the house

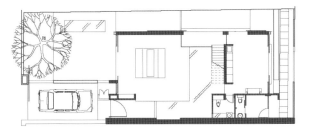

First Floor

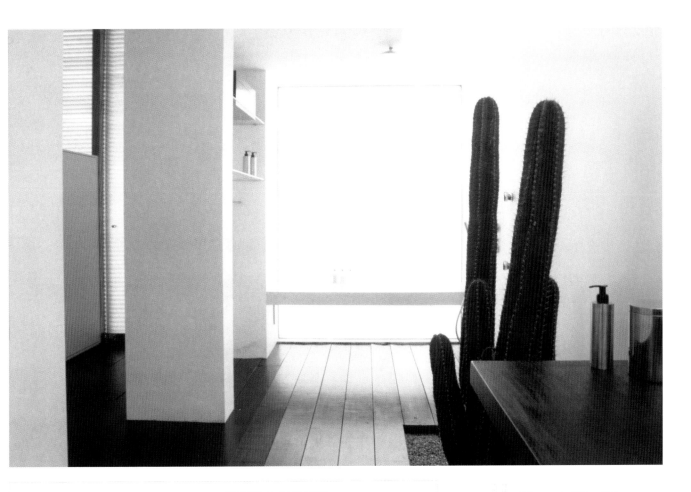

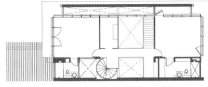

Second Floor

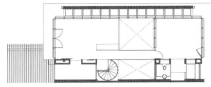

Third Floor

In addition to the central
lightwell, diffused daylight
was introduced into the
first-story living spaces by
detaching the gable wall
of the house.

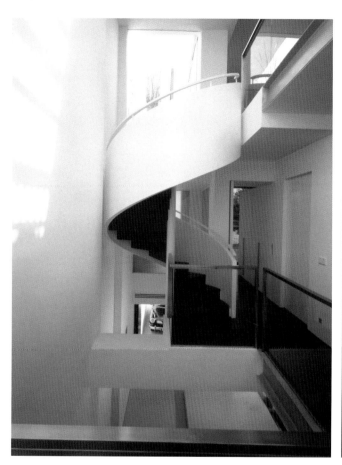
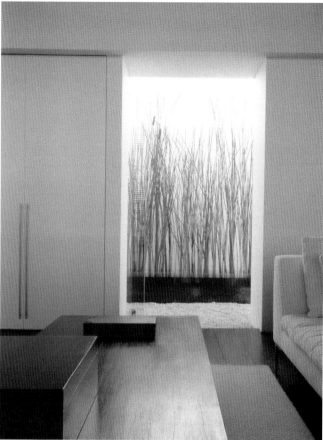

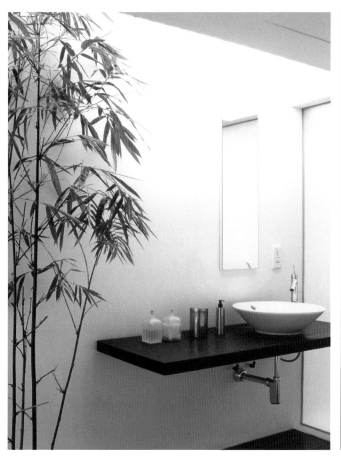

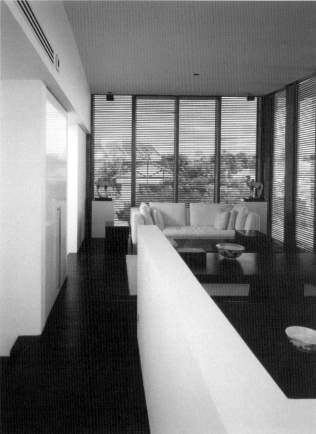

The interior was crafted by employing planes, surfaces, voids, and light to produce multiple spatial experiences within the finite volume.

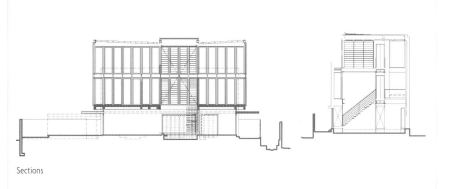

Sections

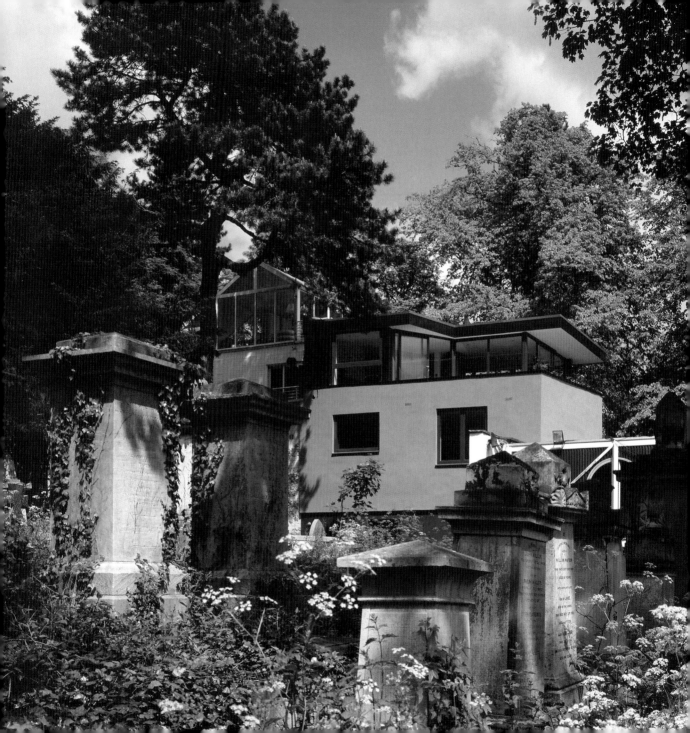

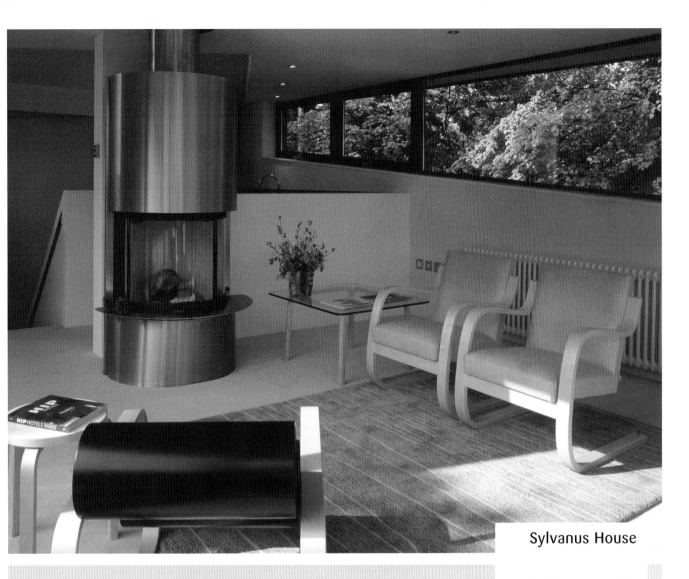

Sylvanus House

The peculiar location of this residence, situated on a sloping site within Highgate Cemetery in London, inspired the creation of a multilevel house with a unique composition and layout. The construction appears to gently twist and open up toward the winter sun, while a deeply overhanging roof forms a canopy to control the summer heat.

Architect: bere:architects
Location: London, United Kingdom
Date of construction: 2004
Photography: Peter Cook/VIEW

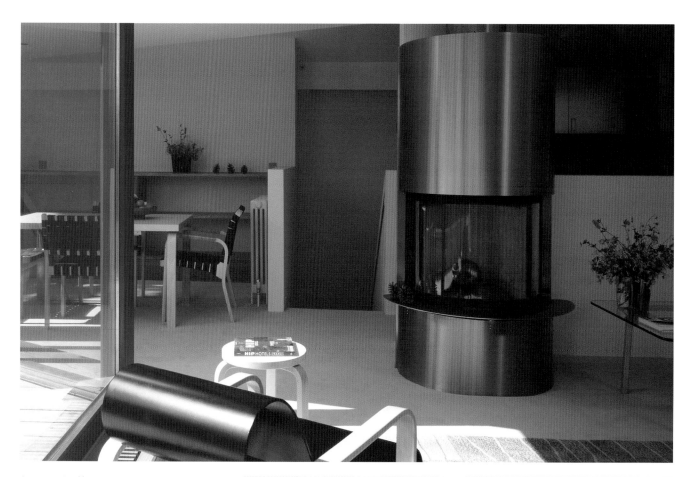

An unconventional layout presents asymmetrical lines, sloping ceilings, and an exterior terrace that casually looks out over the gravestones of Highgate Cemetery.

Floor Plan

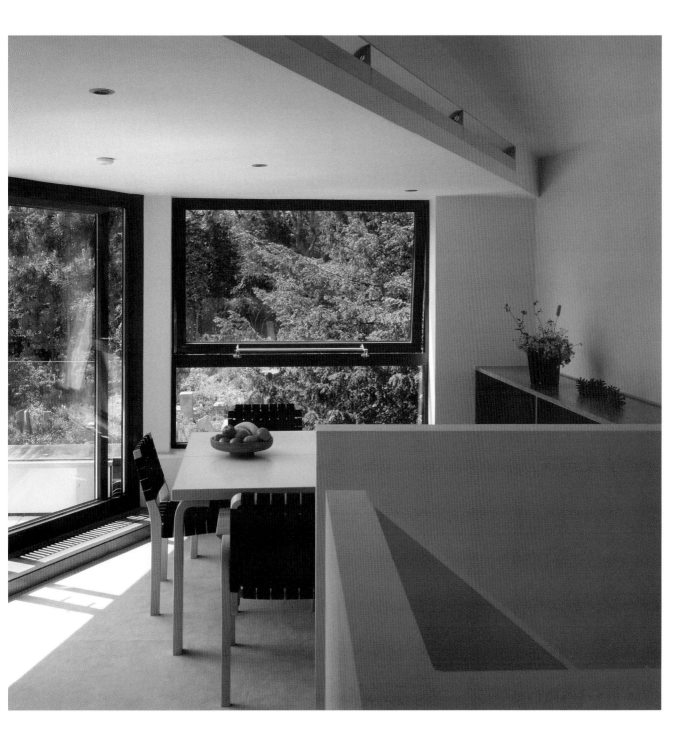

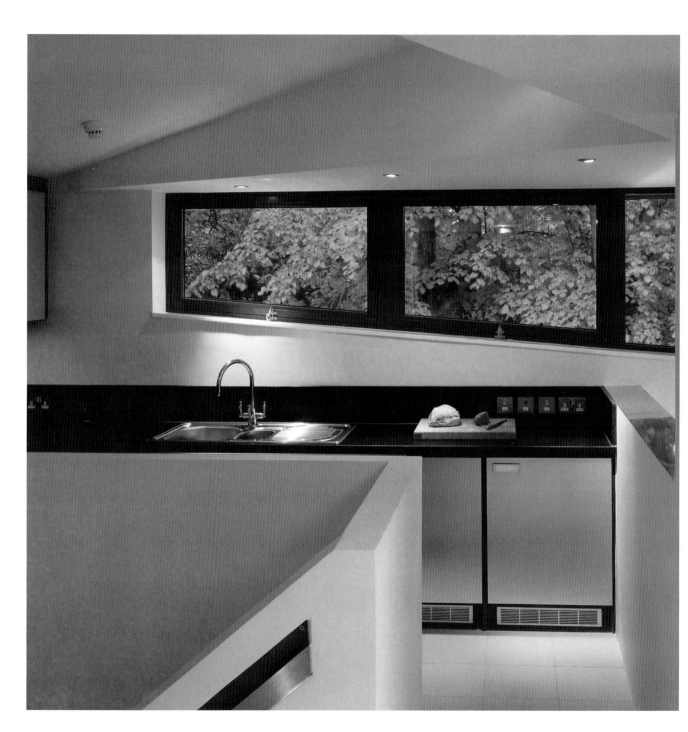

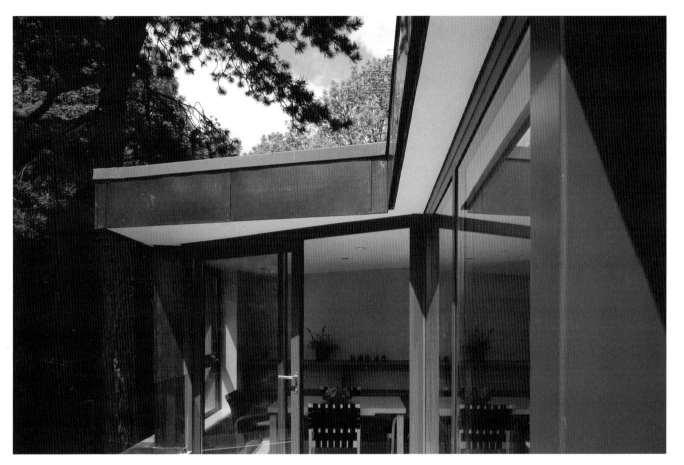

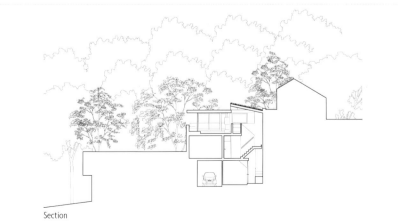

Section

Sloping windows and angled lines can create a dynamic effect in contrast to linear furnishings. The top floor terrace reveals glimpses across London, which at night shimmers magically through a veil of trees.

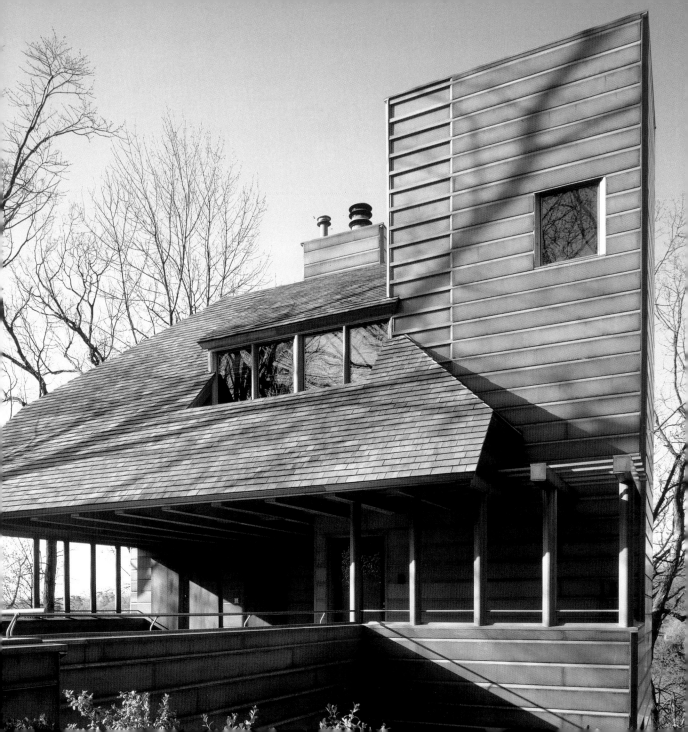

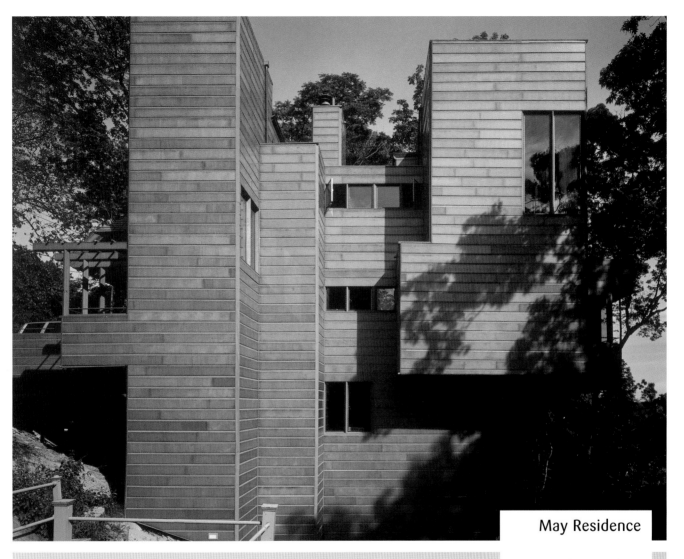

May Residence

Architect: Jonathan Levi Architects
Location: Brookline, MA, United
States
Date of construction: 1999
Photography: Anton
Grassl/Jonathan Levi Architects

Located in a suburb near Boston, this house was designed for an adult couple who wanted a comfortable, functional, and adaptable home for their retirement. The essential parameters of the design plan were dealing with the elongated shape of the property in combination with the steep angle of the terrain, providing views and creating access for vehicles.

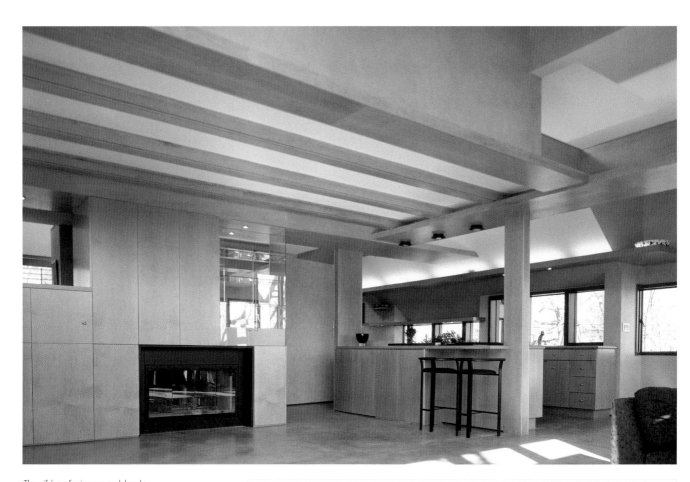

The wife's profession as a cook largely determined the configuration of the residence and the importance of this activity within the house.

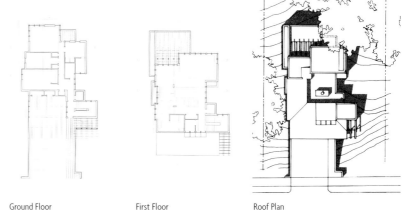

Ground Floor First Floor Roof Plan

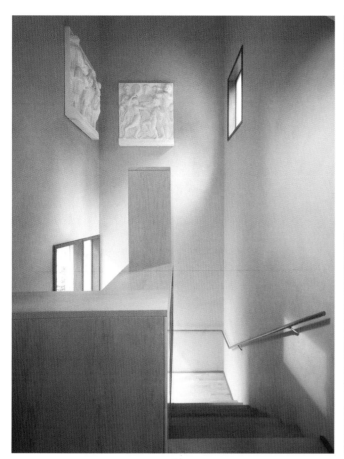

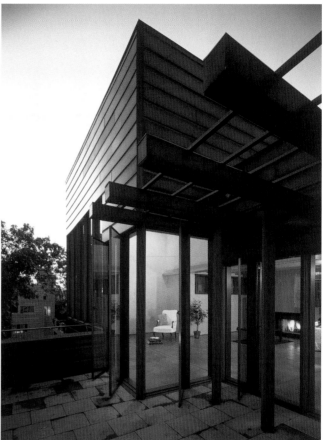

Windows were inserted wherever possible to introduce light into tipically darker areas such as staircases and hallways.

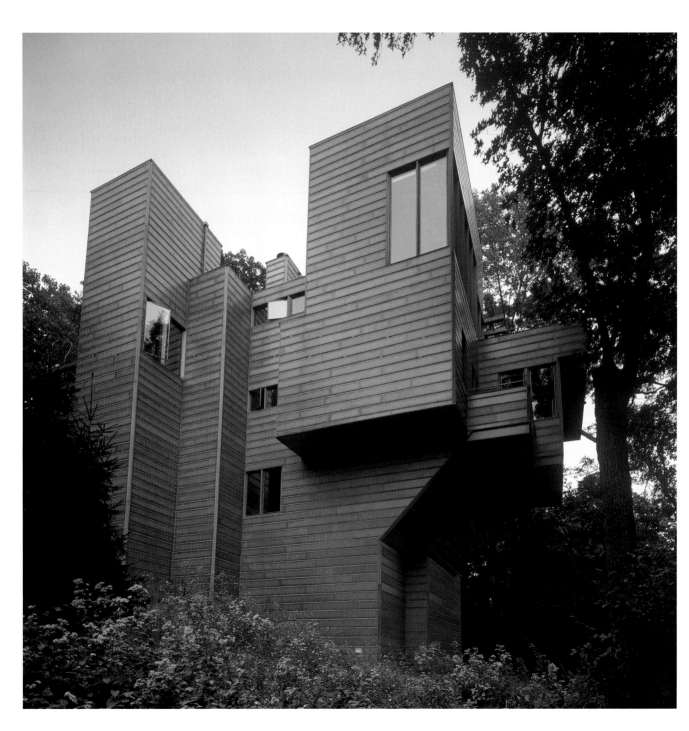

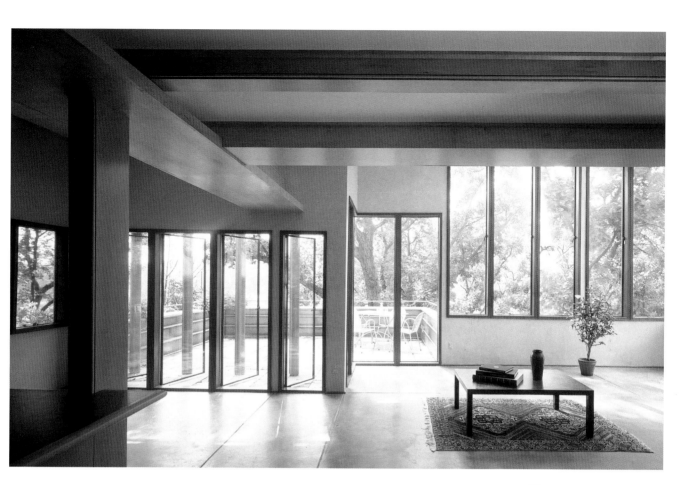

42

The extensive use of wood inside the house reflects the exterior structure, creating a sense of coherence and unity.

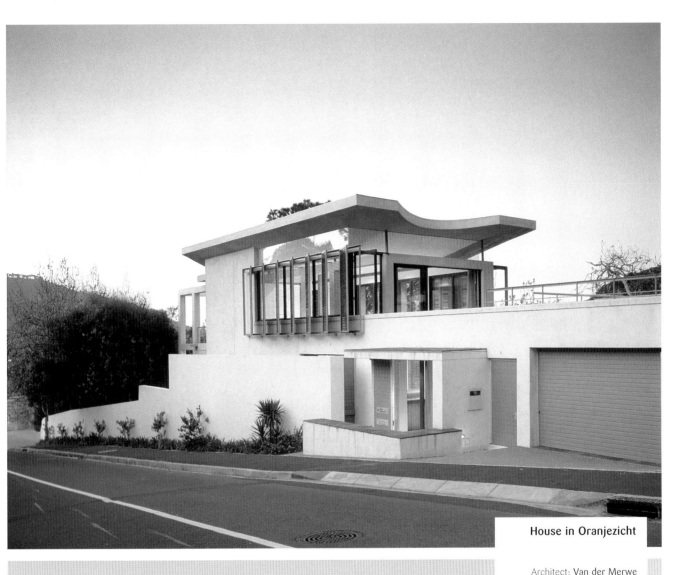

House in Oranjezicht

This house sits on a 45-degree slope on a long and very narrow plot in Oranjezicht, a residential area of Cape Town. Surrounded by typical housing complexes and a dense forest of pine trees, the house was designed to meet the family's needs, preserve the existing vegetation, and optimize the view of the landscape.

Architect: Van der Merwe
Miszewski Architects
Location: Cape Town, South Africa
Date of construction: 2000
Photography: Van der Merwe
Miszewski Architects

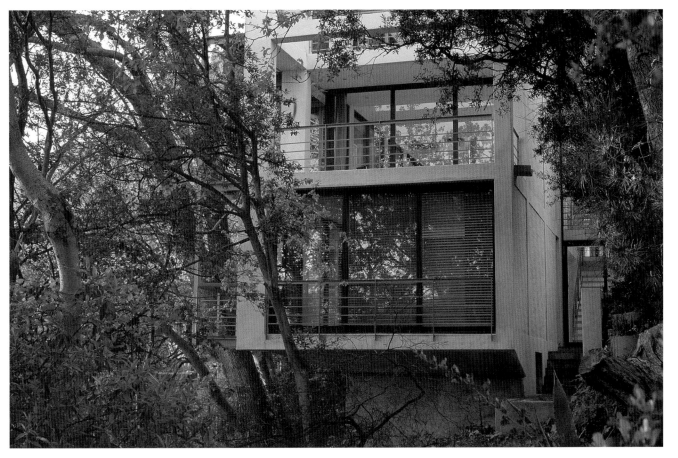

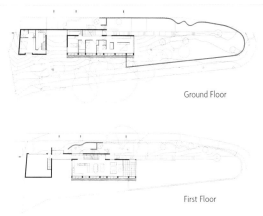

Ground Floor

First Floor

Due to the physical features of the site, the house is narrow and arranged on a structural orthogonal grid that follows the contours, thus minimizing the amount of excavation required.

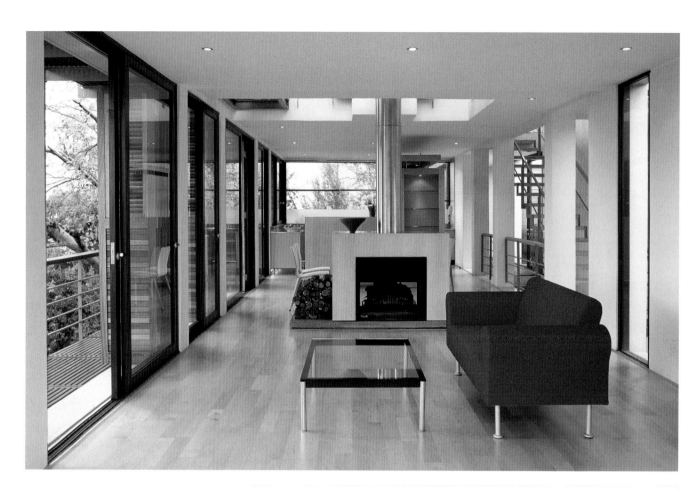

The rectangular unit is broken up and enriched with consecutive elements such as the fireplace, the stairs and the double-height ceiling.

Second Floor

Roof Plan

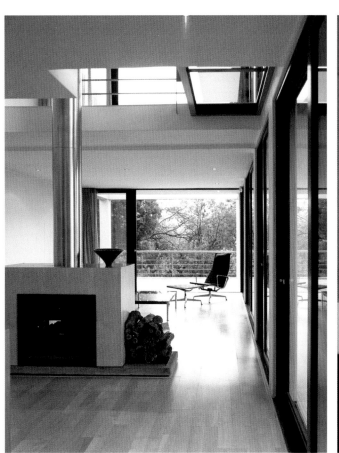

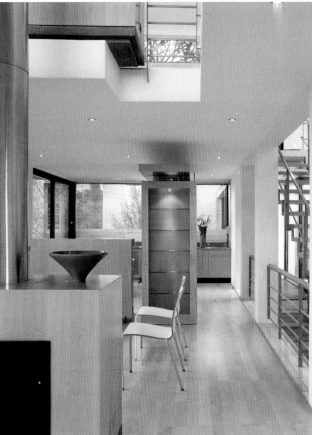

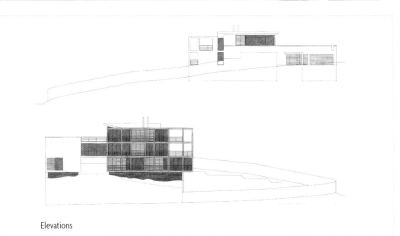

Elevations

The central void not only
brings light into the living
areas, but also gives the
space a vertical dynamic
which is emphasized by
the fireplace.

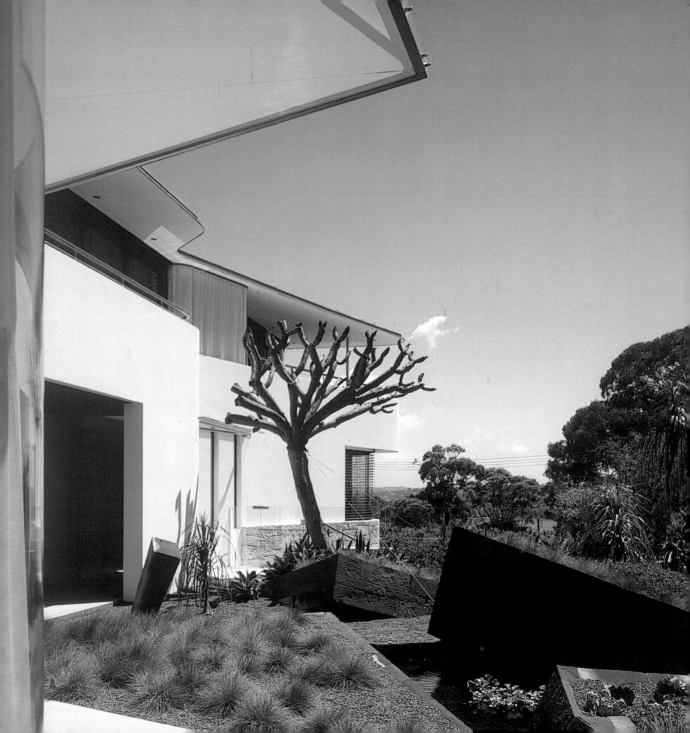

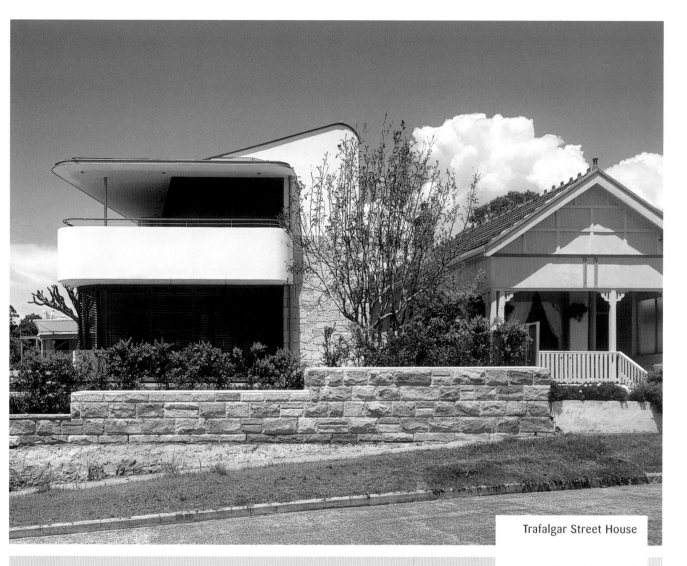

Trafalgar Street House

Architect: **Luigi Rosselli**
Location: **Sydney, Australia**
Date of construction: **2004**
Photography: **Richard Glover/VIEW**

In an attempt to relate to its natural context, this house adopts an organic plan that reflects the fluidity and morphology of the natural landscape, characterized by carved sandstone cliffs, the surging ocean, and sweeping skyscapes.

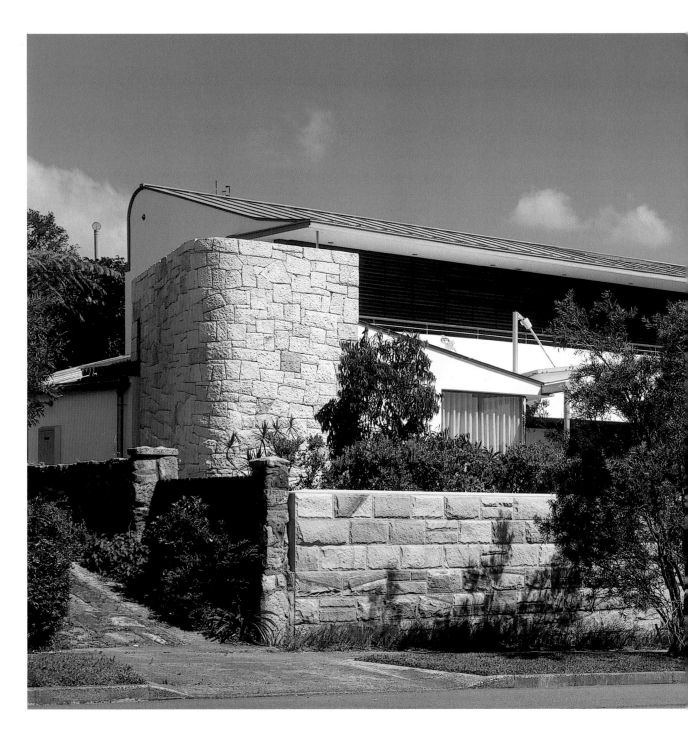

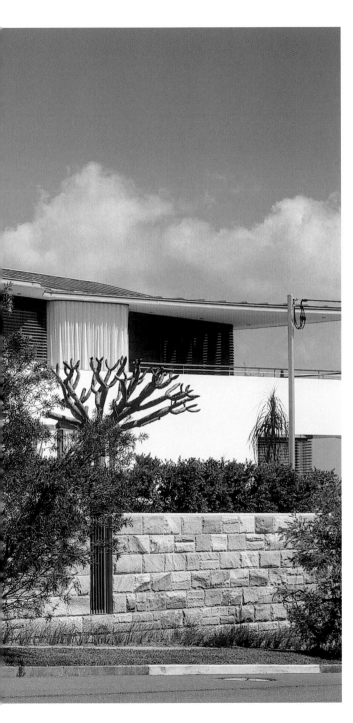

Rising from its sandstone foundation, the dwelling presents a rich synthesis of form and texture in relation to the street, heightened by subtle orientations that reveal both intimate and grand views of the exterior.

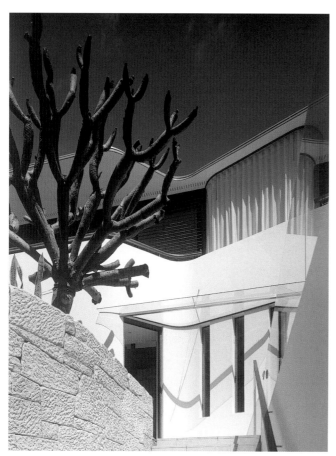

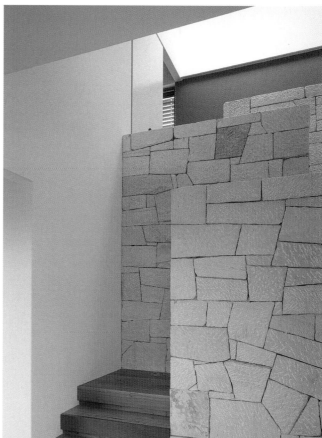

The main windows of the living areas and bedrooms were oriented toward the east to obtain the best view over the ocean.

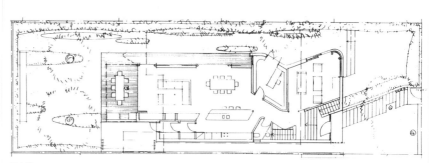

First Floor

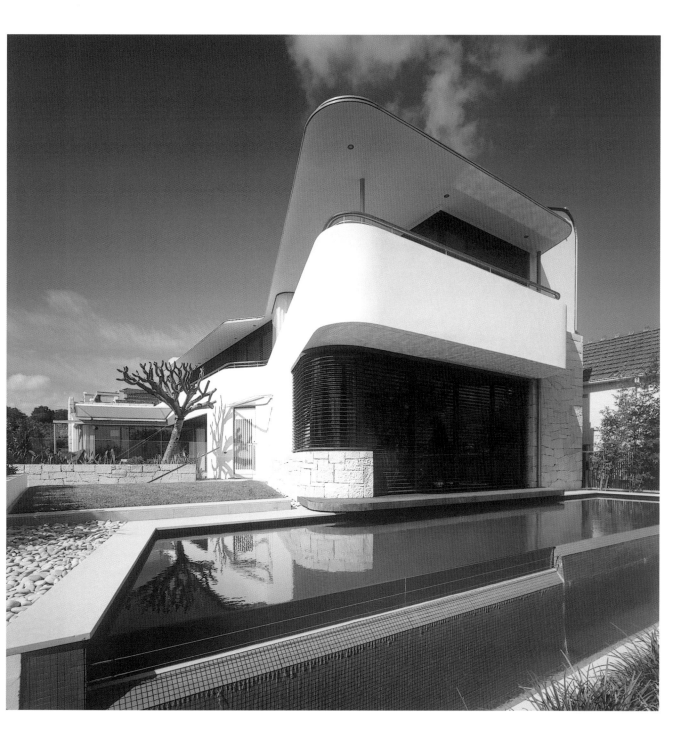

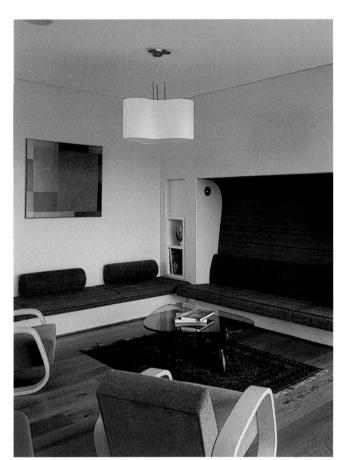
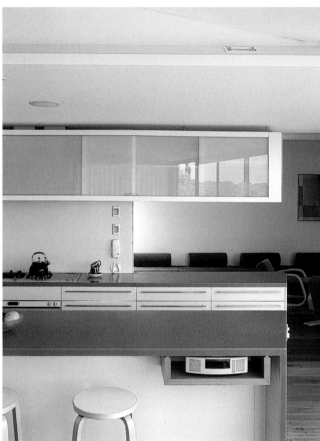
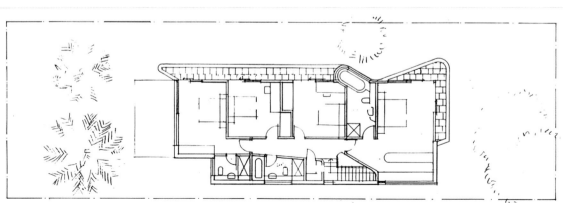

Second Floor

Consistency between the exterior and interior design can result in more fluid, coherent spaces. Whereby similar materials and built-in furnishings that seamlessly flow into one anotherw are used.

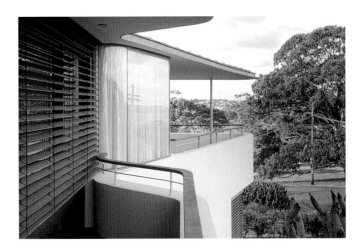

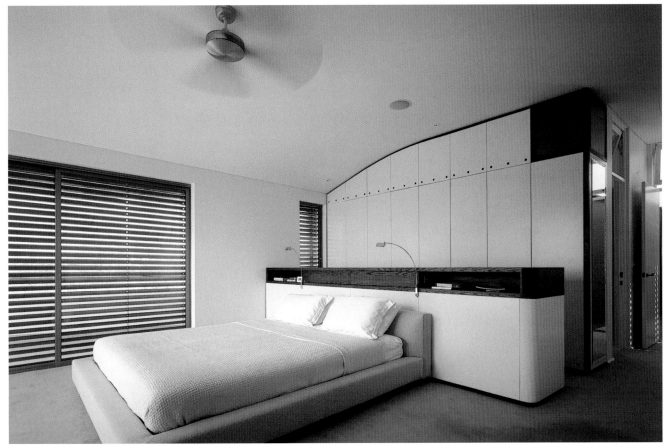

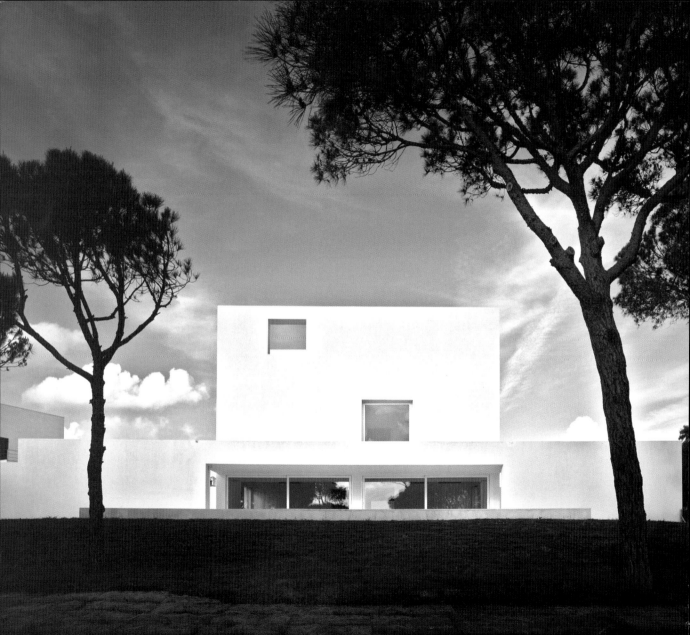

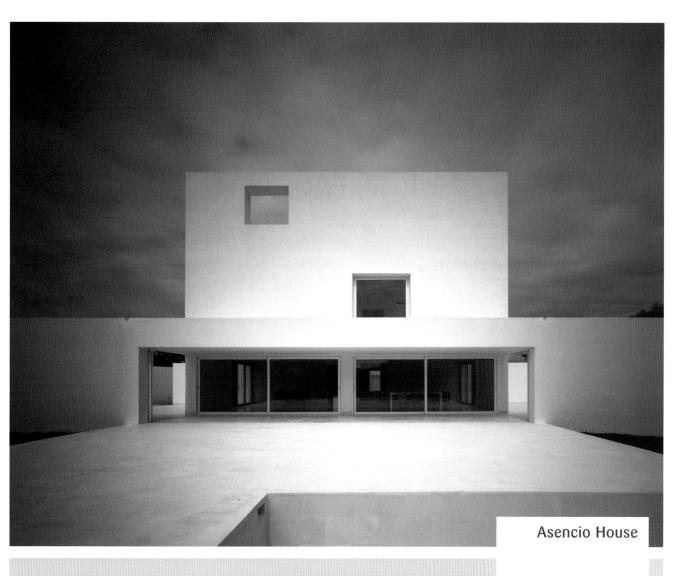

Asencio House

The intense white light of Cádiz is the driving element behind the design of this family house in the south of Spain. A simple, white construction reflecting the typical style of Andalusia, the house is designed to filter the light diagonally so as to penetrate all areas of the home and become the unifying element of the project.

Architect: Alberto Campo Baeza
Location: Cádiz, Spain
Date of construction: 2001
Photography: Hisao Suzuki

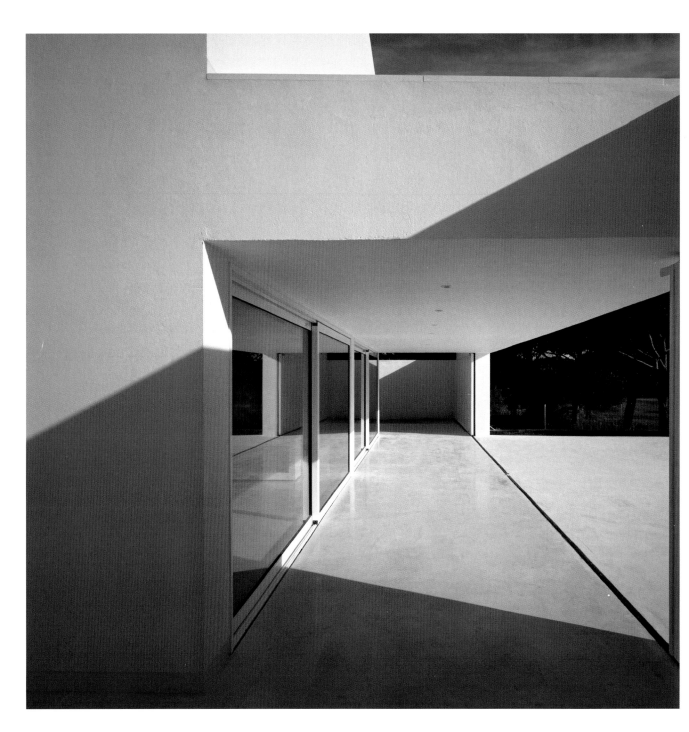

In a house with multiple levels, a carefully planned interior space can result in dramatic lighting effects. The strategic placement of skylights in this house demonstrates how light can be manipulated to create bands that illuminate various areas of the home from one source.

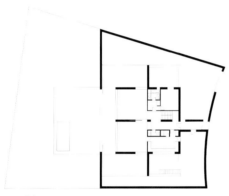

Ground Floor

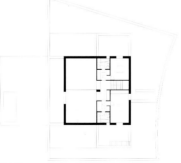

First Floor

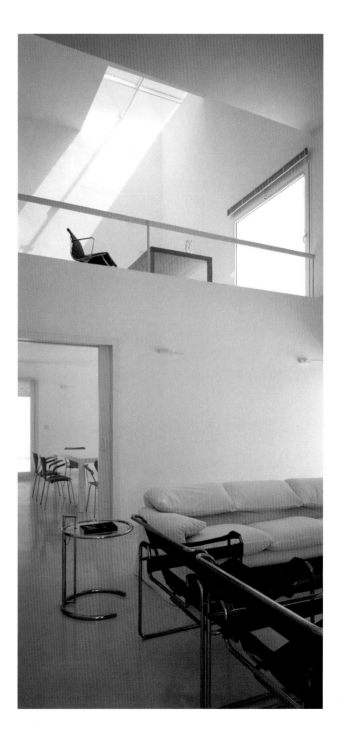

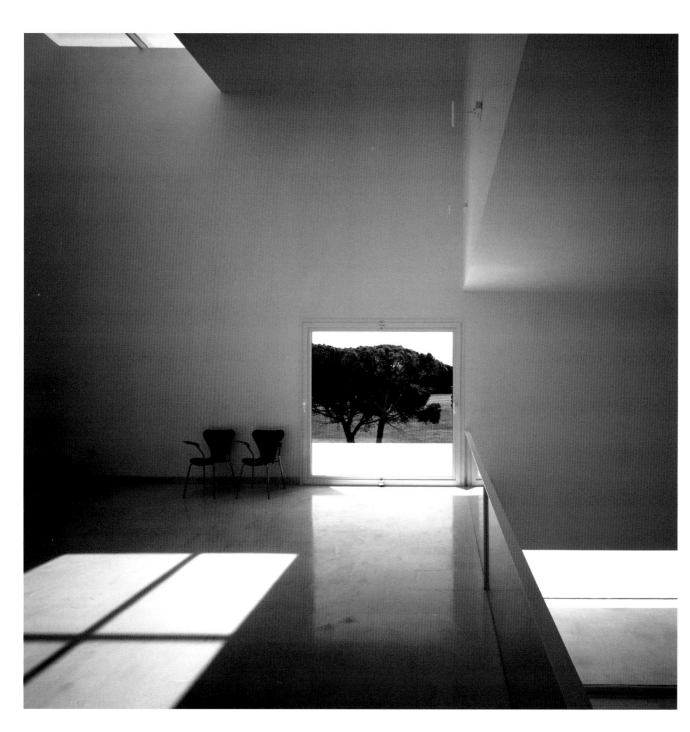

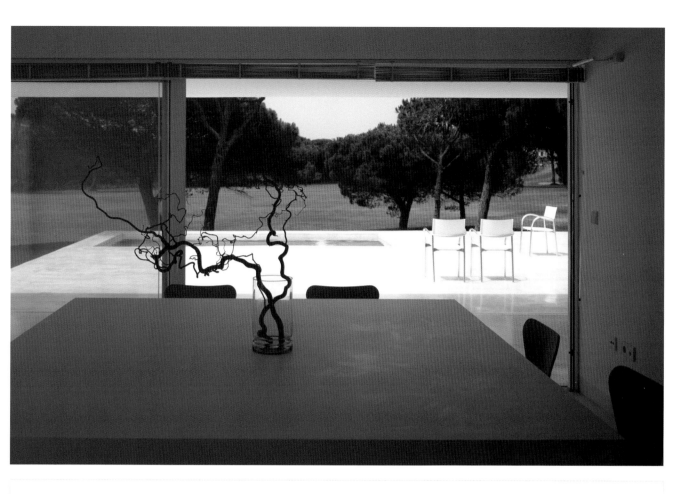

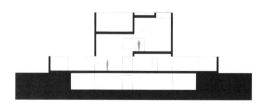

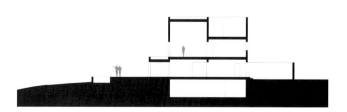

Sections

Doors need not always be vertical: In this house, large, square glass doors frame views of the pine grove landscape belonging to the golf course located in front of the home.

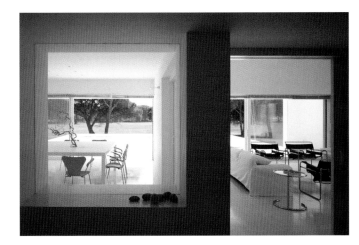

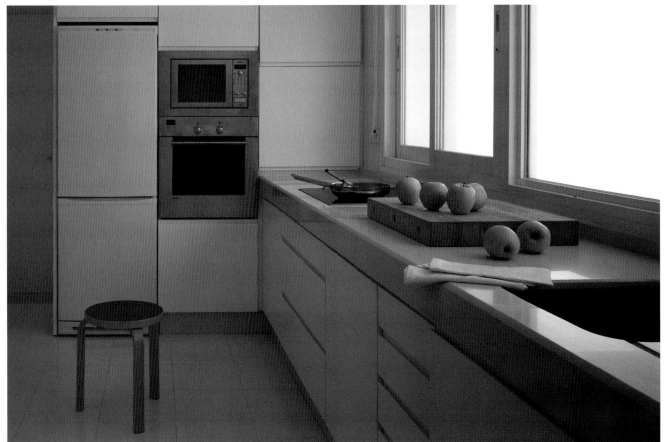

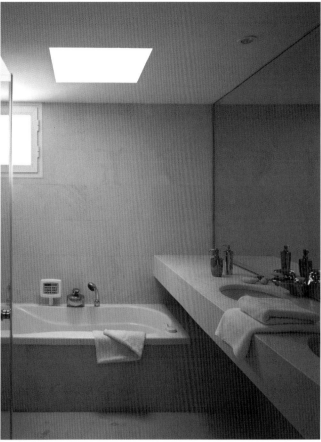

The square plan divides the private and public spaces between the front and back of the house. The front half houses the common living areas, dining room, and library, while the rear, in addition to the vertical circulations, contains the bedrooms and bathrooms.

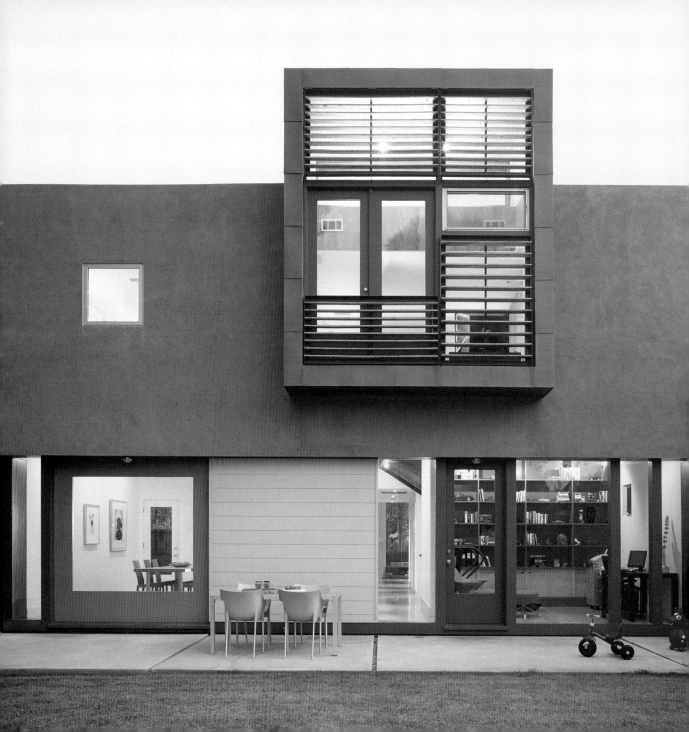

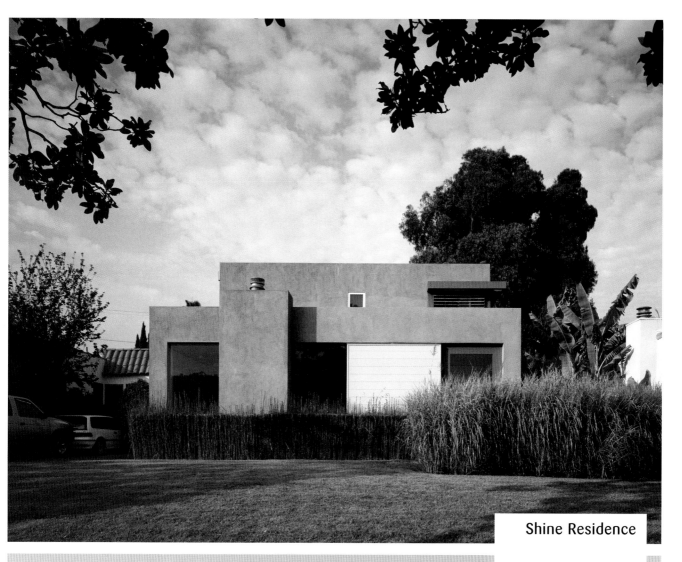

Shine Residence

This house was designed as the architectural prototype of a contemporary single-family home for a middle-class family keen on the latest interior design trends. A simple floor plan and distinctive structural traits give this house a unique character and represent the architects' signature design.

Architect: Koning Eizenberg
Location: Santa Monica, CA, United States
Date of construction: 2001
Photography: Benny Chan/Fotoworks

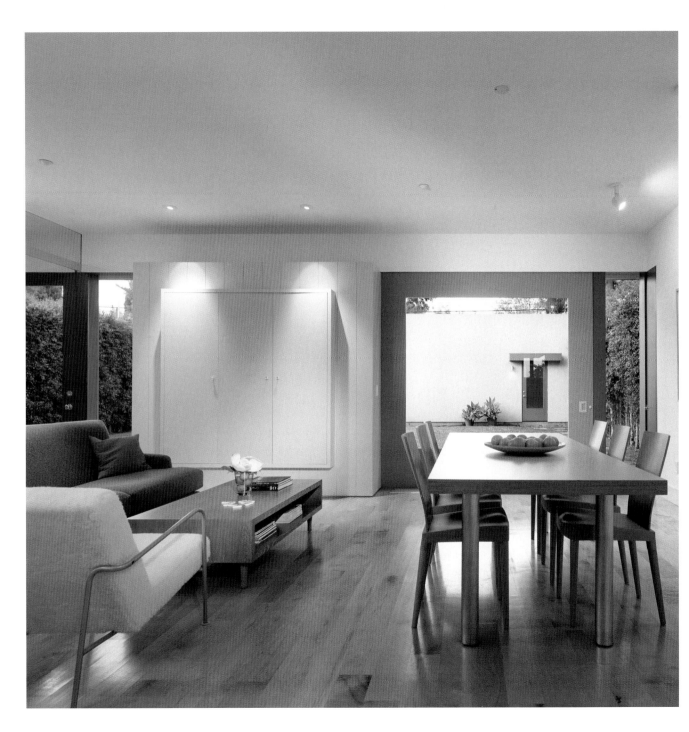

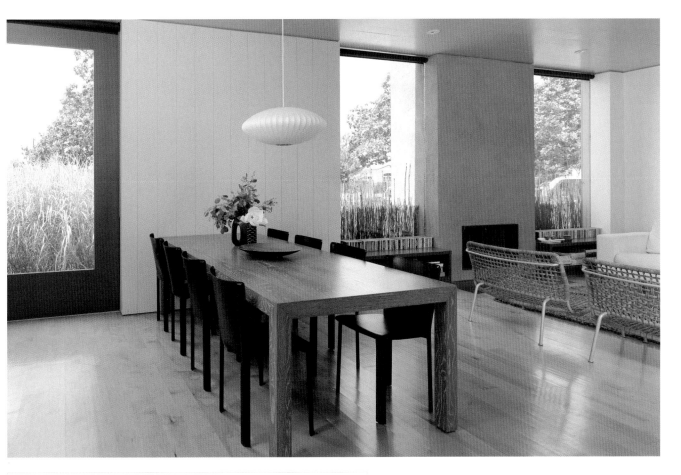

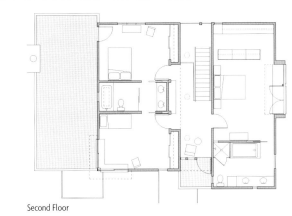

Second Floor

Extensive glazed surfaces
frame the exterior views
and generate a heightened
sense of space.

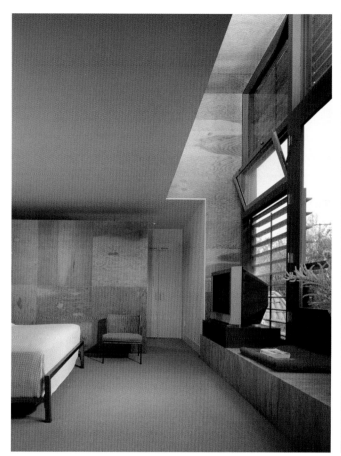
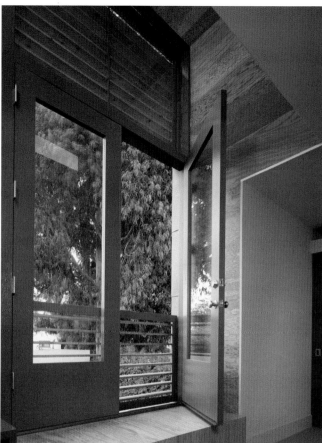

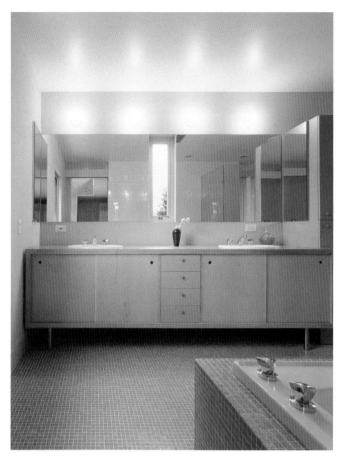

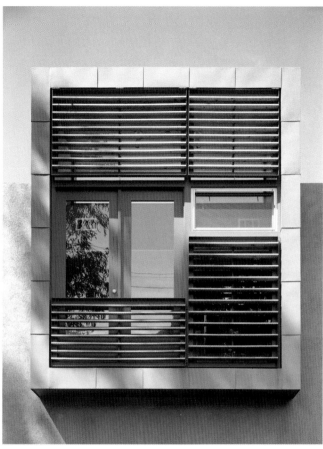

Although mosaic tiles are most often used along bathroom walls, this design features an entire floor covered with this material, which joins seamlessly with the bathtub.

Structural details like the ones used by Koning Eizenberg in many of their projects can lend a house a very unique style. Oversized picture-frame doors and the pop-out window of the master bedroom are perfect examples of this kind of feature.

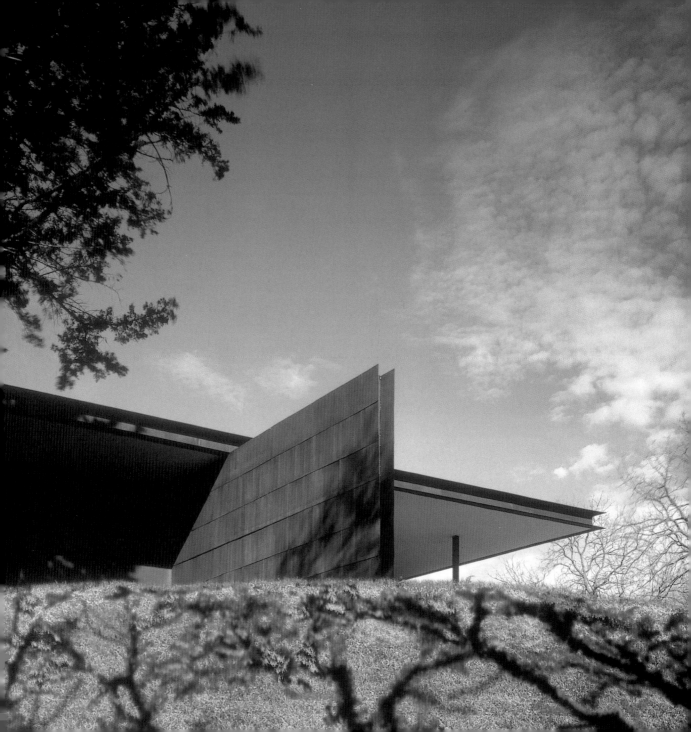

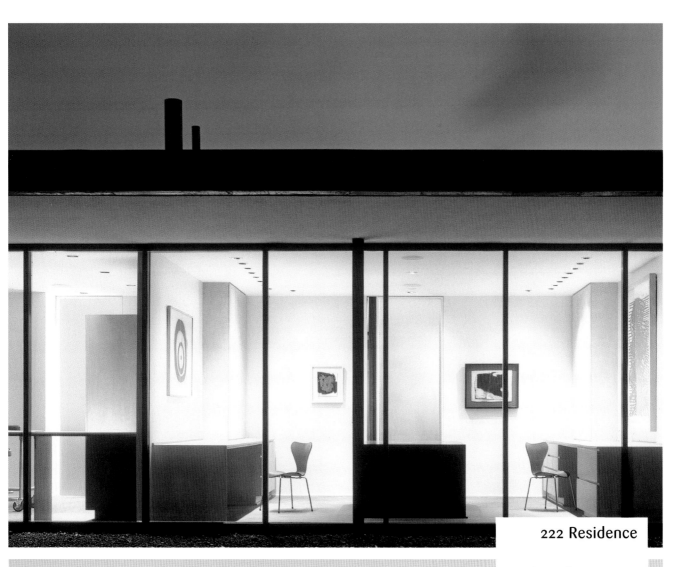

222 Residence

This 3,500-square-feet residence, located in Oklahoma, adopts a highly modern appearance in contrast to the traditional neighborhood in which it is set. Isolated to guarantee privacy from surrounding homes, the house consists of an impressive, linear structure lined with rusted steel panels and an elegant interior that boasts an important art collection.

Architect: Elliot + Associates
Location: Oklahoma City, OK, United States
Date of construction: 2003
Photography: Bob Shimer/Hedrick Blessing

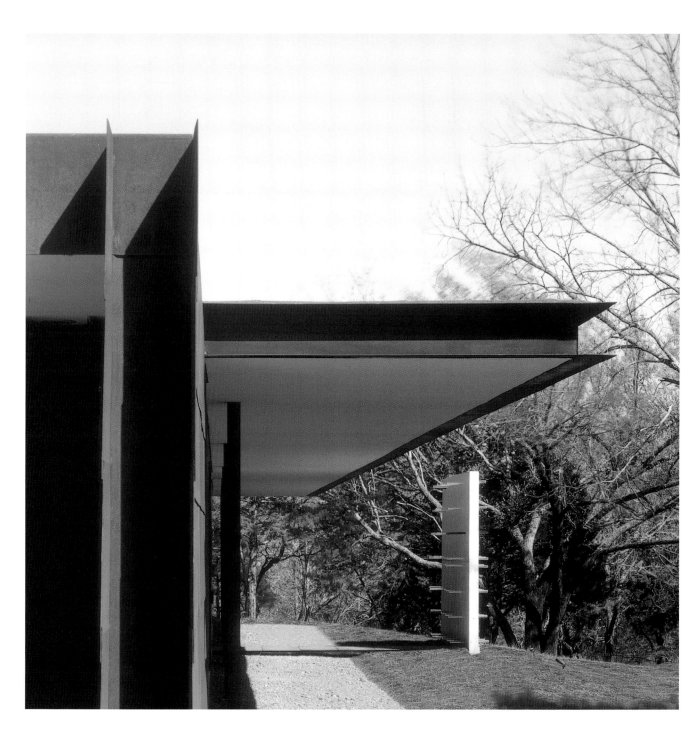

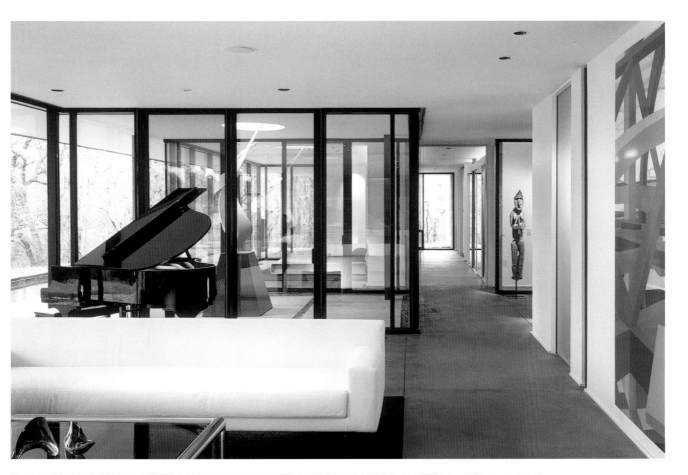

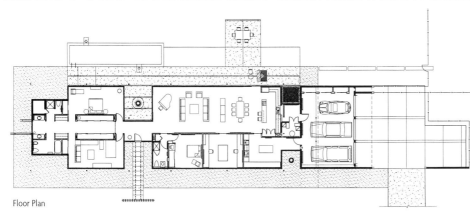

Floor Plan

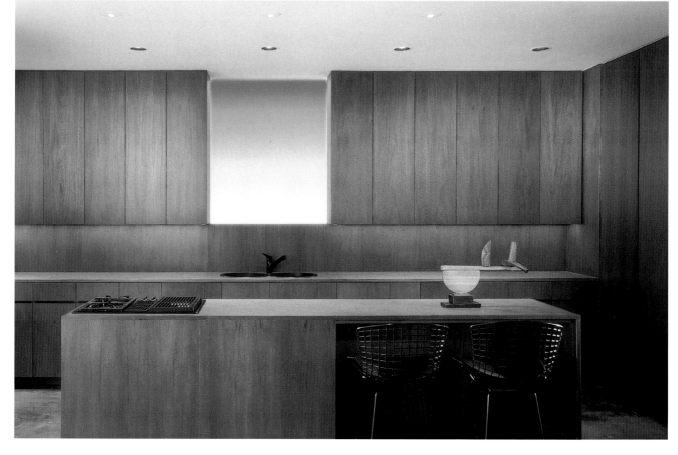

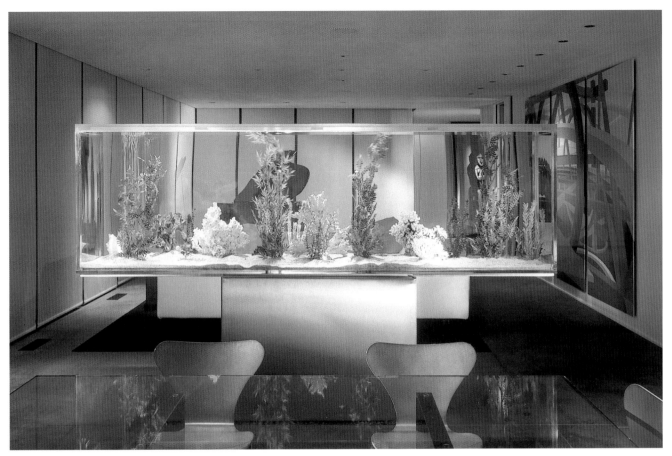

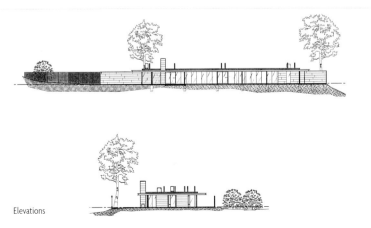

Elevations

Given the lack of windows in the kitchen, a glowing, backlit panel was created as yet another piece of art that in this case mimics the presence of a window and produces the sensation of natural light.

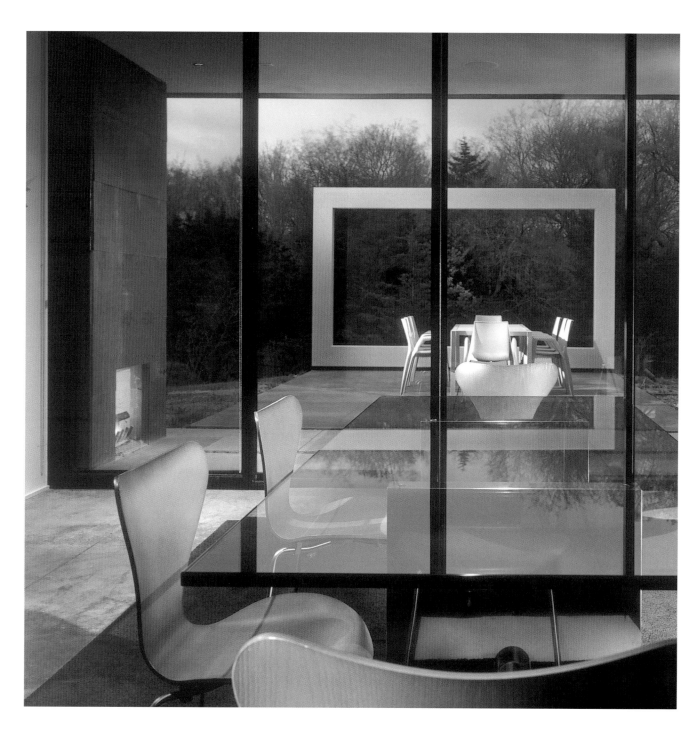

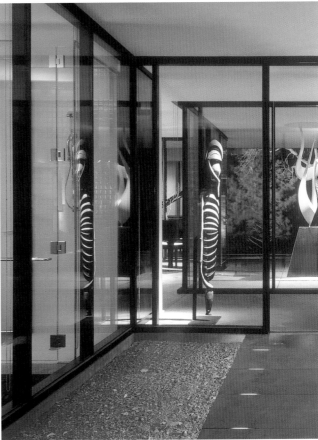

The existing art collection was arranged
to complement the scale and natural
light. Nevertheless, the dominant feature
of the project is the landscape, which
can be contemplated from every angle
through the full-length glass windows.

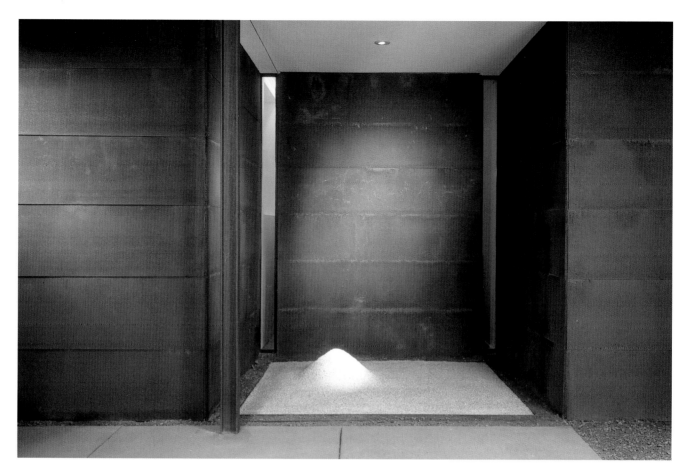

Spatial warmth is created with surface and color, using different materials and finishes for contrasting textures that differentiate the interior spaces.

Elevations

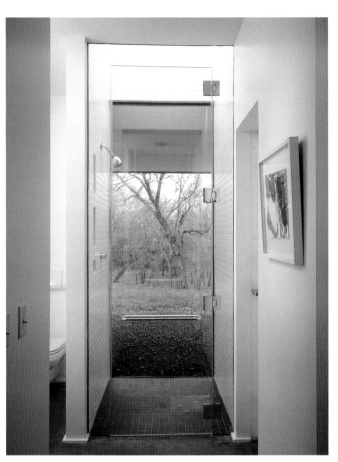
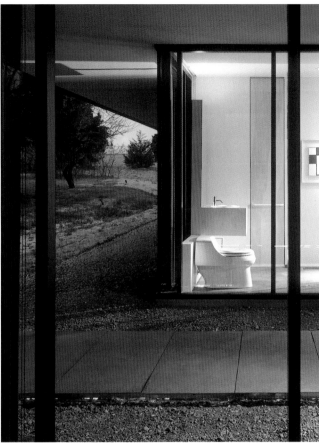

To take advantage of the surrounding landscape and the privacy of the site, glass can also be used in more private spaces such as the bathroom to provide a soothing view and create a greater sense of connection with nature.

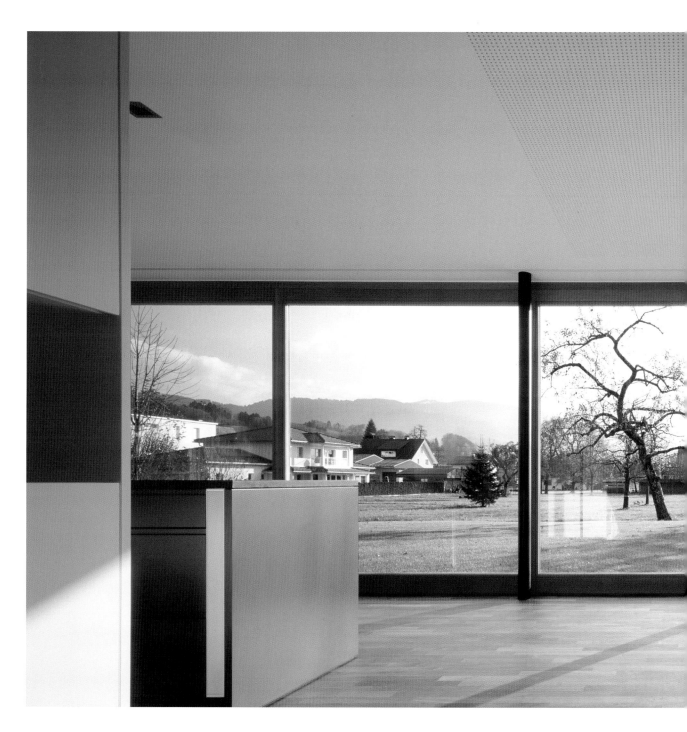

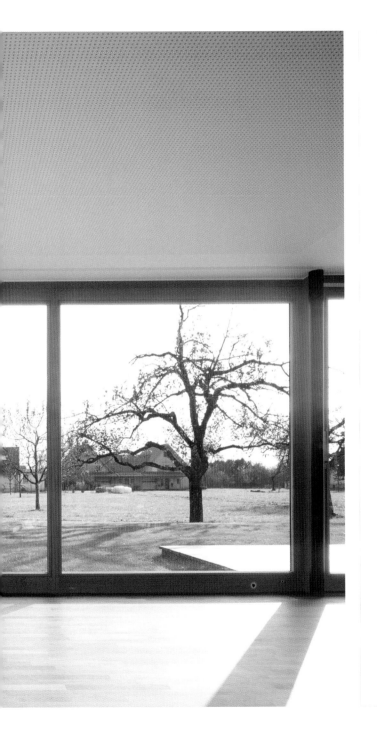

Town

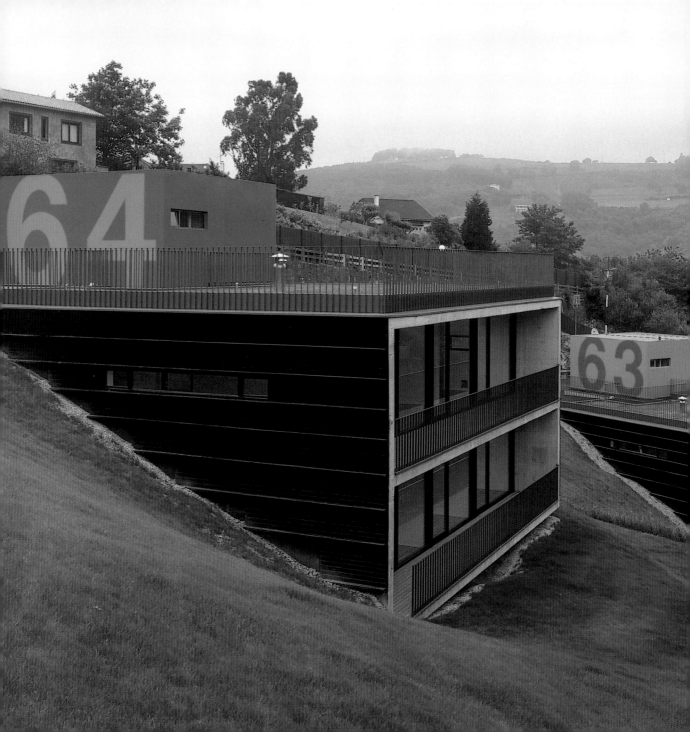

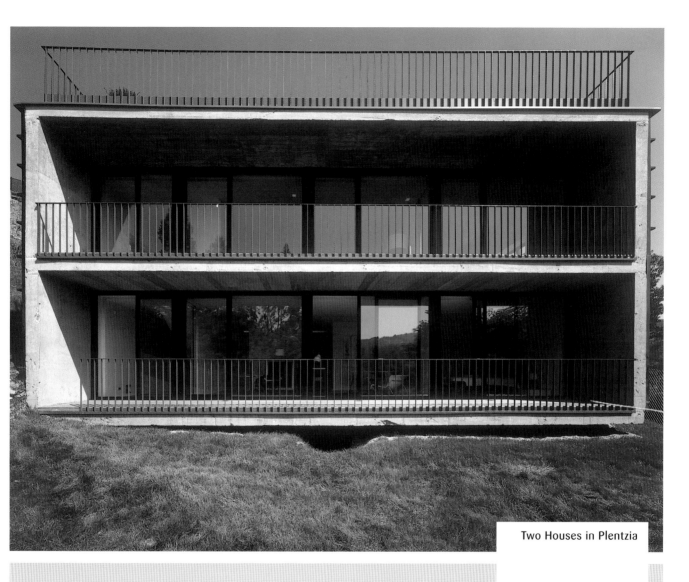

Two Houses in Plentzia

Embedded in a steep, green hill and oriented toward the sea, these two single-family houses in Vizcaya merge with the landscape in an attempt to minimize their effect on the site and provide the future tenants with the best possible view of the valley.

Architect: AV62 Arquitectos
Location: Plentzia, Spain
Date of construction: 2003
Photography: Eugeni Pons

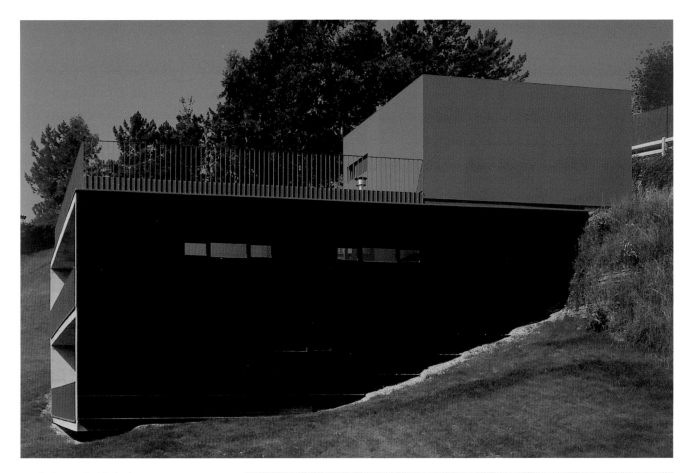

Partially dug into the hill, the house is accessed through the top level, which boasts a landscaped rooftop garden and blue structure that contains a garage.

Roof Plan

Elevation

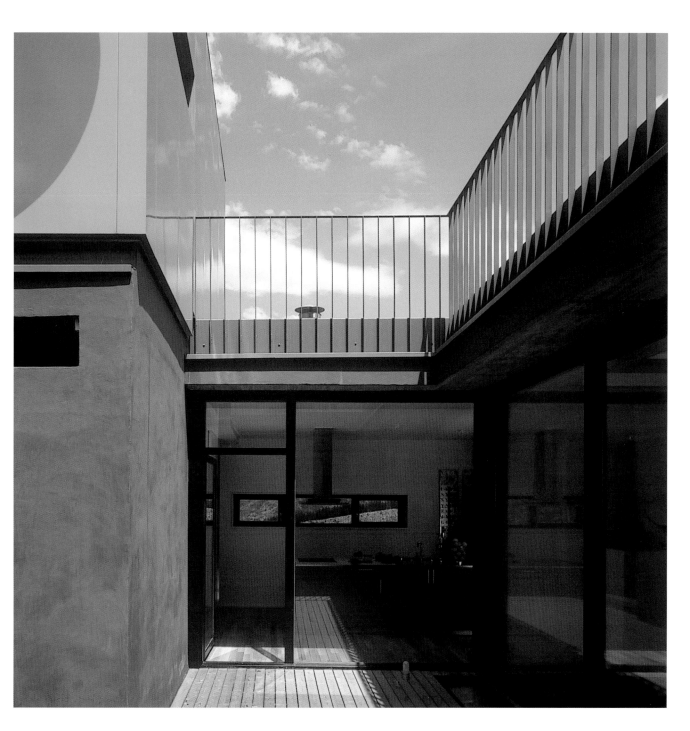

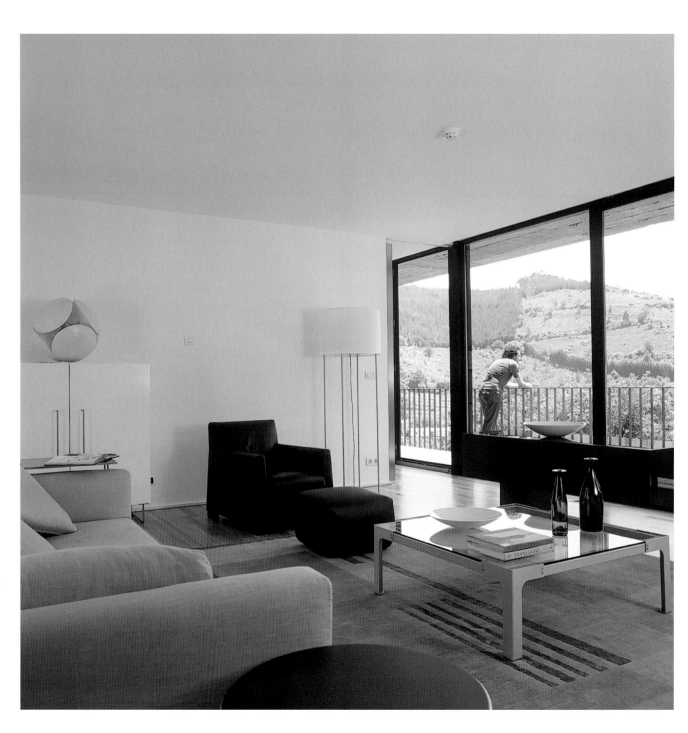

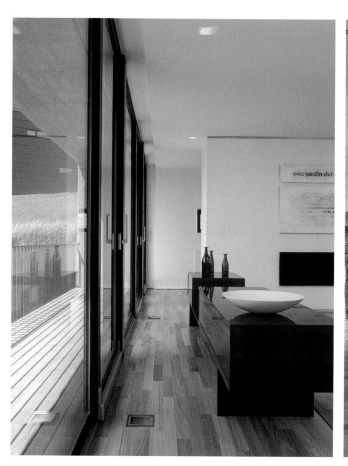
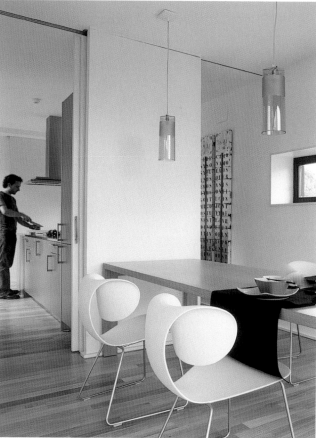

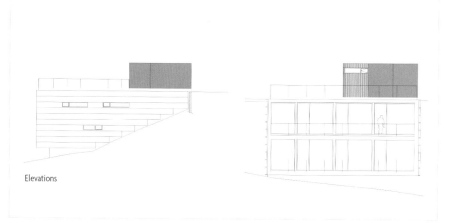

Elevations

The living areas were designated to the upper level to take advantage of the scenic views. Sliding panels offer the possibility of closing off the kitchen from the dining and living area.

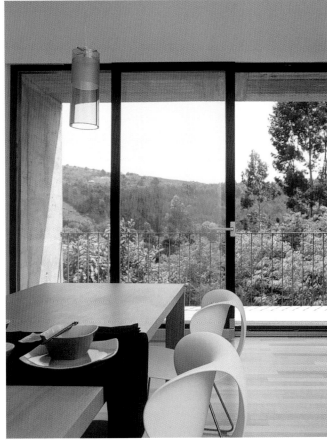

The dining table acts as an
extension of the kitchen
counter, creating
a sense of continuity
between the two areas.

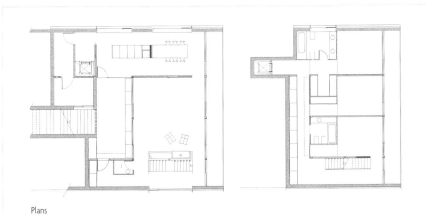

Plans

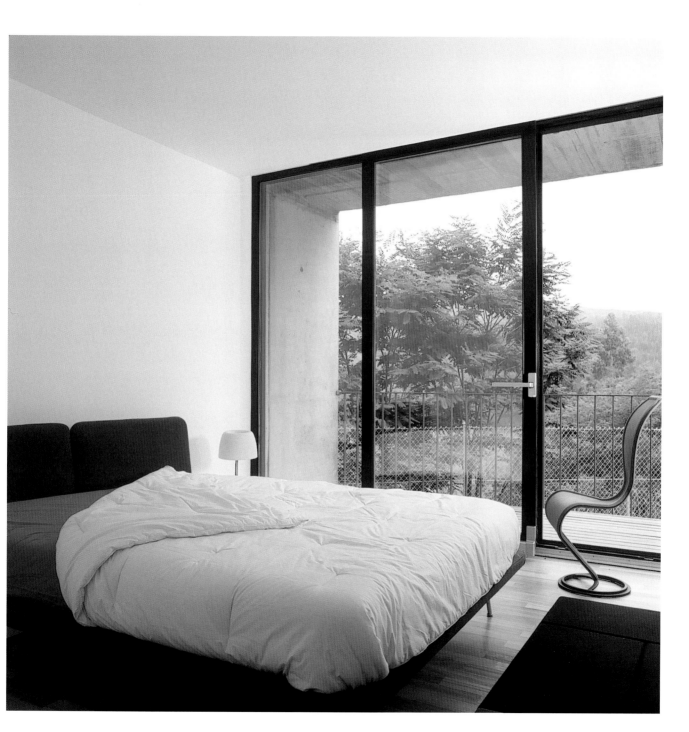

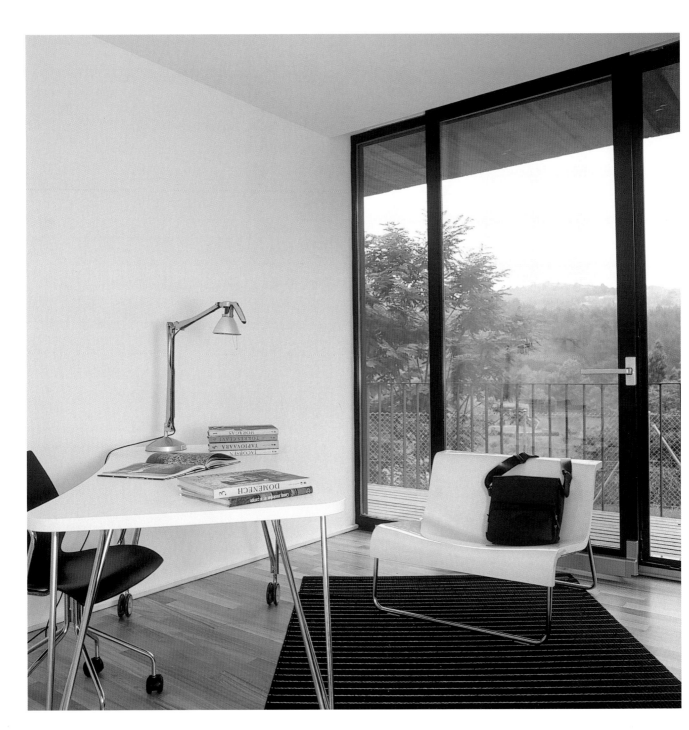

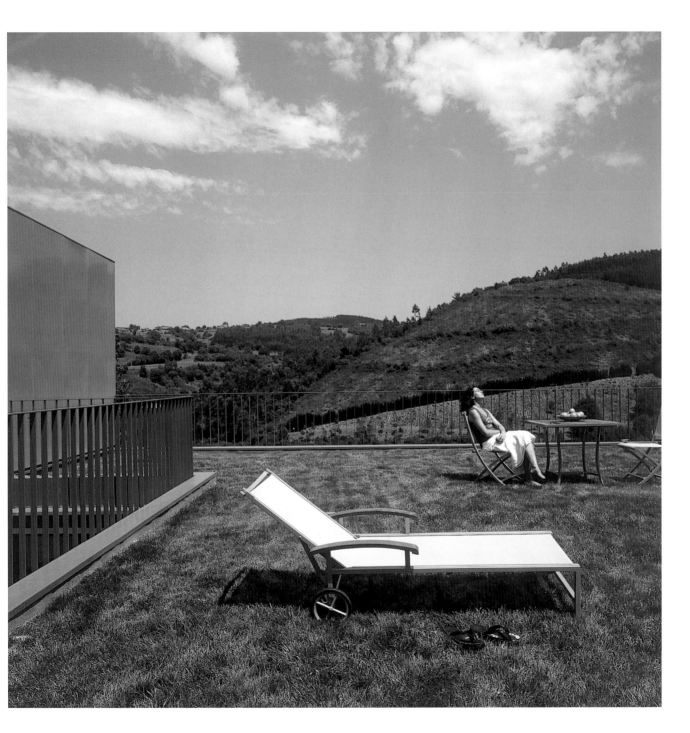

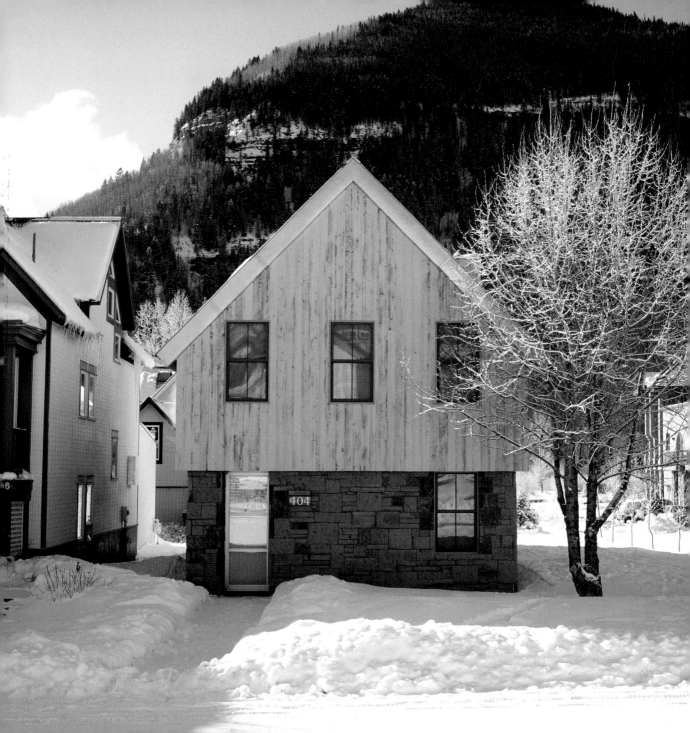

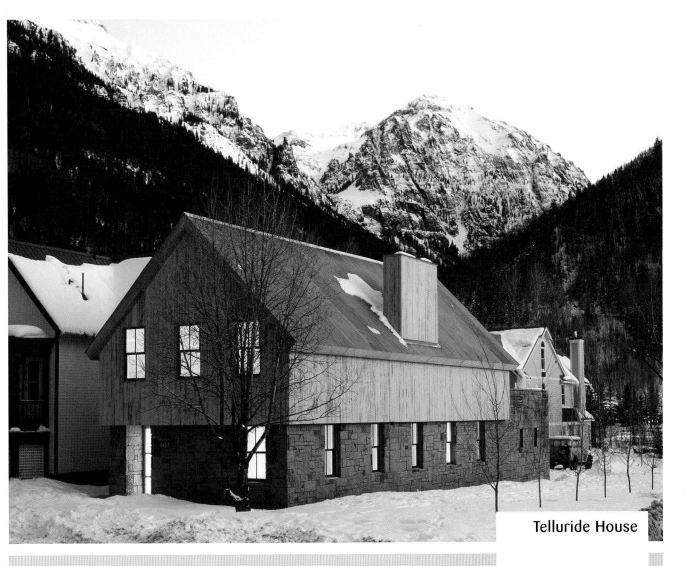

Discreetly incorporated into a context of vernacular building forms, this house, located in the ski resort town of Telluride, adopts a traditional pitched-roof structure differentiated from the surrounding houses by a layered façade composed of weathered wood and natural stone.

Architect: John Pawson
Location: Telluride, CO,
United States
Date of construction: 2001
Photography: Undine Pröhl

The public zones, including the living, kitchen, and dining areas were allocated to the second floor to take advantage of the mountain view through glazed gable ends.

Site Plan

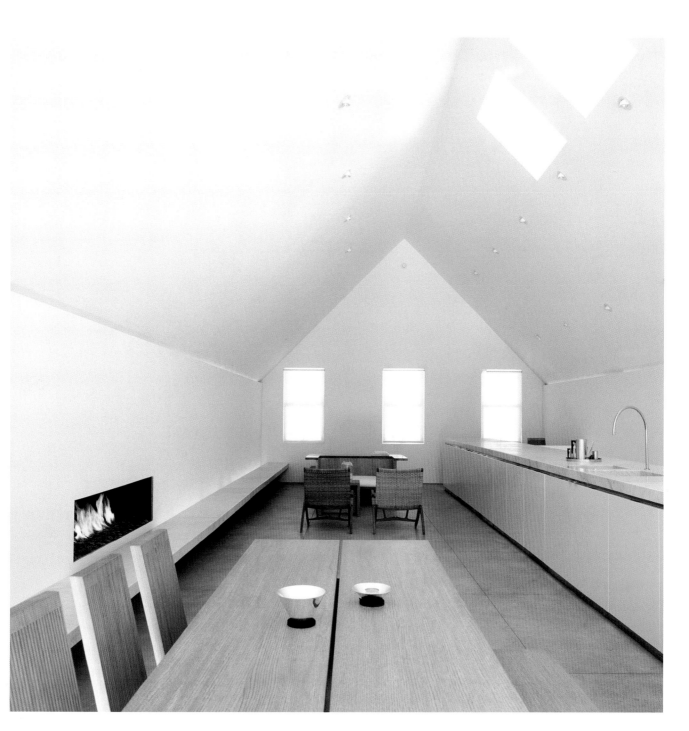

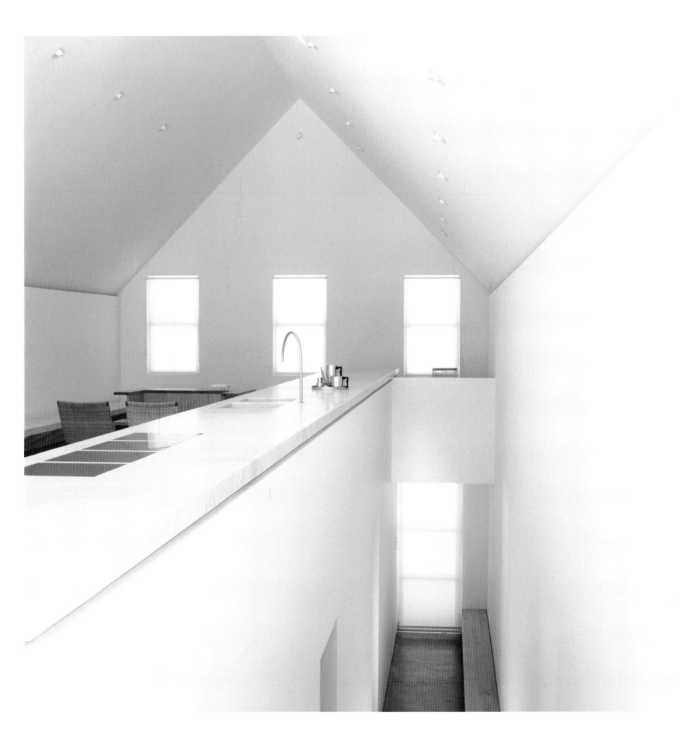

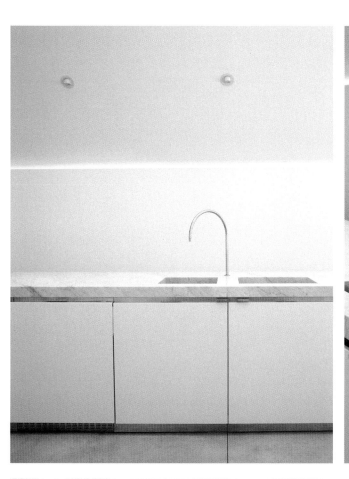

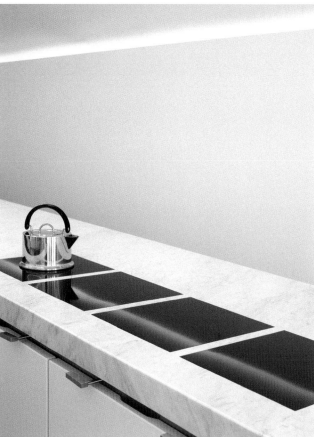

Ground Floor

First Floor

Bands of indirect lighting
can give spaces
a contemporary feel
and minimize the need
for additional light fixtures.

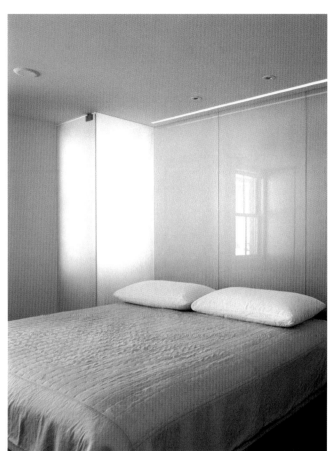

56

The glass panels that enclose
the shower also serve as a
headboard for the bed. The
choice of materials reflects
the local palette and the
architect's signature style.

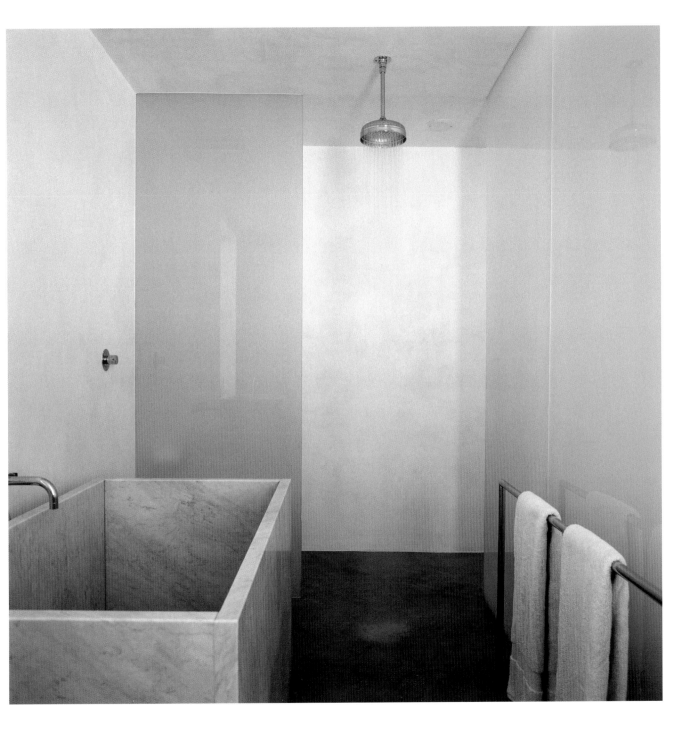

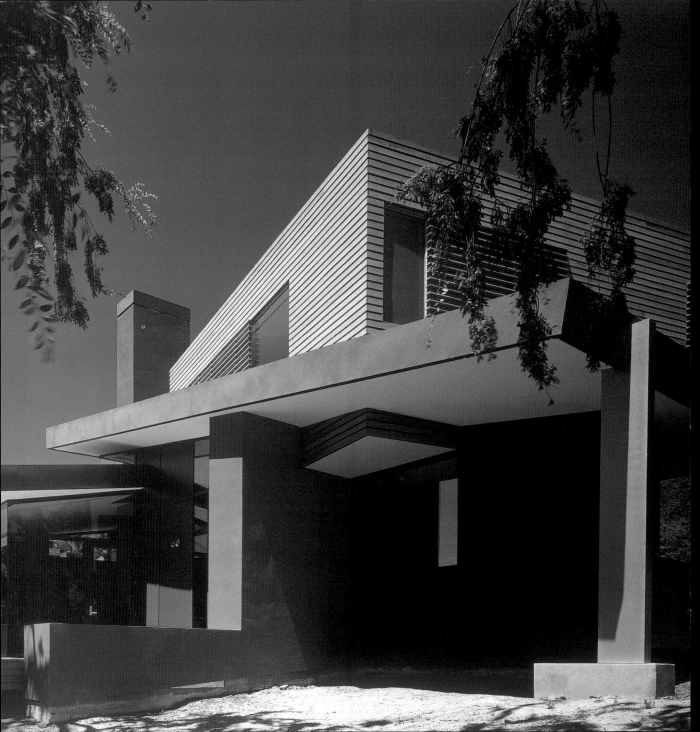

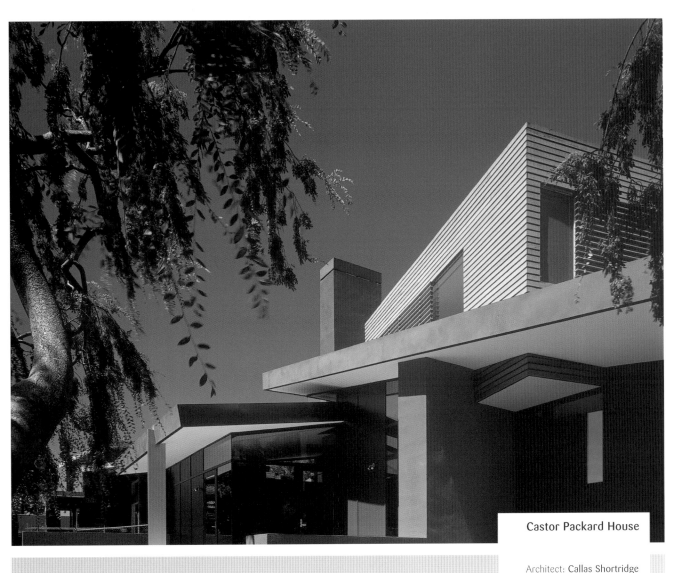

Castor Packard House

Architect: Callas Shortridge
Architects
Location: Portola Valley, CA,
United States
Date of construction: 2002
Photography: Tim Griffith

This house replaced one of the many modern homes built during the 1950s in Portola Valley, California. The architects were challenged to create a design that would fit in with the older, existing context and at the same time embody contemporary ideals.

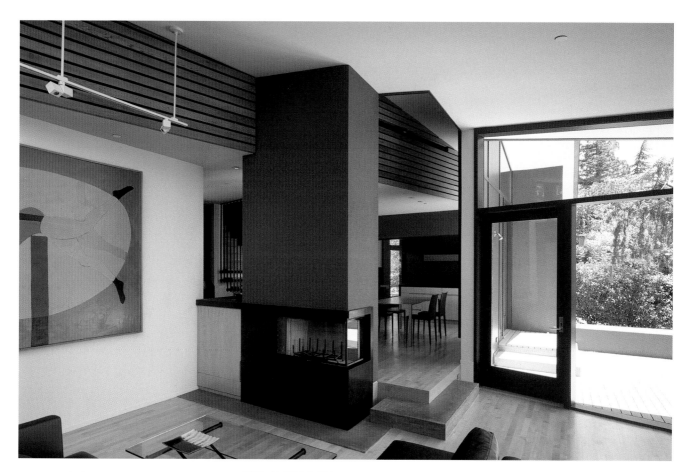

In response to the client's wish
for attractive work areas,
the architects focused on both
the public areas and those used
for business meetings.

Ground Floor

First Floor

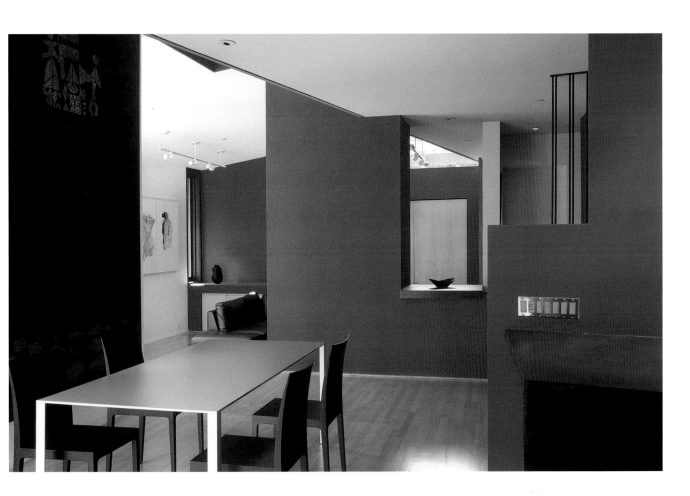

57

The use of color references the original context of the house, integrating both the interior and the exterior into the historical neighborhood.

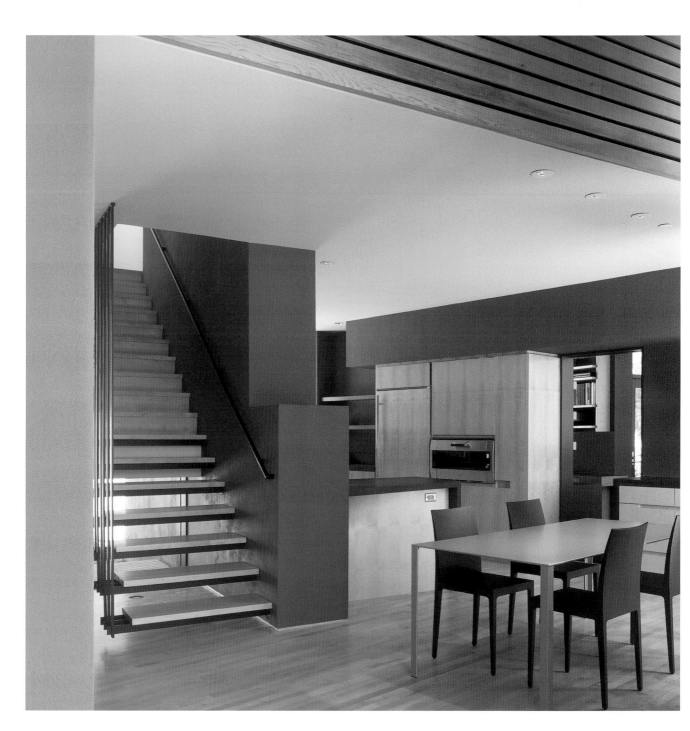

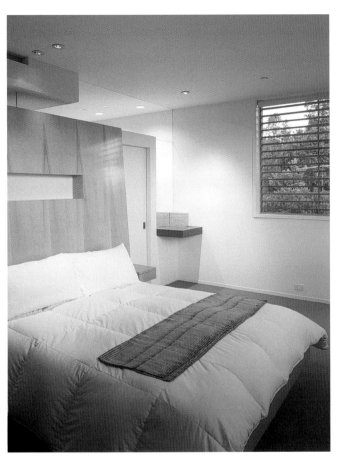

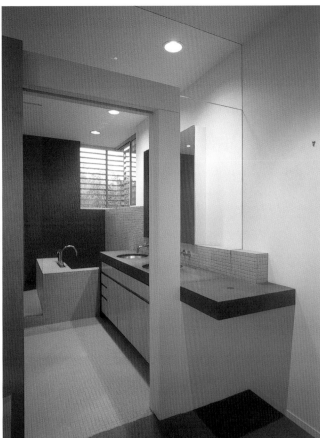

The orientation of the upper level, which contains the bedrooms, is shifted slightly to enable the best view of the valley.

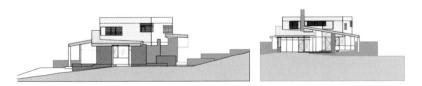

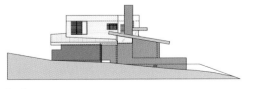

Elevations

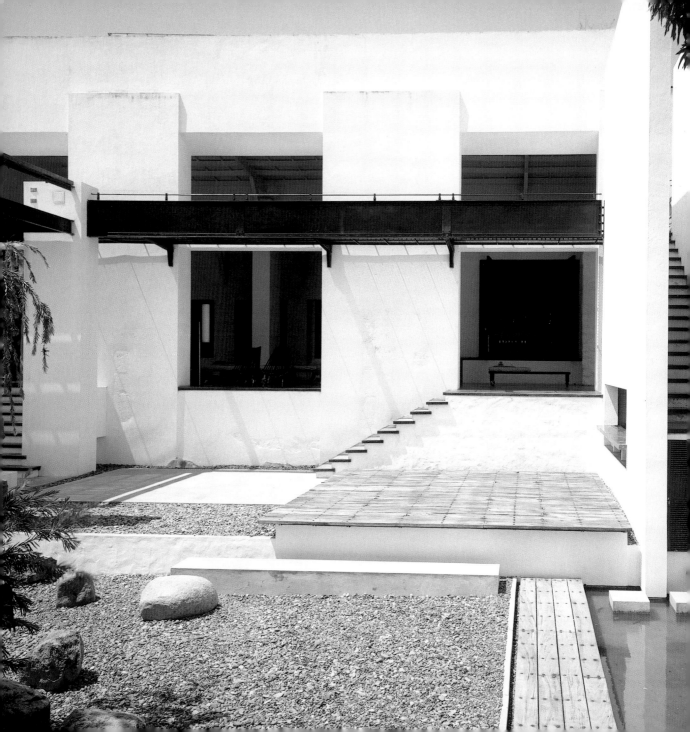

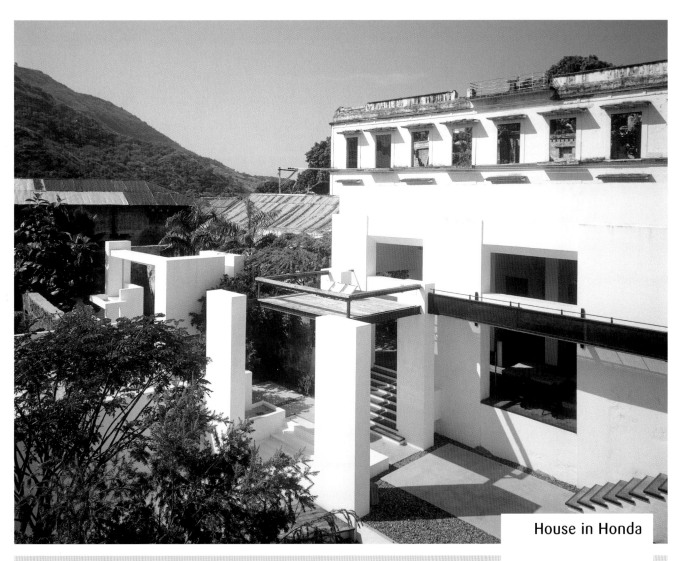

House in Honda

This dwelling comprises two properties facing the street, that once featured
residential and storage buildings. Only the façades and colonial stone walls
of these buildings were preserved and incorporated into the project.
A labyrinth-like layout organizes a multitude of spaces for relaxing and
contemplating the landscape.

Architect: Guillermo Arias + Luis
Cuartas
Location: Honda, Colombia
Date of construction: 2003
Photography: Eduardo
Consuegra

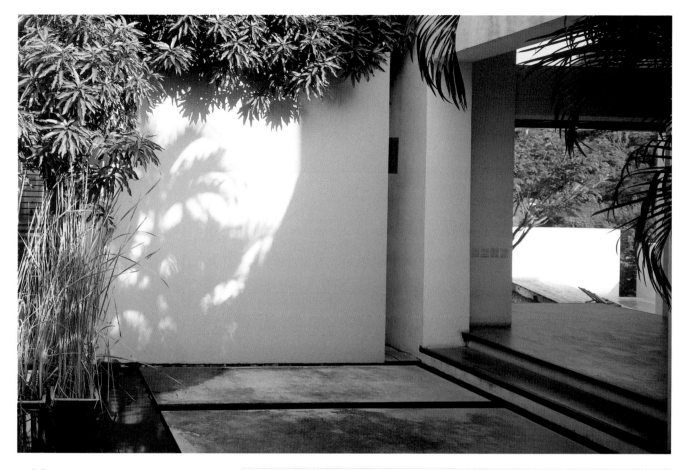

59

The integration of trees and plants can make any house in the country an extension of the landscape that surrounds it.

Ground Floor

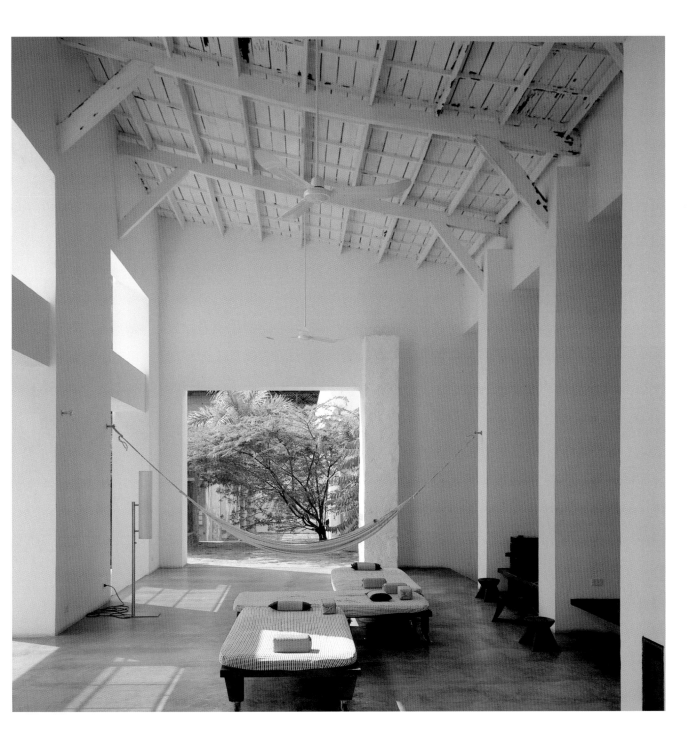

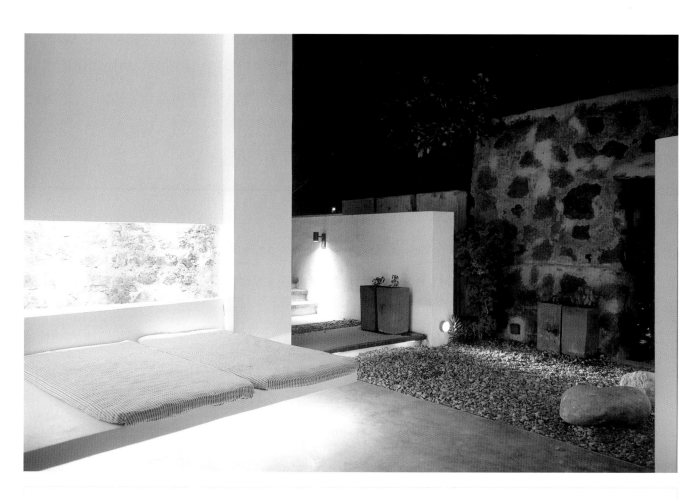

First Floor

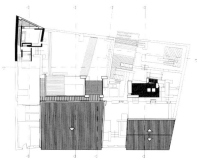

Roof Plan

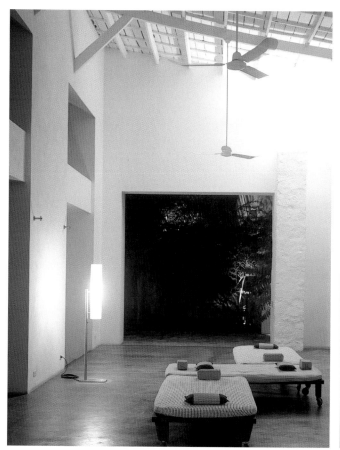

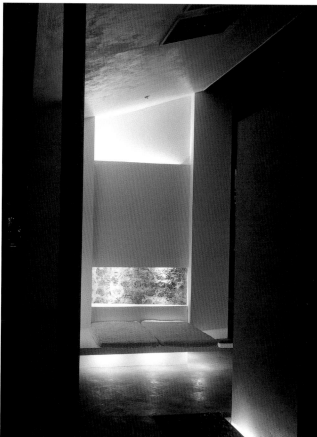

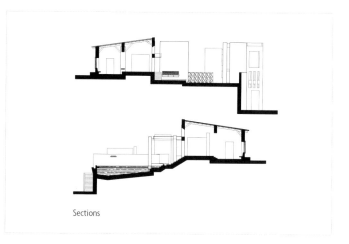

Sections

Every room faces one
of the exterior areas,
each representing a
particular theme, including
a patio with aromatic herbs,
a citrus tree garden, a rock
garden, and a patio with
red peppers.

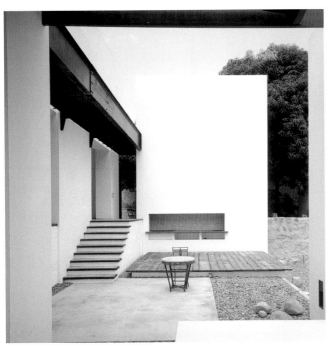
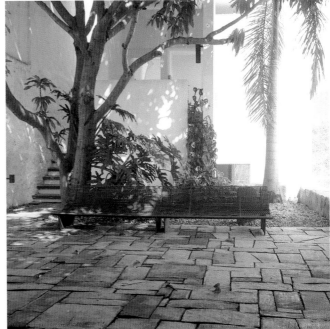
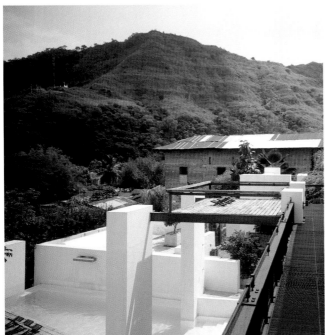
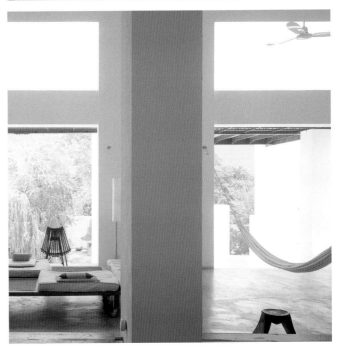

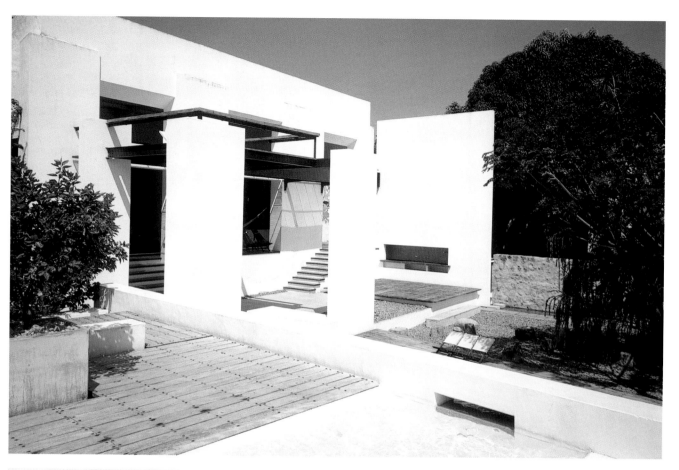

Axonometry

Water acts as the unifying element of
the project, in the form of either a pool,
a fountain,0 or a pond.

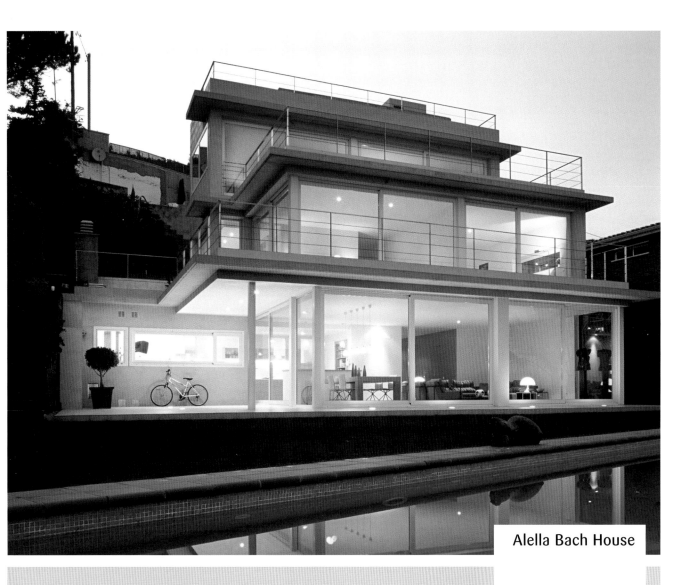

Alella Bach House

This three-story house on top of a hill in the Maresme was designed for a family who wished for a contemporary home with ample terraces and a view of the exterior from every room in the house. The site was also optimized with a garden, a terrace, and an outdoor swimming pool.

Architect: Joan Bach
Location: Maresme, Spain
Date of construction: 2004
Photography: Jordi Miralles

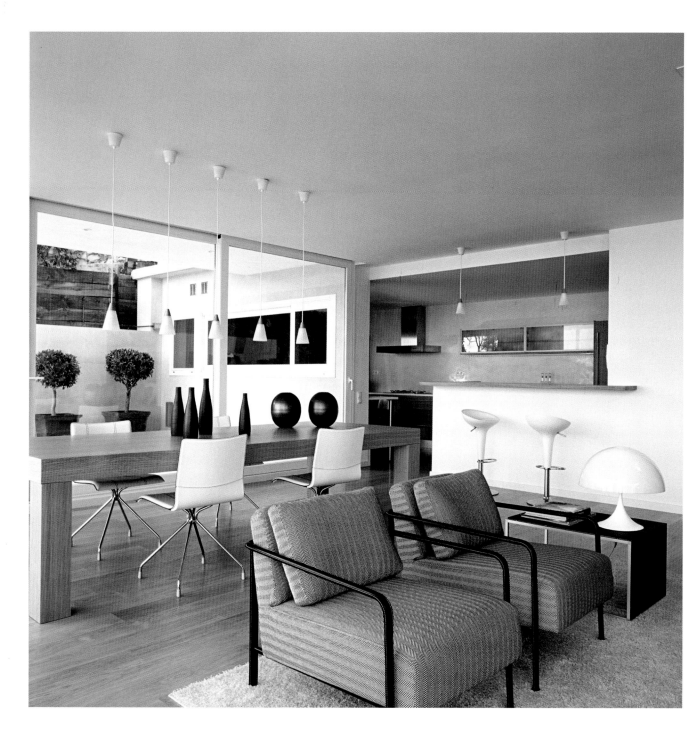

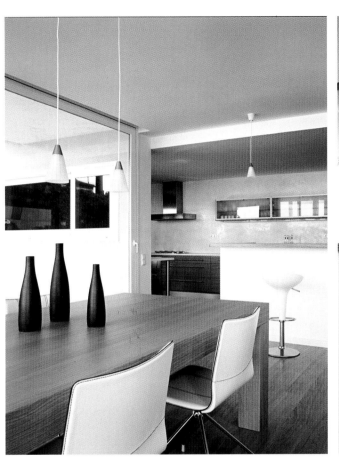

61

A narrow counter with stools can convert the kitchen into a cozy breakfast area for two.

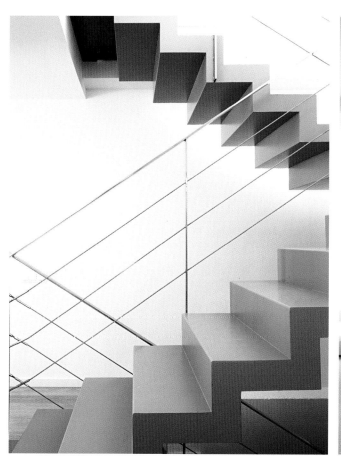
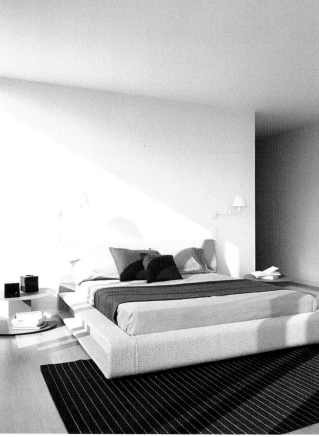

Color can be applied not
only through furnishings
and decorative objects,
but also through
structural elements
such as the staircase.

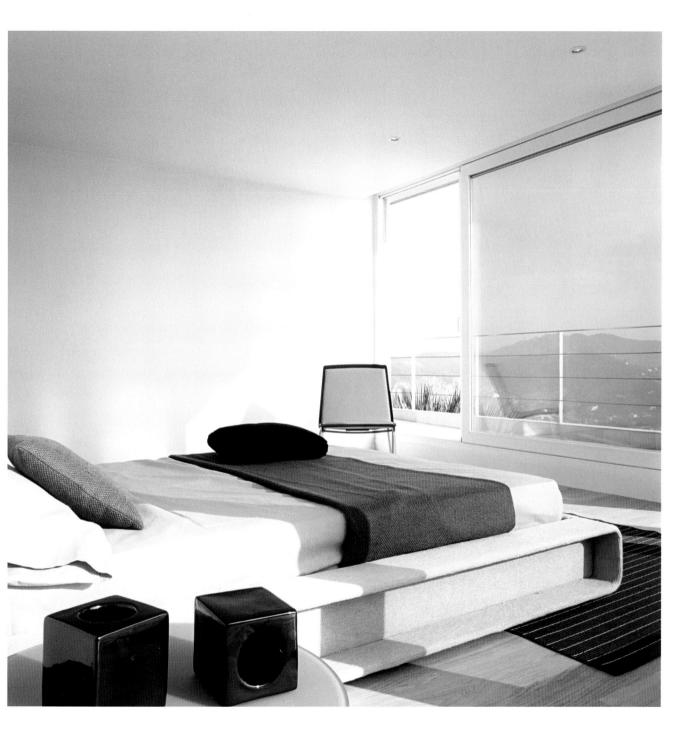

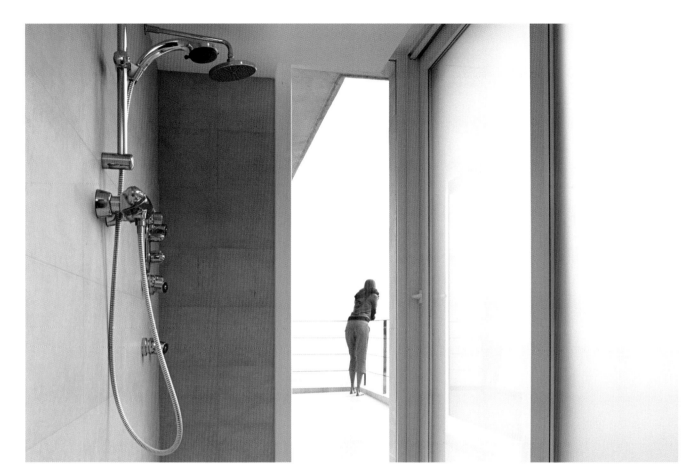

Terraces wrap around the upper levels
of the home, providing a vantage
view from every point in the house,
including the bathroom.

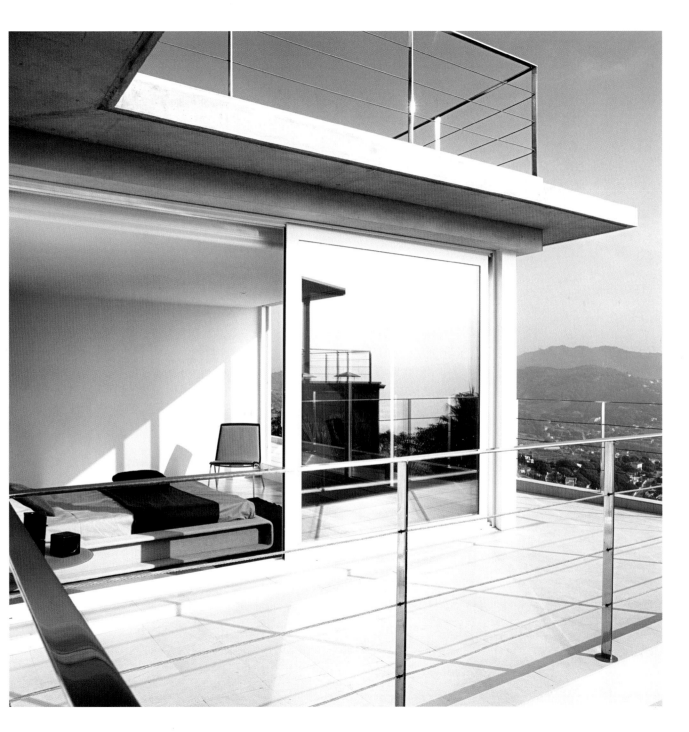

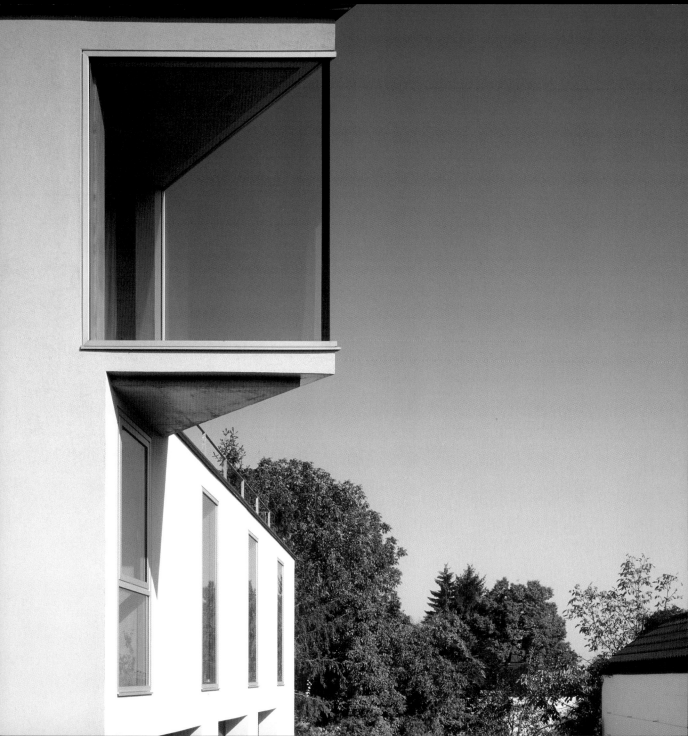

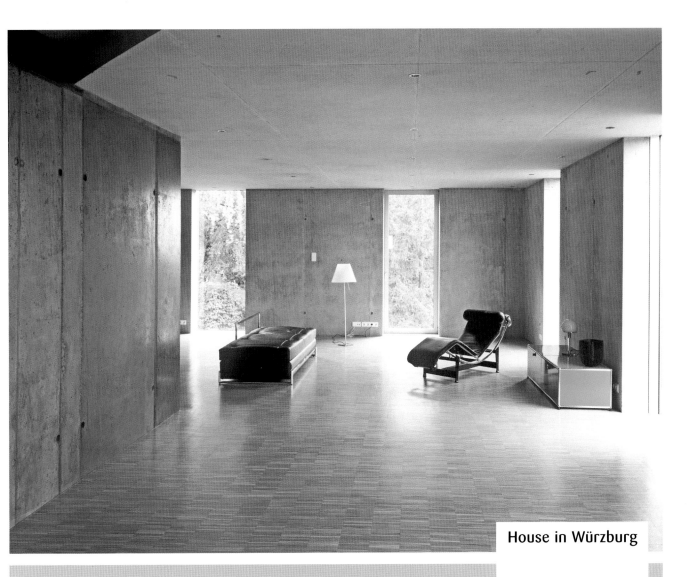

House in Würzburg

This property is located in a purely residential area on a southern slope west of the city of Hoechberg. The orientation of the house was determined by the view of Würzburg Castle, which resulted in a triangular-shaped third floor that incorporates extensive glass areas to optimize the view.

Architect: Bernhard Heid Architekten
Location: Würzburg, Germany
Date of construction: 2004
Photography: Stefan Meyer

The floors are made of industrial-quality oak parquet, while special fittings are made out of natural beech wood.

Floor Plans

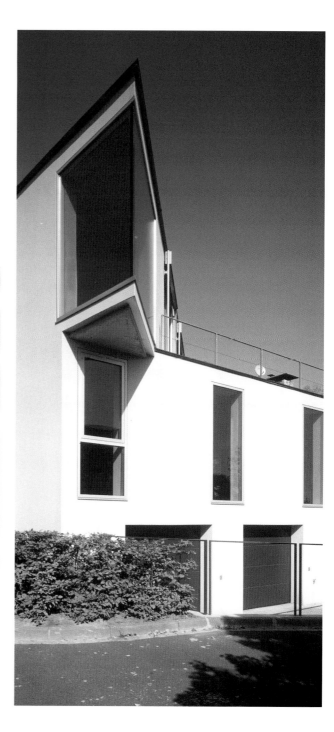

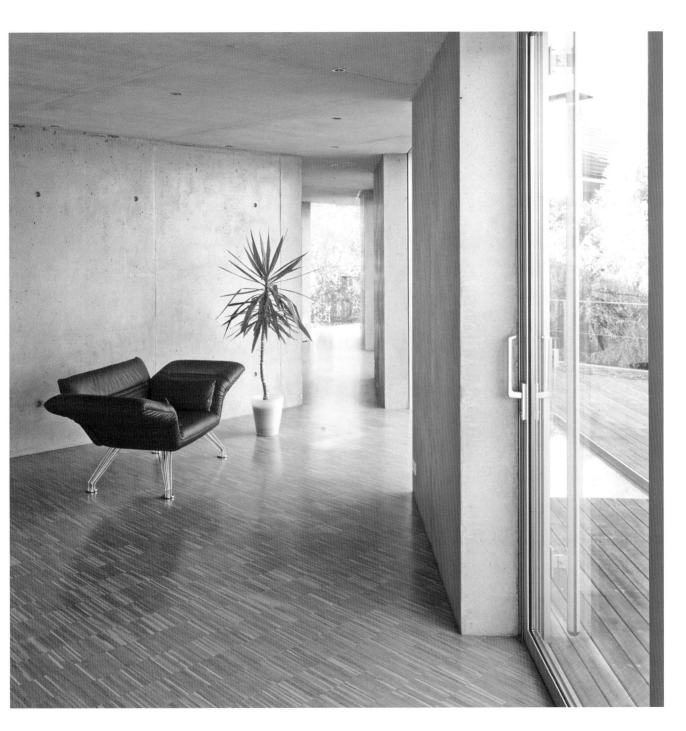

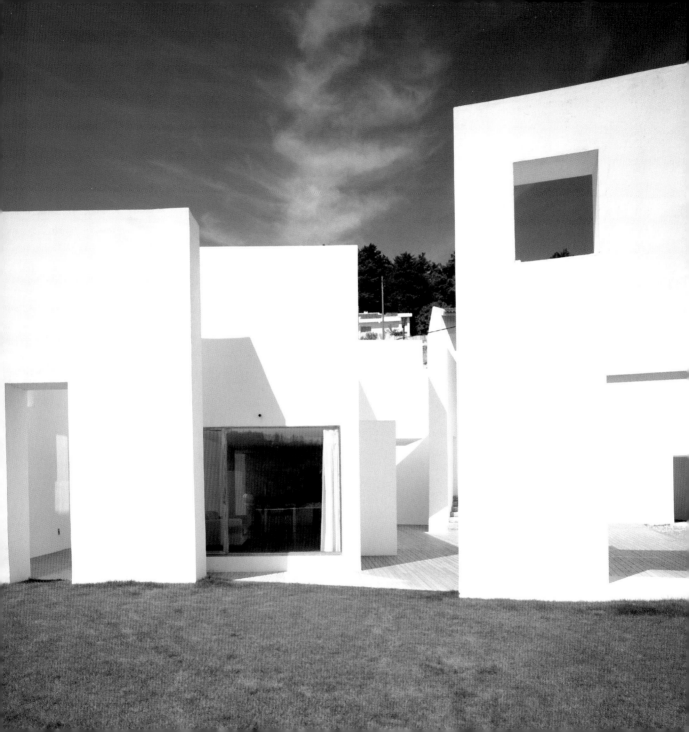

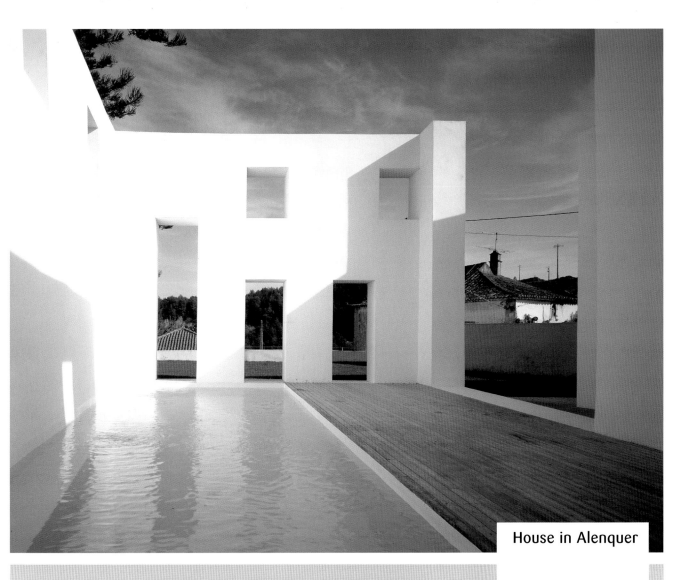

House in Alenquer

A series of white structures arranged around a pool and deck constitute this project, whose starting point was the remaining external walls of an existing house. The ambiguity of the limits delineated by the structures creates a dynamic relationship between the interior and exterior spaces.

Architect: Aires Mateus
Location: Alenquer, Portugal
Date of construction: 2003
Photography: Daniel Malhão,
Jorge P. Silva, Francisco Mateus

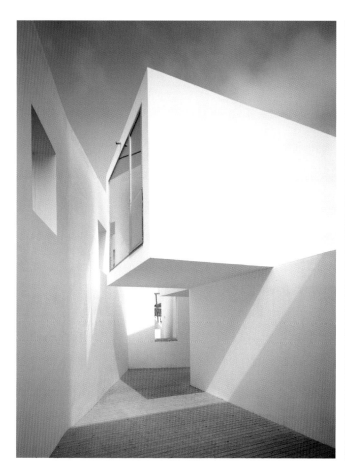
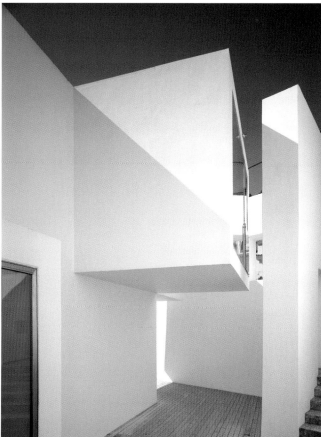

The insertion of a wooden deck between the freestanding structures lends the house the atmosphere of a small, private complex with its internal/external passage ways that lead from one structure to another.

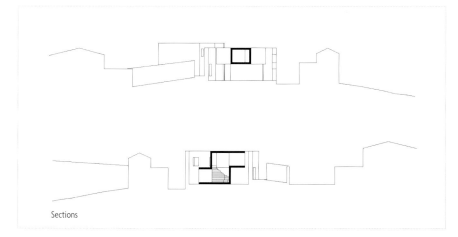

Sections

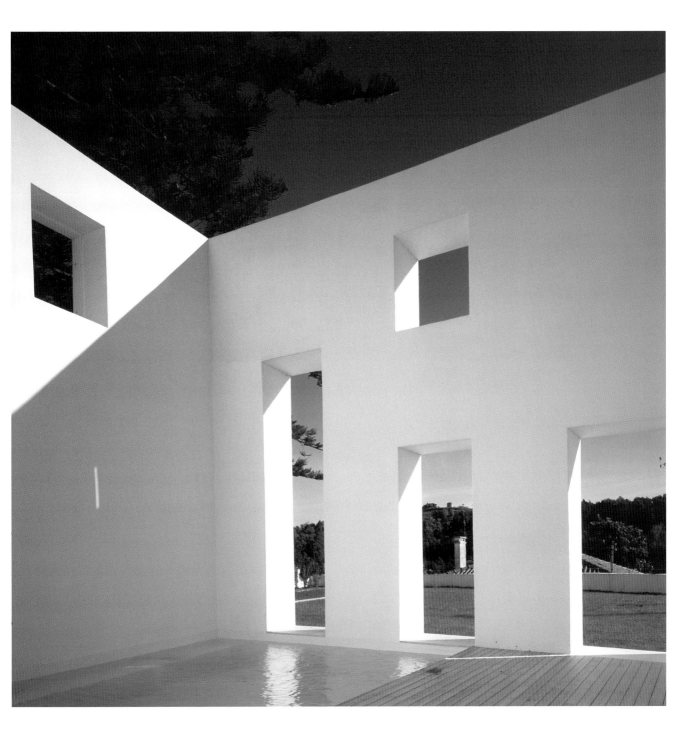

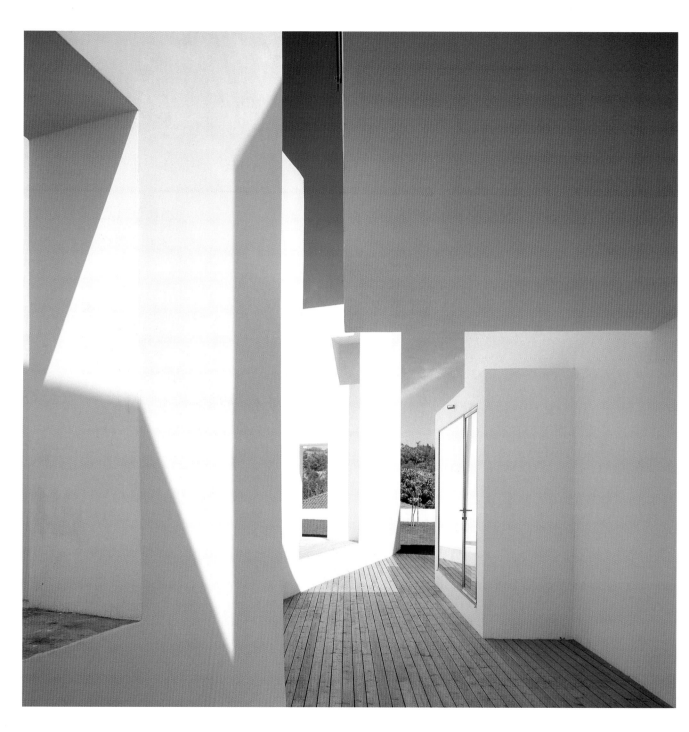

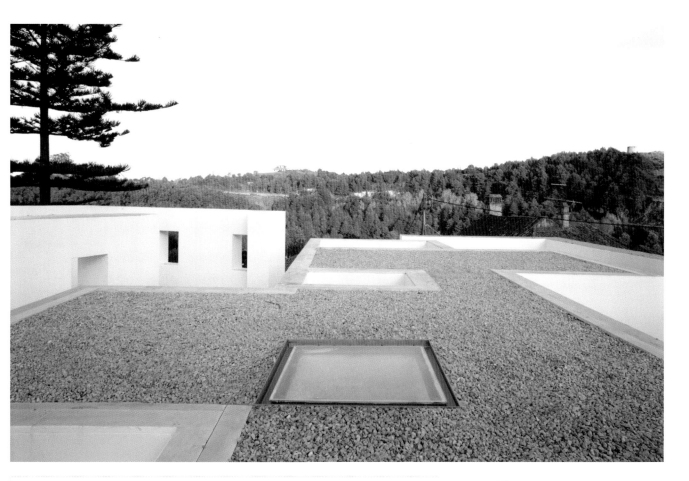

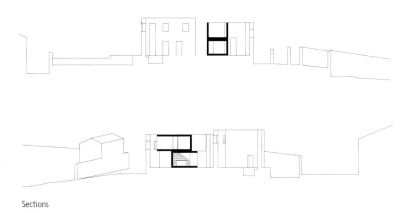

Openings made in the walls
act as picture frames that
capture the view of the
green landscape.

Sections

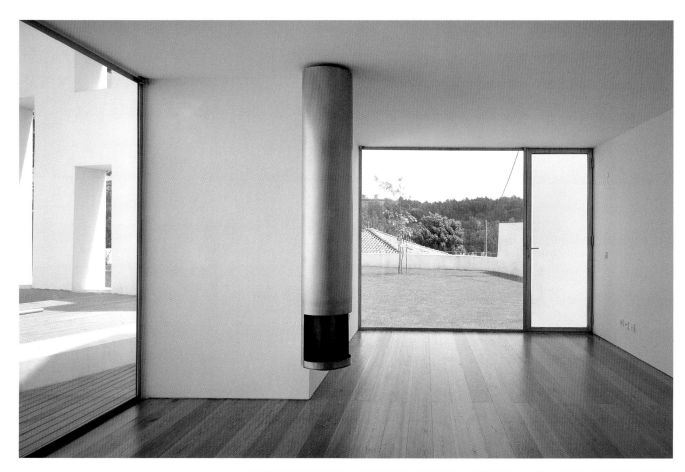

In contrast to the exterior, the interior spaces are clearly defined and autonomous, and are permanently linked to the exterior through fulllength windows.

Ground Floor

First Floor

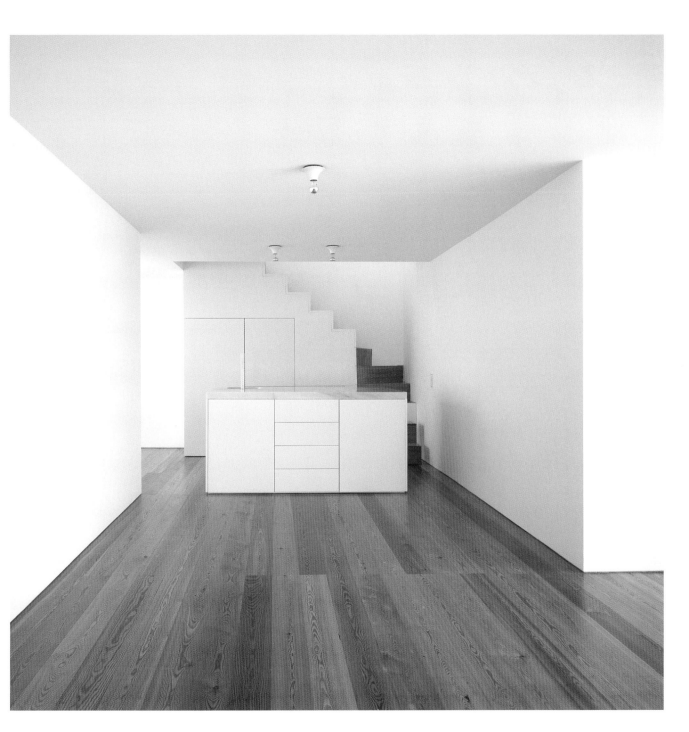

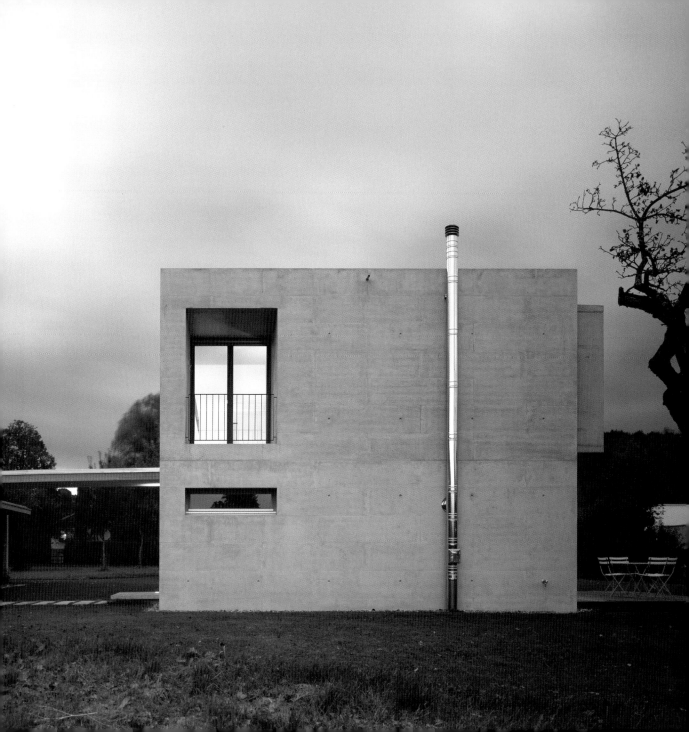

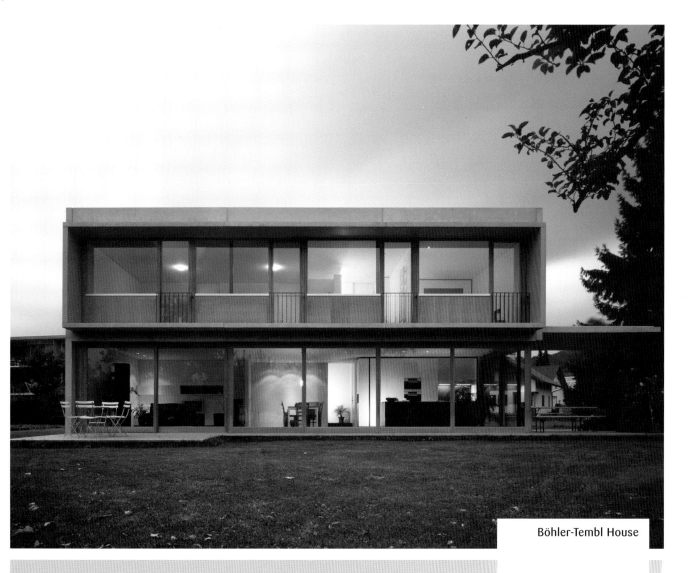

Böhler-Tembl House

Located east of the Rhine Valley atop the hills of the west side of Steußergs Mountain, this house is wrapped in concrete and articulated through two levels of glazed façades that rest on a wooden deck and look out toward a grove of fruit trees.

Architect: ArchitekturBüro,
Christian Lenz
Location: Wolfurt, Austria
Date of construction: 2003
Photography: Adolf Bereuter

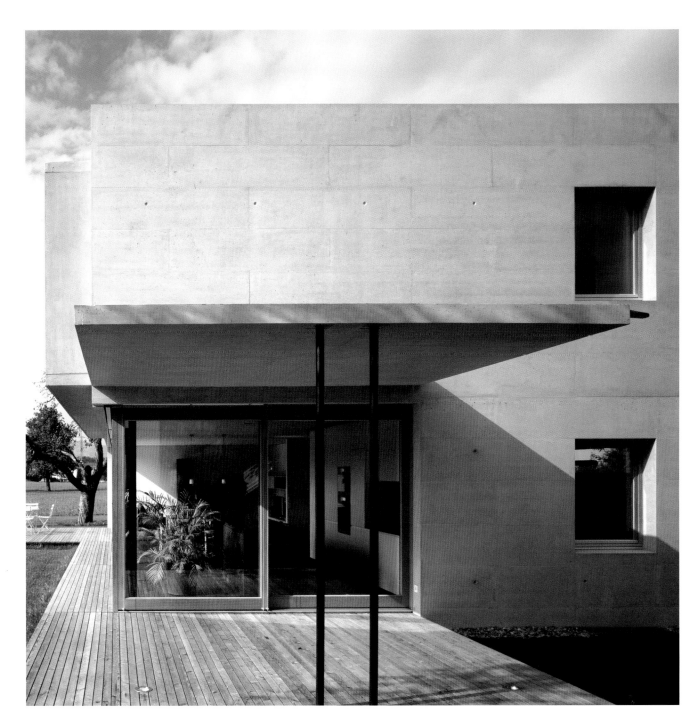

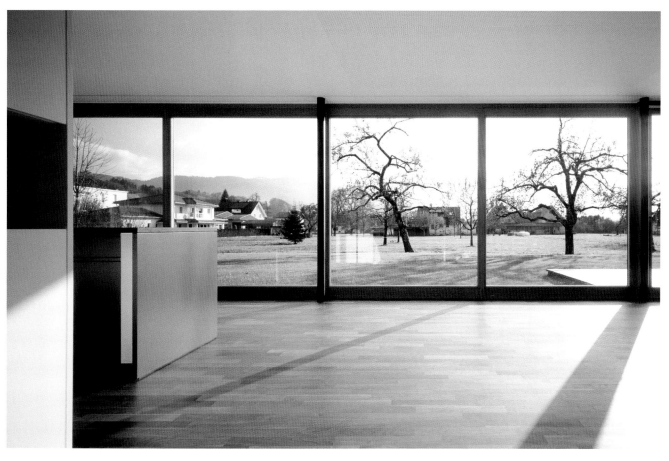

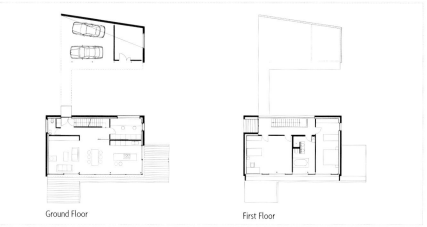

Ground Floor

First Floor

A cantilevered extension of the concrete cube was designed at the rear of the house to create a carport, while another, located on the side, creates a shaded terrace that can be used as a breakfast or dining area.

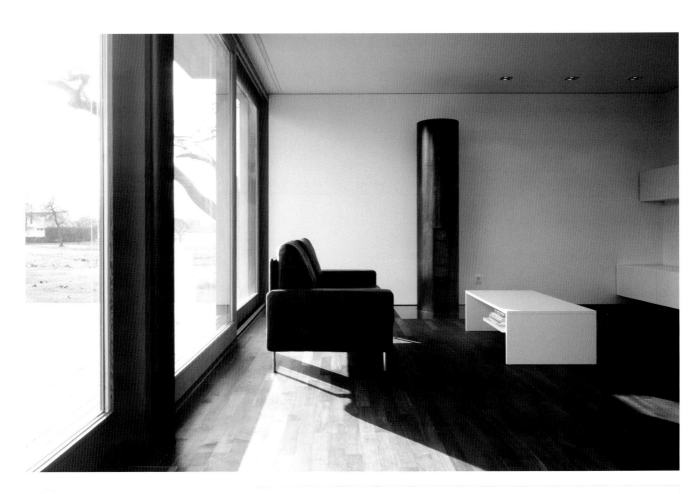

In a minimalist space, a sculptural object such as a contemporary chimney can double as a functional and a decorative element.

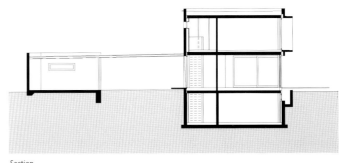

Section

A balcony that extends from the concrete cube provides shade to the upper-floor terrace, where the bedrooms and bathrooms are located.

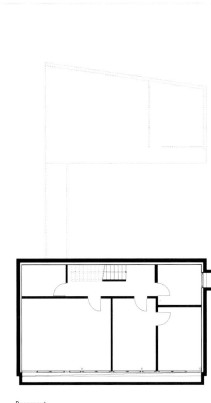

Basement

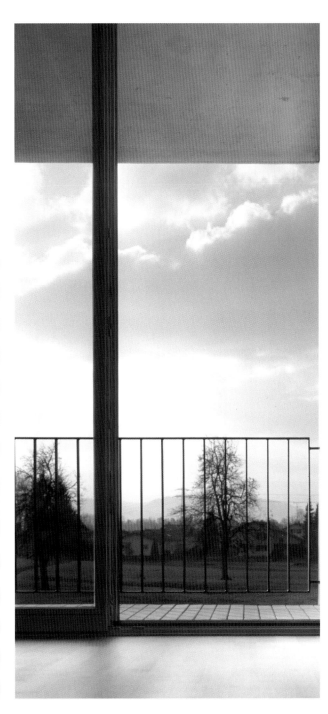

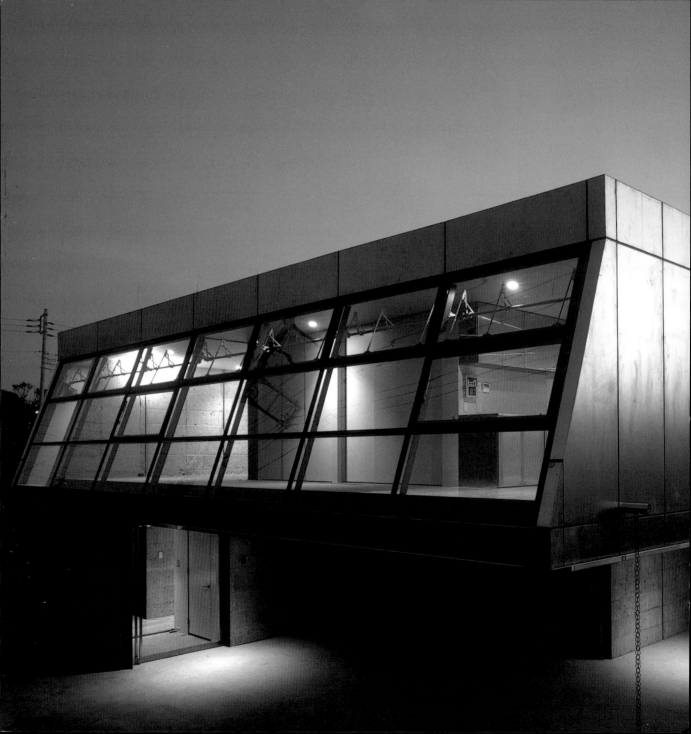

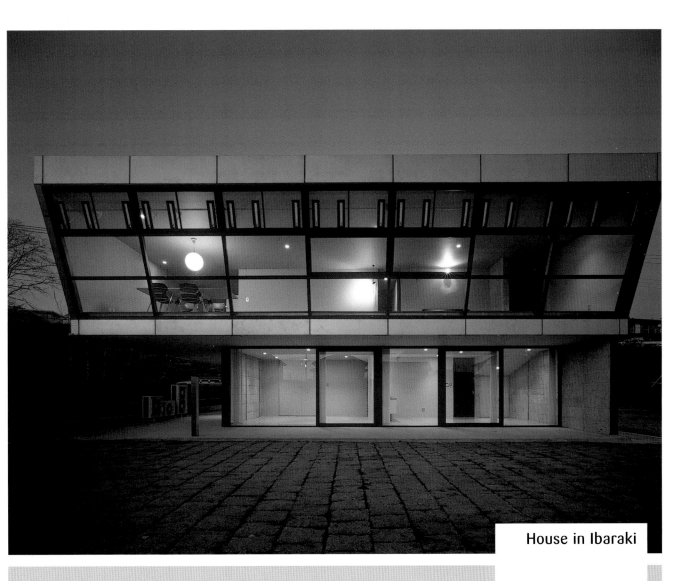

House in Ibaraki

Flanked by rows of traditional houses, this bold structure takes on an unconventional form consisting of two rectangular structures. Oriented toward the path of the sun, the slanted façades of the upper structure echo the angles of the typical pitched-roof pattern and subvert it with a flat roof that parallels the ground.

Architect: SUWA
Location: Ibaraki, Japan
Date of construction: 2004
Photography: Nacása & Partners

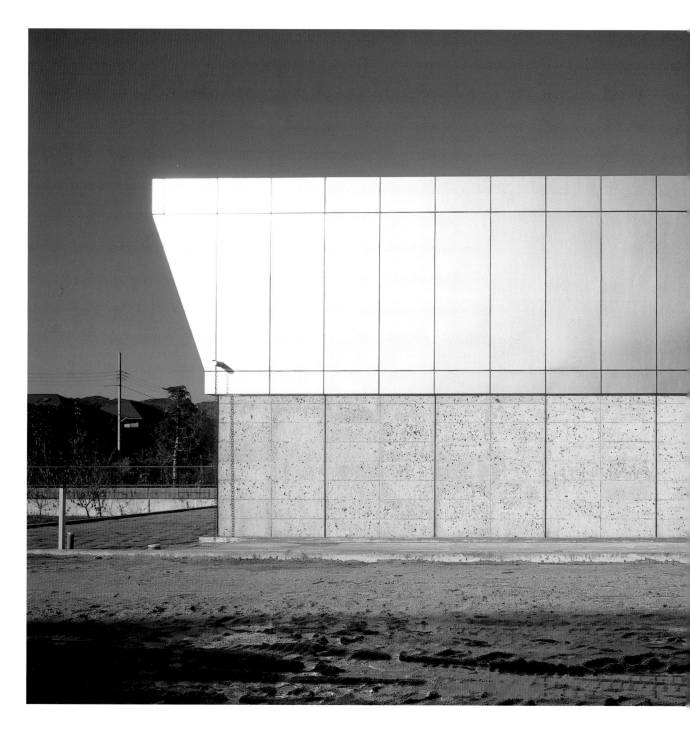

The contrast of different
materials and finishes,
such as polished steel
and textured stone,
generates a modern and
dynamic effect.

First Floor

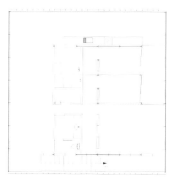

Second Floor

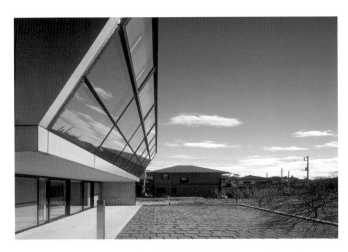

During the day, the main façade reflects the horizon; at night, the interior lights up and is transformed into a glowing beacon.

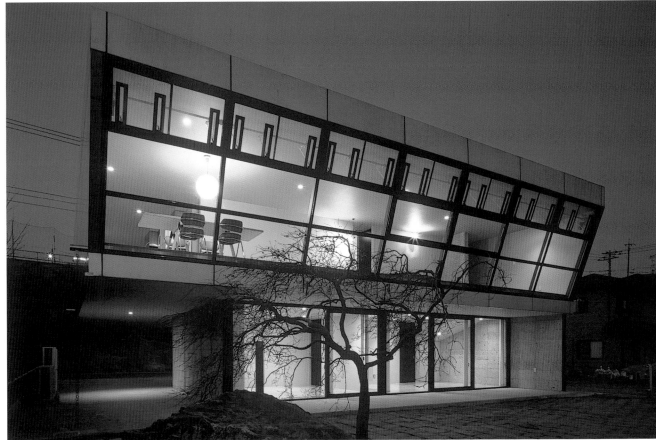

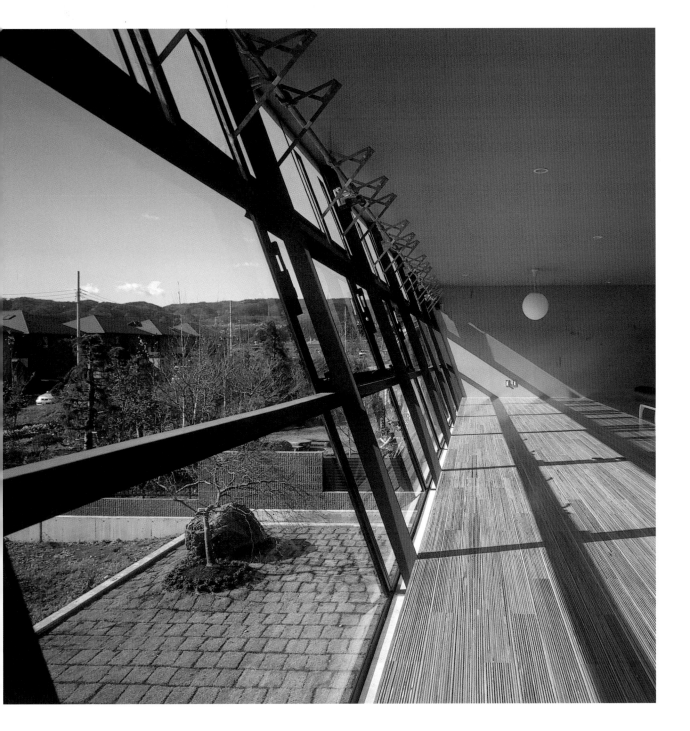

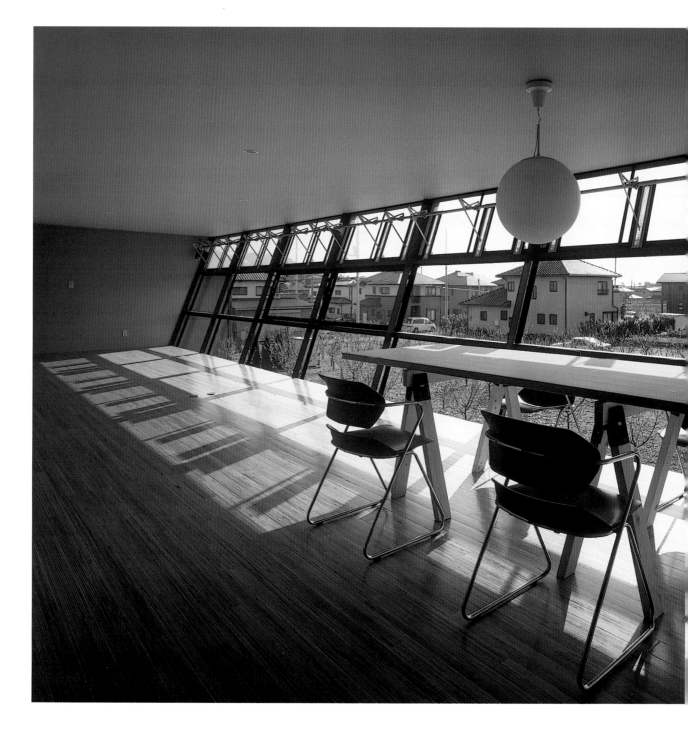

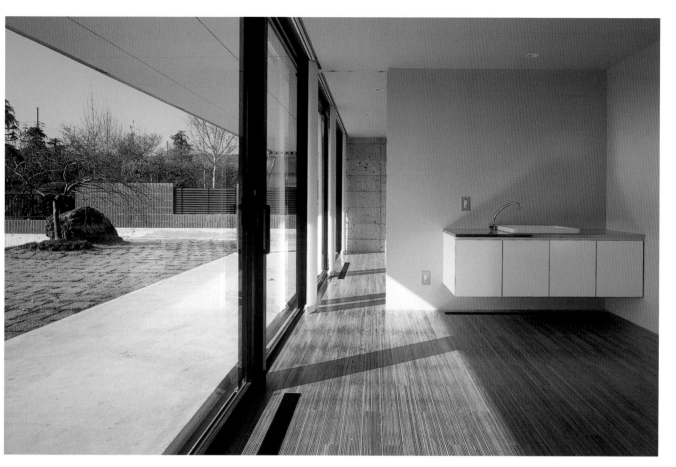

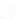

The wood floors inside the home also offer a contrast in texture to the smooth surfaces and rough stone walls.

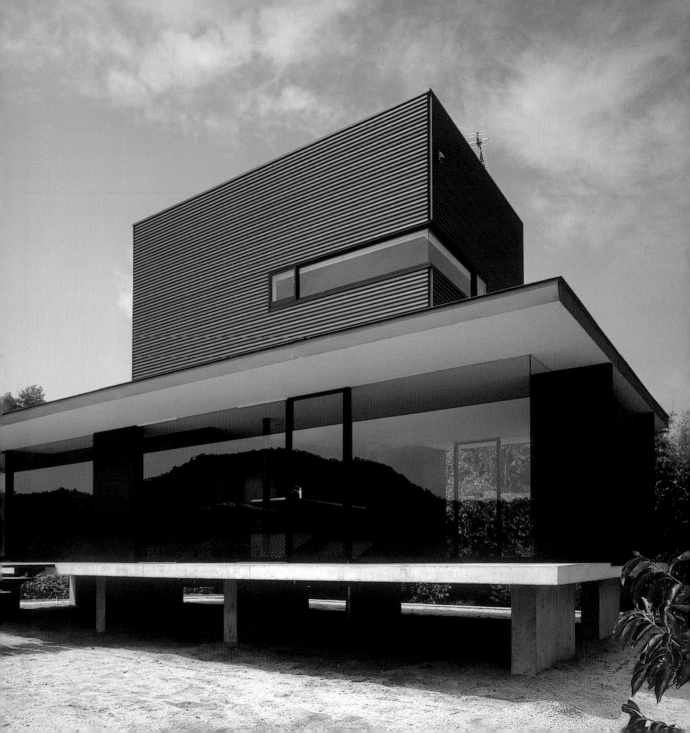

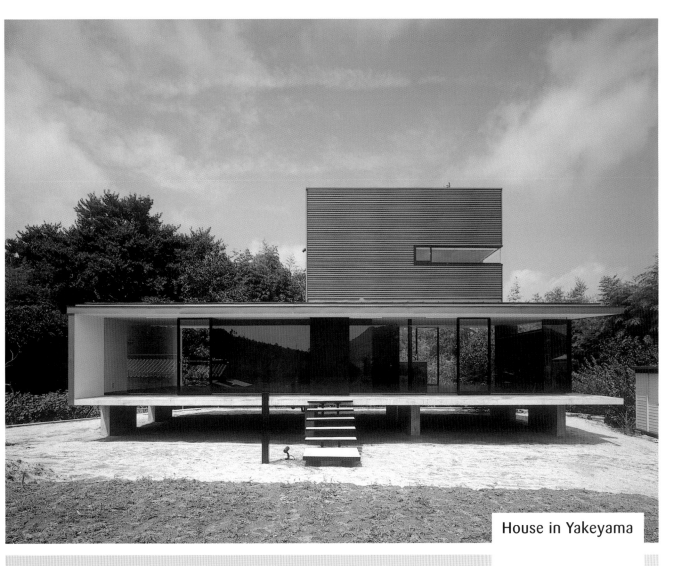

House in Yakeyama

Set on a slightly sloping terrain in the small town of Yakeyama, located in Kure City, this house, designed for a couple in their 20s, was conceived as a modern version of a country house, with the intention of maximizing the view of the surrounding green landscape.

Architect: Suppose Design Office
Location: Hiroshima, Japan
Date of construction: 2004
Photography: Nacása & Partners

70

The entire structure was raised about three feet off ground level to obtain a better view toward the south and to solve problem of the sloping terrain.

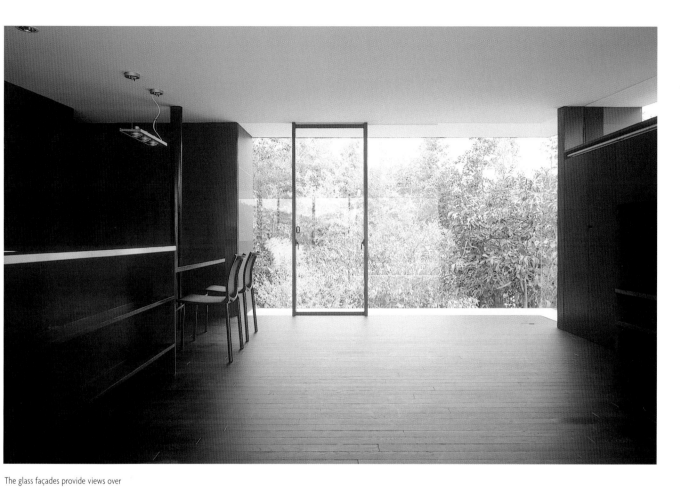

The glass façades provide views over
a bamboo grove to the north and
of the streets and houses of Yakeyama
to the south.

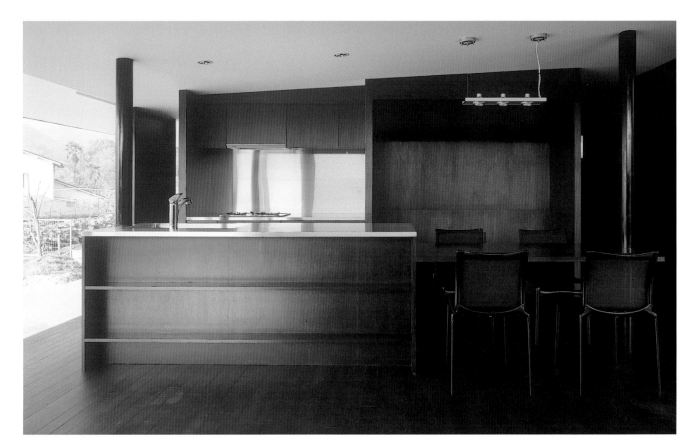

The raised floor level, referred to as taka-yuka, is typical of traditional Japanese architecture. It aids ventilation and prevents the entry of insects and rainwater.

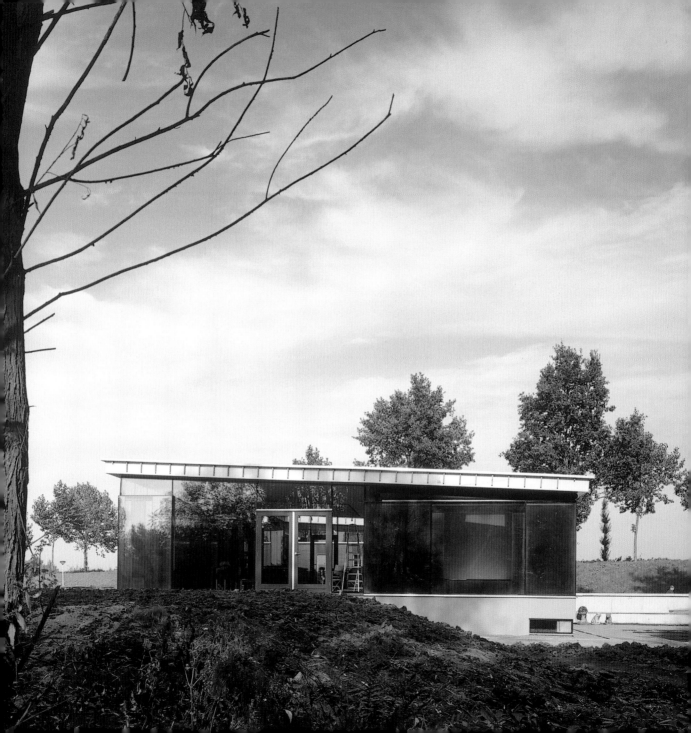

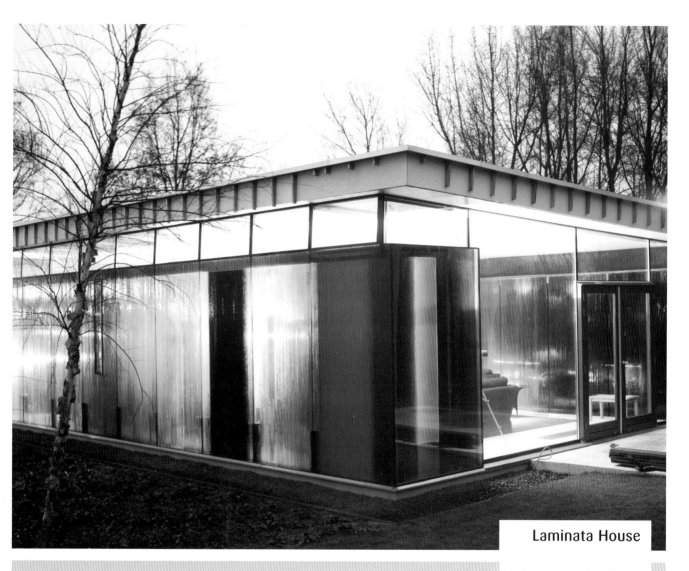

Laminata House

A novel and imaginative application of glass characterizes this house, designed almost wholly out of this material. The layering of multiple plates of glass offers not only a robust and resistant structure, but also a great deal of privacy, thanks to the effect that light has on the superimposed layers.

Architect: Kruunenberg Van der Erve Architecten
Location: Leerdam, Netherlands
Date of construction: 2001
Photography: Luuk Kramer, Christian Richters

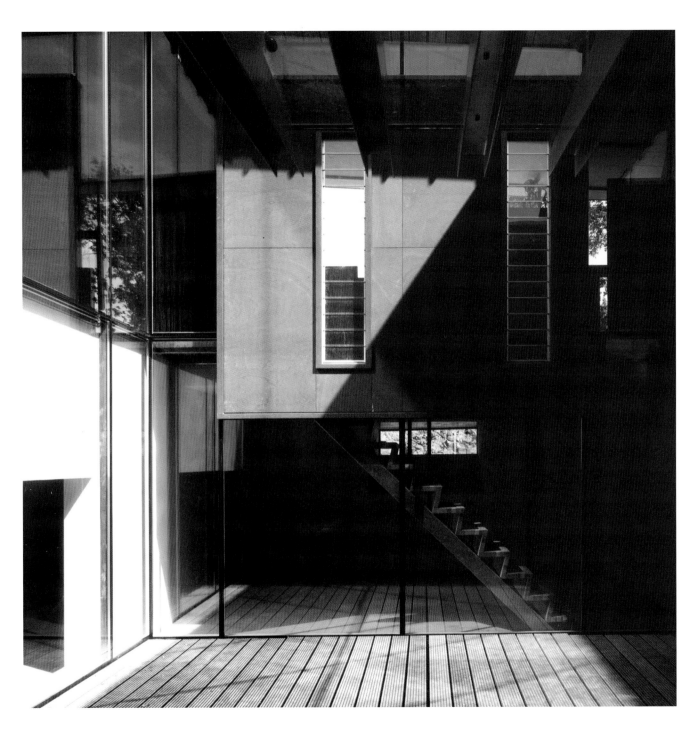

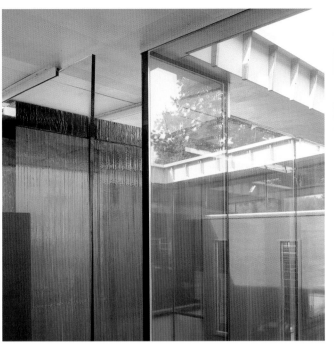

The large number of layers permits natural light to penetrate through the glass, yet still brings about the necessary translucency to ensure privacy.

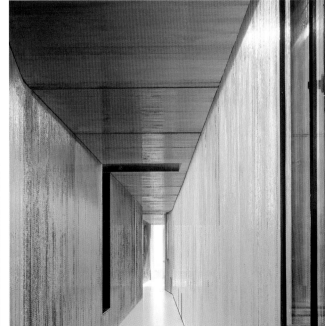

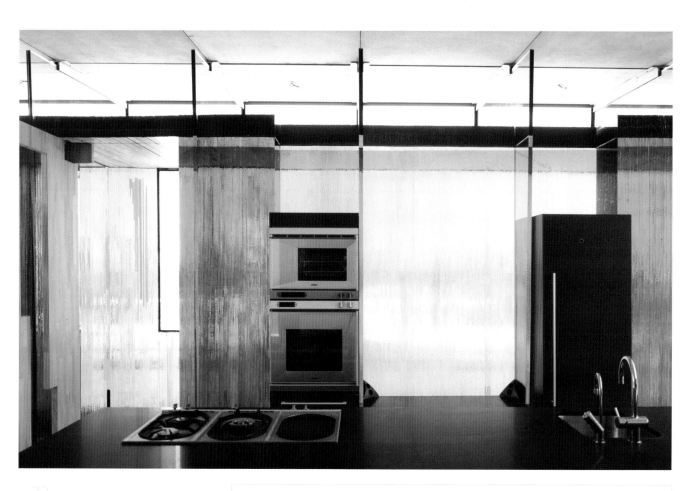

The technical complexity of the façades contrasts with the simplification of the interior organization. A central patio allows the entry of natural light into all the rooms.

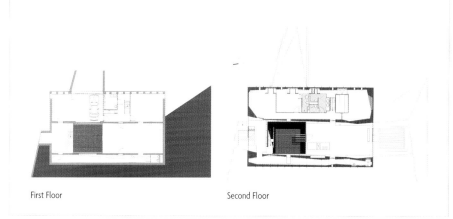

First Floor

Second Floor

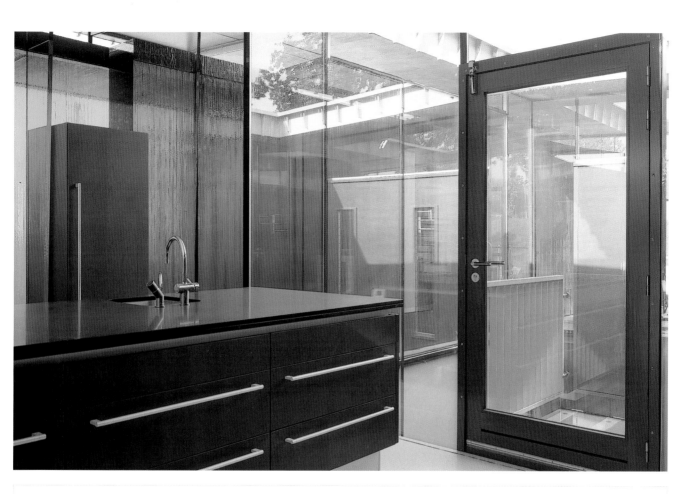

Elevation

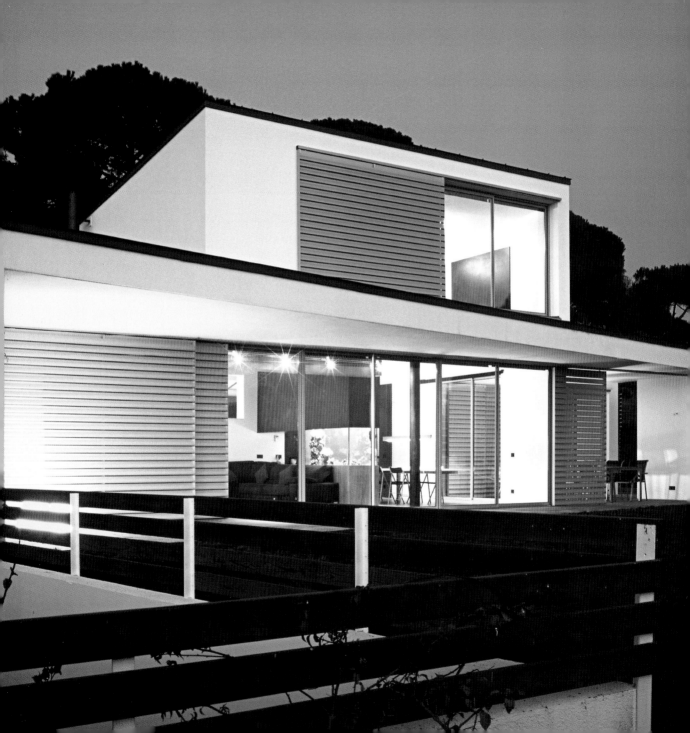

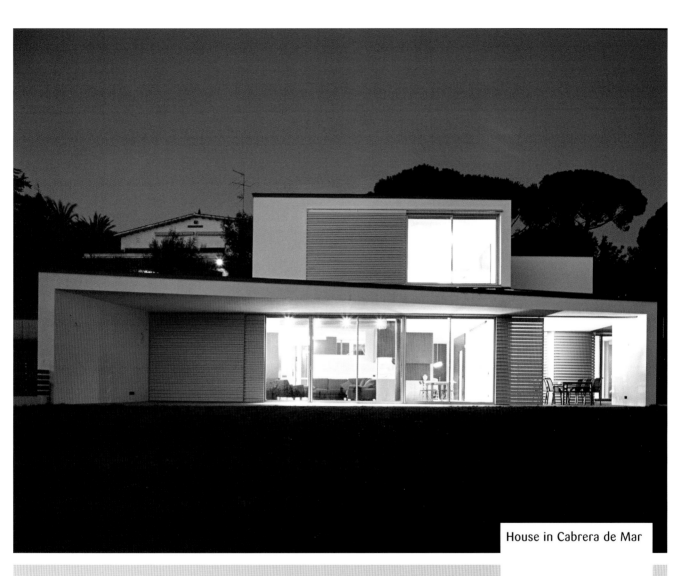

House in Cabrera de Mar

Located on the coast north of Barcelona, this house establishes a close relationship between interior and exterior through a series of transitional spaces characterized by the integration of furniture into the architecture that composes the space and materials that reflect the natural context of the site.

Architect: Ramón Pintó
Location: Cabrera de Mar, Spain
Date of construction: 2003
Photography: Jordi Miralles

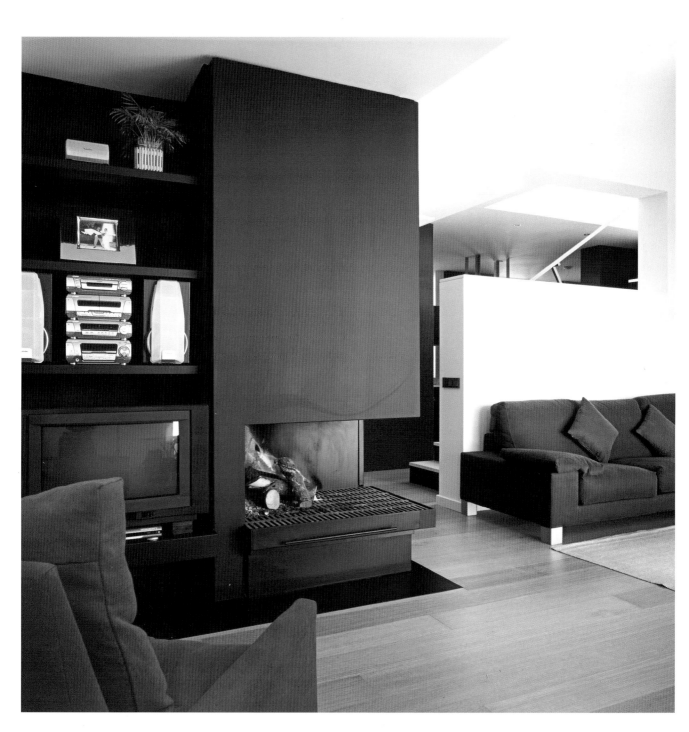

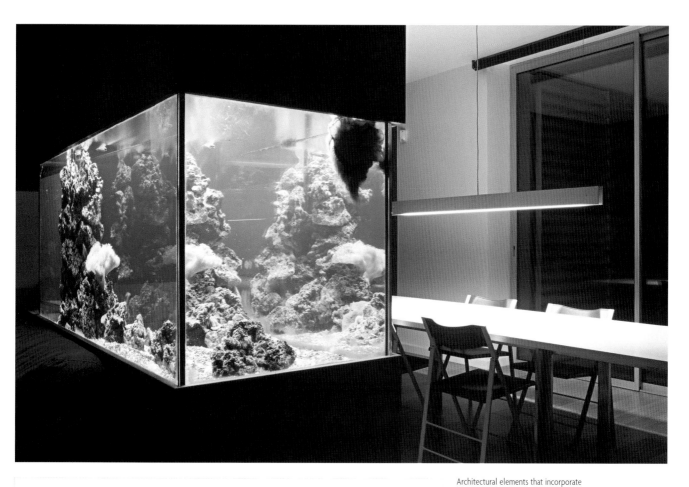

Ground Floor

First Floor

Architectural elements that incorporate furniture include the stairwell/storage, the fireplace/shelves, and the pillars/closets that define the interior space. Decorative elements such as the aquarium also serve to differentiate spaces like the dining room from the living area.

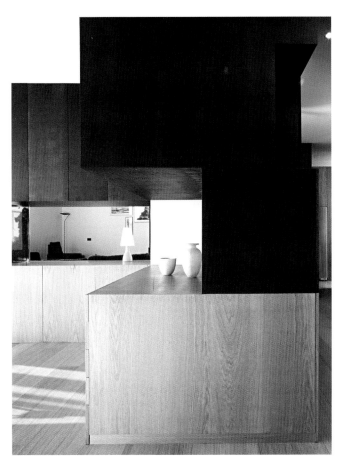
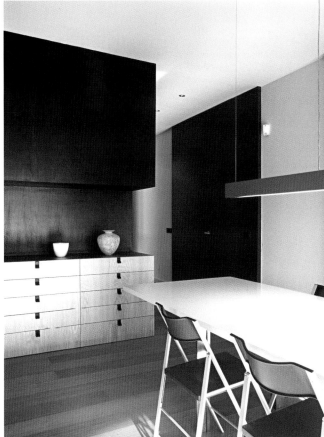

73

Dark and light wood can be combined with other solid colors to create a dynamic design that adapts to a variety of furnishings.

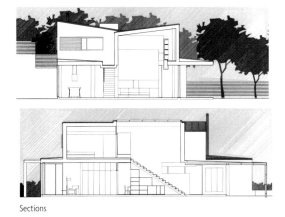

Sections

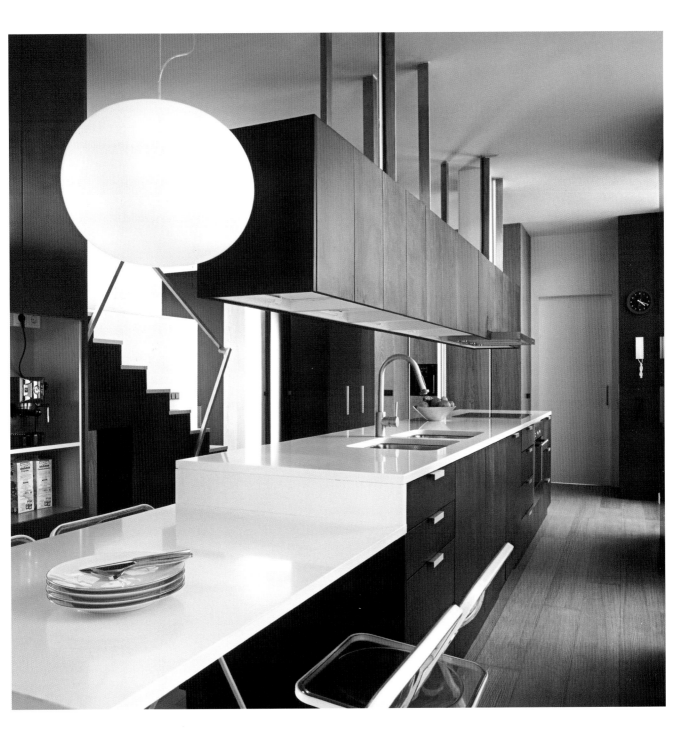

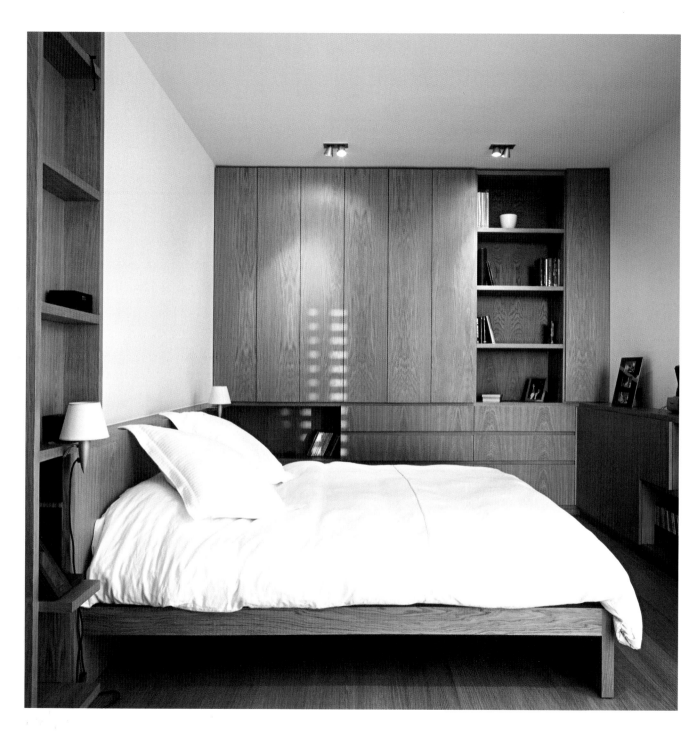

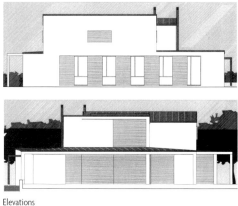

Elevations

For a lightweight effect, anodized aluminum was chosen for the exterior cladding, which contrasts with a durable wooden deck placed on the exterior floors.

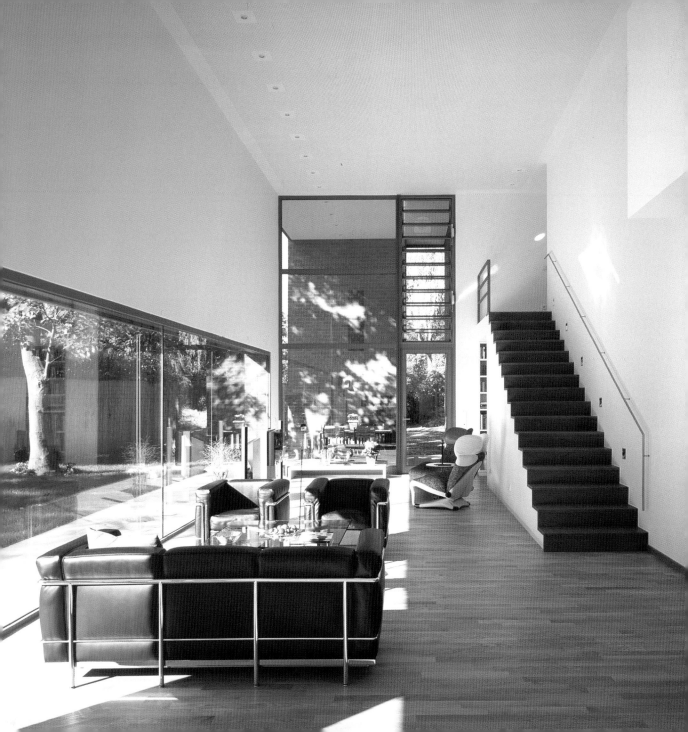

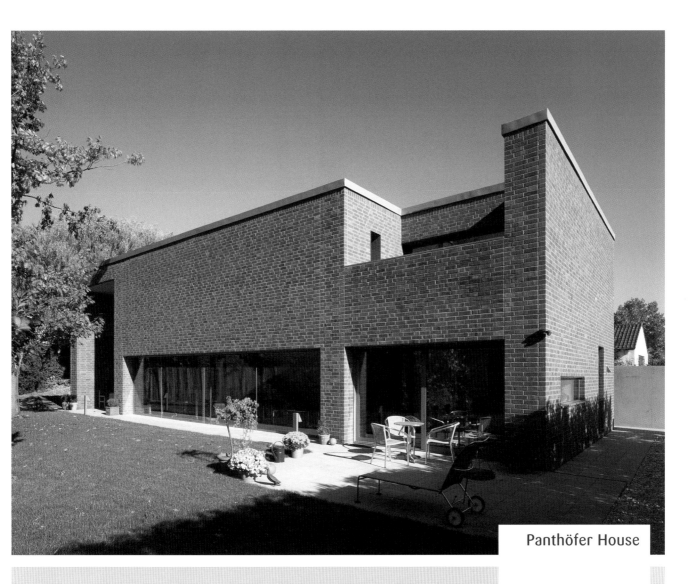

Panthöfer House

Set within a 1960s housing development, this house for a small family was proposed as a contemporary insertion into the traditional neighborhood. The new linear structure, despite being constructed with a traditional material like brick, adopts a simple and modern form and contains within it a spacious, open-plan layout.

Architect: Döring Dahmen Joeressen
Location: Meerbusch, Germany
Date of construction: 2003
Photography: Manos Meisen

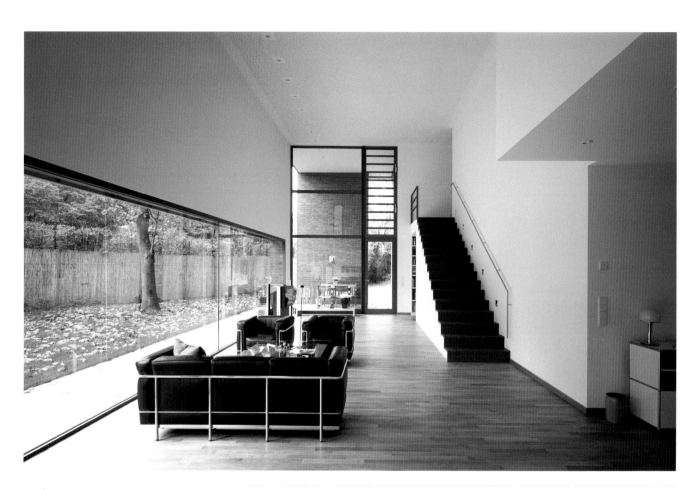

The windows toward the exterior were placed only on the lower floor in order to prevent any visibility of the interior from the street.

Ground Floor

First Floor

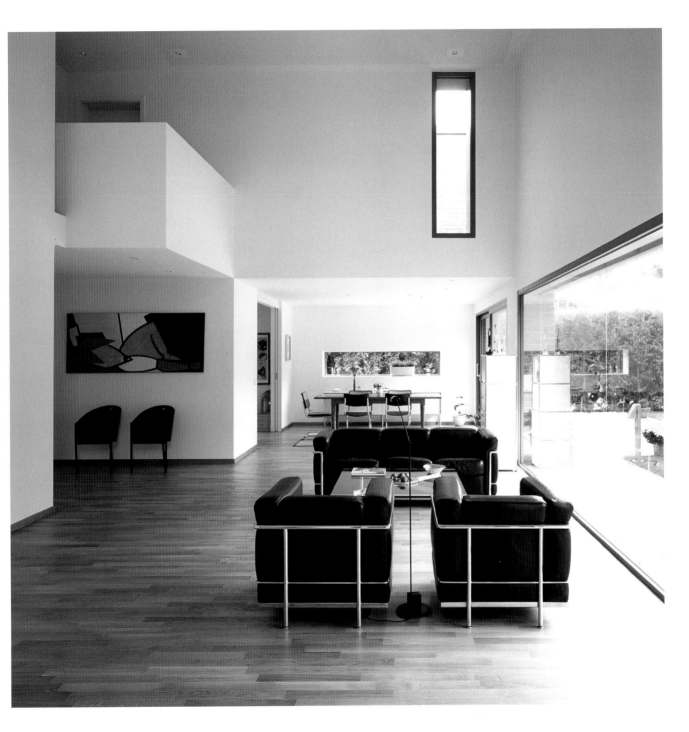

A concrete partition was inserted into the center of the house to accommodate the staircase that leads to the children's bedrooms upstairs.

Sections

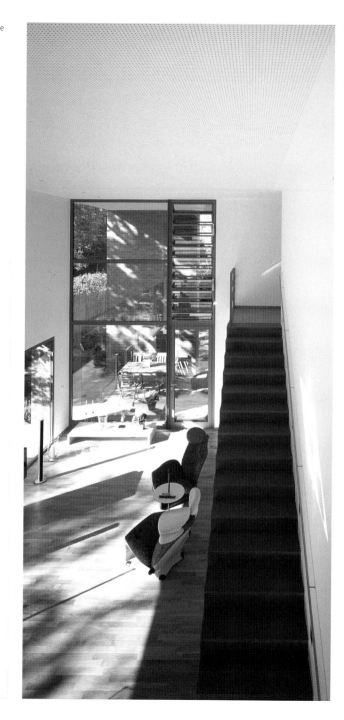

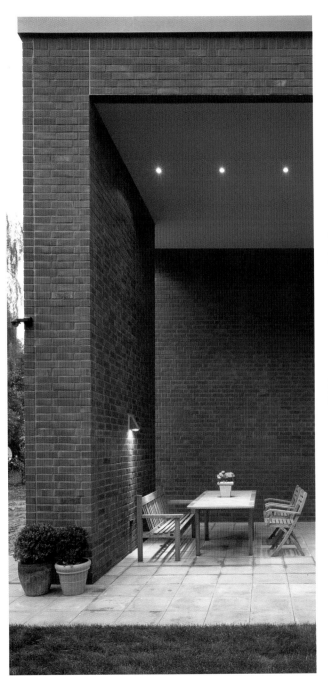

A tall portico structure provides shade and shelter from rain while maintaining the sensation of open space.

Elevations

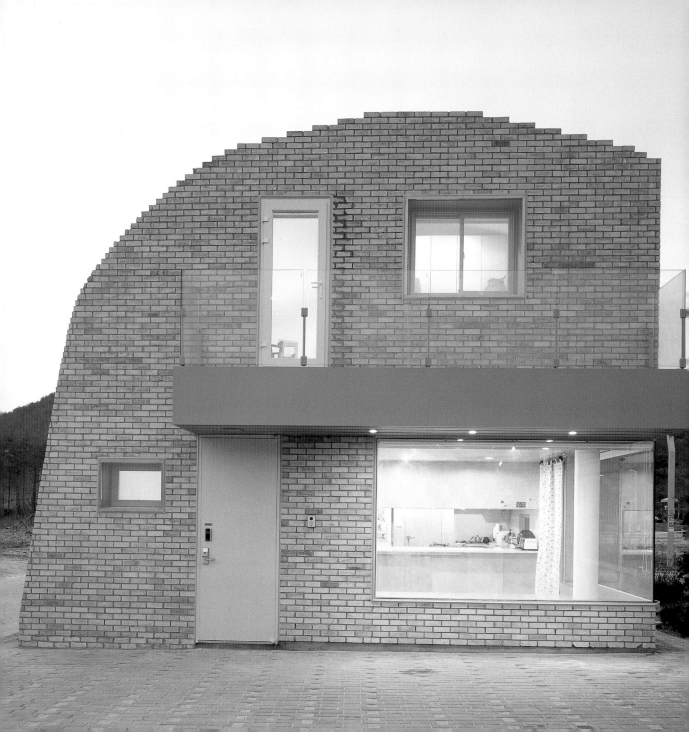

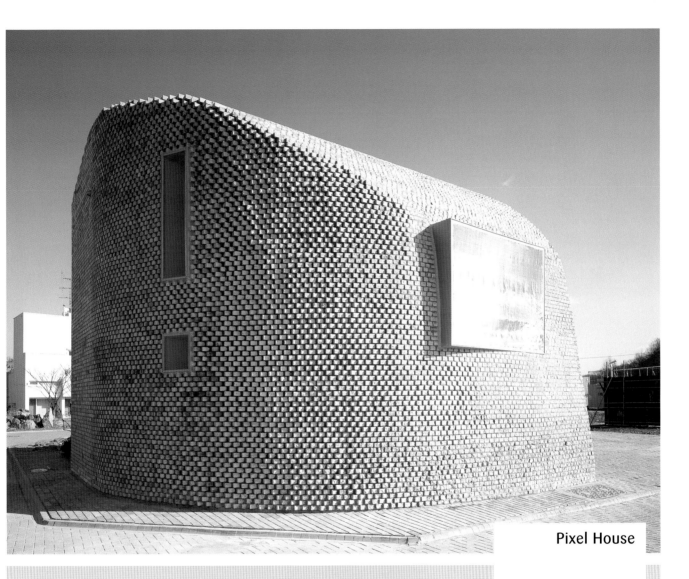

Pixel House

The last in a row of houses and clearly defined by front- and backyard spaces, this unusual house resembles a pixelated rock, with its serrated brick edge and organic shape. The use of simple, orthogonal bricks to create a smooth shape parallels the relationship between the individual house and the hilly landscape in which it is situated.

Architect: Slade Architecture
Location: Heyri Art Valley, South Korea
Date of construction: 2004
Photography: Yong Kwan Kim

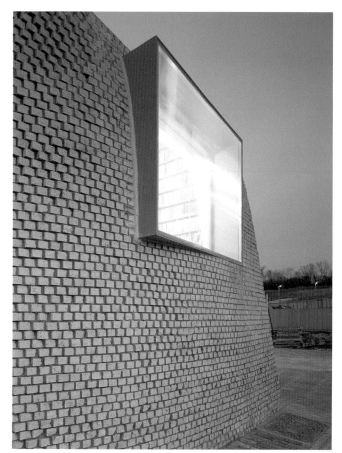

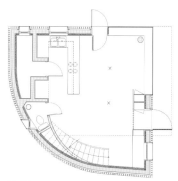

First Floor

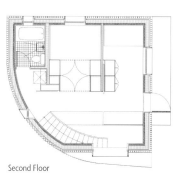

Second Floor

The bricks provide a tangible sense of scale, similar to the way that the number of pixels determines the smoothness of a digital image; thus, the smoothness of this house is determined by the brick module, resulting in a 9,675-"pixel" house.

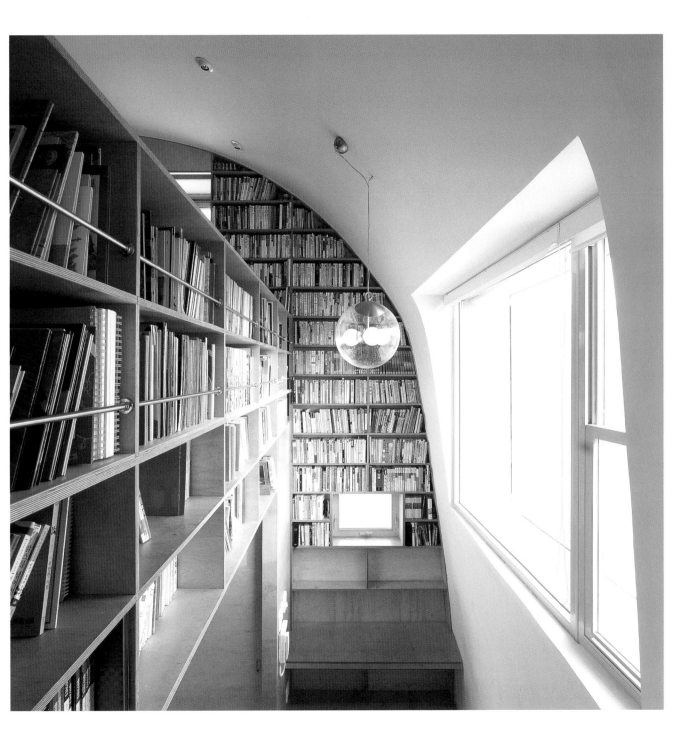

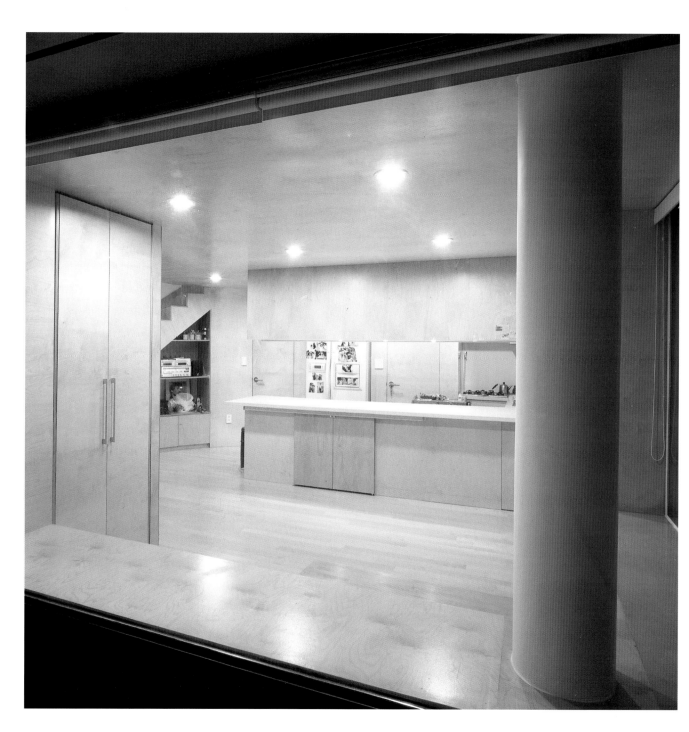

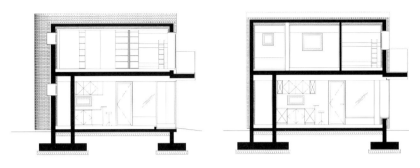

Sections

A double-height space created by the staircase was utilized for a working desk and library. Common areas were situated on the ground floor. The bedrooms on the upper floor are defined by sliding woodes panels.

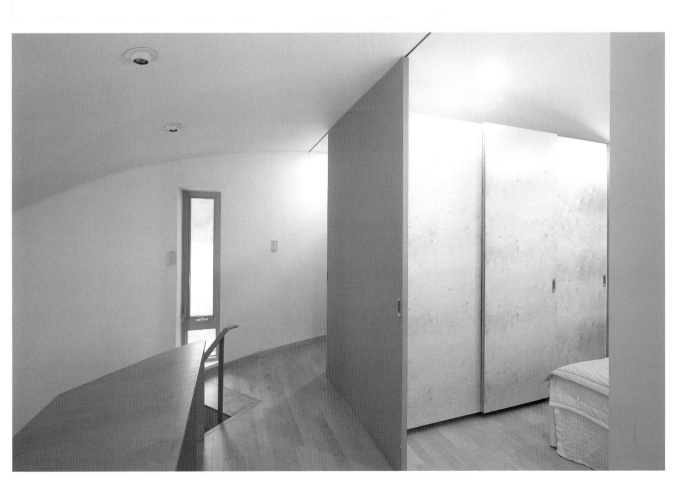

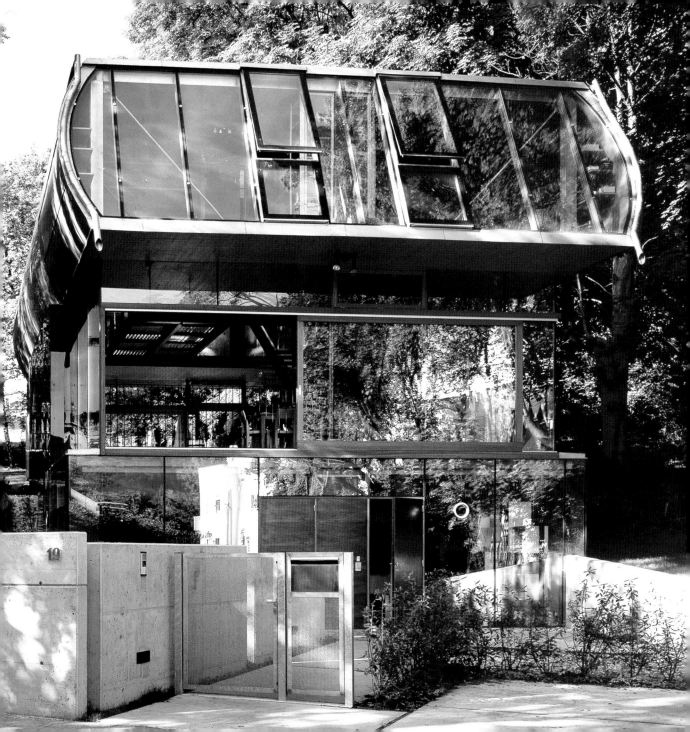

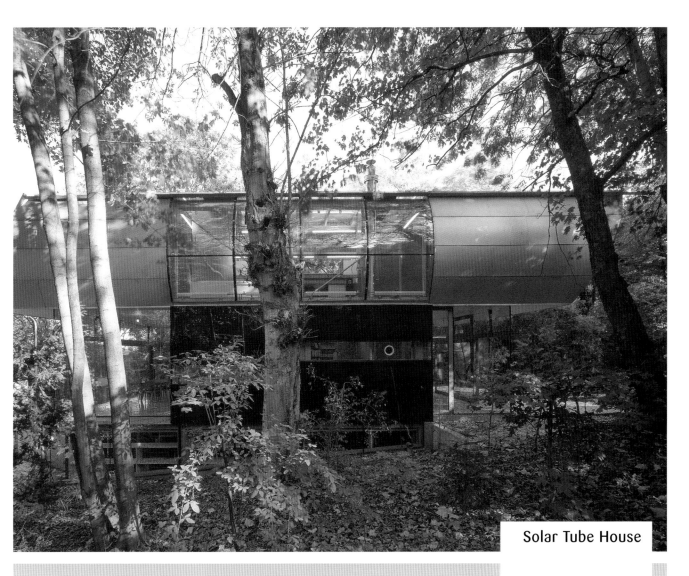

Solar Tube House

The privacy afforded by the heavily wooded site allowed the architects to employ generously glazed façades. In addition, the partial transparency of the roof and floors gives the house the sense of being an atrium among the trees. Its close interaction with the surrounding landscape and energy-saving characteristics constitute a project fully integrated with nature.

Architect: Driendl* Architects
Location: Vienna, Austria
Date of construction: 2001
Photographer: Bruno Klomfar,
James Morris

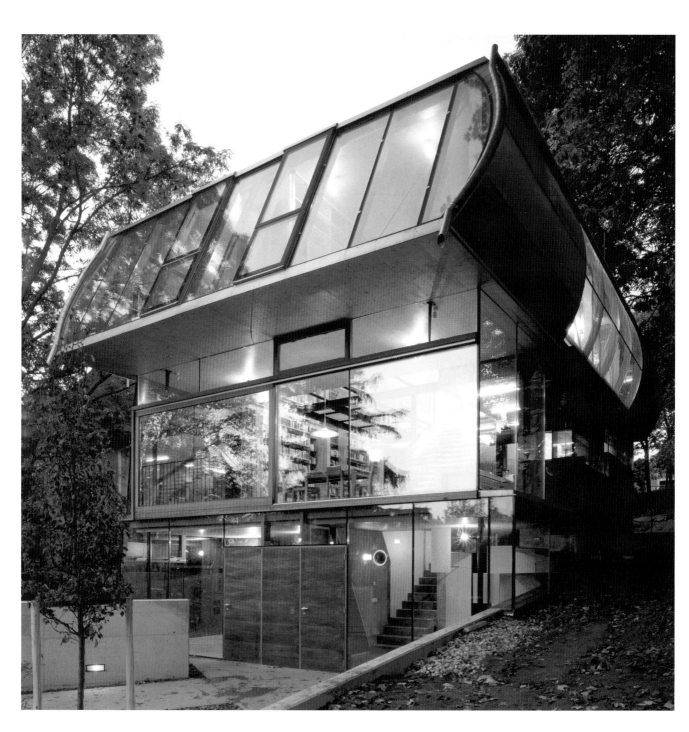

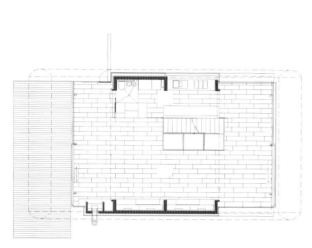

Ground Floor

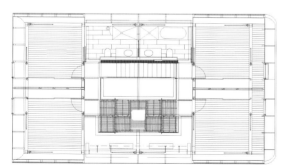

First Floor

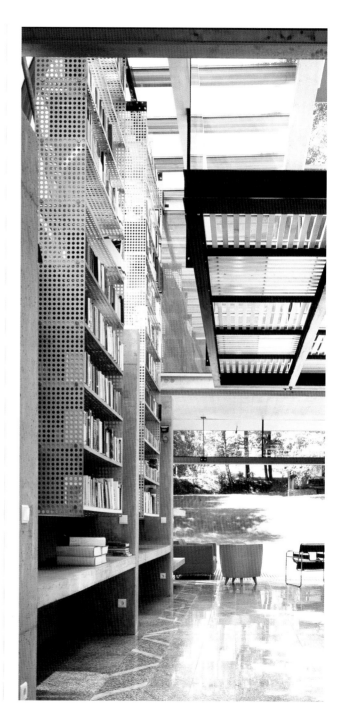

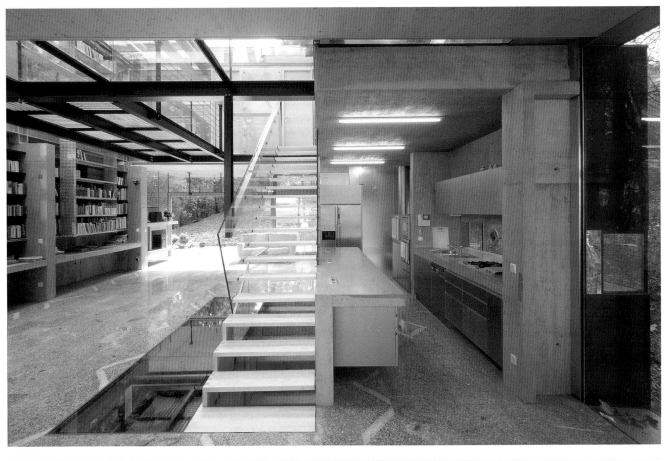

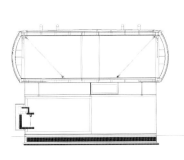

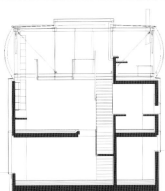

Sections

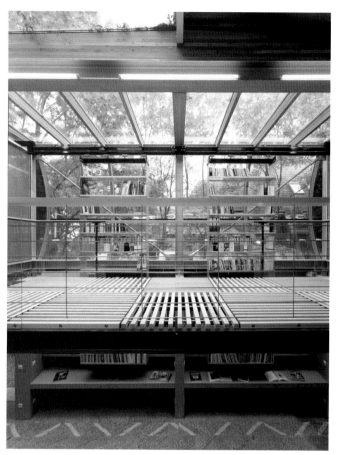
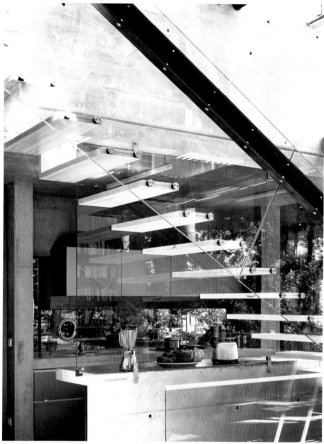

A glass railing can be
the perfect solution
for introducing a staircase
without visually obstructing
a space and maintaining
a diaphanous and luminous
environment.

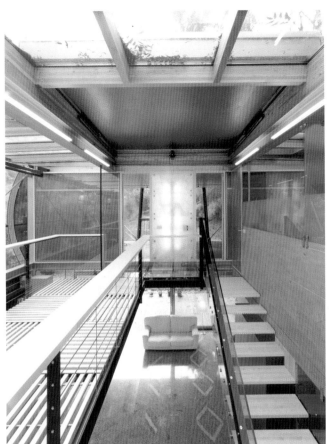
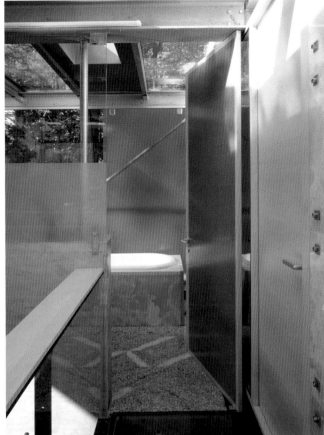

The cool appearance of concrete and steel can be contrasted by combining them with warmer materials such as wood and translucent glass.

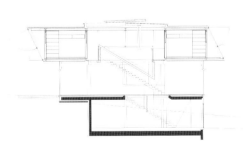

Section

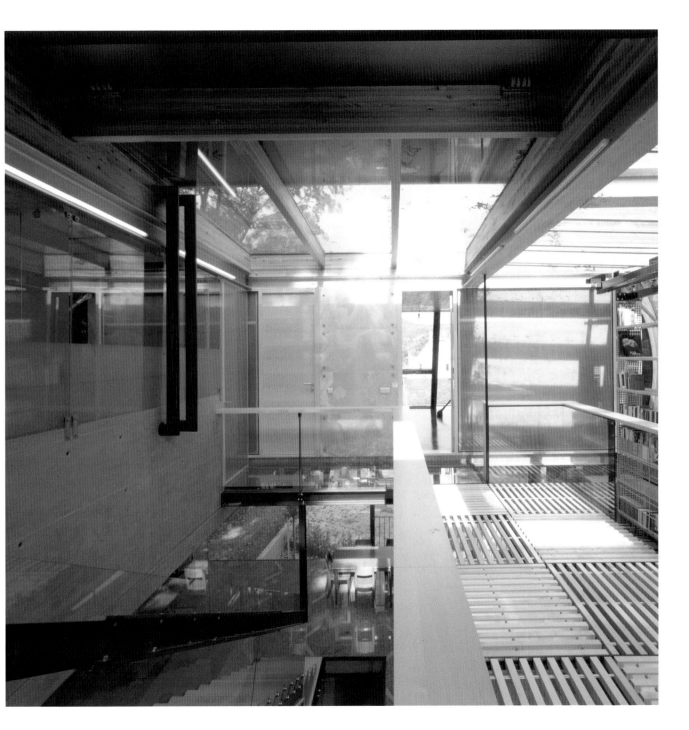

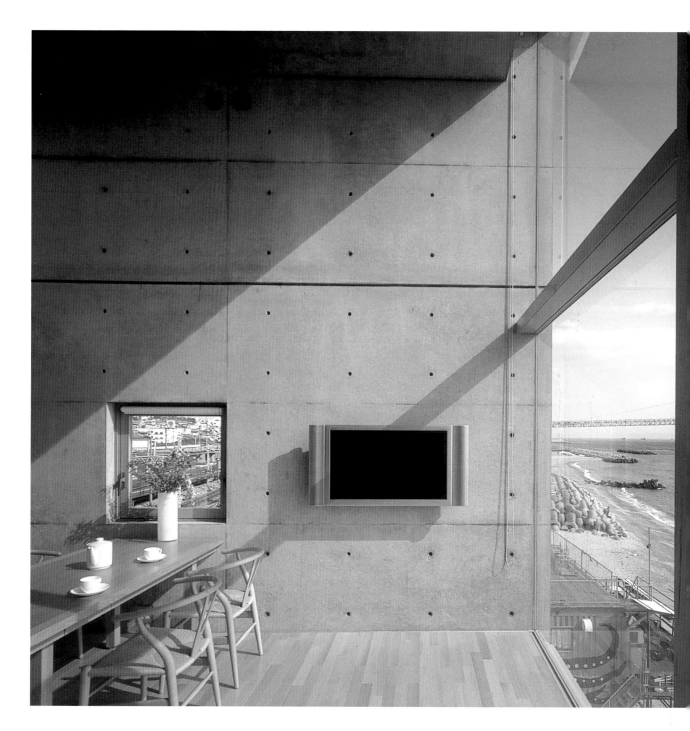

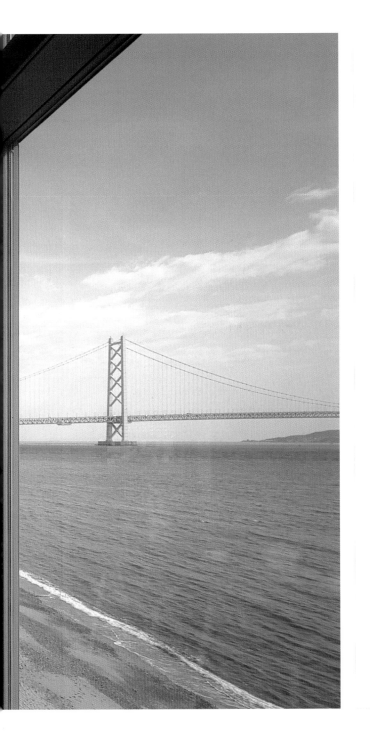

Waterfront

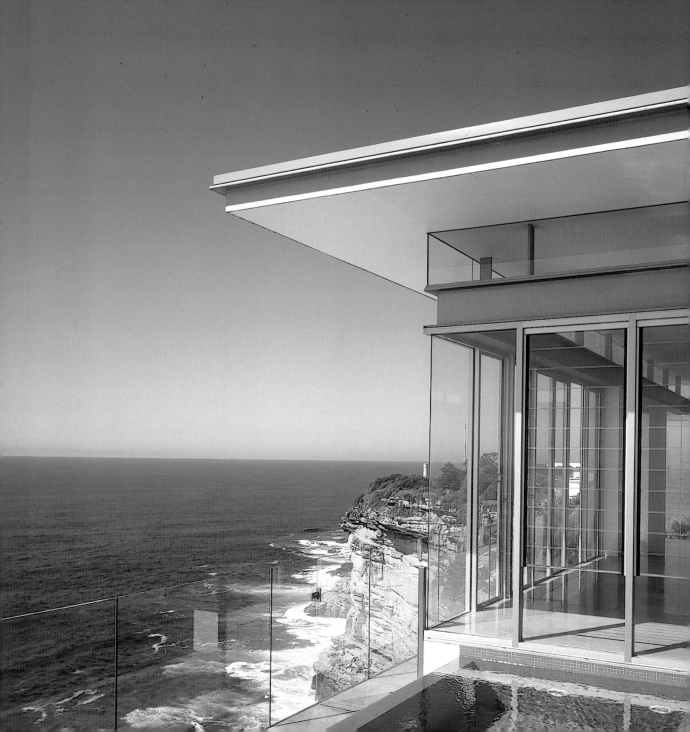

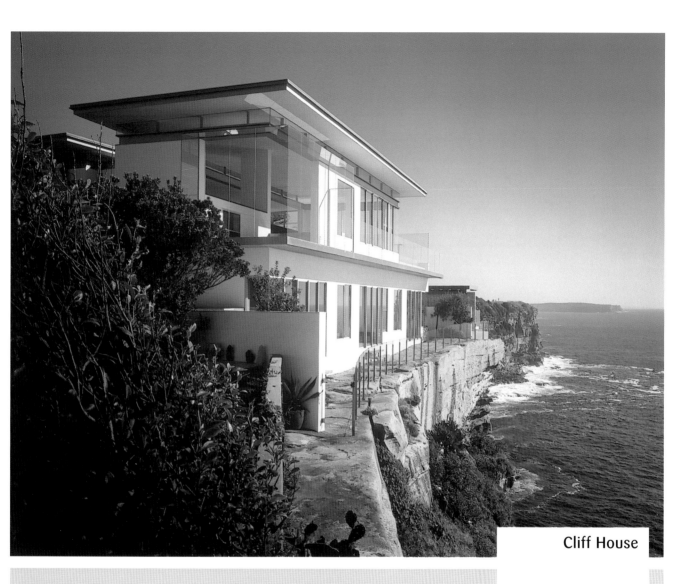

Cliff House

Architect: Walters & Cohen
Location: Sydney, Australia
Date of construction: 2003
Photography: Richard
Glover/VIEW

Composed of a pair of two-story rectilinear structures that enclose a double-volume arrival space, this house is poised on a rocky sandstone cliff, looking out toward the South Pacific Ocean through glass façades that maximize the siting of the building.

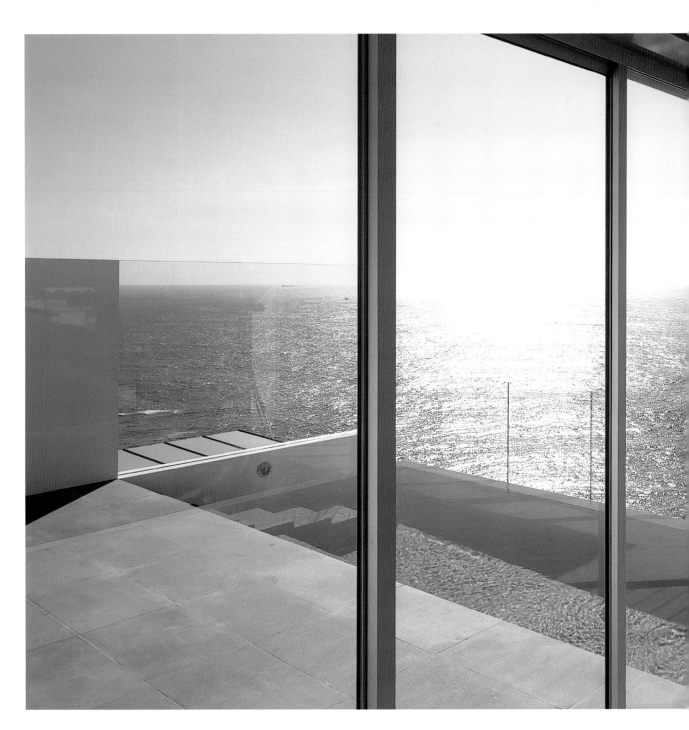

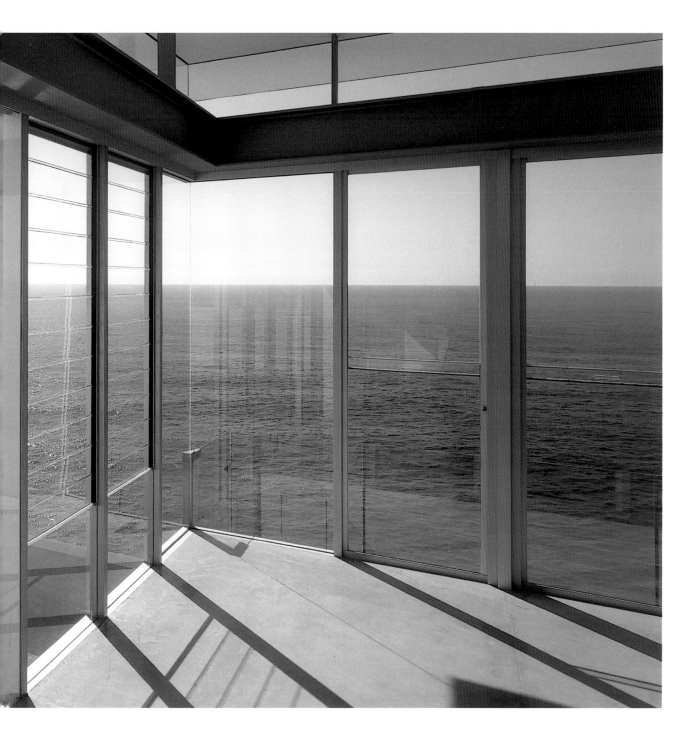

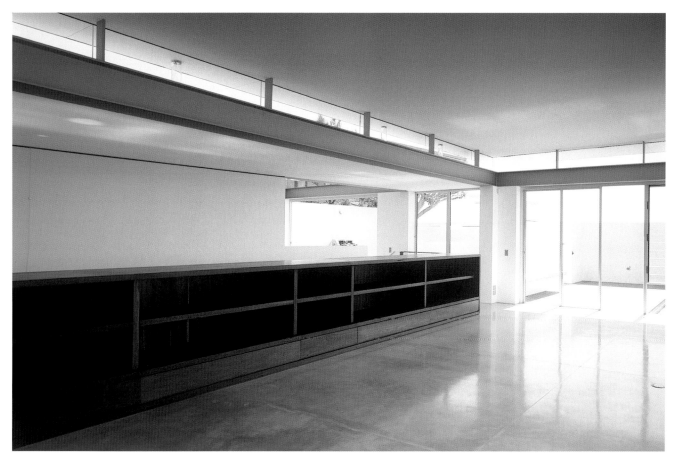

The architects chose to allocate the bedrooms to the ground floor, taking advantage of the vantage point obtained from the upper level to situate the kitchen, dining, and living area, which opens out onto a garden terrace and infinity-edge pool.

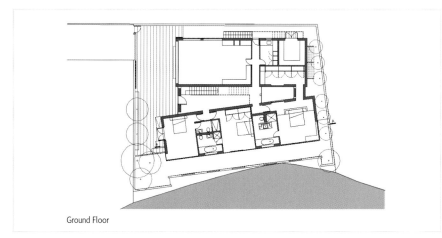

Ground Floor

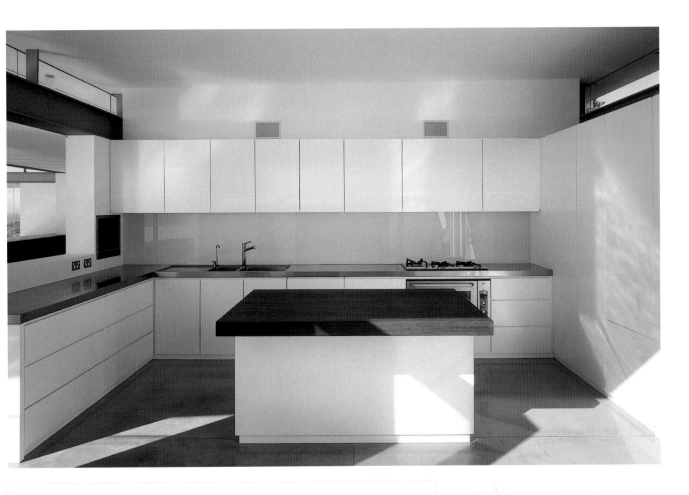

The upper floor incorporates a band of clerestory windows above two steel channels that conceal perimeter lighting.

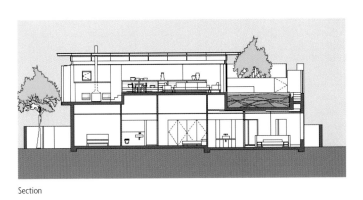

Section

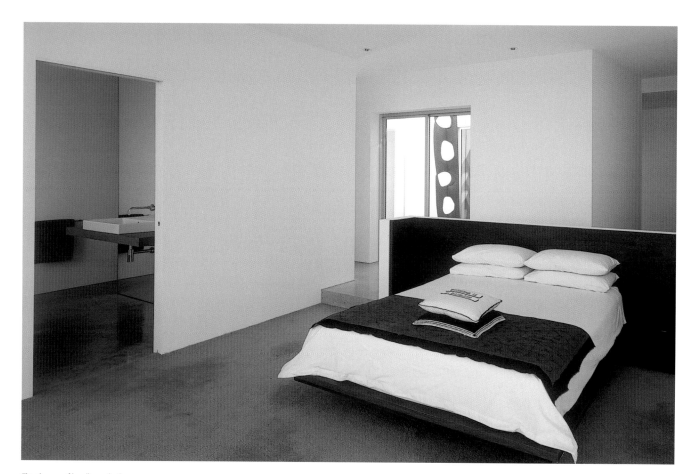

The absence of handles and other
elements constitutes part of the
minimal detailing stressed by both
the client and the architects in charge
of the design.

The living accommodations maximize the view and create a sense of living on the bow of an ocean liner. Placing the bathtub, for example, against the full-lenght glass walls enhances this effect.

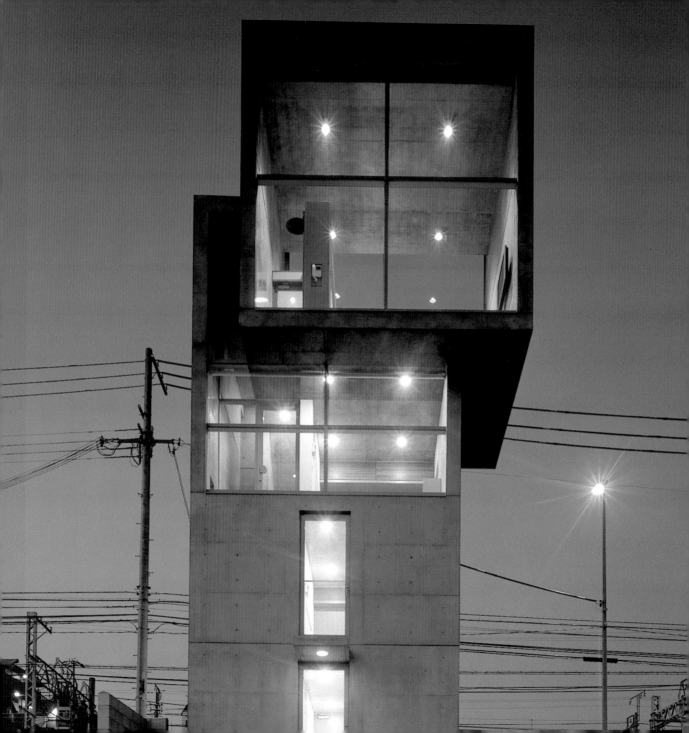

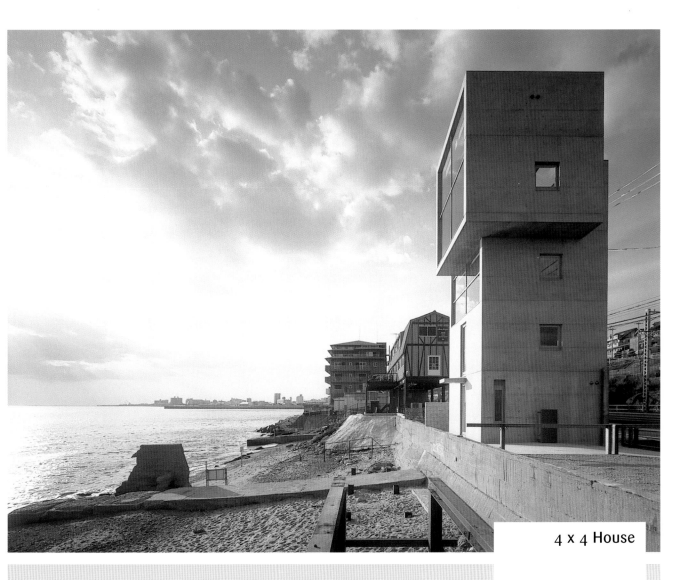

4 x 4 House

This beachfront house looks out toward Awaji Island, four kilometers away and epicenter of the 1995 Great Hanshin earthquake. Taking its name from the square, four-by-four-meter plan on which it is based, the project rises vertically from the ground to provide an escalating view of the spectacular landscape.

Architect: Tadao Ando
Location: Kobe, Japan
Date of construction: 2003
Photography: Mitsuo Matsuoka,
Shigeo Ogawa, Tadao Ando

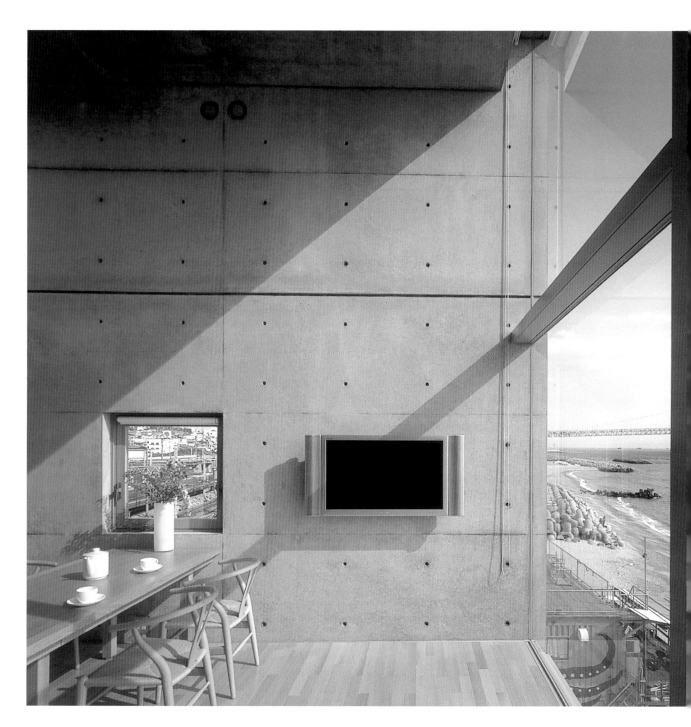

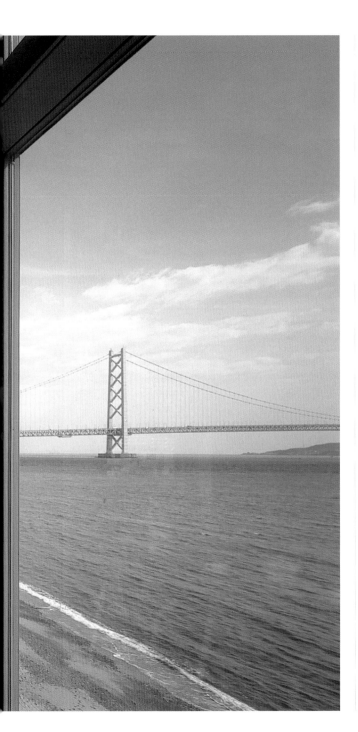

Ground Floor

First Floor

Second Floor

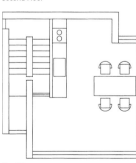

Third Floor

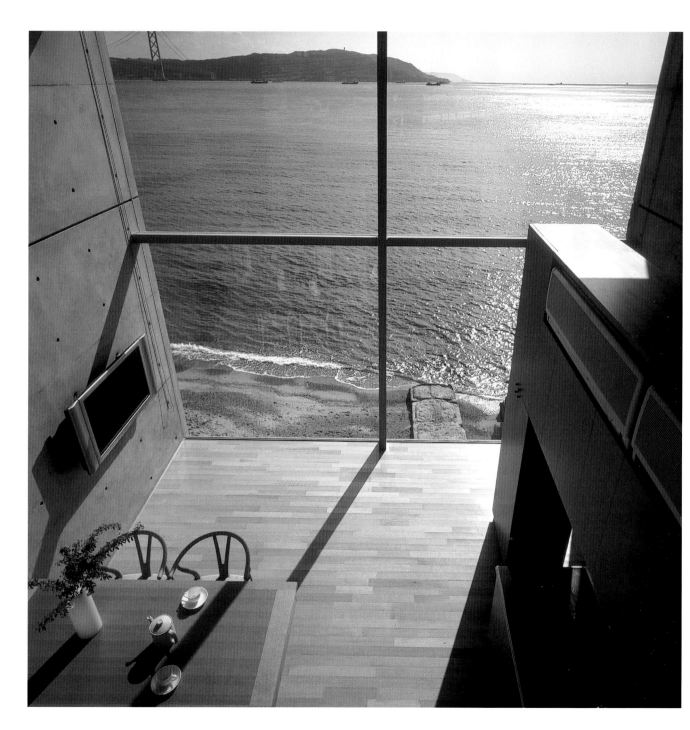

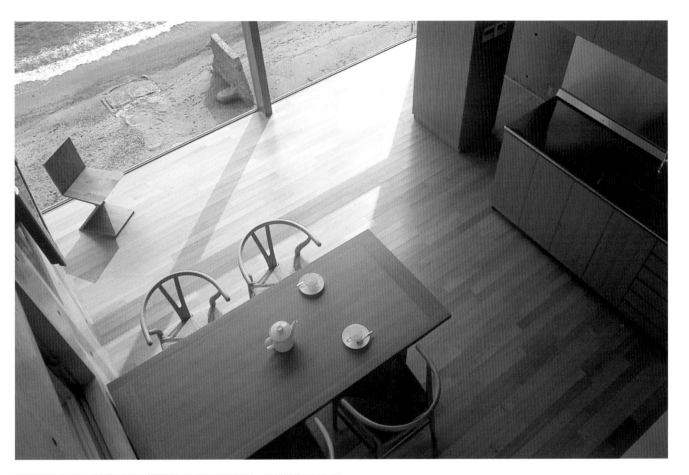

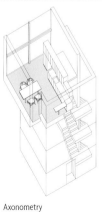

Axonometry

The most contemporary designs can be combined with more traditional details, such as in this modern interior, which incorporates classic modern furnishings like the Zig Zag chair by Rietveld, with traditional Japanese chairs.

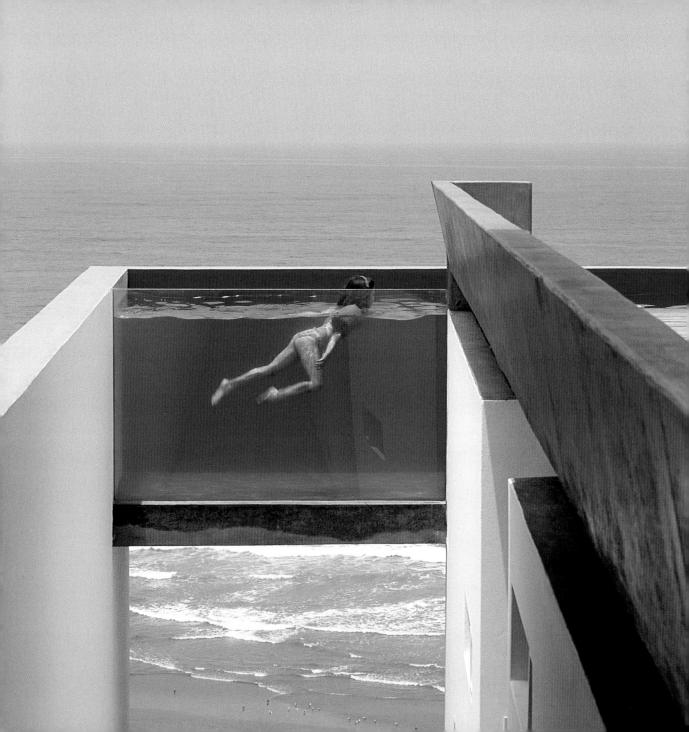

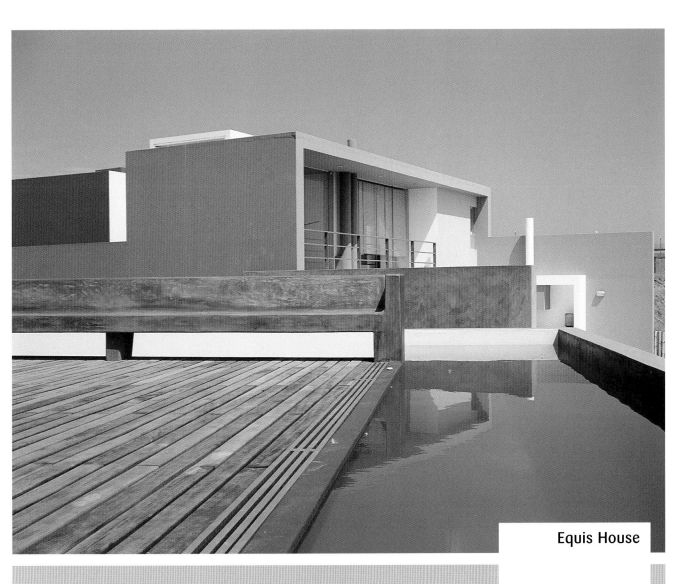

Equis House

This house on the Peruvian coast was designed to be respectful of the site and fully rooted in the land as if it had always been there. The sand-colored mass sprawls across the plot, creating a stepped series of levels with ample terrace decks and glass walls to ensure the most dramatic views of the Pacific Ocean.

Architect: Barclay & Crousse
Location: Cañete, Peru
Date of construction: 2002
Photography: Barclay & Crousse

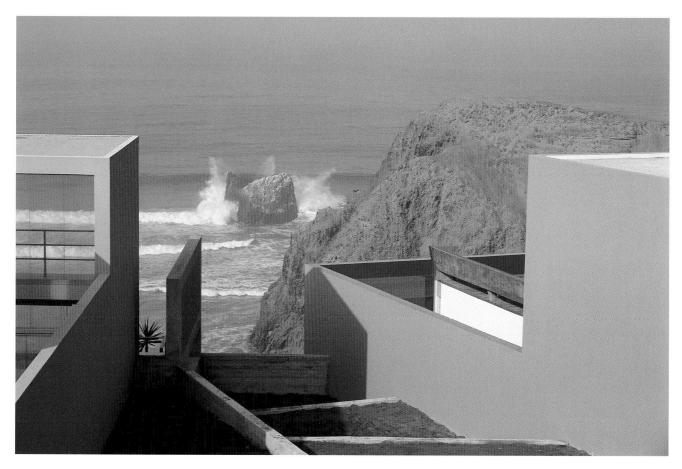

Tones in ochre and sand, much like those
used in pre-Columbian constructions
along the Peruvian coast, were applied to
the façades to mitigate the effect of
the weathering caused by the desert dust.

Site Plan

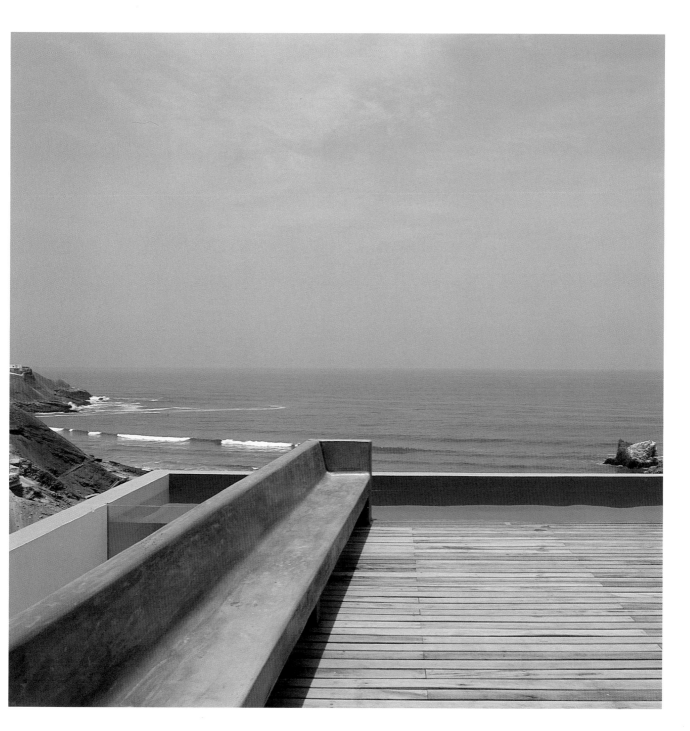

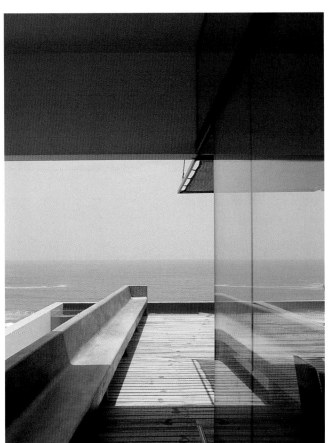
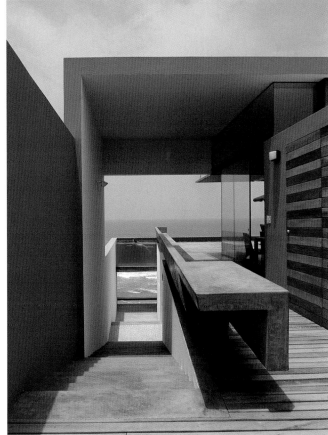

84

The swimming pool was conceived
as an aquarium, its visible body of
water superimposed on the view
of the ocean and arid landscape
that surrounds the house.

Ground Floor

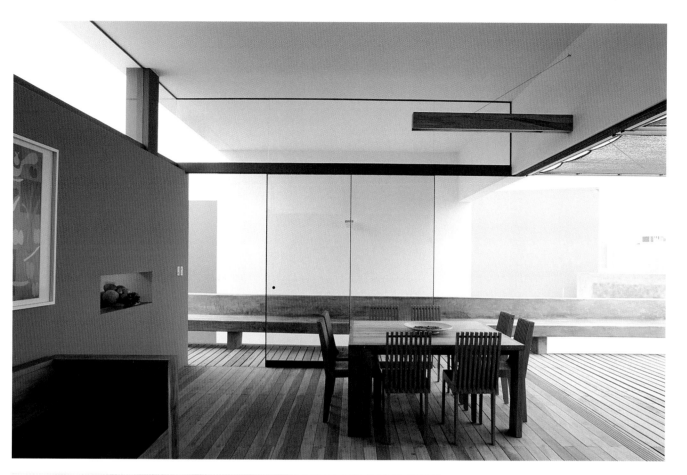

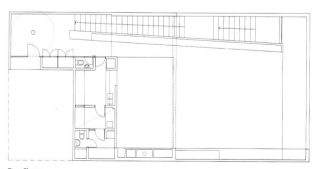

First Floor

The gradual excavation of interior spaces produced ambiguous boundaries between interior and exterior zones.

A sliding glass panel and projecting roof transform the living and dining areas into a spacious open-air terrace.

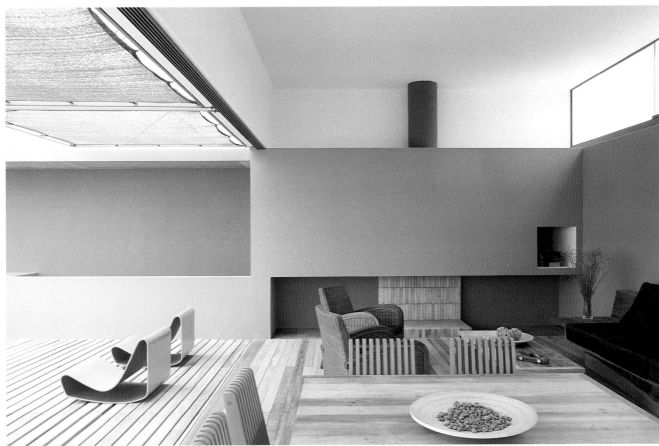

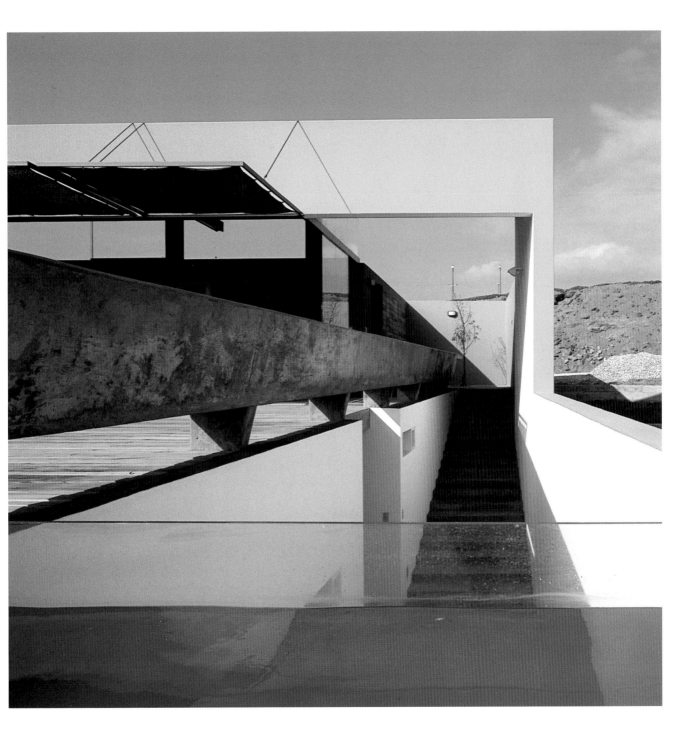

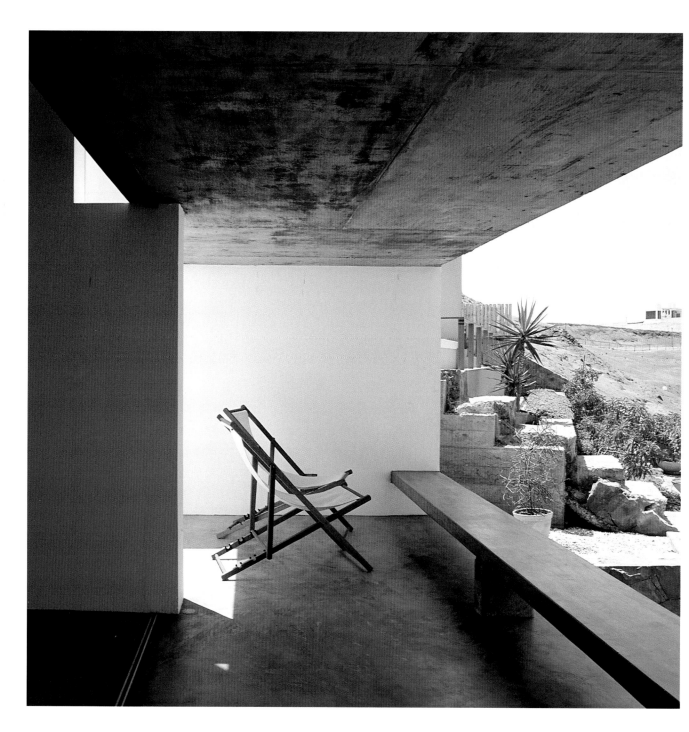

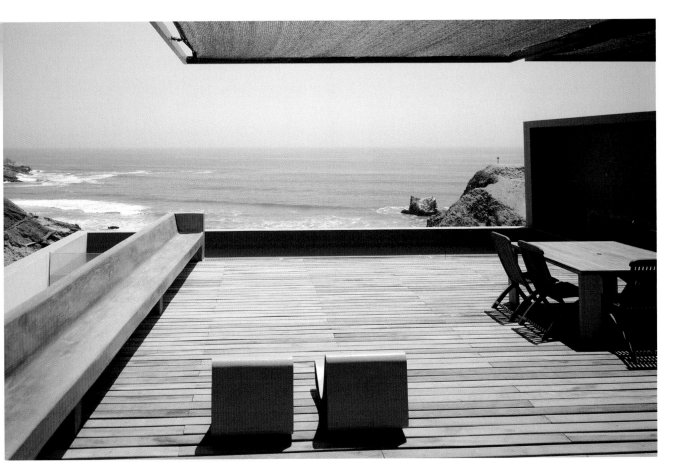

Conceived as an artificial beach, a large
terrace expands toward the ocean and
at the same time shades the level below,
which contains the guest and children's
bedrooms.

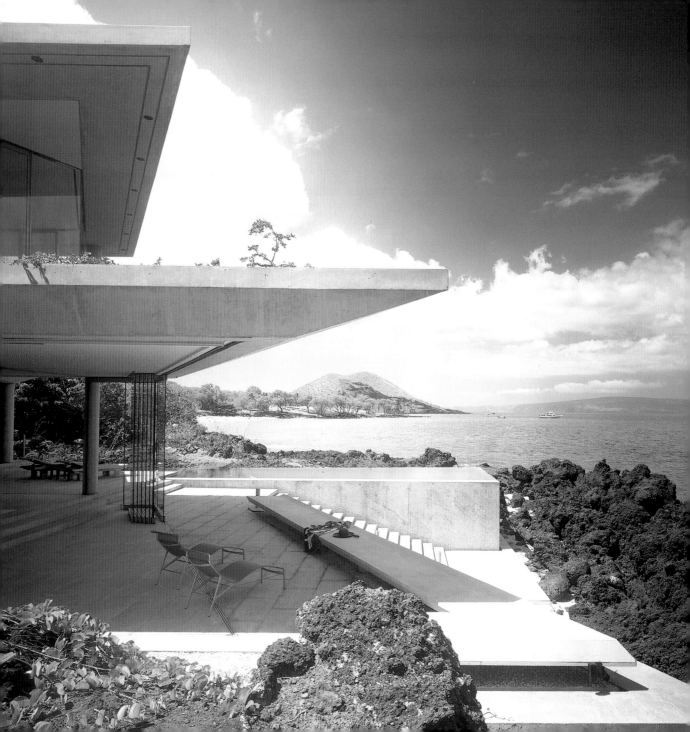

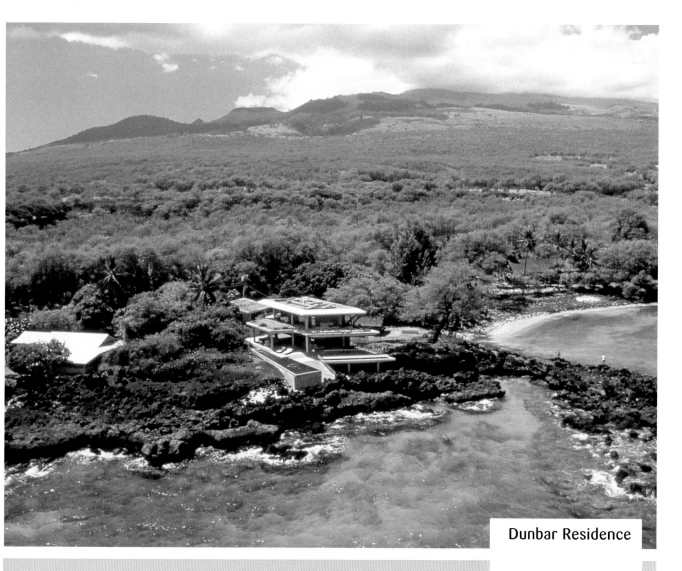

Dunbar Residence

This house in Makena is a spectacular vision of orderly civilization amid chaotic nature. Surrounded by a green expanse of thick vegetation and partially submerged in the waters of the Pacific, the house features stunning views through seamless glass windows and appears ship-like from the ocean.

Architect: Nick Milkovich and Arthur Erickson
Location: Maui, HI, United States
Date of construction: 2000
Photography: Ron Dahlquist

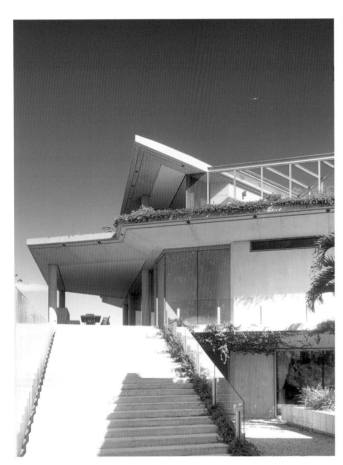

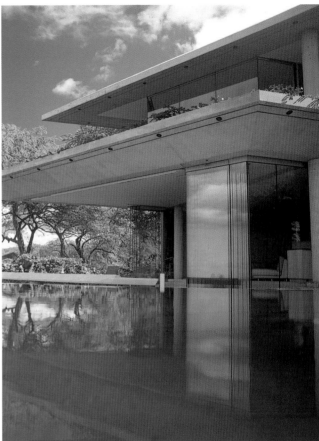

The use of unframed glass creates a seamless effect that allows an uninterrupted panoramic view of the landscape.

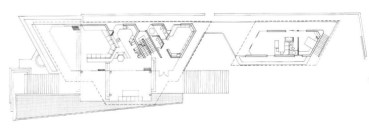

Ground Floor

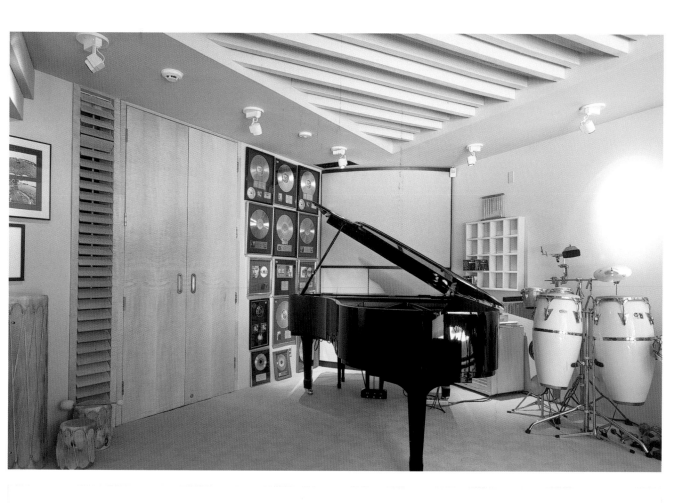

Upper Floor

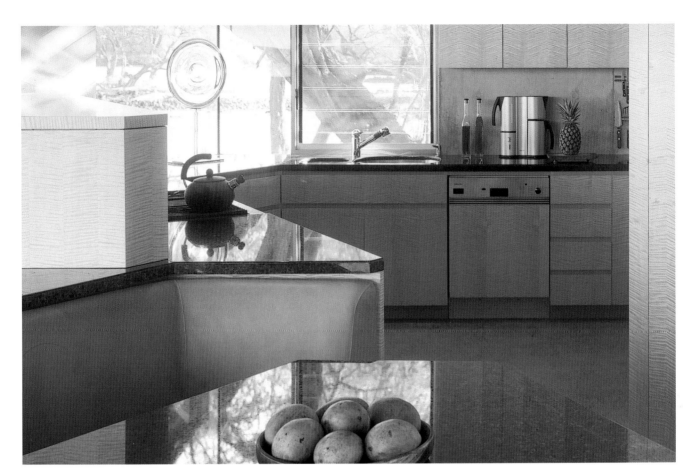

88

Post-tension concrete and aluminum surfaces were employed to reduce maintenance and protect the house from the effects of the climate.

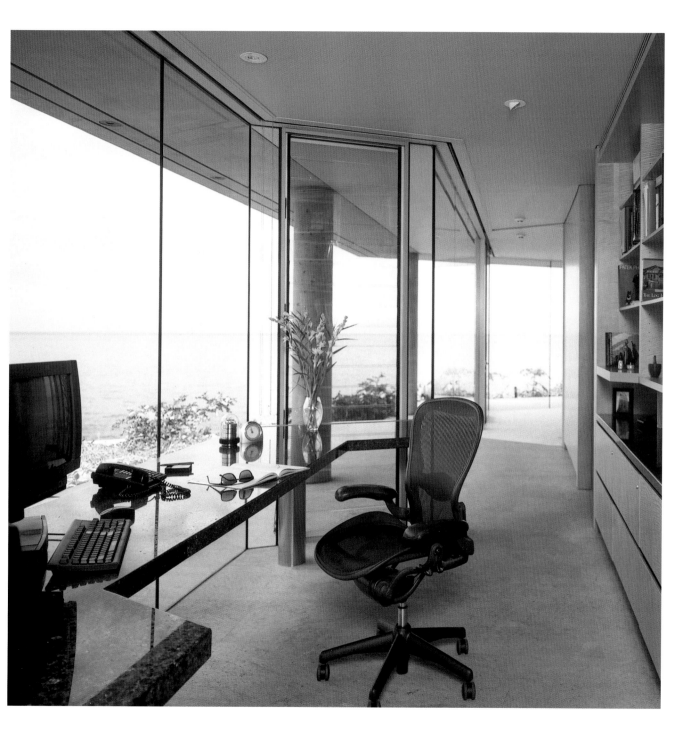

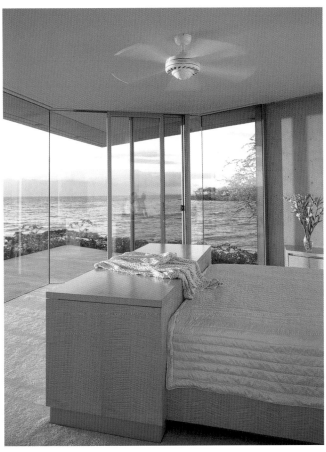

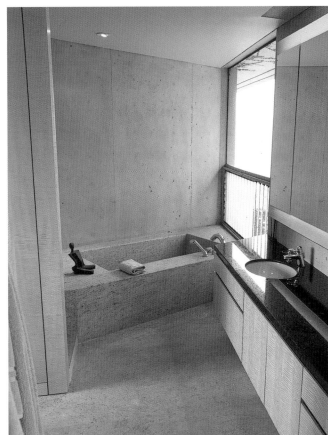

Site Plan

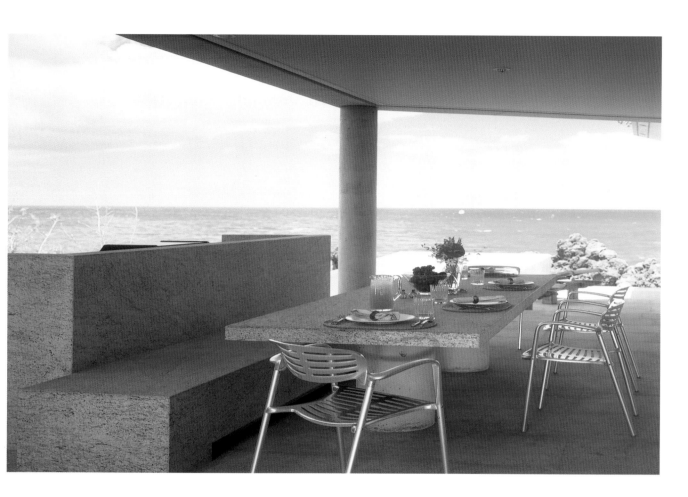

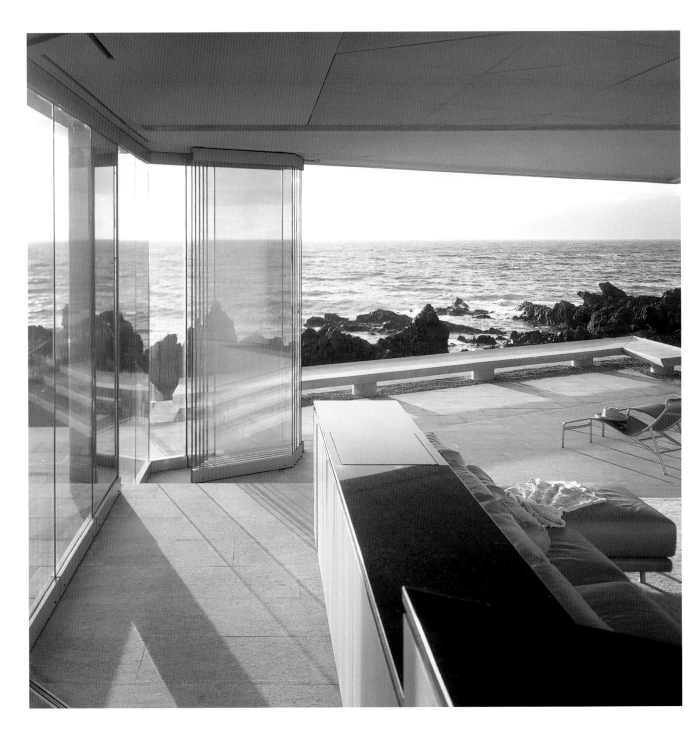

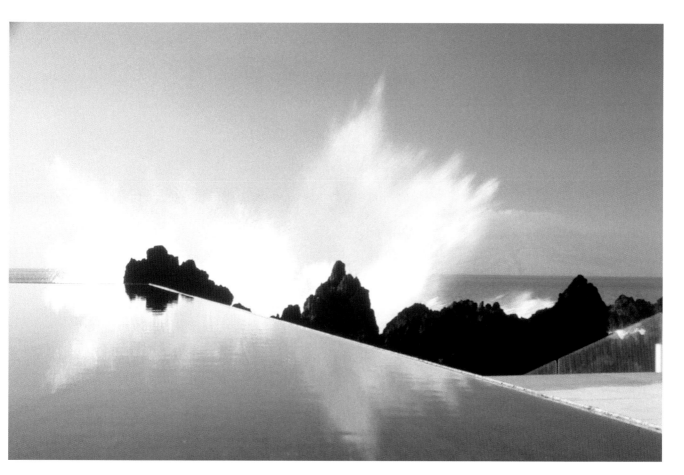

A tapered lap pool borders the entrance
terrace; its water spills over the edges
to create an infinite border between
itself and the ocean.

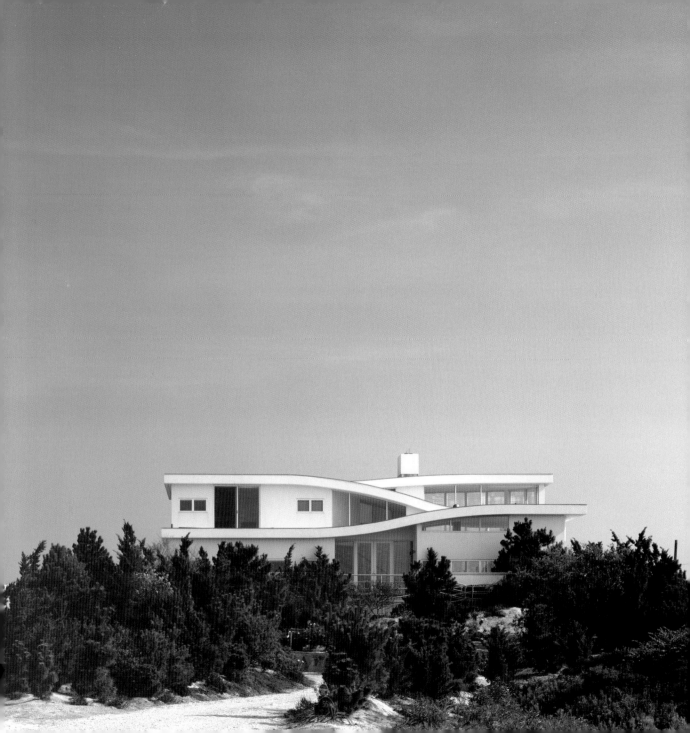

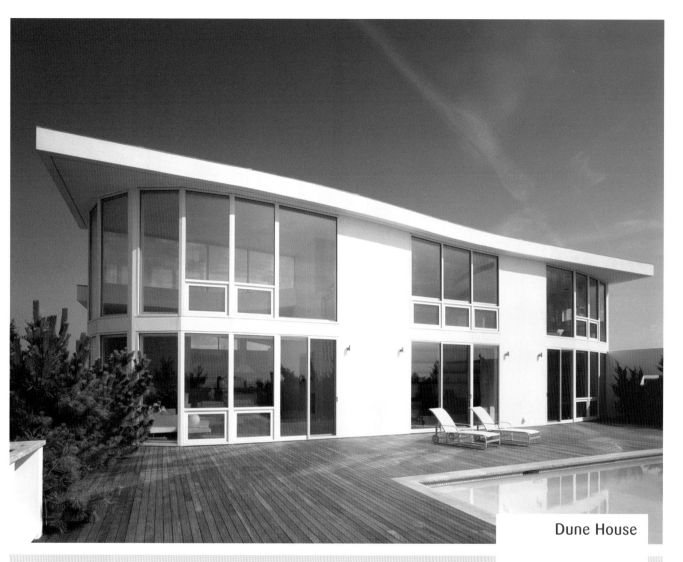

Dune House

This house in East Quogue is set between the ocean and the bay on a shifting dune, expressing the movement of the sea and the sand through a series of undulating roof structures that mark the transition between land and water.

Architect: Lynne Breslin Architects
Location: Long Island, NY, United States
Date of construction: 2004
Photography: Eduard Hueber/Archphoto

The living room opens onto a wooden deck that extends through the tall grass toward the sea in the form of a narrow walkway.

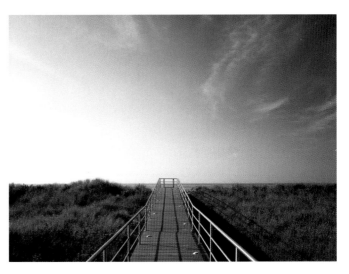

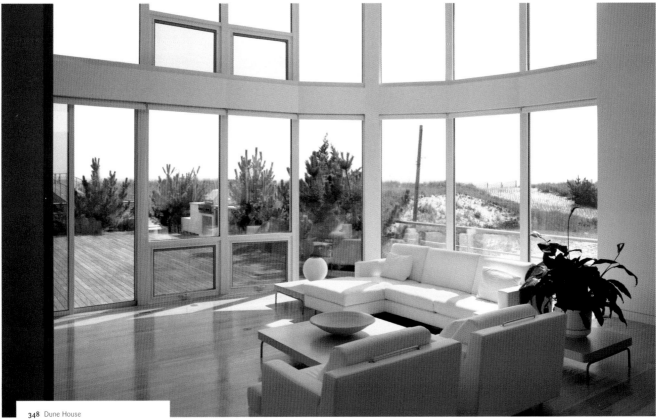

Ground Floor

First Floor

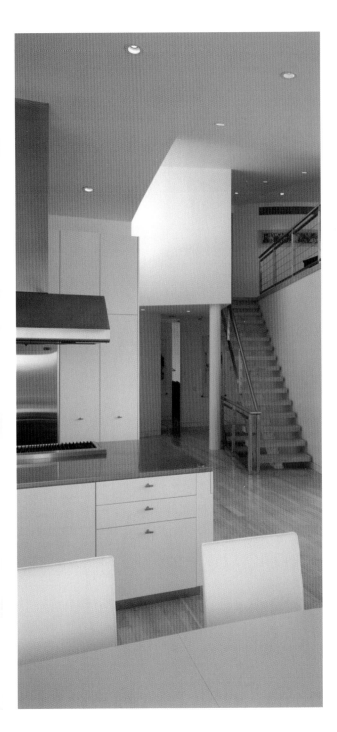

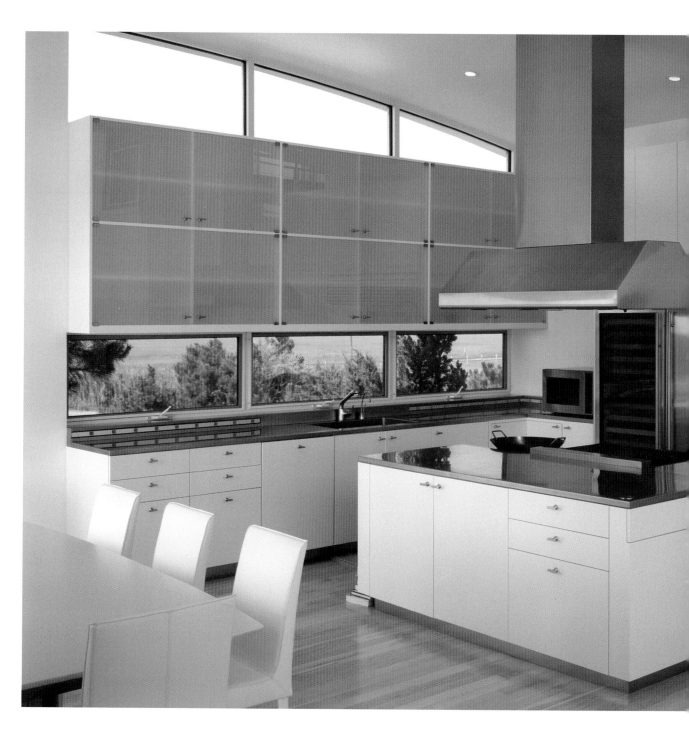

To emphasize the commanding views of the landscape, materials and palette were limited.

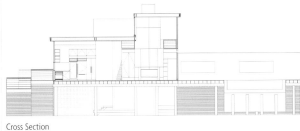

Cross Section

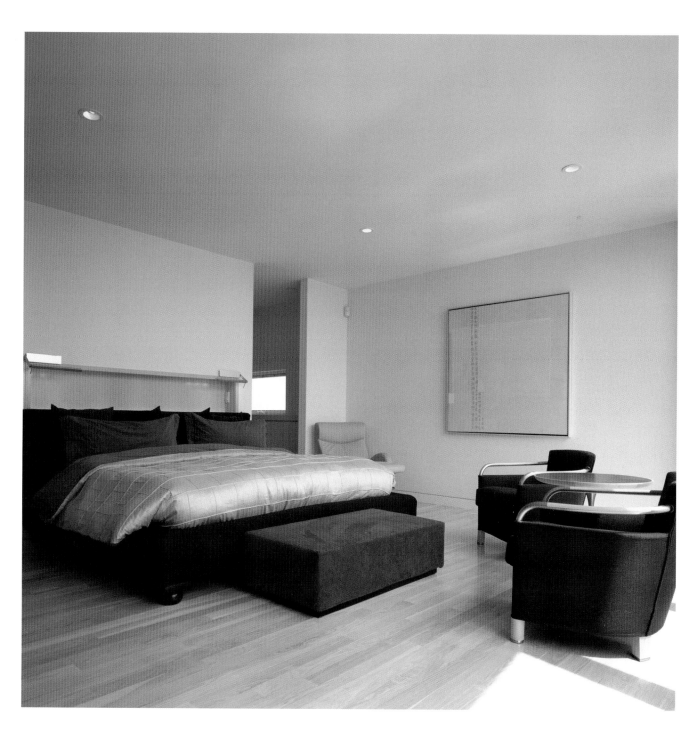

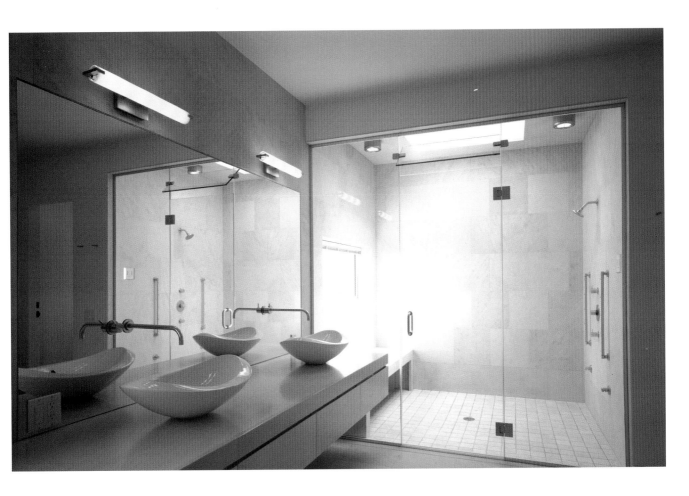

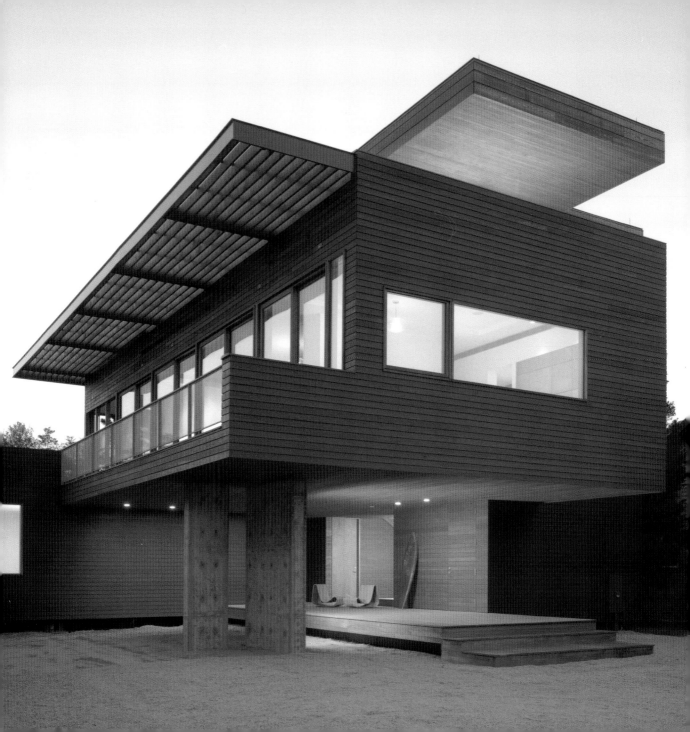

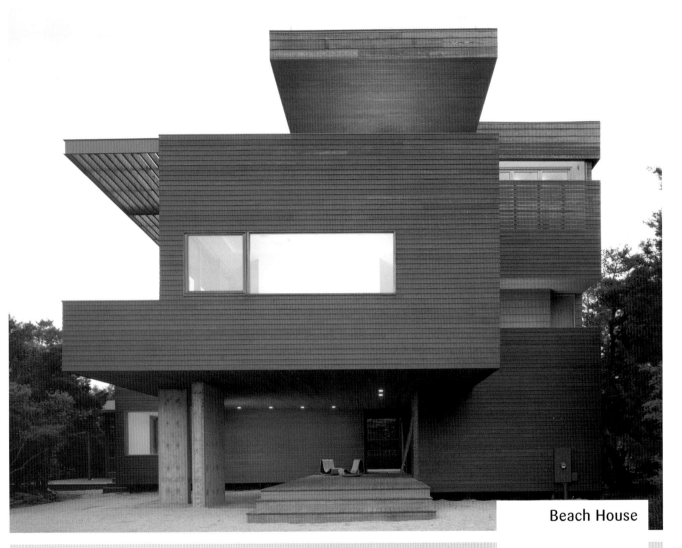

Beach House

The densely wooded character of the site led the architects to raise the main structure of this house in order to further integrate the living spaces with the enveloping vegetation. Linear, interlocking rectangles punctuated by bands of glass allow the tenants to enjoy a variety of perspectives over the landscape.

Architect: Christoff:Finio
Architecture
Location: Long Beach Island,
NY, United States
Date of construction: 2003
Photography: Elizabeth Felicella

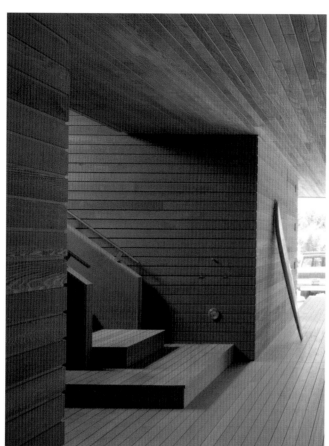

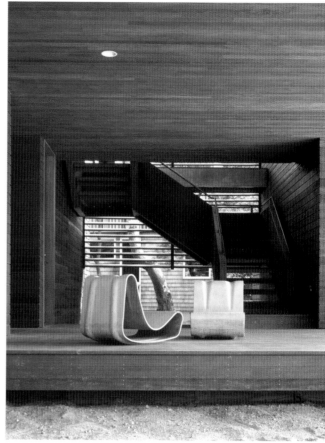

By situating the living spaces and bedrooms on the upper floors, the ground floor became the perfect place to accommodate a guest room, office and gym, and storage room.

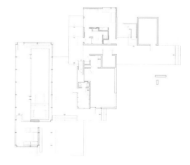

Ground Floor

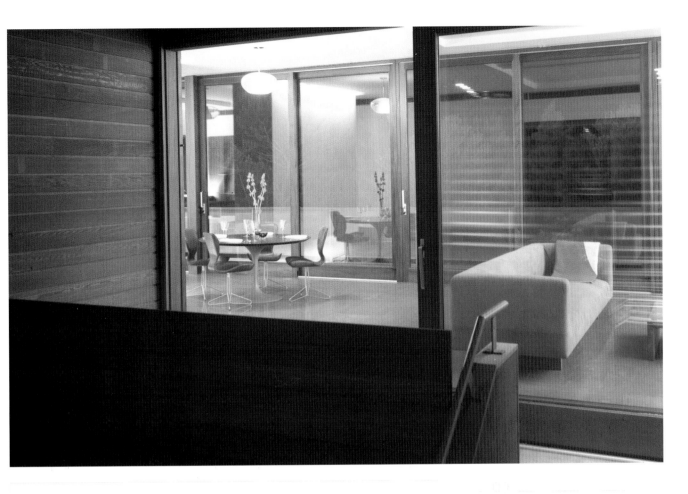

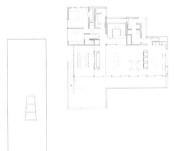

First Floor

Second Floor

A metal framework reinforces the wooden structure and supports the large projections that emphasize the relationship with the surroundings.

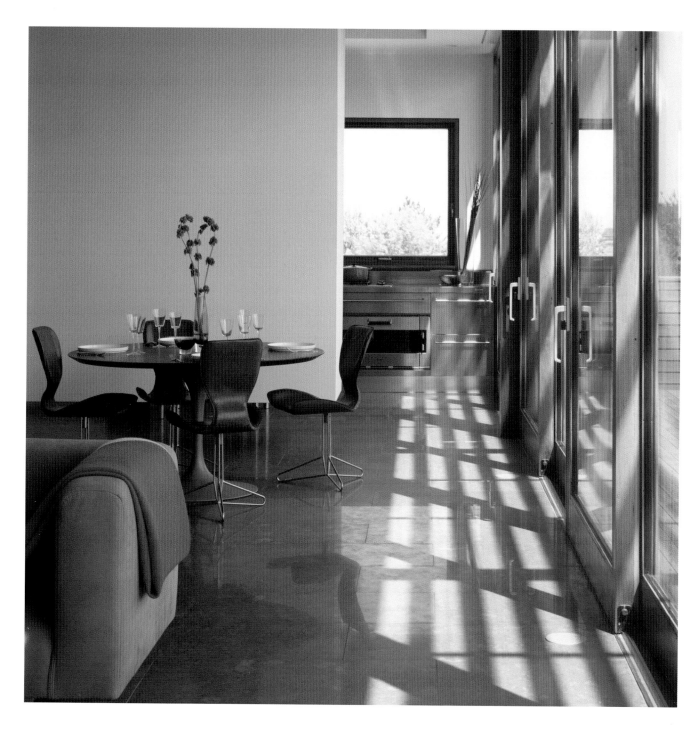

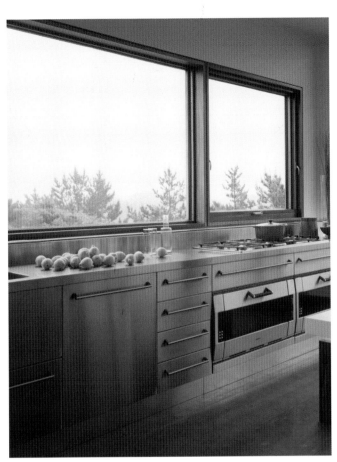
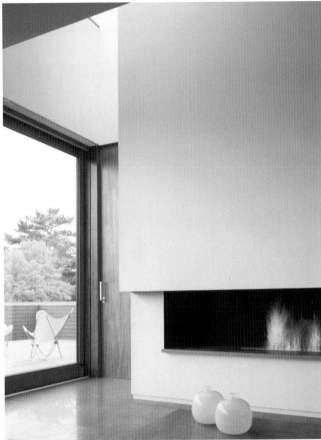

A predominantly gray palette is
effected by using stone for the
floors throughout. Color is provided
through the decorative elements.

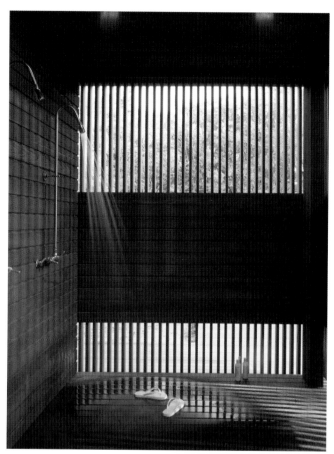
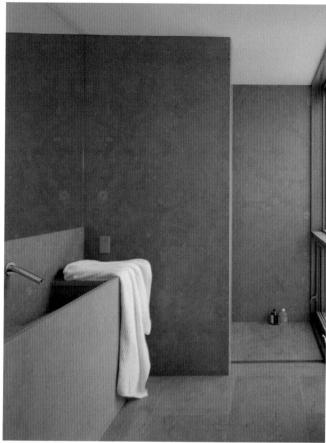

A shower is conveniently located on
the ground floor next to the private
gym and fashioned from wooden slats
that permit the entry of light.

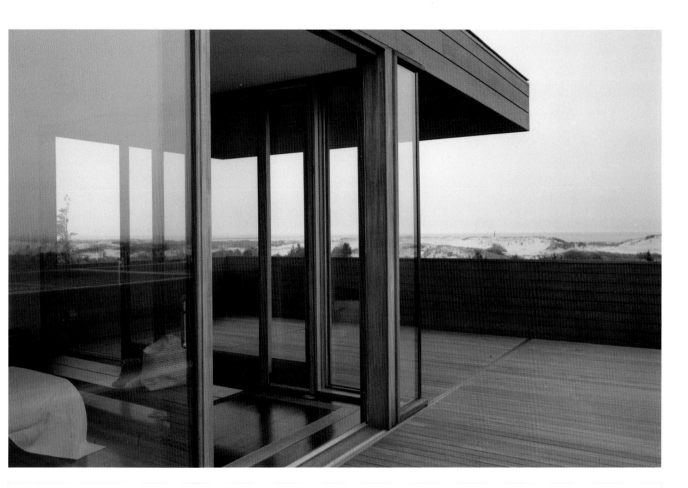

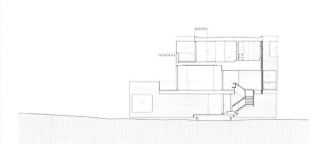

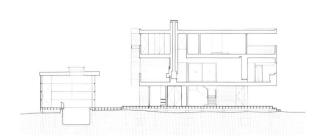

Sections

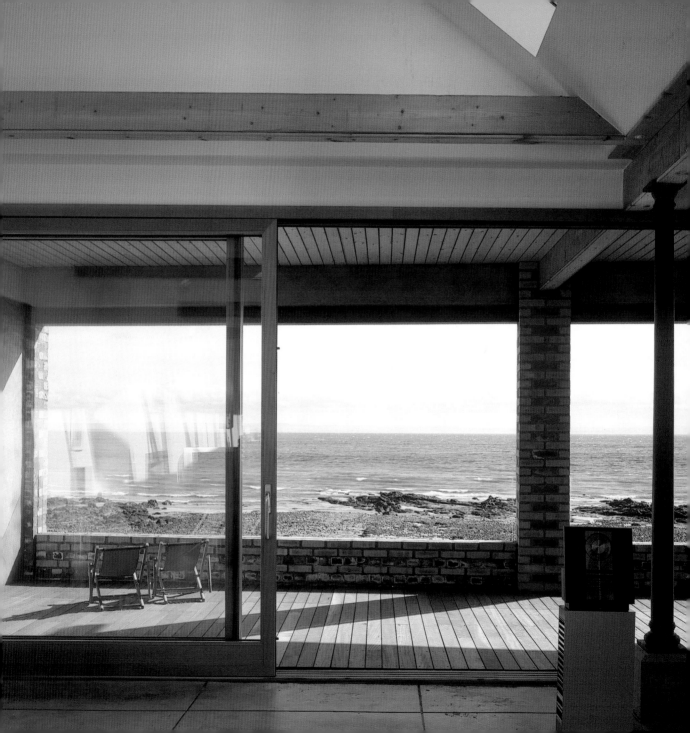

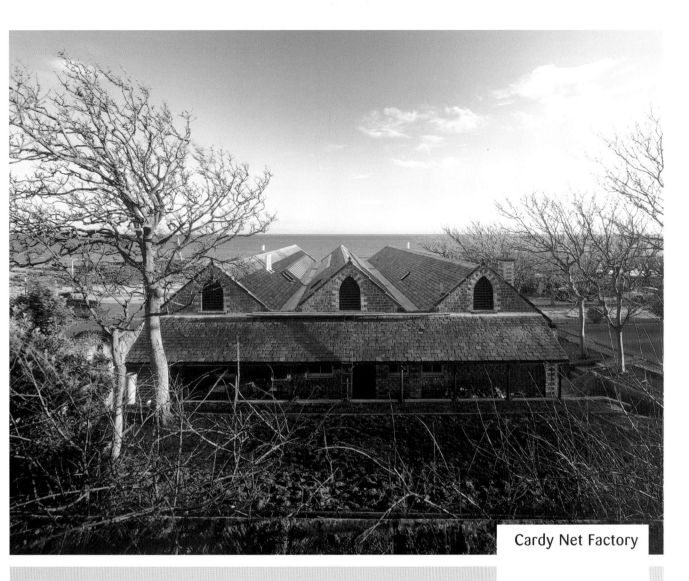

Cardy Net Factory

A fishing net factory during the late 1800s, this building was converted into a home and vacation rental for the architects. The project entailed the preservation of the special qualities of this unusual Victorian construction while creating a large, single-level floor that would optimize the views of the beach and the sea.

Architect: Mike Rolland
Location: Lower Large Fife, Scotland, United Kingdom
Date of construction: 2000
Photography: Peter Cook/VIEW

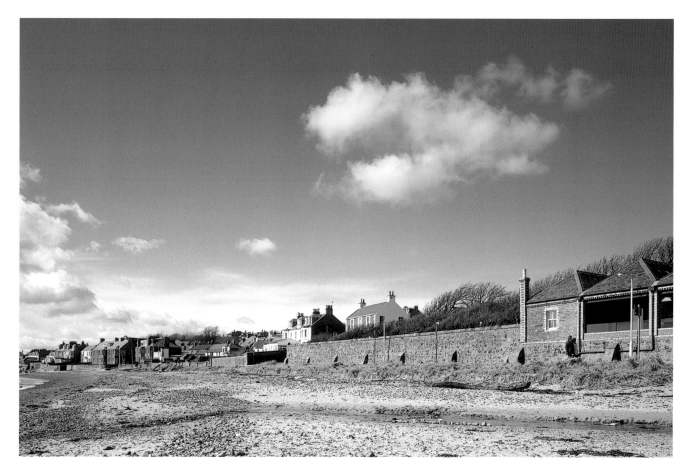

Due to the extensive deterioration of the existing factory structure, the building was completely gutted and reduced to four walls, with the help of local tradesmen.

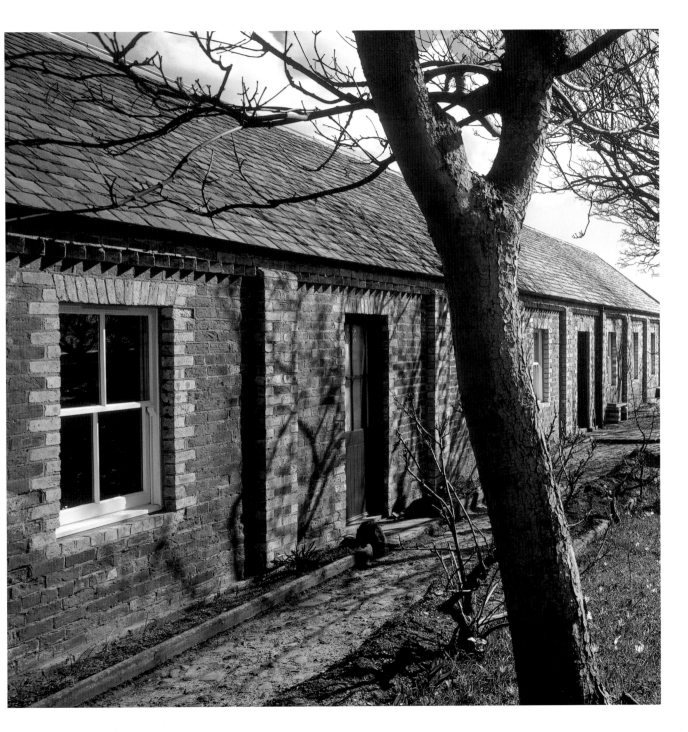

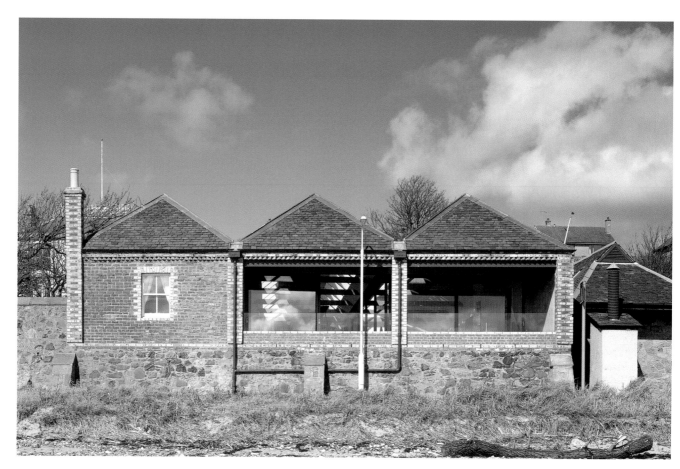

Inspired by the simplicity of the original structure, the architects wished to integrate a strikingly modern interior into a 5000-square-foot space and to contrast the existing elaborate Victorian elements.

Ground Floor

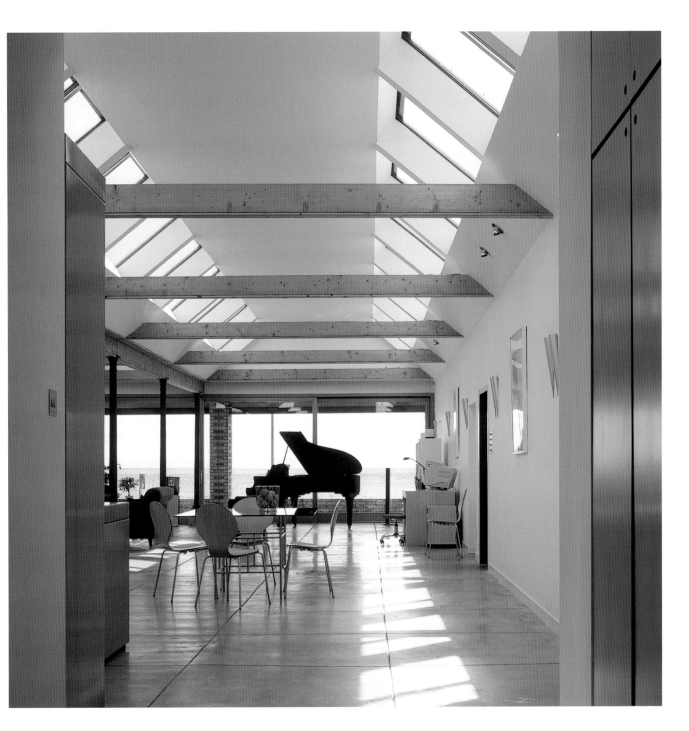

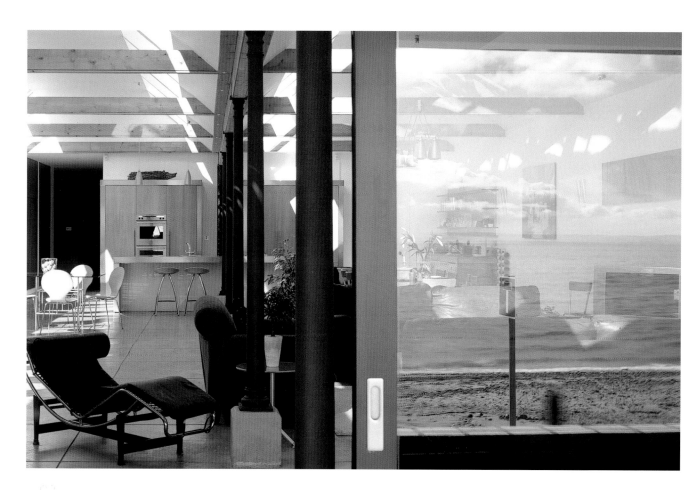

Skylights were placed along the length of the main living space in order to bring light into the back of the house.

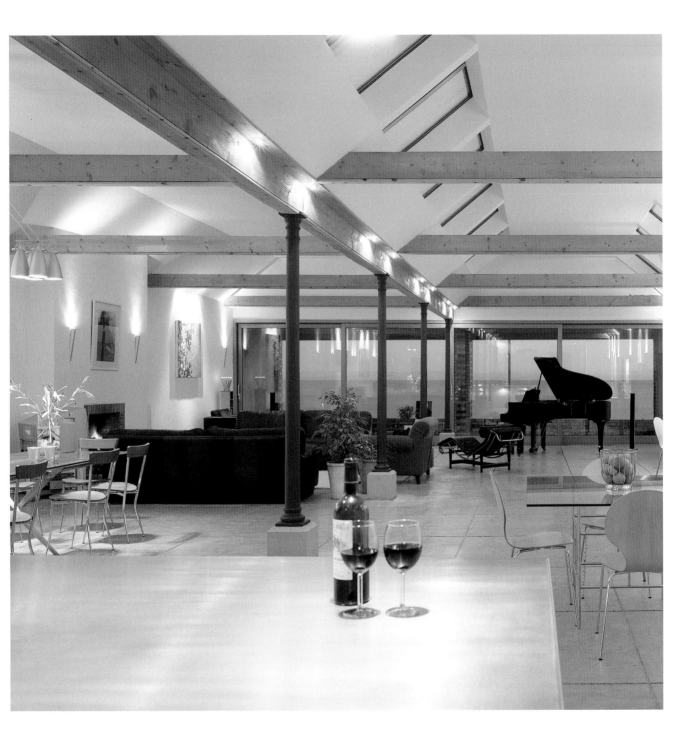

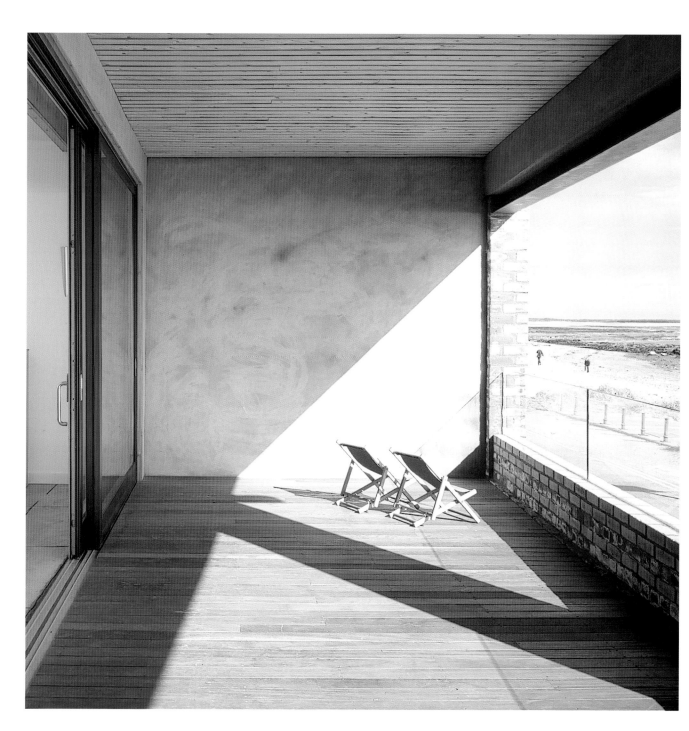

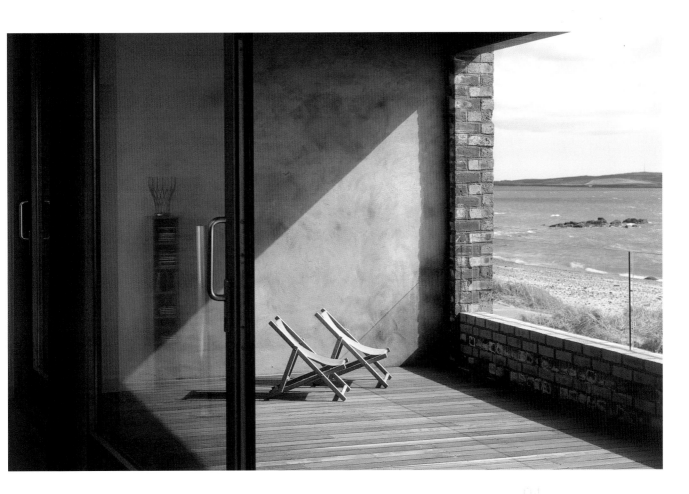

Old windows were replaced
with large sliding glass
doors framed in oak.
A glass balcony leaves
the brick structure
undisturbed and maintains
the view of the beach.

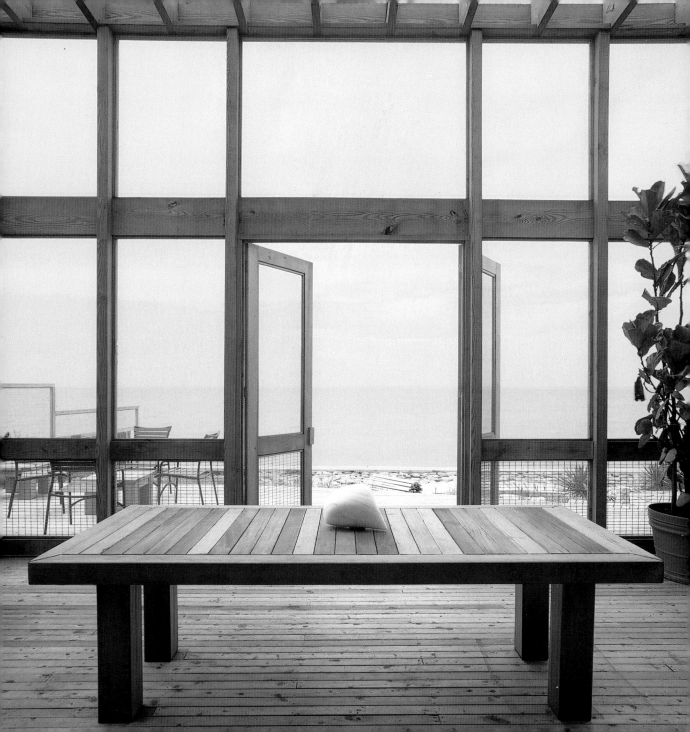

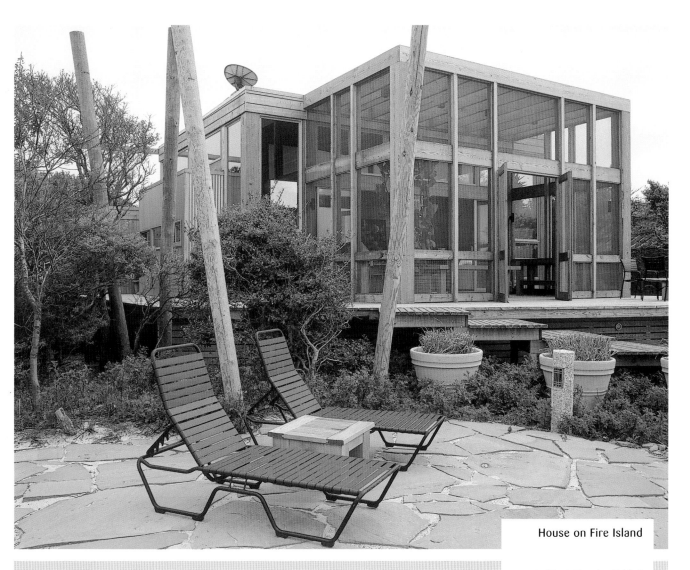

This residence is situated on the north side of Fire Island, where the fragile ecosystem prohibits the use of cars and wooden walkways replace concrete streets out of respect for the environment and the constantly shifting sand dunes. The house looks out to the ocean through a timber-framed glass structure.

Architect: Bromley Caldari Architects
Location: Fire Island, NY, United States
Date of construction: 2002
Photography: Jose Luis Hausmann

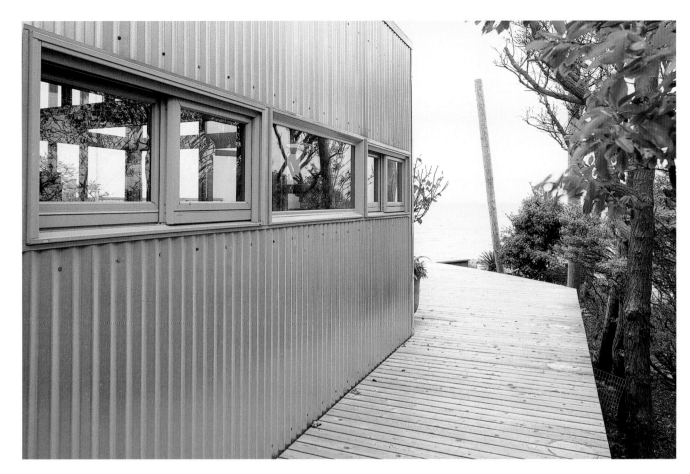

A small walkway leads to the guest
pavilion, followed by a barbecue
area, a swimming pool, and the main
entrance at the far end.

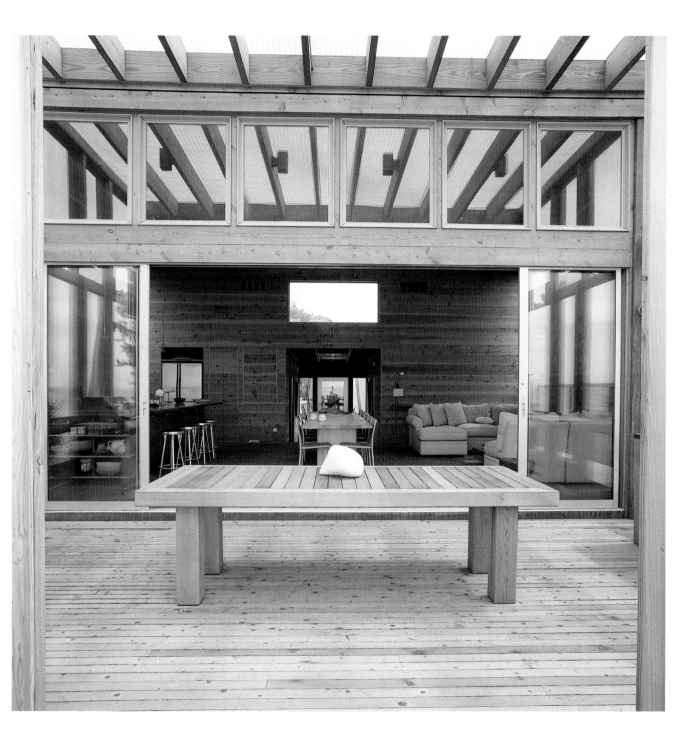

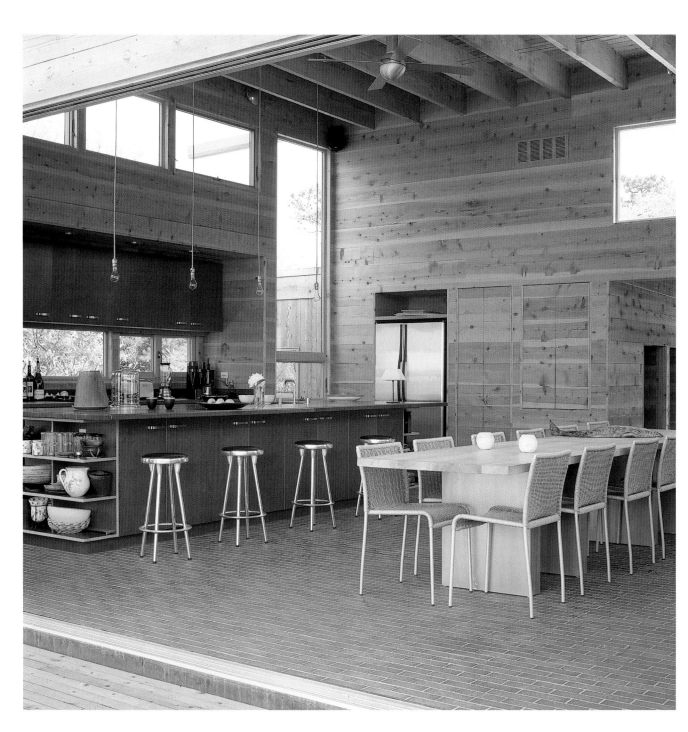

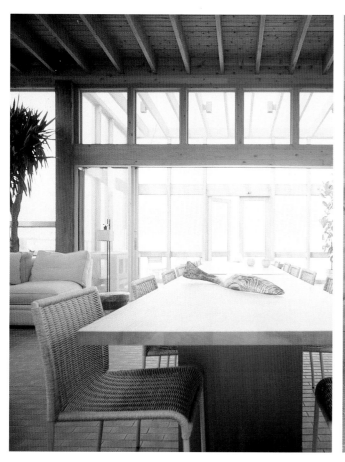

The pavement was laid in brick, zinc panels were used in the wet areas, and cedar and pine panels were used with structural beams to create large, airy spaces within the home.

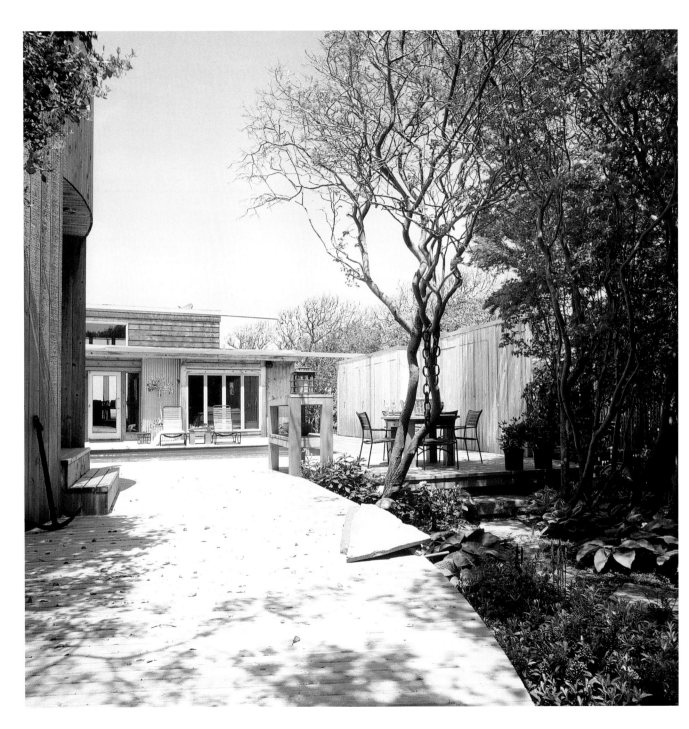

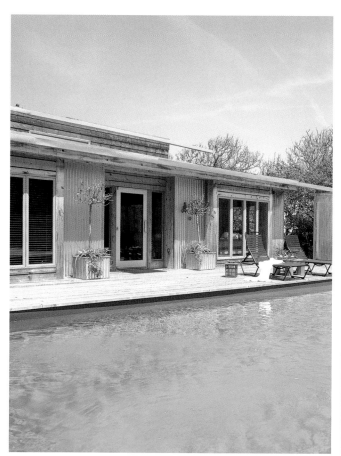

96

The guest pavilion, completely independent from the main house, also serves as a painting studio when not occupied by visitors.

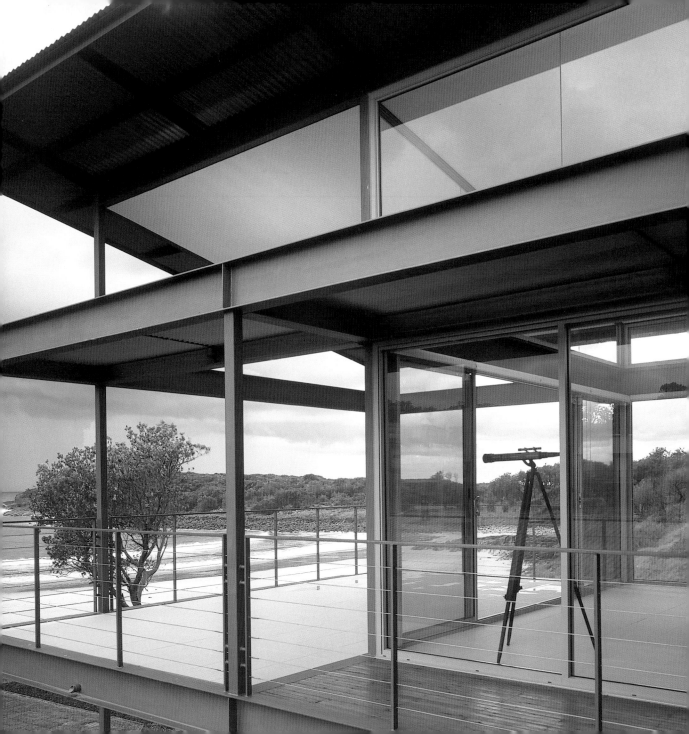

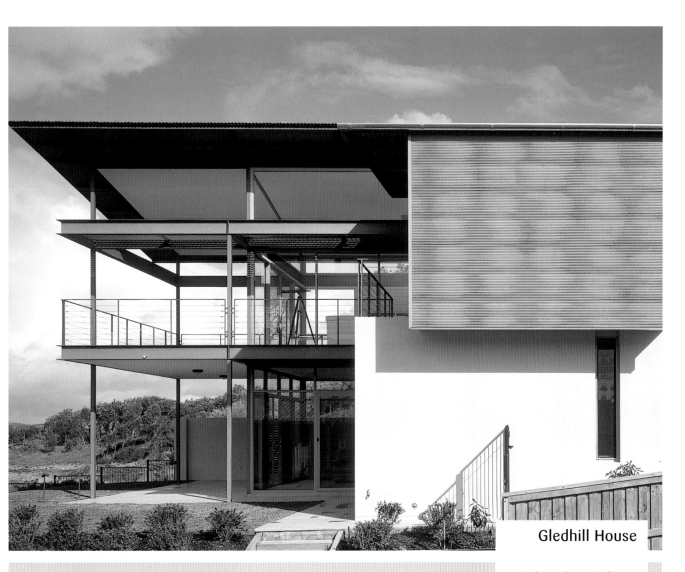

Gledhill House

Architect: Tanner Architects
Location: New South Wales, Australia
Date of construction: 2002
Photography: Richard Glover/View

On a sheltered inlet on the eastern coast of Australia, this vacation home looks past rocky headlands and windswept bush to a small, sandy beachfront. Careful planning made it possible to ensure privacy from neighbors while capturing natural light and retaining views of the natural scenery.

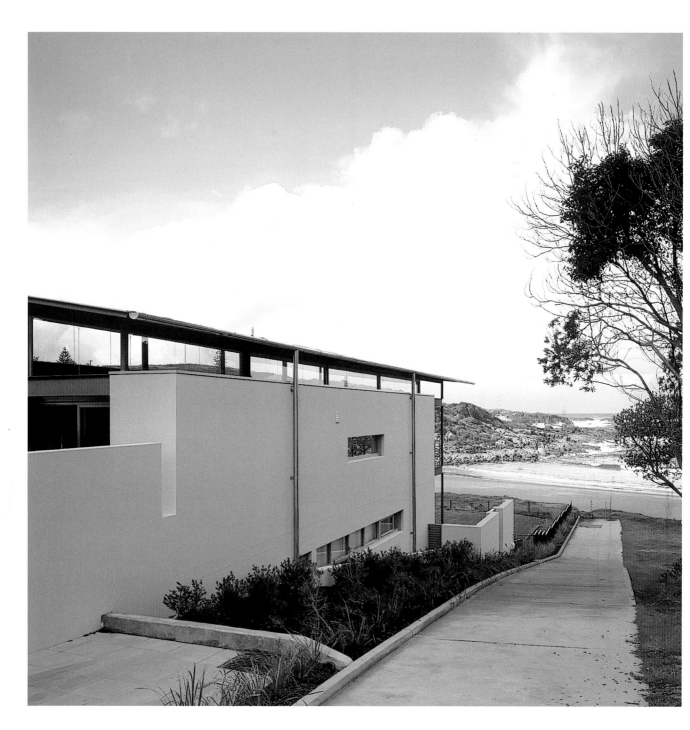

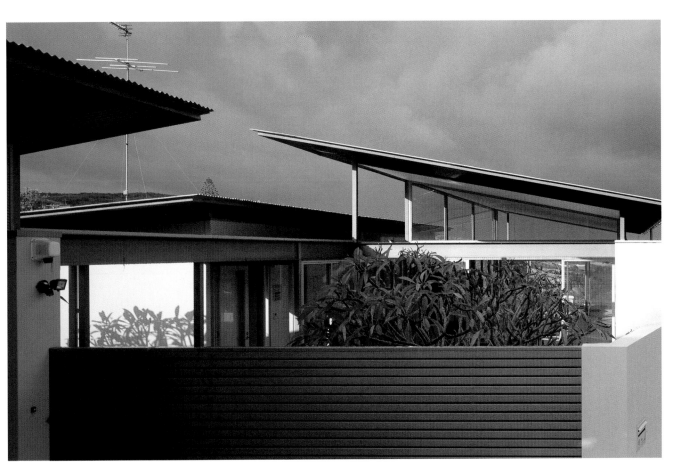

Ground Floor

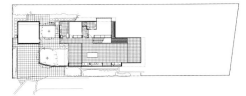

First Floor

In order to protect against the corrosive effects of the ocean, steel sections were finished in micaceous iron oxide, aluminum doors and windows were power-coated and the roofs were made out of a watertight material called Zincalume.

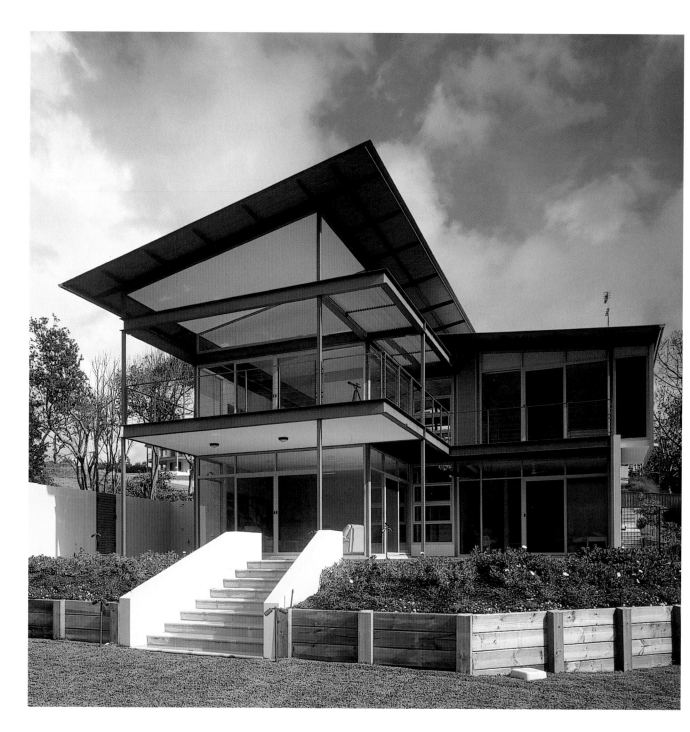

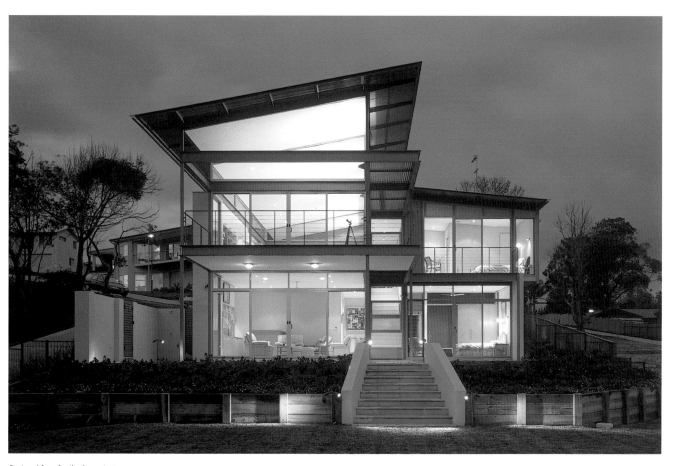

Designed for a family, the project was
conceived as two compartments:
the top level for the parents and the
lower level for the children and
the communal zones.

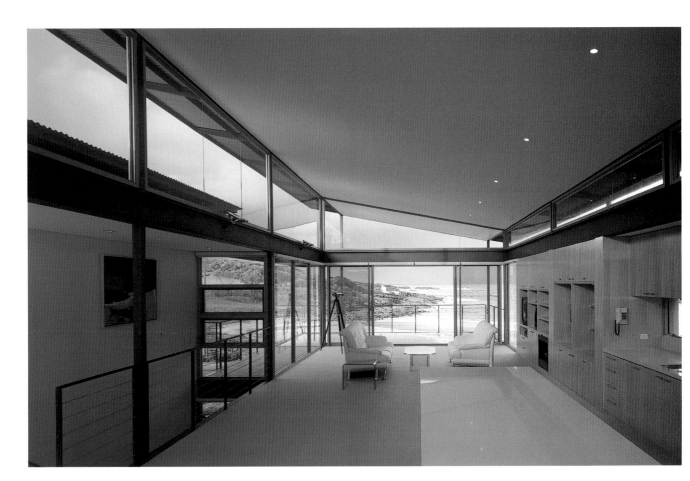

98

A tiled roof and high-level
windows in the main
living space offer shade
during the summer months
and sunlight throughout
the winter.

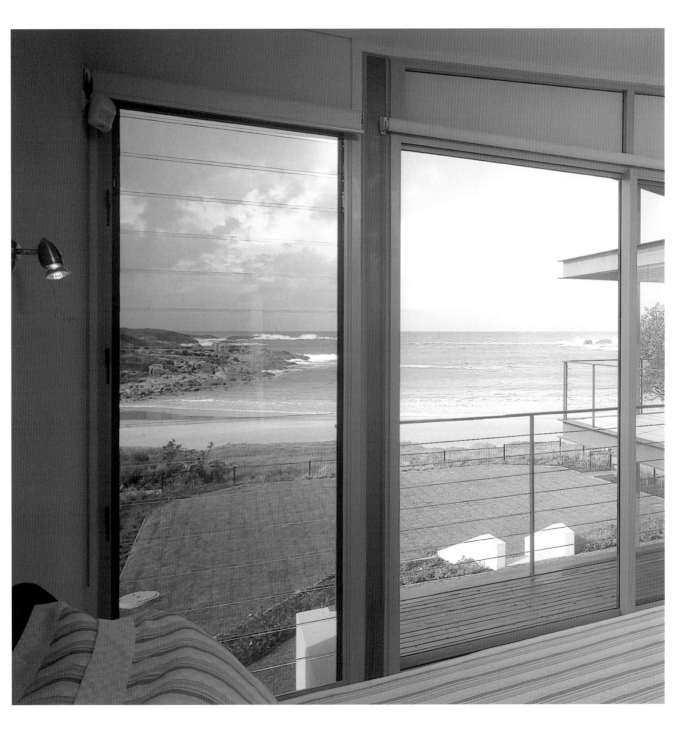

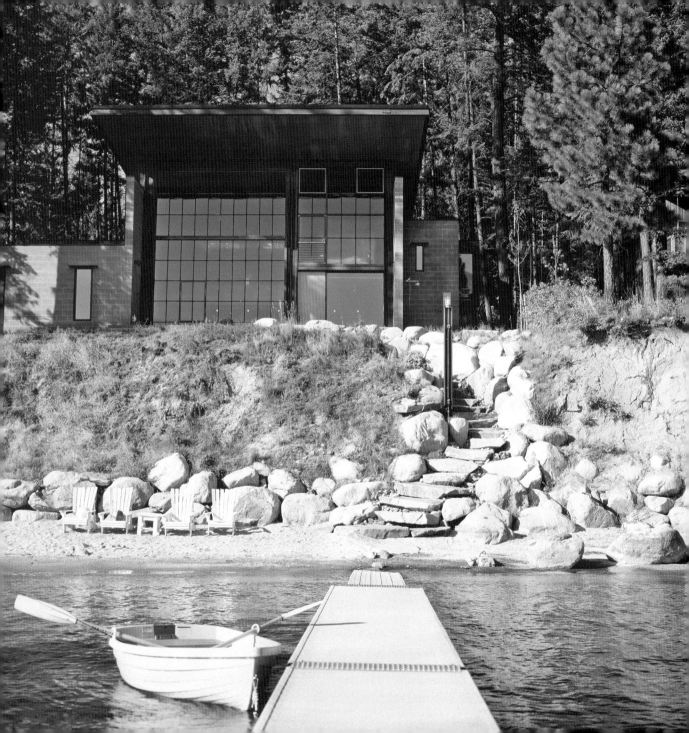

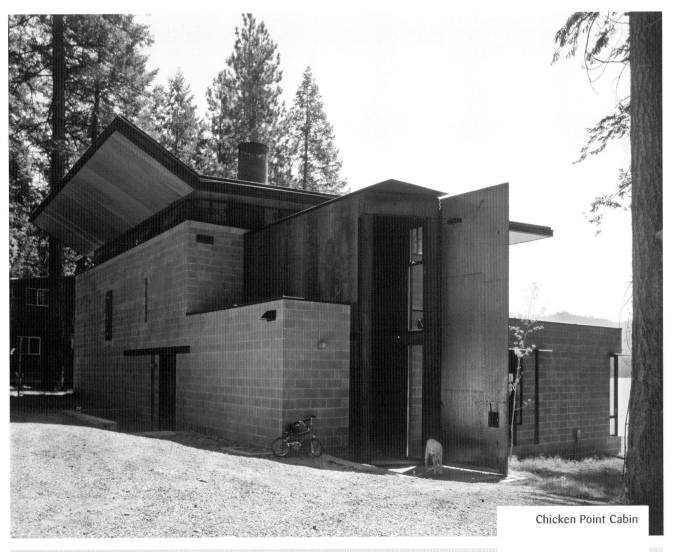

The idea for this project consisted of building a lakeside cabin in the woods, with a large window that would open onto the surrounding landscape. The resulting window wall, which measures 30 by 20 feet, opens the entire living space to the forest and lake beyond.

Architect: Olson Sundberg
Kundig Allen Architects
Location: Northern Idaho,
United States
Date of construction: 2004
Photography: Undine Pröhl

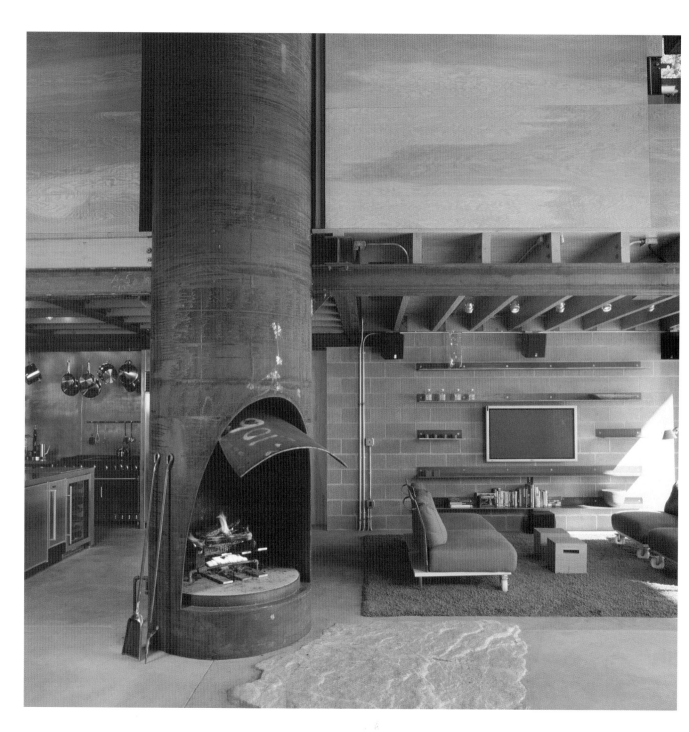

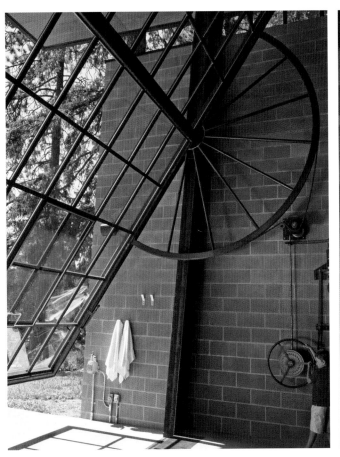

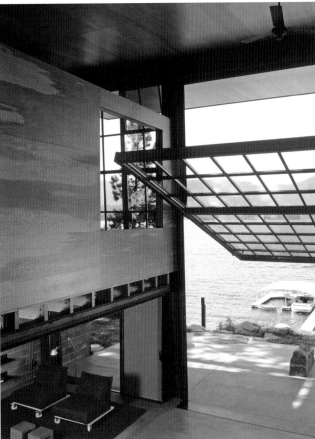

The house is composed of three main parts: a concrete box, a plywood insert, and a four-foot-diameter steel fireplace. Open interior spaces are intended to be a seamless extension of the natural setting.

Site Plan

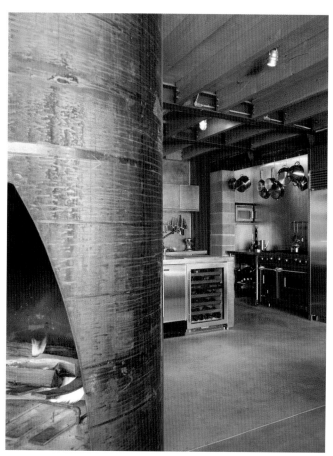

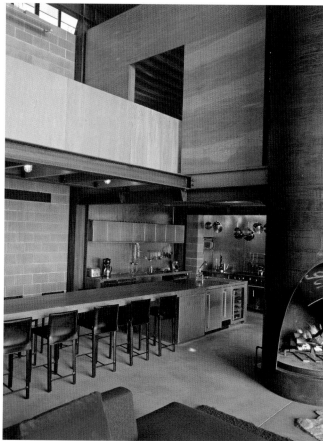

Low-maintenance materials like concrete, steel, and plywood were used in keeping with the concept of a cabin. They were left unfinished to age naturally and acquire a patina that fits in with the natural setting.

Ground Floor

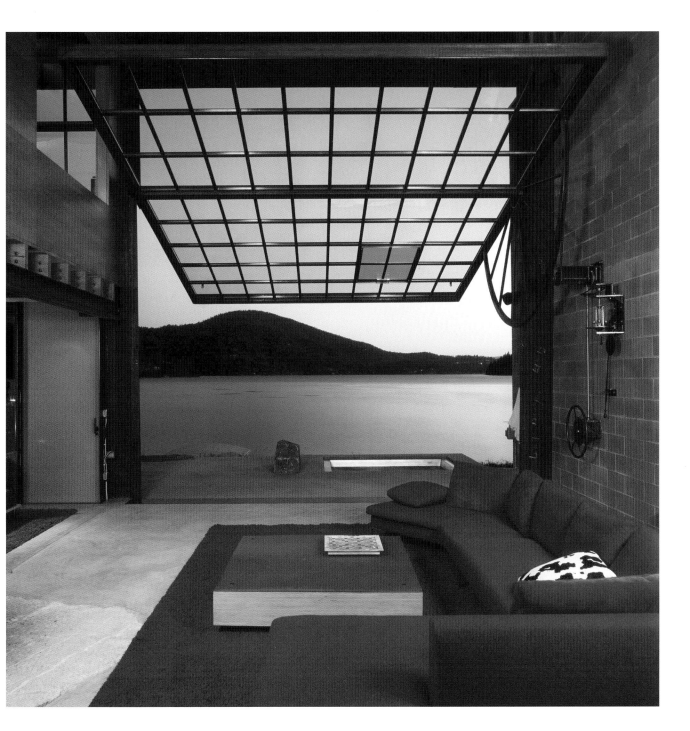

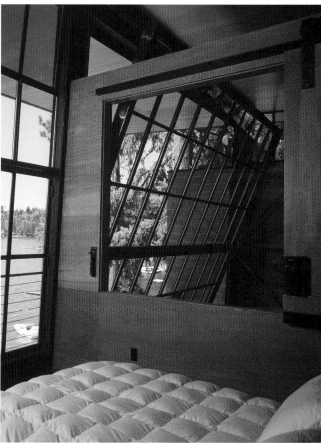

Another picture window was opened in the bedroom wall to enable access to the views provided by the large window wall in the living area.

First Floor

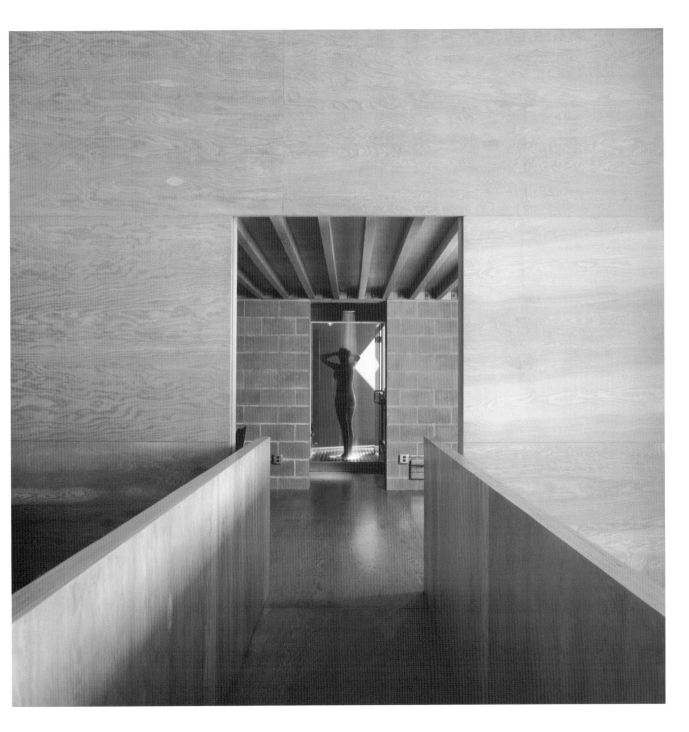

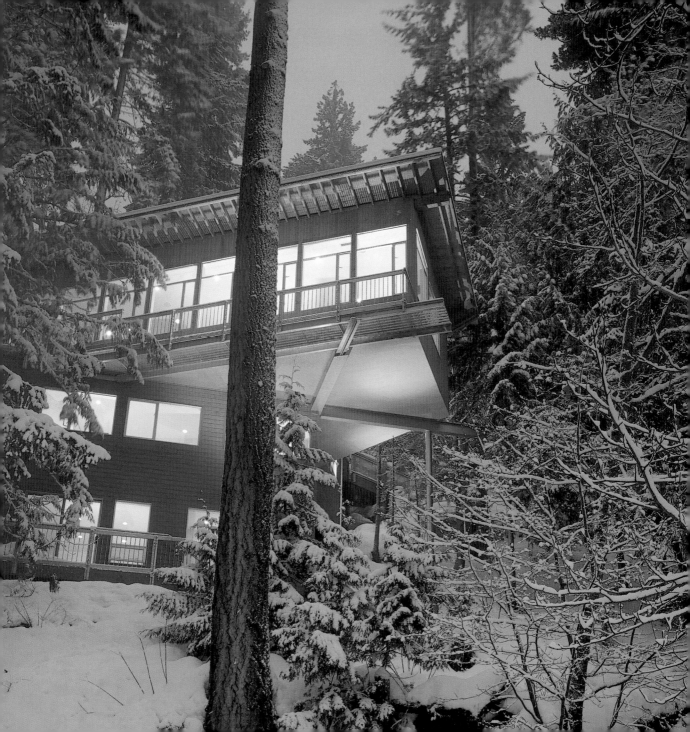

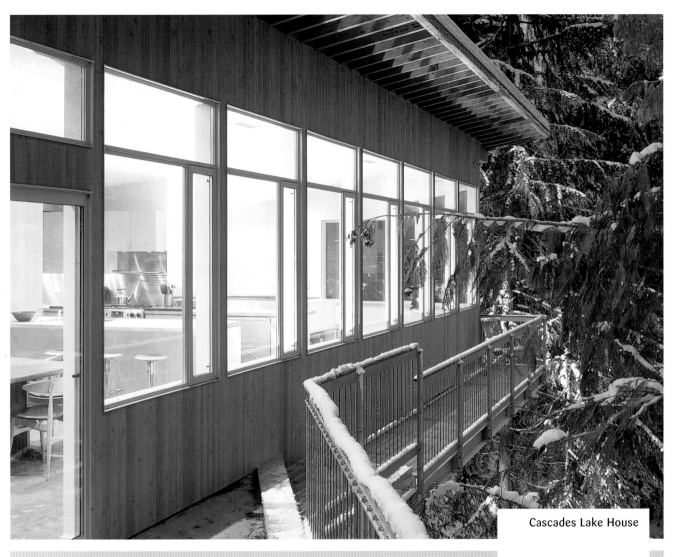

Cascades Lake House

Architect: Eric Cobb Architects
Location: Cascade Mountains,
WA, United States
Date of construction: 2000
Photography: Steve Keating,
Eric Cobb

This house was chosen as a vacation home because of its unique character, its setting, and its proximity to the city of Seattle. Located alongside a lake crowded with tall firs and cedars, the house consists of three parts: a box-shaped upper unit, a narrow two-story section below it, and an inclined cantilevered shelf that joins them.

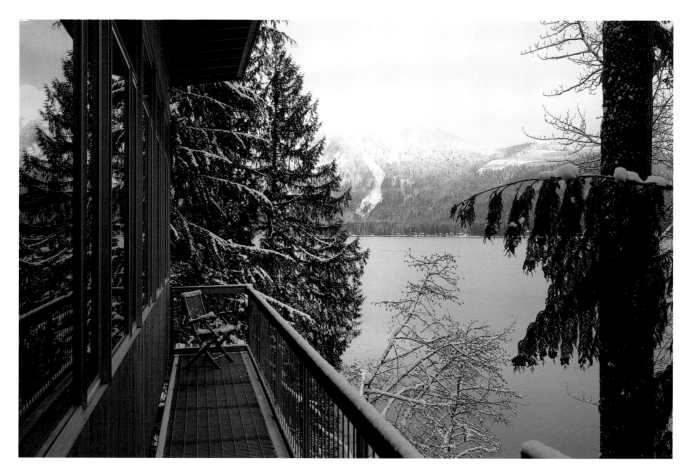

102

The exterior balcony functions
as a catwalk, emphasizing
the projection of the upper unit,
and also provides a vantage
point for gazing out onto the
lake and enjoying the natural
setting.

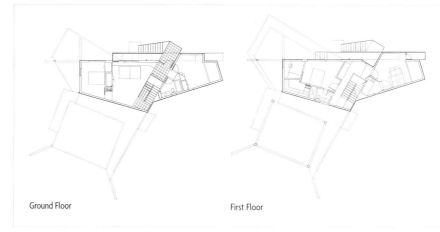

Ground Floor

First Floor

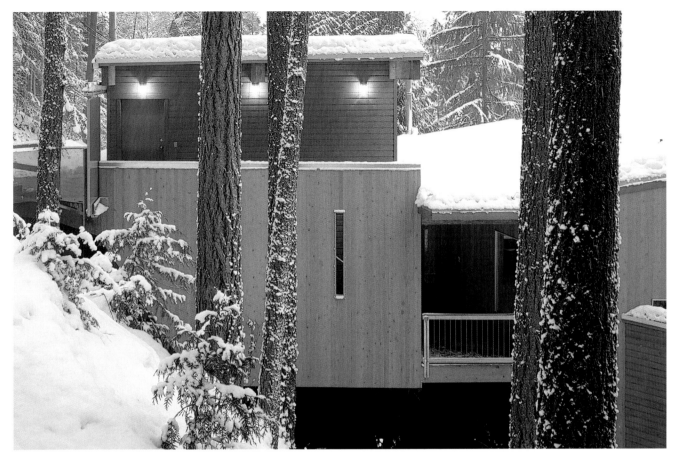

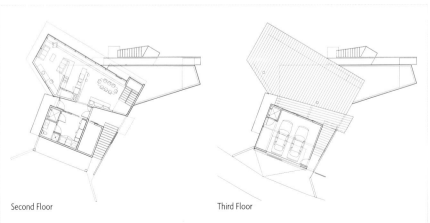

Second Floor

Third Floor

The small box-shaped unit,
which is linked to the
main entrance by exterior stairs,
is used as a garage.

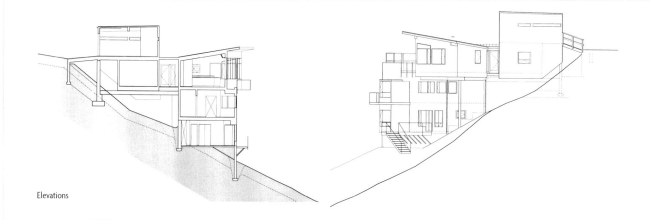

Elevations

A chalkboard surface can be
applied to any wall to
double as a playful message
board for both children
and adults.

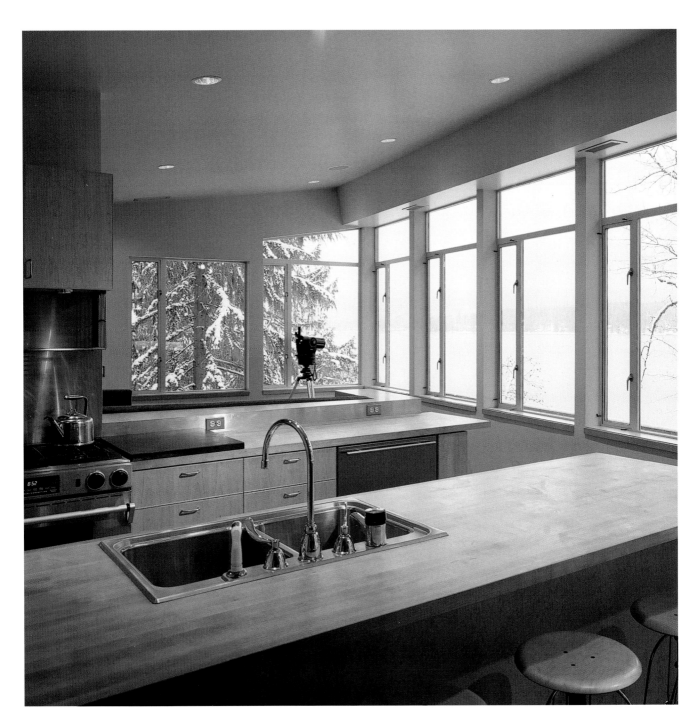

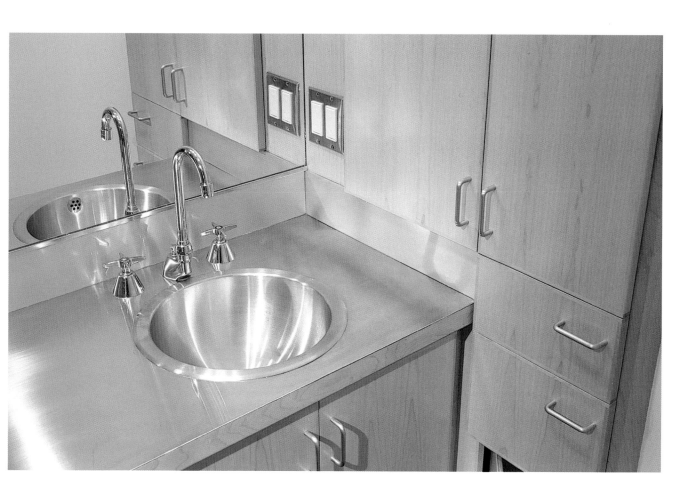

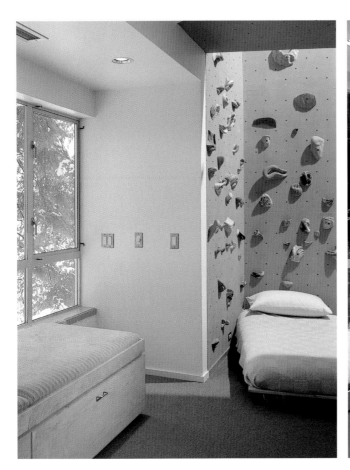

105

A rock-climbing wall was
installed inside the two-story
unit, vertically linking the two
bedrooms. Custom-made
furnishings double as extra
beds for guests.

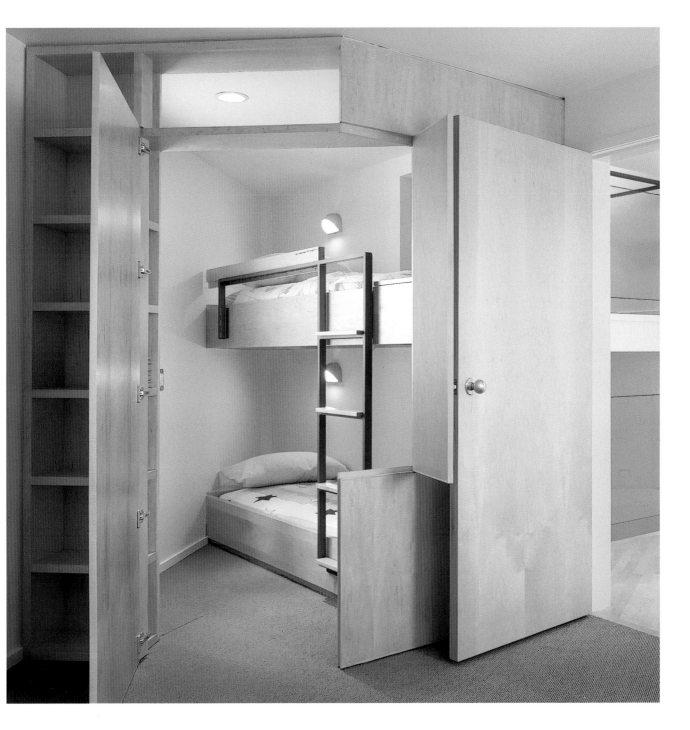

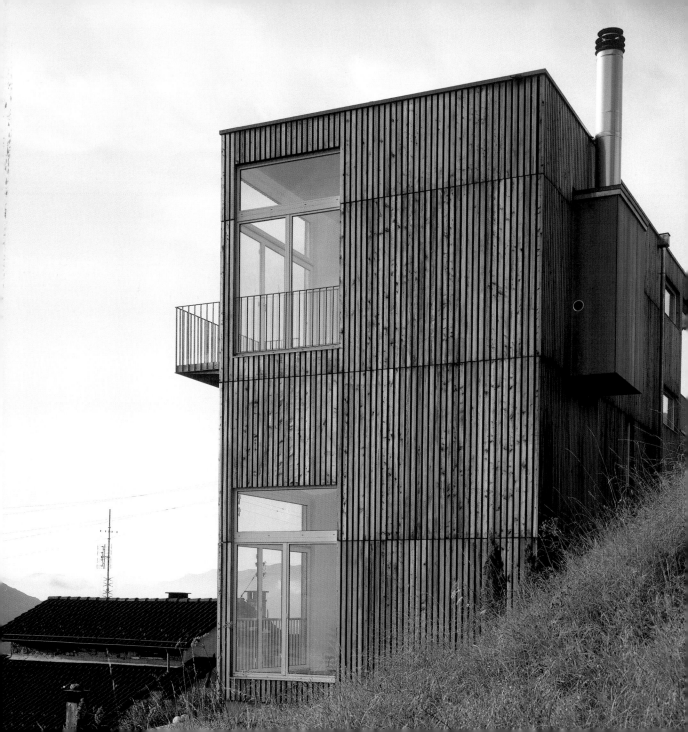

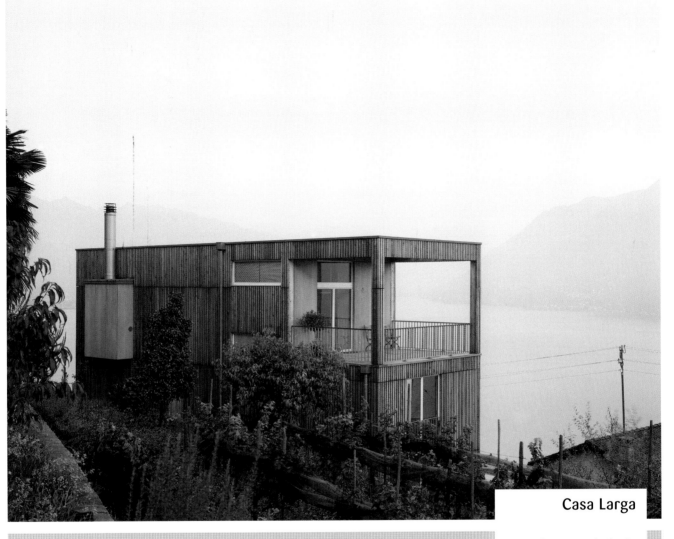

Casa Larga

Architect: Daniele Claudio
Taddei
Location: Kloten, Switzerland
Date of construction: 2001
Photography: Bruno
Helbling/zapaimages

This wooden house, located in a rural area where stone is the primary construction material, was inspired by the agricultural buildings of the region. Defined by the architect as a granary for an artist, the house incorporates a working studio and maximizes the view of Lake Maggiore.

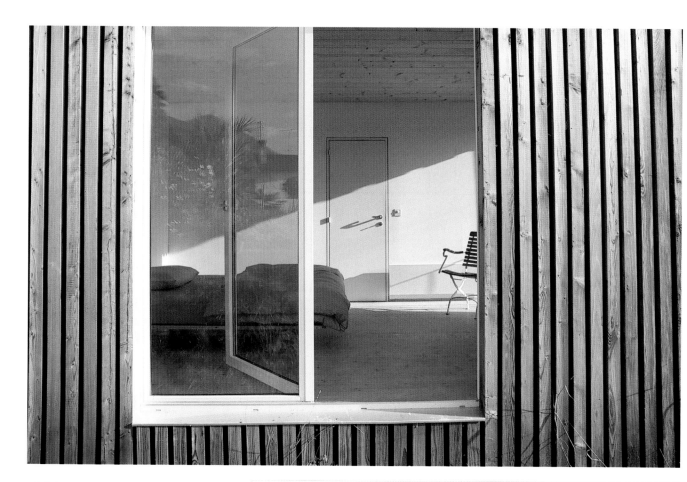

The exterior cladding, composed of narrow wooden boards, emphasizes the verticality of the house, while a balcony facing the west acts as a horizontal counterpoint.

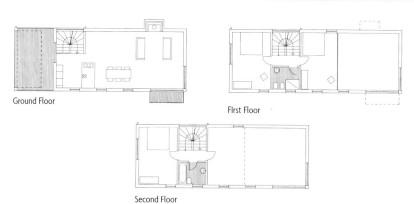

Ground Floor

First Floor

Second Floor

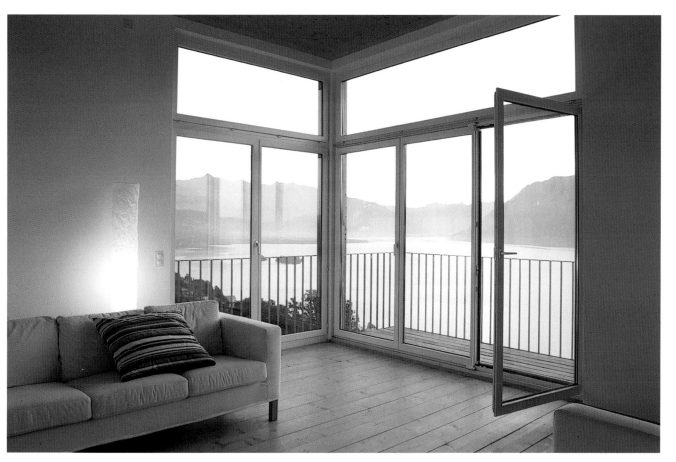

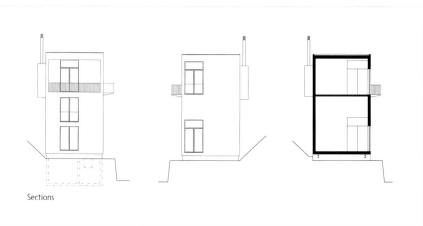

Sections

The interior walls are fabricated
from insulated panels that
are lighter and more flexible.
The structural walls are made
of concrete.

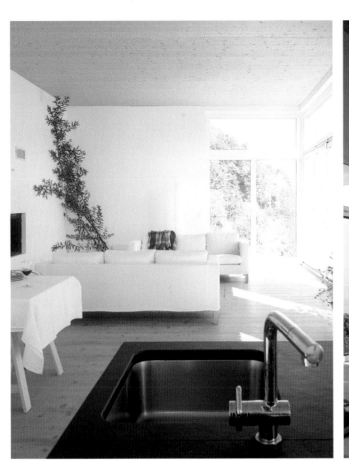

Elevation

The location on the highest part of a hill represented a construction challenge, given that there was no existing entrance from the highway. In response, the architects opted for a prefabricated wooden structure that was assembled in three days with the aid of a helicopter.

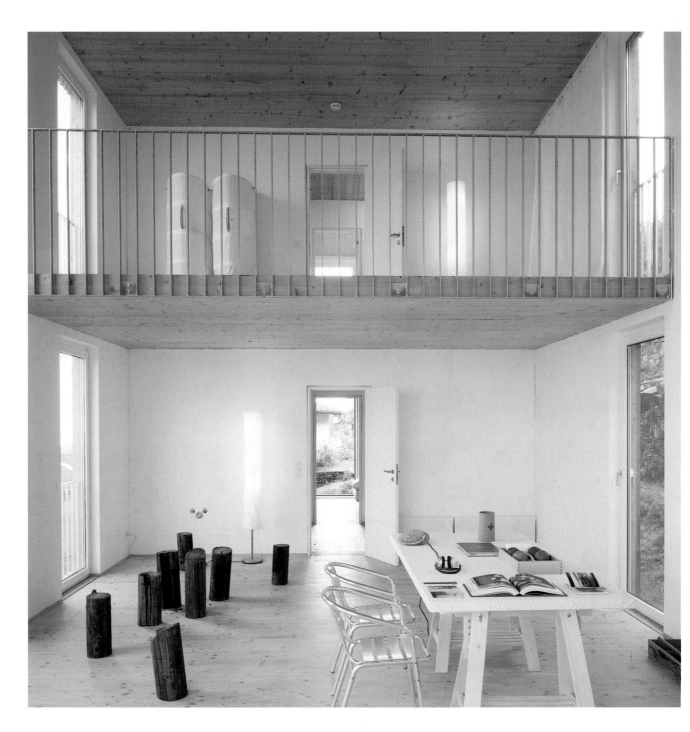

Natural elements like stone and wood make this house feel warm, comfortable, and at one with nature.

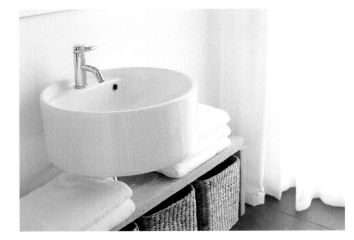

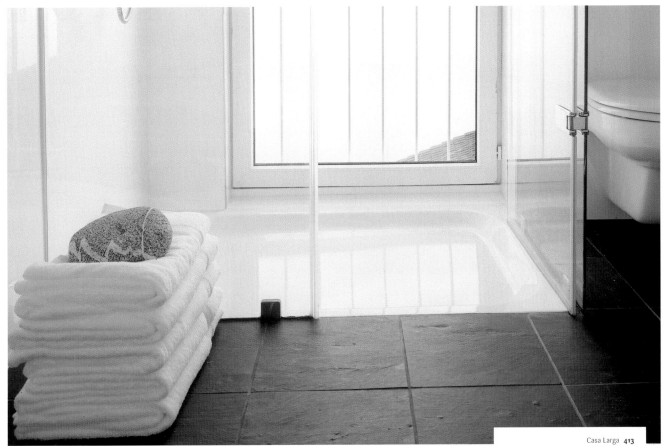

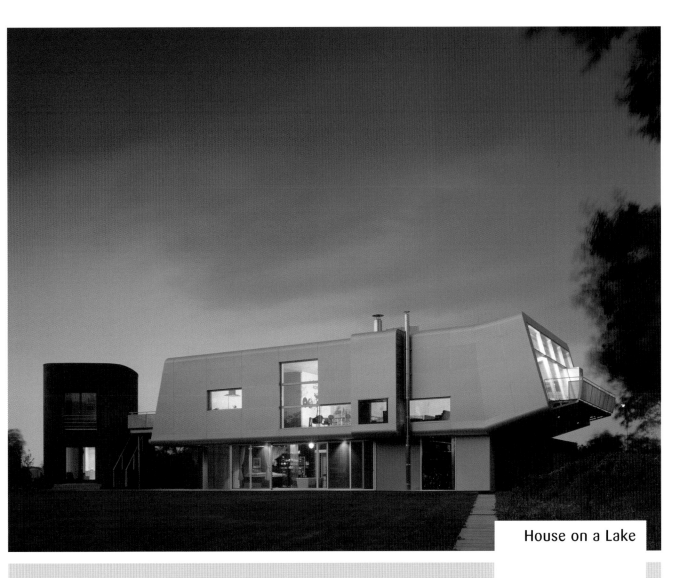

House on a Lake

A futuristic, tube-like residence wrapped in metal sheets overlooks a nearby lake in a small Austrian village. The top structure culminates in an upward gesture that articulates a glass façade and terrace deck, creating a dynamic interaction with the landscape.

Architect: Eichinger oder Knechtl
Location: Münchendorf, Austria
Date of construction: 2003
Photography: Eduard Hueber/
Archphoto

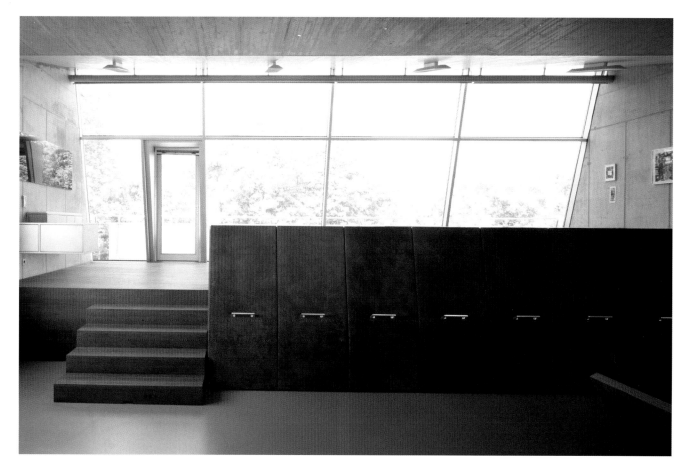

The concrete structure encloses
a dramatic interior space intensified
by glass façades at either end
of the house.

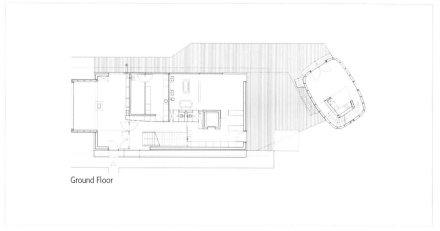

Ground Floor

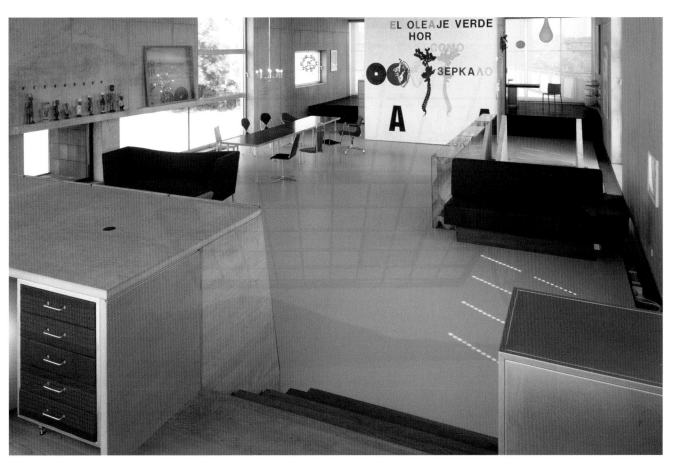

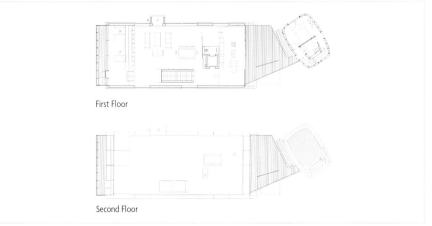

First Floor

Second Floor

An artistic mural can serve as an attractive surface for a partition or storage unit, such as this one, which accommodates a small bathroom.

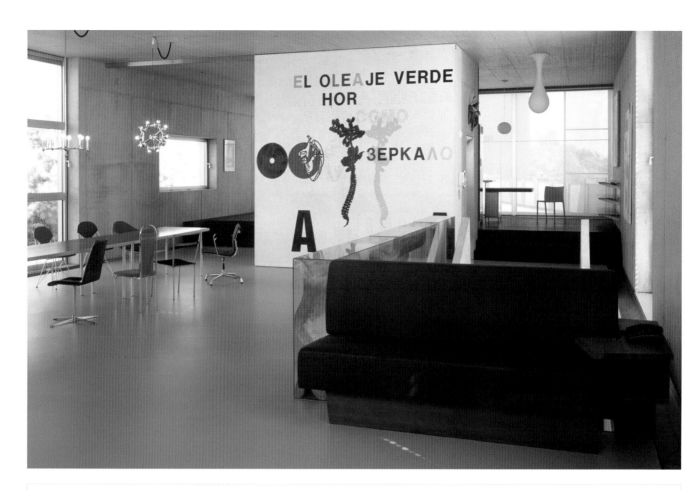

Sections

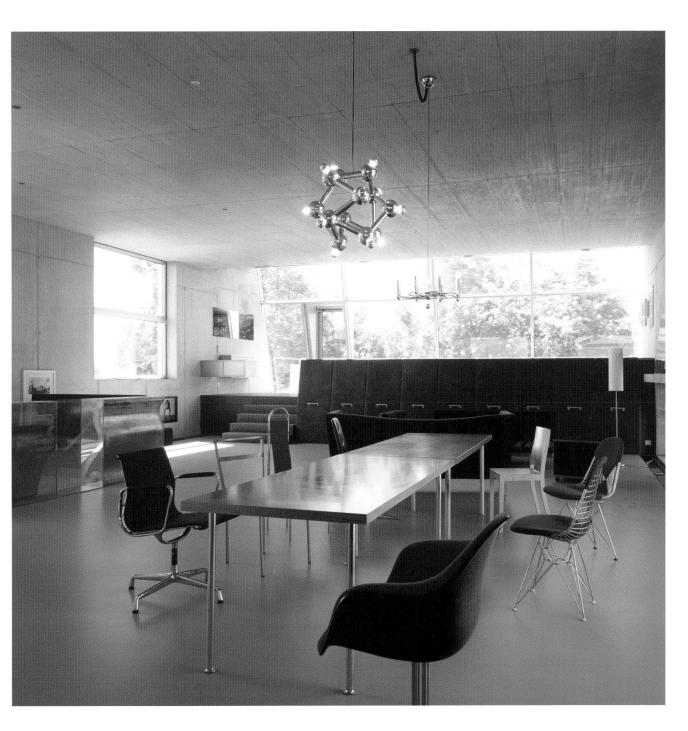

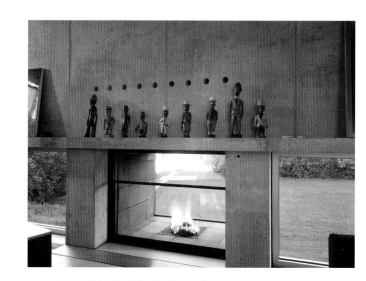

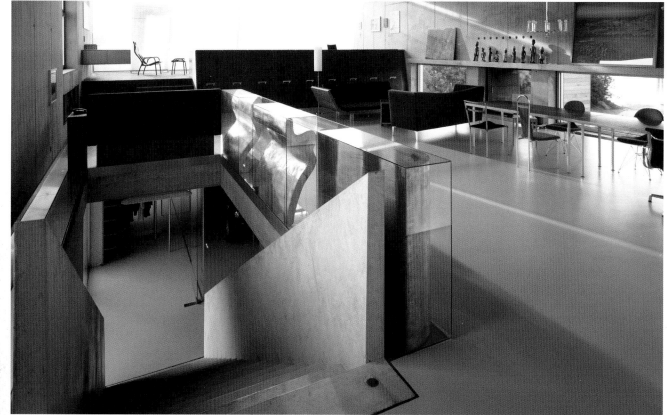

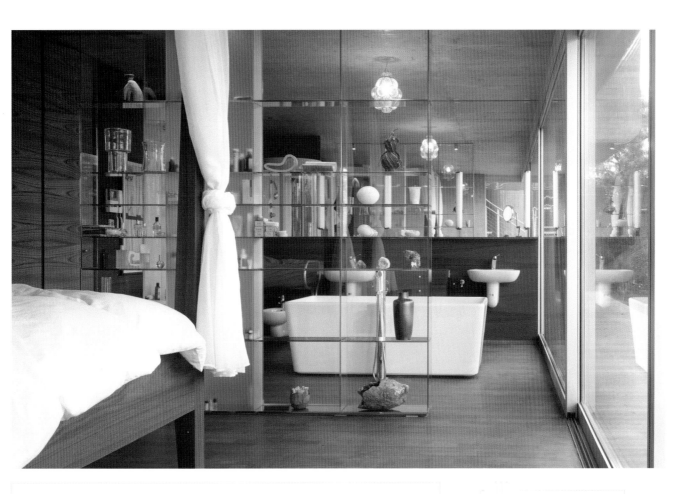

Elevation

A glass partition between
the bathroom and
bedroom provides shelves
for storage as well as
a visual distinction between
the two areas.

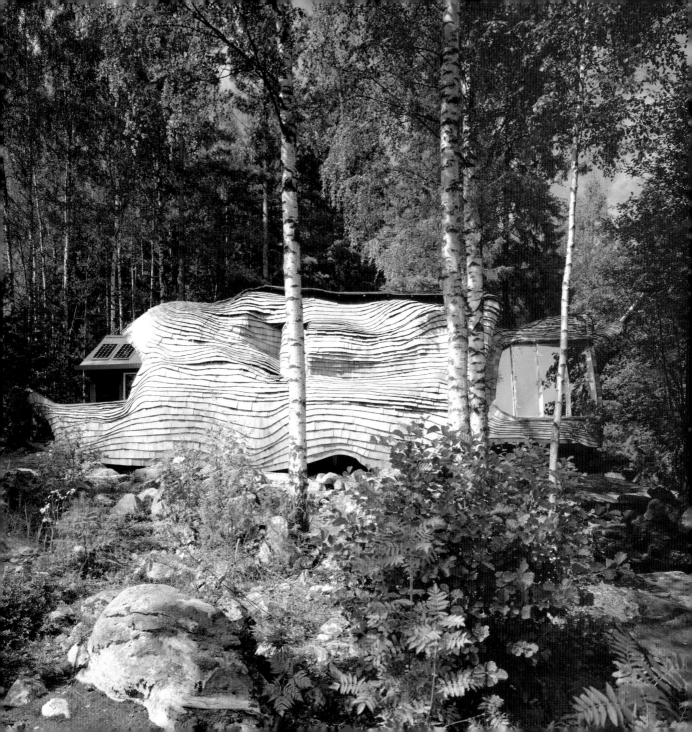

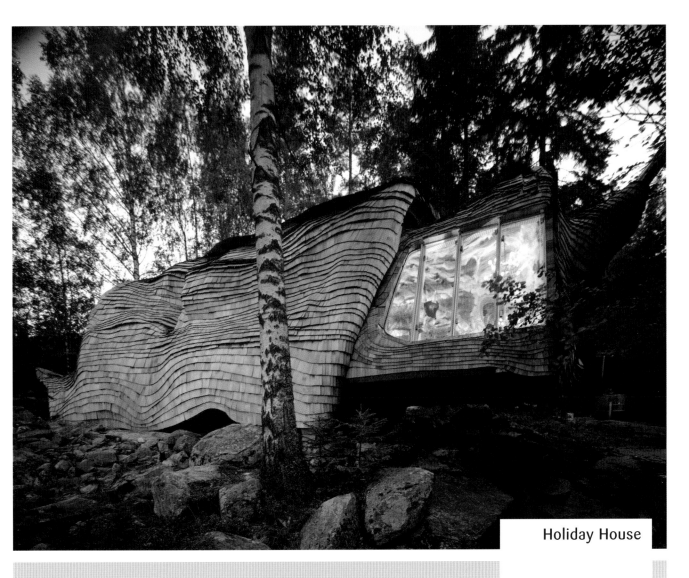

Holiday House

Built as an extension to a cabin dating back to the 1800s, this house located on the shore of the lake Övre Gla in the Glasgoken nature preserve of Sweden, reflects the natural surroundings through a unique implementation of wood as the main structural element.

Architect: 24 H Architecture
Location: Övre Gla, Sweden
Date of construction: 2004
Photography: Christian Richters

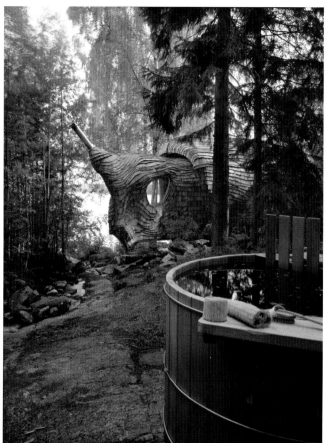

The new house readily adapts to weather conditions, season, or the number of occupants through an extendable structure that offers a compact double skin during the winter, a sheltered terrace during the summer, and an expandable interior space to accommodate guests.

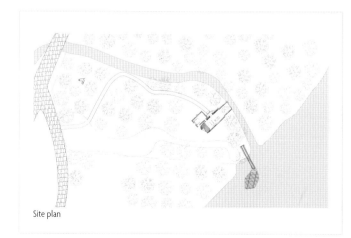

Site plan

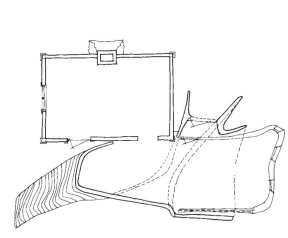

Floor Plan

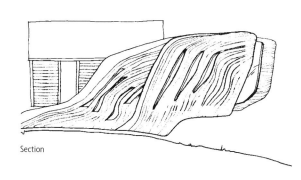

Section

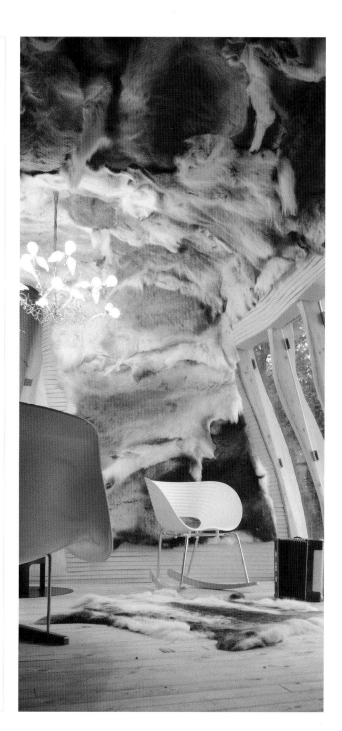

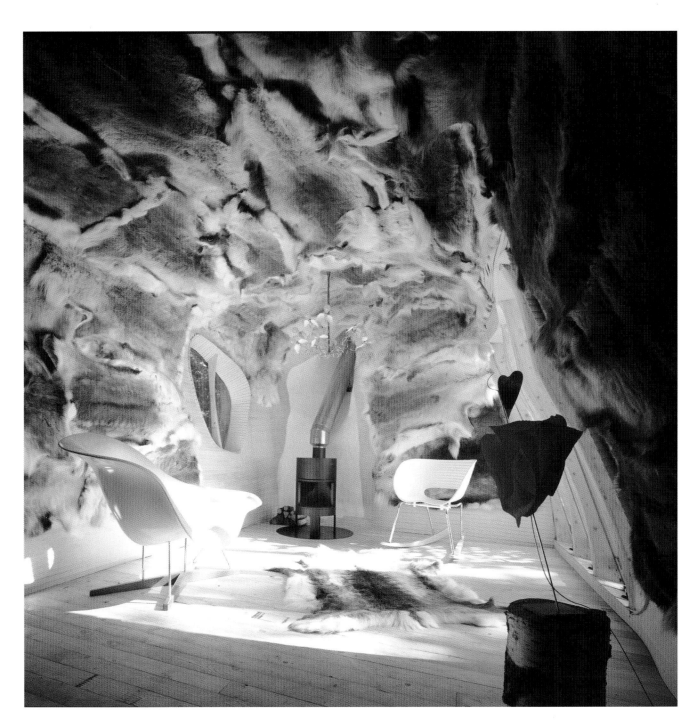

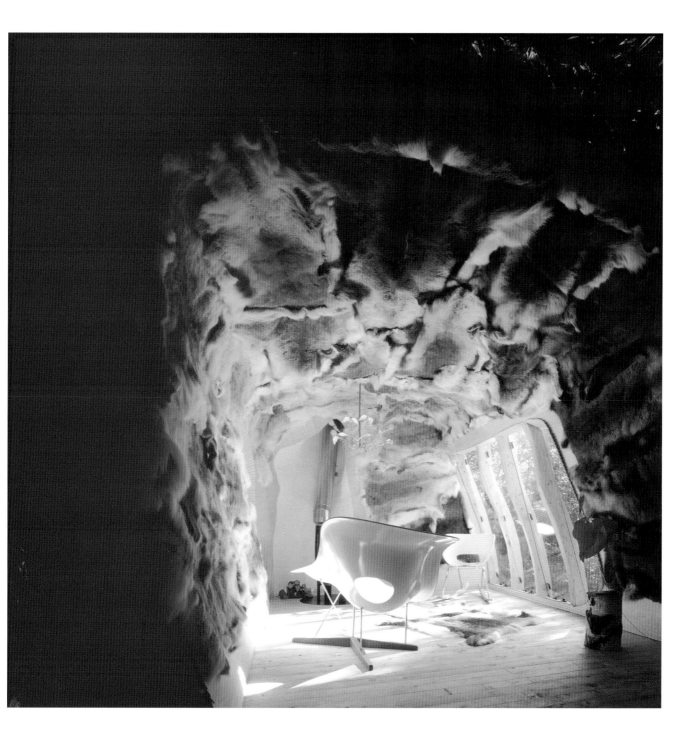

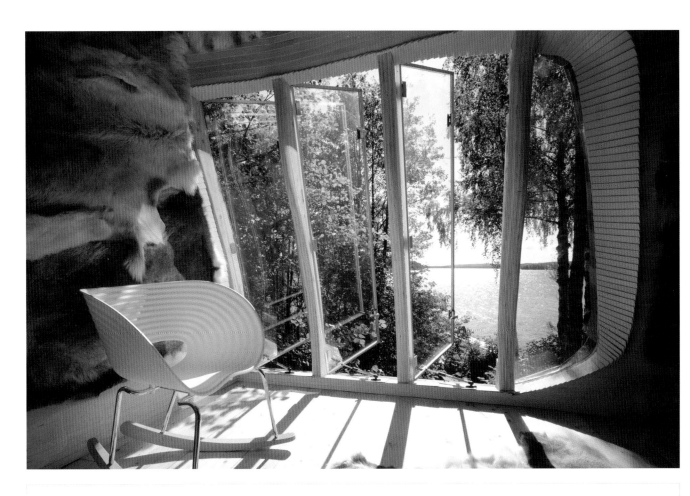

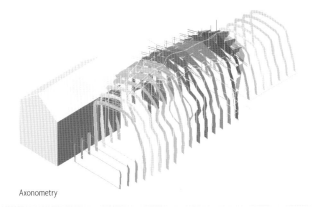

Axonometry

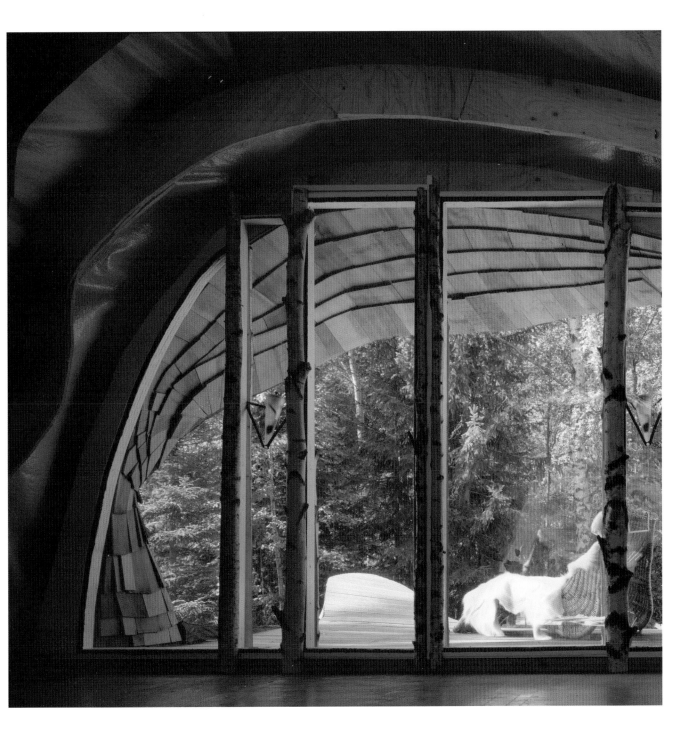

Countryside

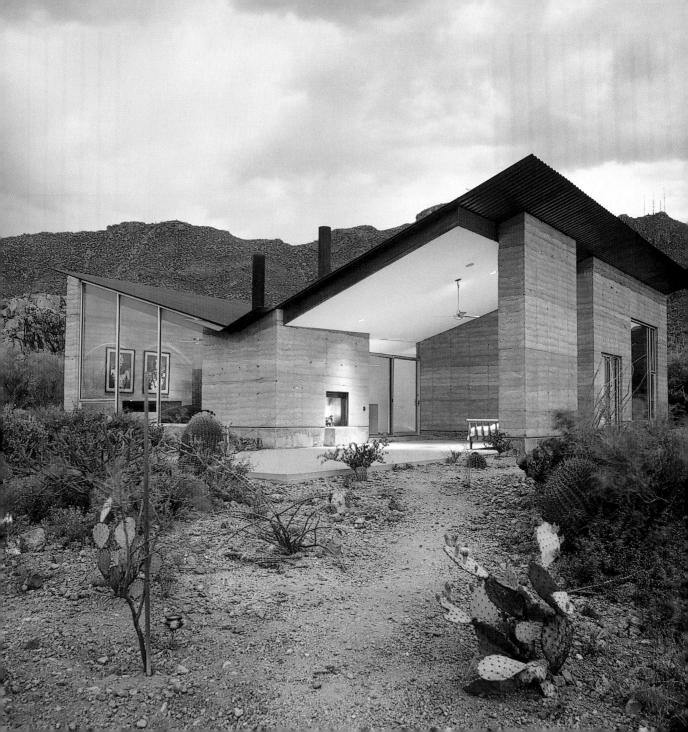

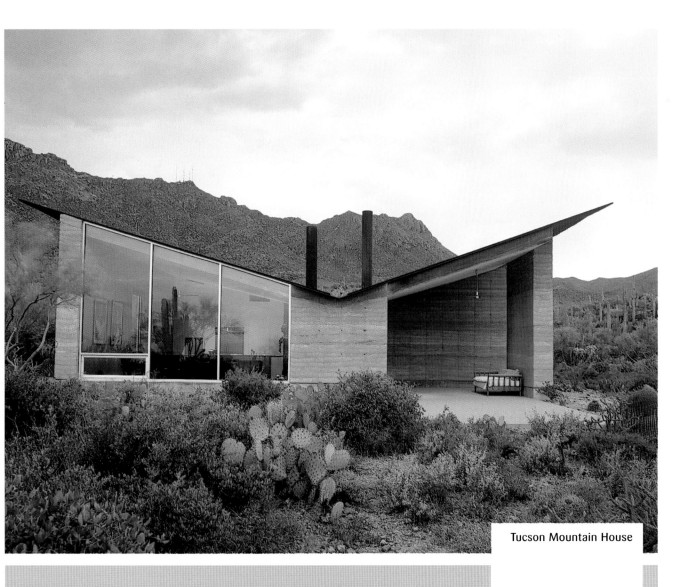

Tucson Mountain House

Set amid a vast desert landscape dotted with sprouting cactus and flourishing shrubs, this house in Tucson, Arizona, camouflages itself through a careful choice of materials and forms that achieve a fully integrated structure designed to respect and embrace the powerful scenery.

Architect: Rick Joy
Location: Tucson, Arizona, USA
Date of construction: 2001
Photography: Undine Pröhl

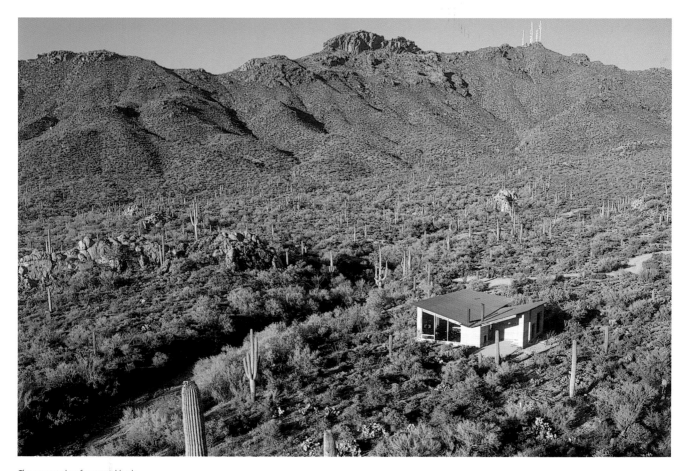

The corrugated roof structure blends
with the surrounding earth tones
in an attempt to establish harmony
between architecture and landscape.

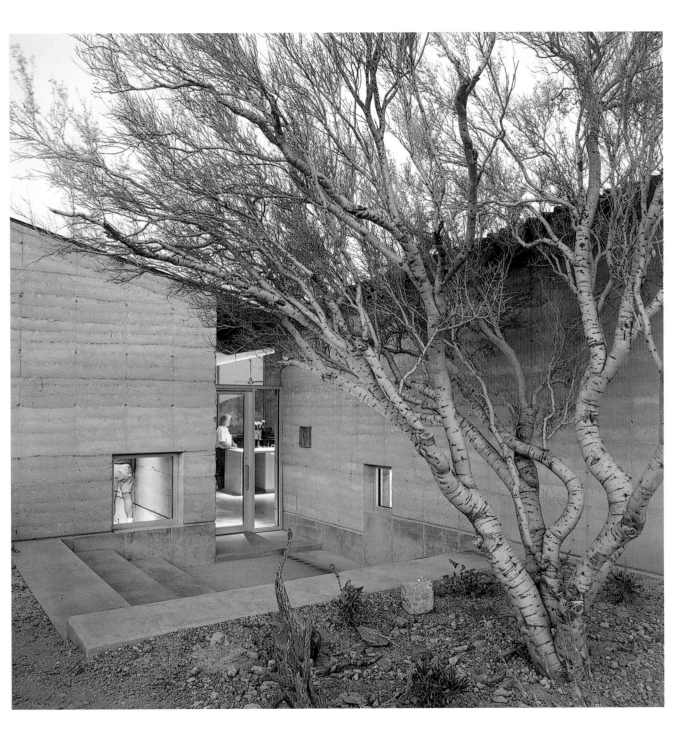

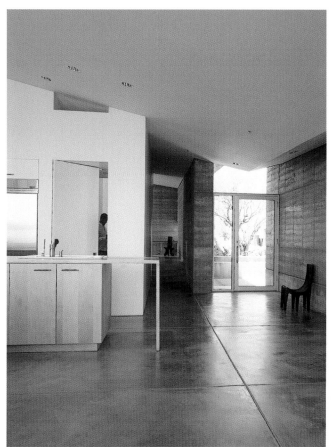
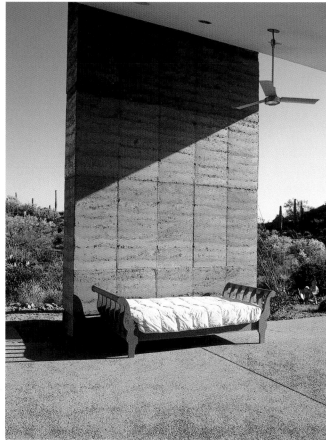

113

The house was constructed
by employing
a rammed-earth technique,
which uses a dirt and
cement mixture that lends
the walls an especially
high degree of insulation,
oundproofing, and
protection against fire.

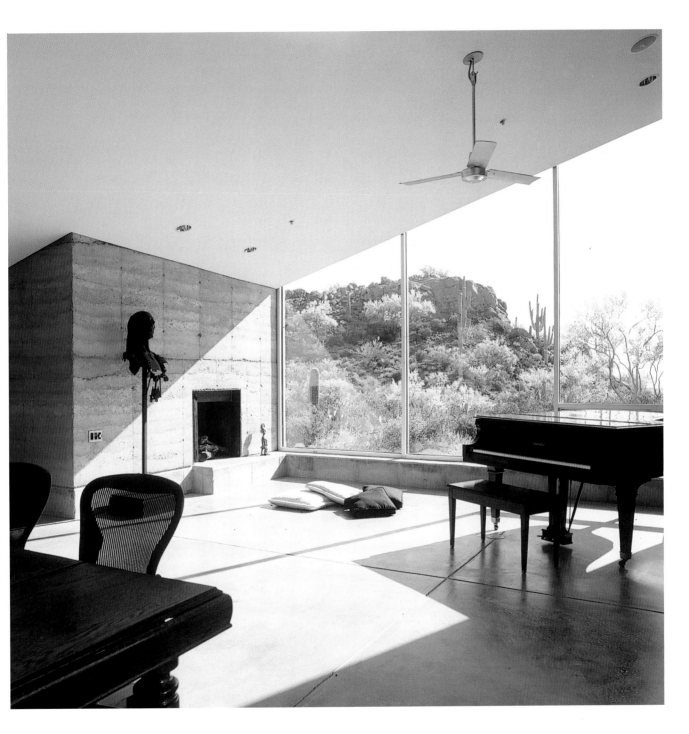

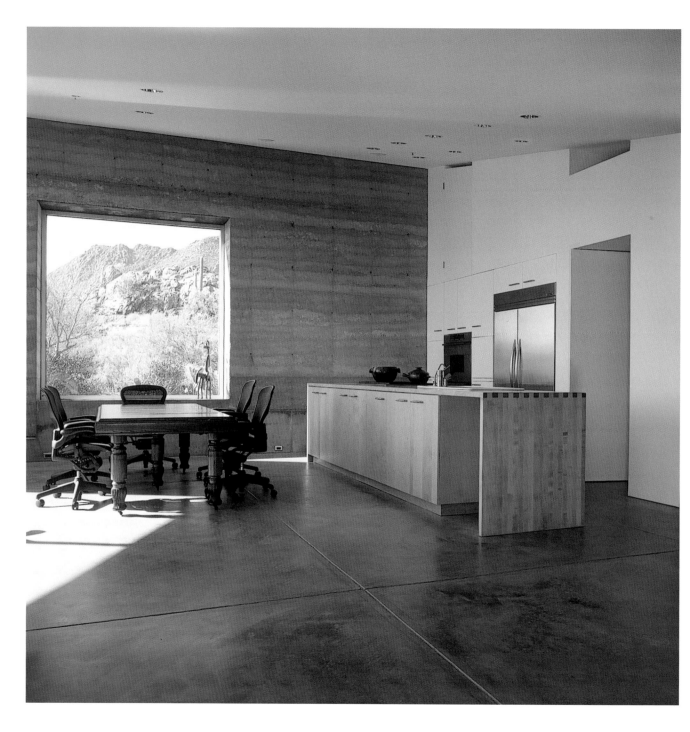

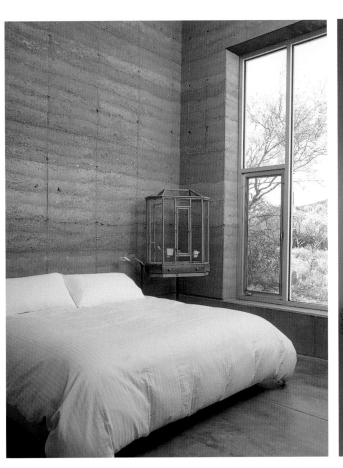
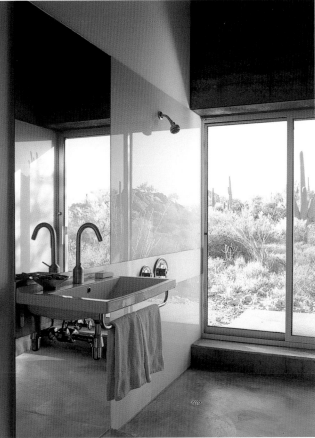

174

High ceilings disperse the
summer heat, while
the materials used serve
to retain warmth during
cold nights.

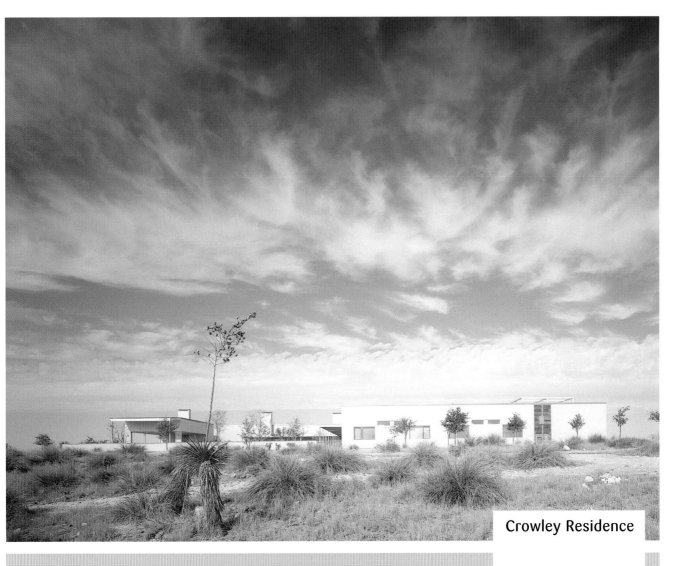

Crowley Residence

A strikingly arid landscape of rolling grass dunes and chiseled mountain ranges surrounds this 8,000-square-foot house in southwest Texas. The sheer exposure and vulnerability of the house to light and heat inspired a design based on the creation of boundaries and limits that allow sweeping vistas over the desert.

Architect: Carlos Jimenez Studio
Location: Marfa, Texas, USA
Date of construction: 2004
Photography: Paul Hester, Hester & Hardaway Photographers

Site Plan

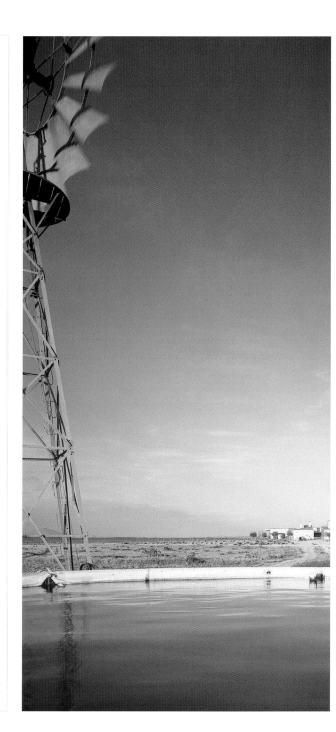

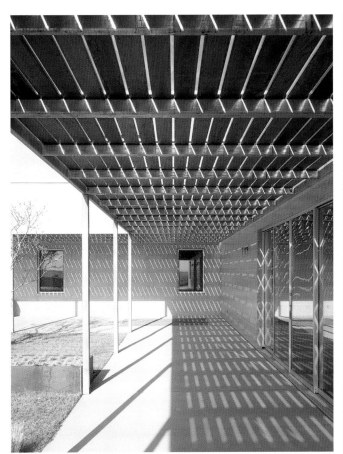
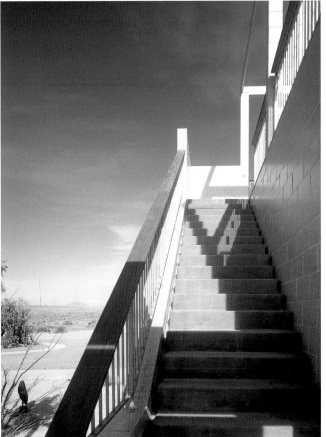

115

The primary building materials, selected to withstand the region's intense and strong winds, include textured concrete block, stucco, galvanized steel, Ipê wood and pecan flooring.

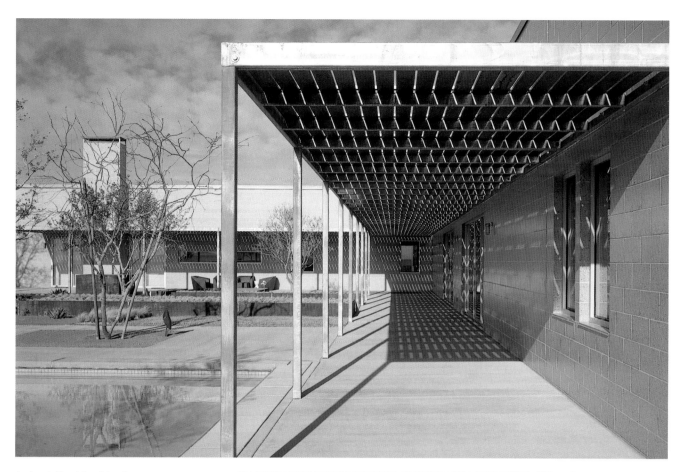

An elongated layout threads together the interior and exterior spaces as well as the courtyards and gardens to create protected and shaded zones.

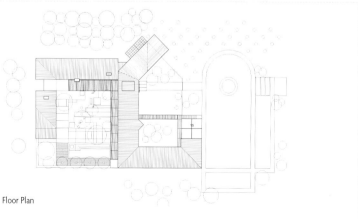

Floor Plan

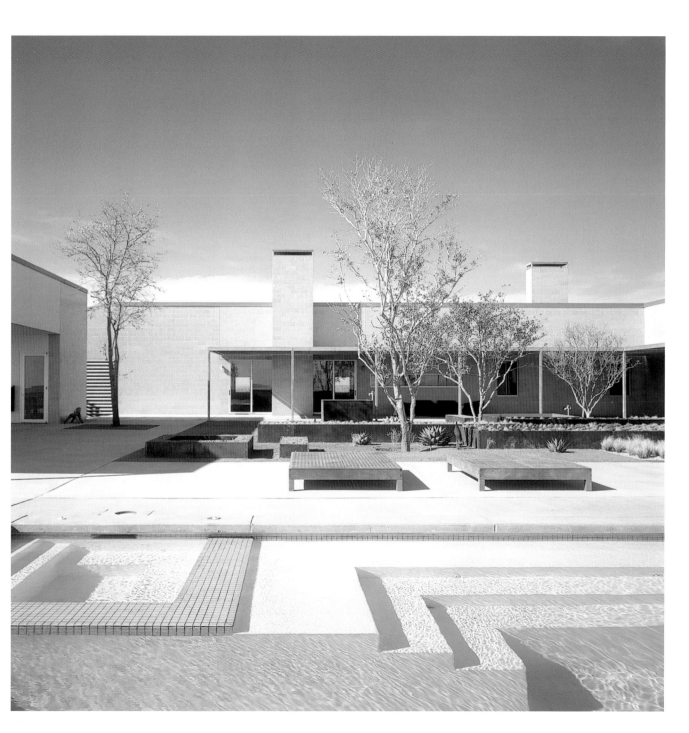

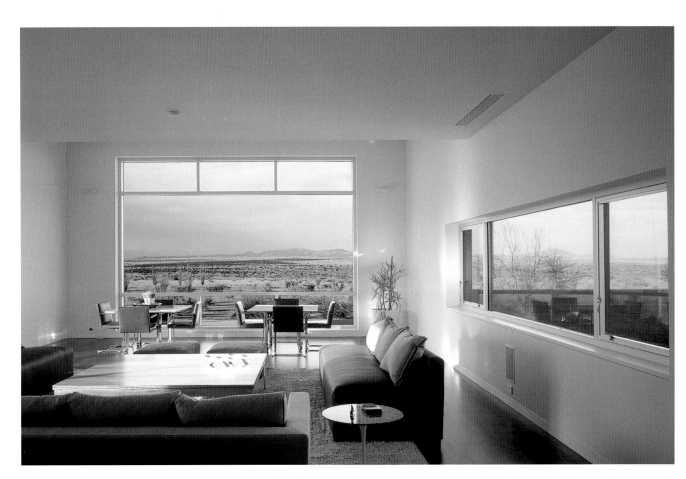

Large-scale windows that frame the landscape can be a dramatic way of decorating a room without the use of objects.

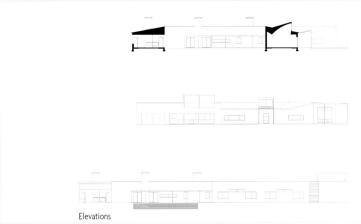

Elevations

Because this home is
situated in such an
expansive site, the creation
of an interior garden or
courtyard can result in
a much more intimate
space than one open to
the landscape.

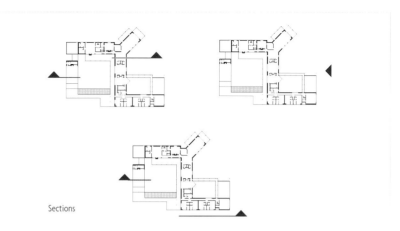

Sections

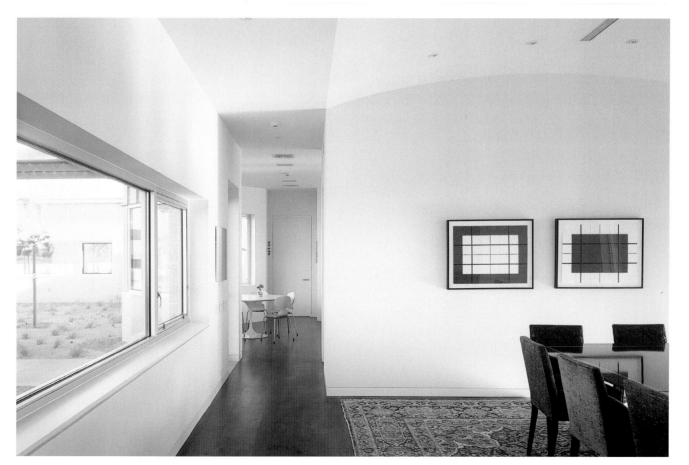

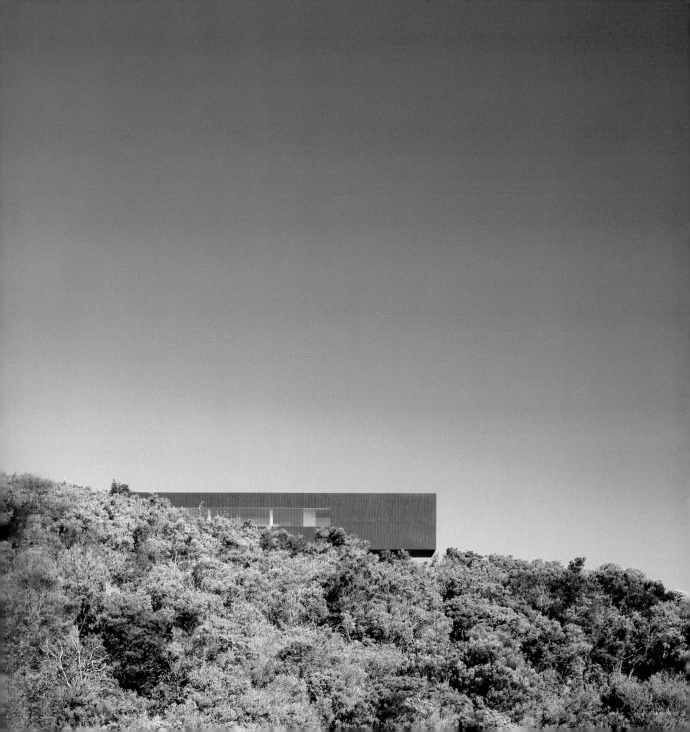

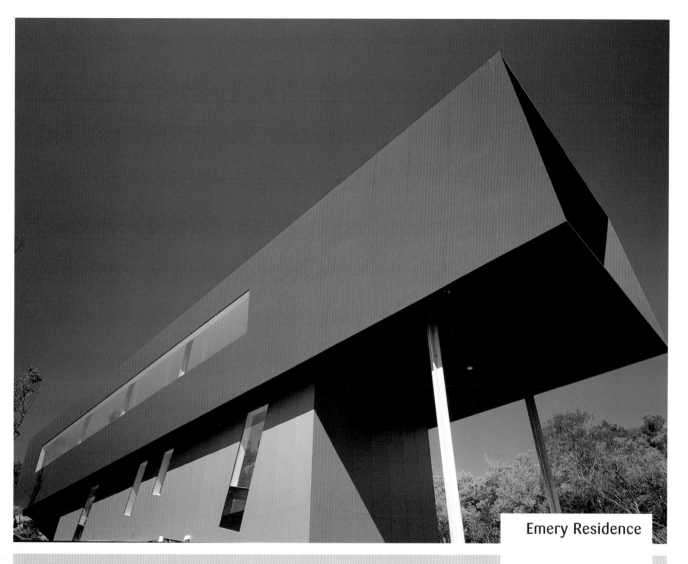

Emery Residence

This project located atop a very steep hill just a few miles south of Melbourne stands out for its bold design composed of linear structures projected toward the sea. The upper structure rises above the medium-size trees that cover the site and cantilevers over the lower structure to create a floating effect from within the house.

Architect: Denton Corker
Marshall
Location: Cape Schanck,
Victoria, Australia
Date of construction: 2000
Photography: Tim Griffith

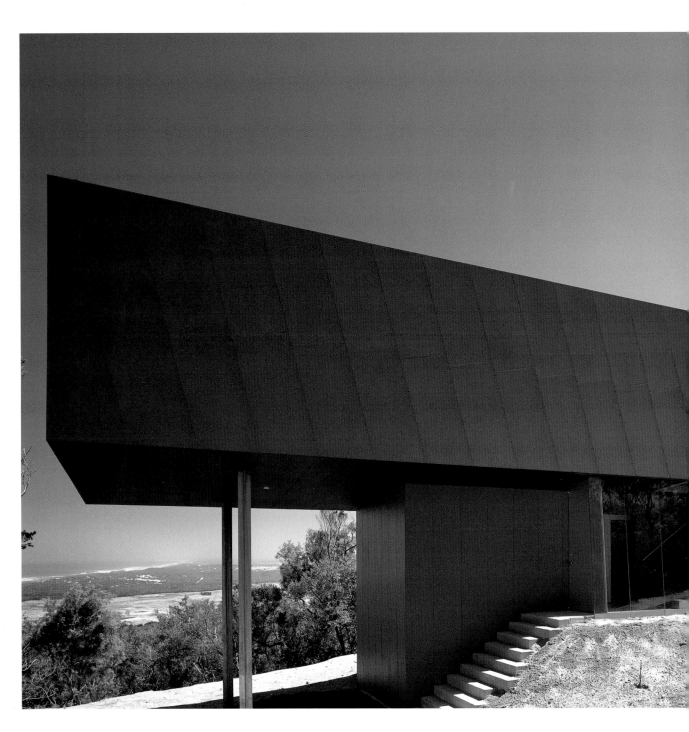

The simplicity of the project is
enriched with subtle details,
such as the diagonal chimney and
the division of the main unit into
two sections, creating the illusion
of being twisted in opposite
directions.

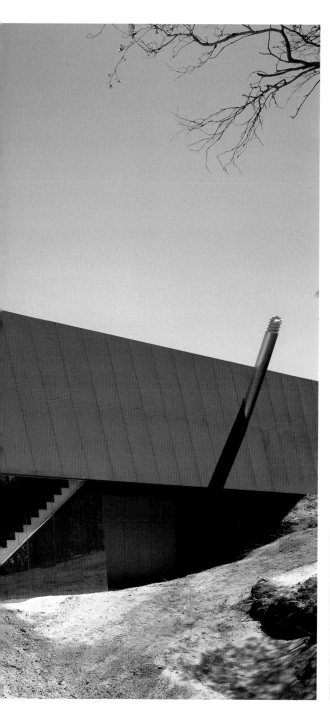

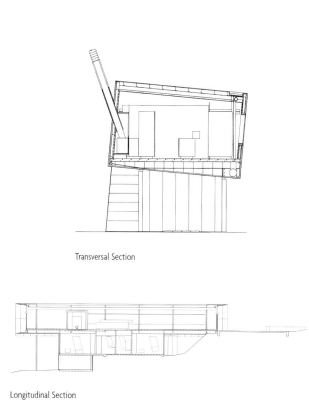

Transversal Section

Longitudinal Section

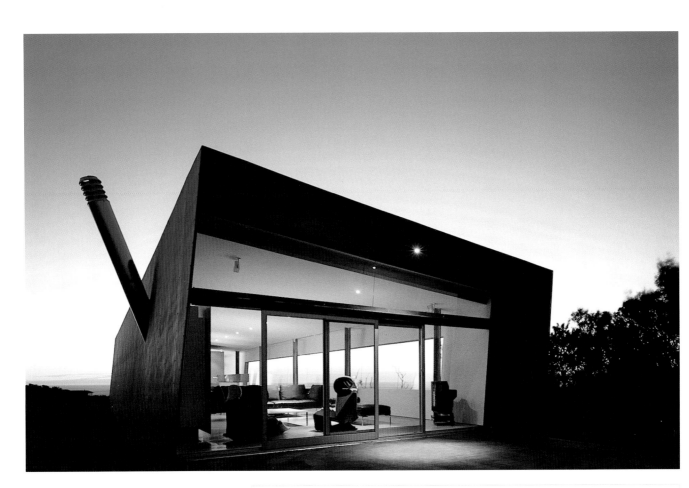

The structure, consisting of a steel frame that supports reinforced concrete slabs, and the proportions of the interior were designed to withstand inclement weather while allowing for a bright, open plan.

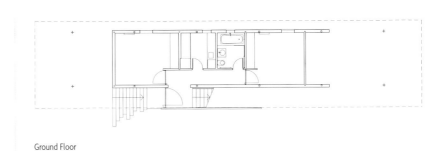

Ground Floor

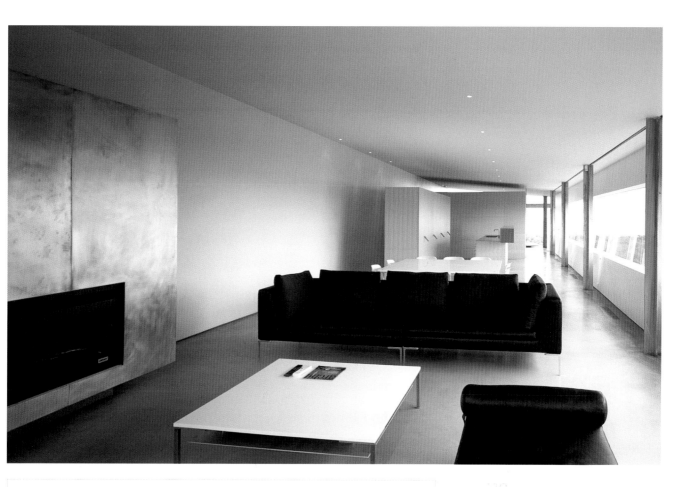

Inside, the walls are finished with white-painted plaster, and boxes covered with wood veneer serve as furniture, dividers, and closets.

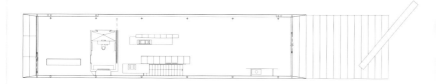

First Floor

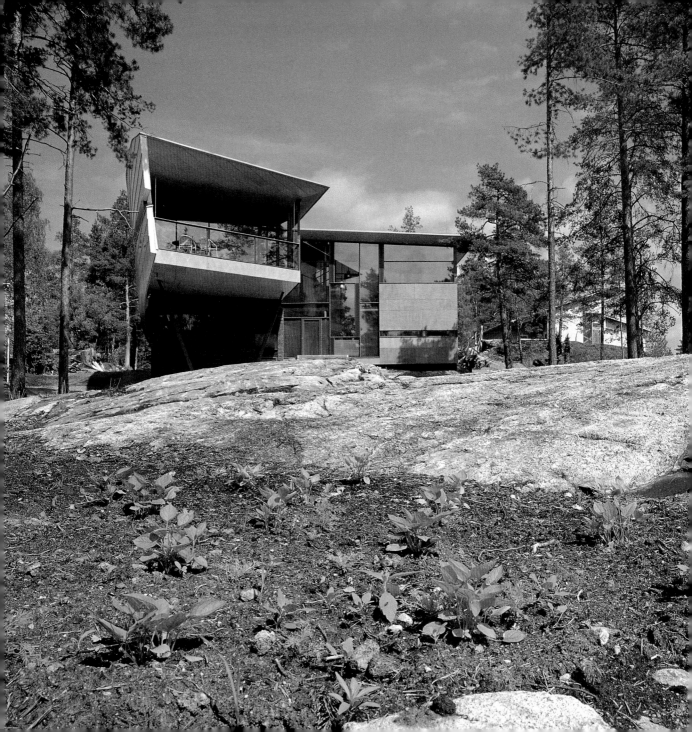

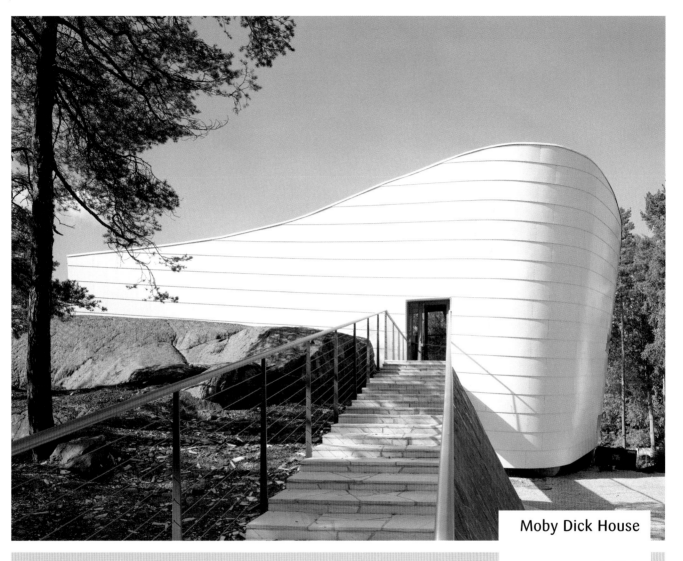

Moby Dick House

This biomorphic house in Finland was designed for a family of four and measures approximately 6,100 square feet. Named after the great white whale known as Moby Dick, the project adopts a curving white structure inspired by the organic form and movement of this colossal creature.

Architect:
Nurmela-Raimoranta-Tasa
Location: Espoo, Finland
Date of construction: 2003
Photography: Jyrki Tasa and
Jussi Tiainen

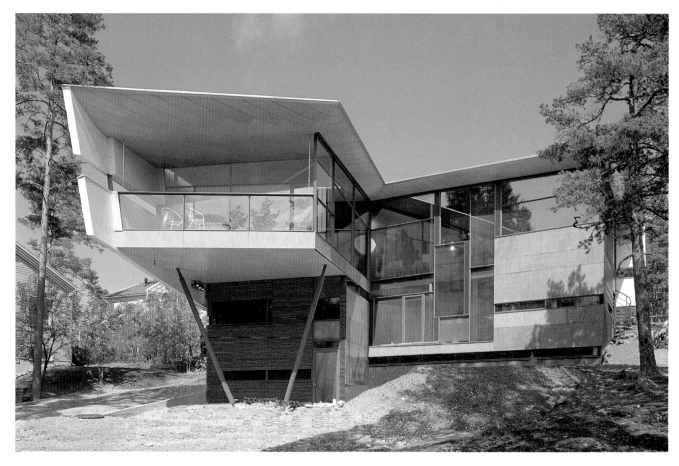

The curved white wall culminates in a large, shaded terrace that looks out toward the wood, evoking the form of a whale's body and open jaws.

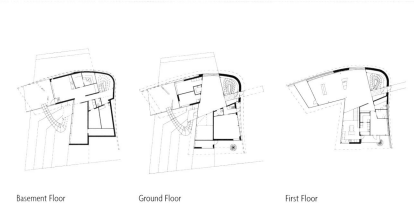

Basement Floor

Ground Floor

First Floor

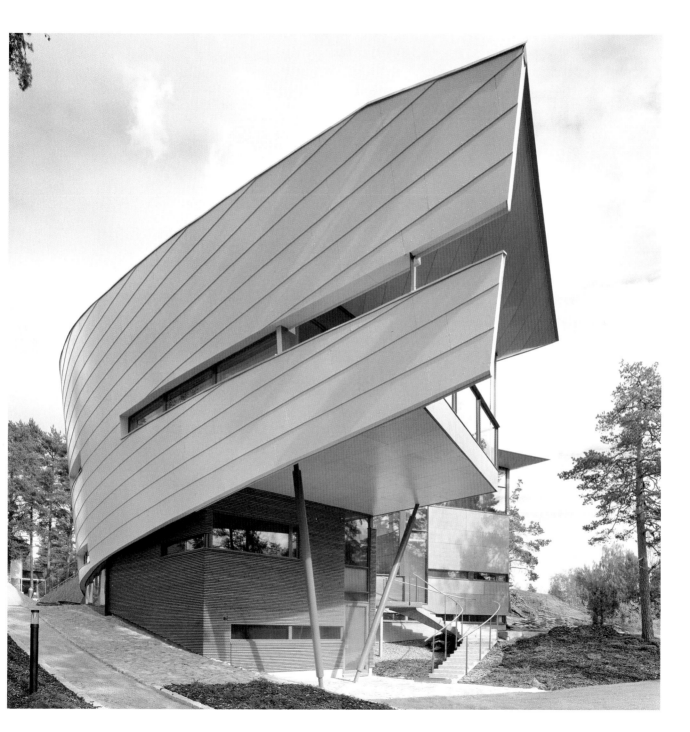

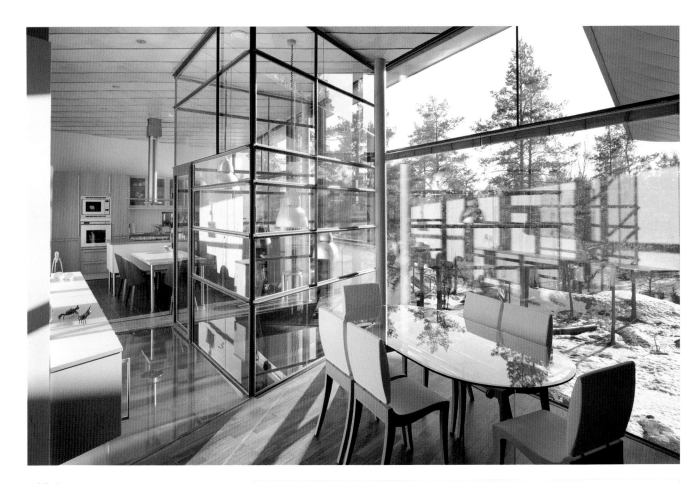

To maintain the fluidity of light, staircases can be contained within glass structures and lit by skylights. The staircase in this living room offers a view of the entire house, either directly or through diverse glass walls.

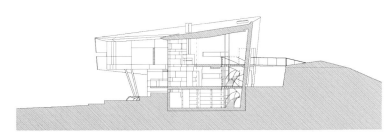

Section

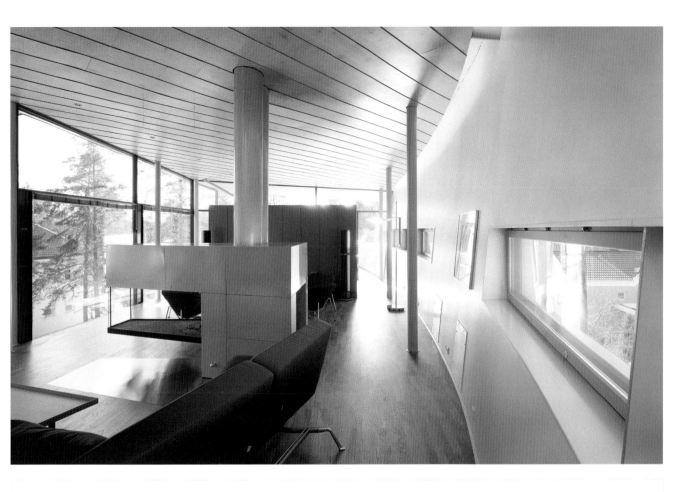

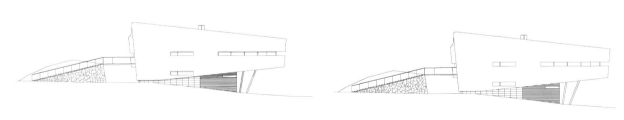

Elevations

An irregular ceiling can give an interior structure an organic feel and create a unique atmosphere. The undulating ceiling on the first floor consists of overlapping birch veneer plates, enabling it to cover the organic form bending in two directions.

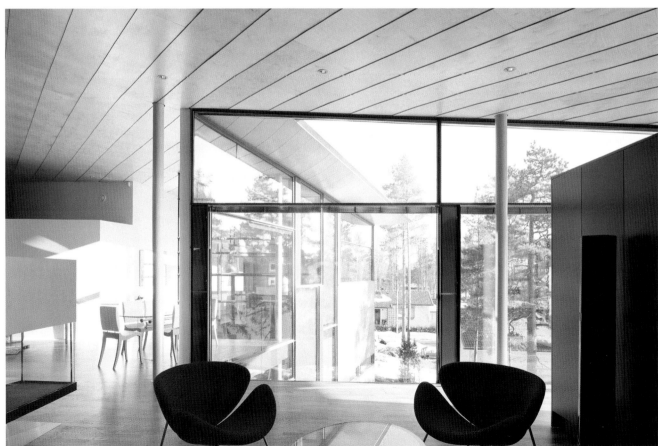

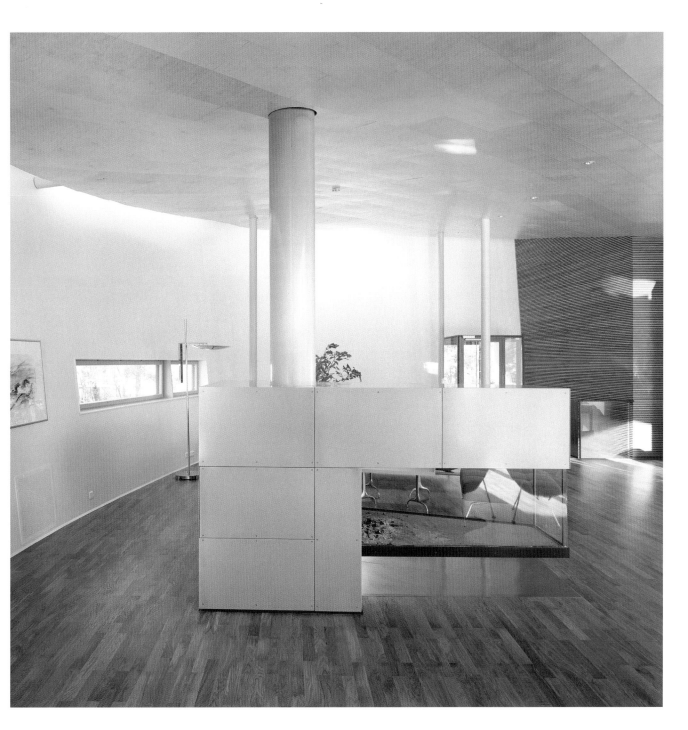

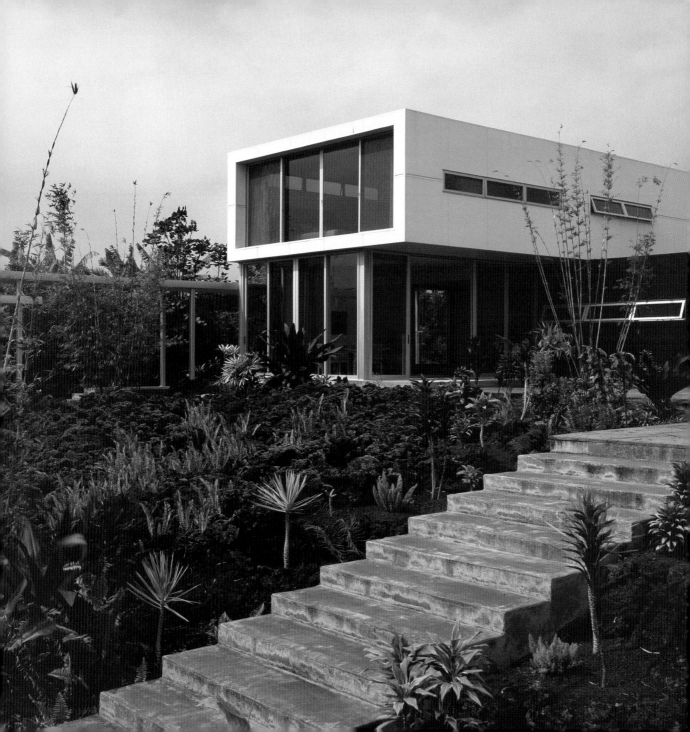

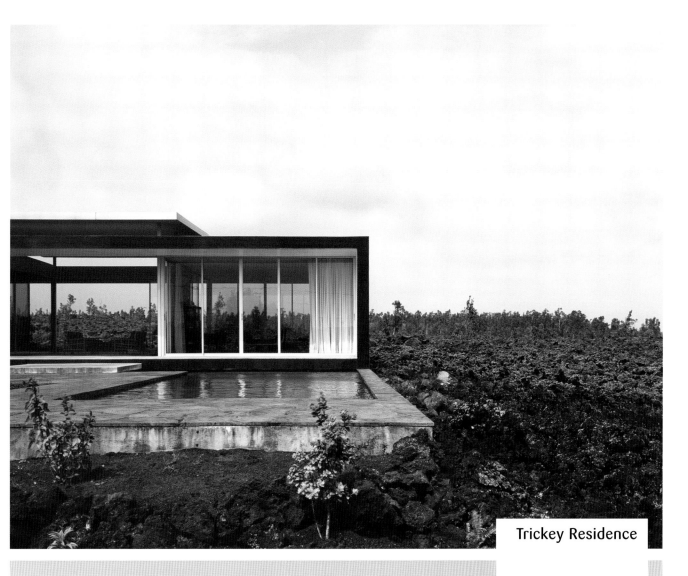

Trickey Residence

Situated in a remote location on the eastern side of Hawaii, this house was built on a lava flow created in 1955, which is owned by the state and consequently is protected from further development. The two boxes that compose the house express the forms and colors displayed by the surrounding volcanic landscape.

Architect: Craig Steely
Location: Hawaii, HI, United States
Date of construction: 2002
Photography: JD Peterson

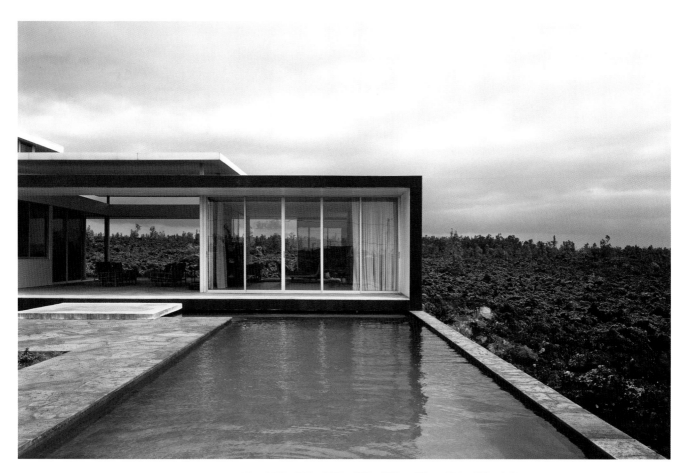

The lower, more transparent box contains
the lanai and living rooms, kitchen,
dining area, and a guest room. While this
box is clad in black glass tile to reflect
the lava, the upper box containing
the master suite is painted light gray to
reflect the clouds.

Ground Floor

First Floor

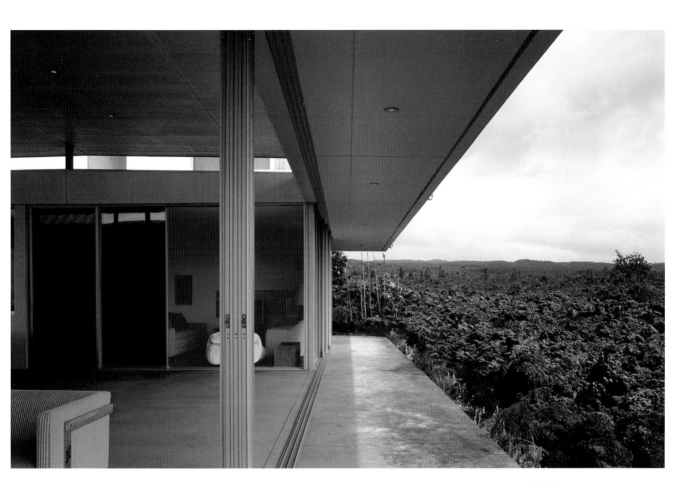

Smooth concrete was used to contrast with the rocky lava landscape in texture, form, and color.

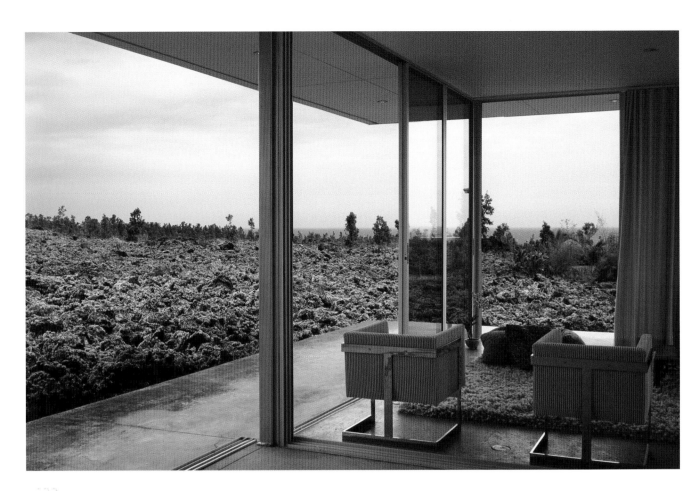

The living area can be
transformed into an
open-air terrace thanks
to full-lenght sliding
glass doors.

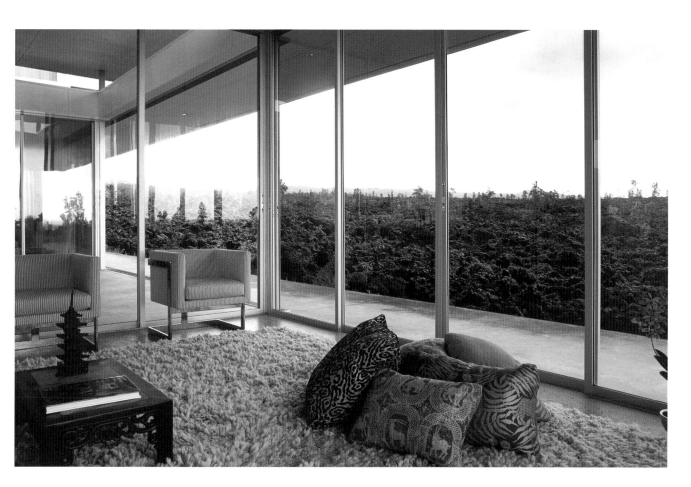

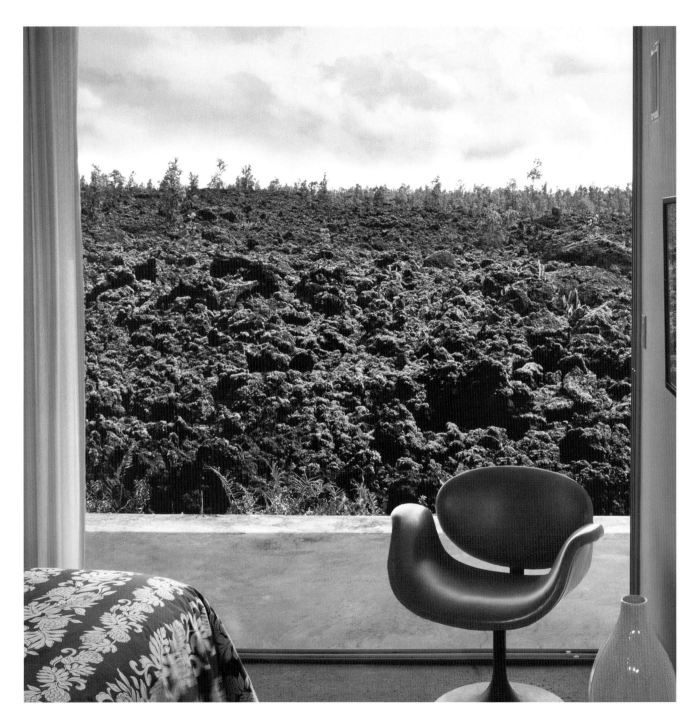

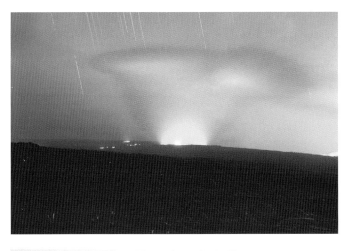

The master suite is contained within a long tube with glass walls at each end, looking out toward the sunrise and lava flow to the east, and toward the sunset and volcanic crater to the west.

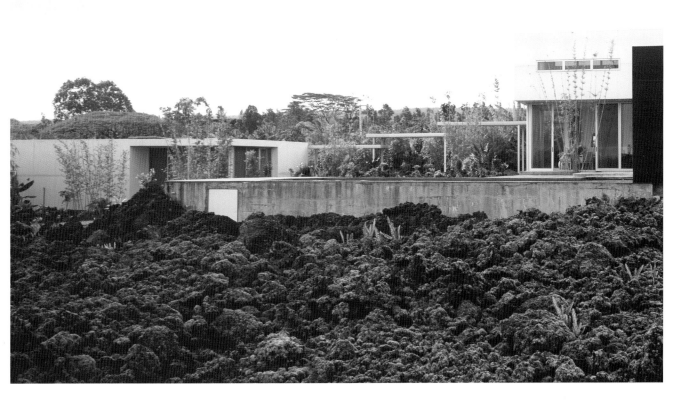

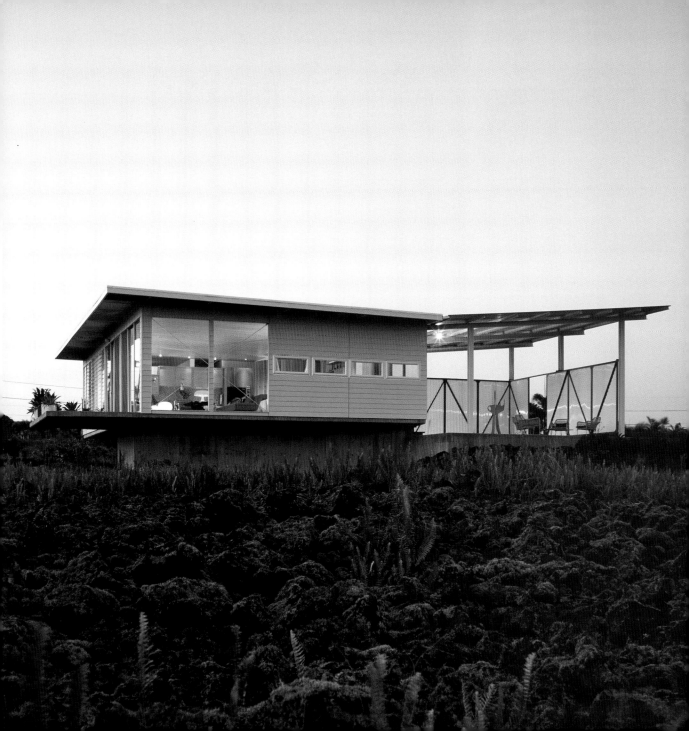

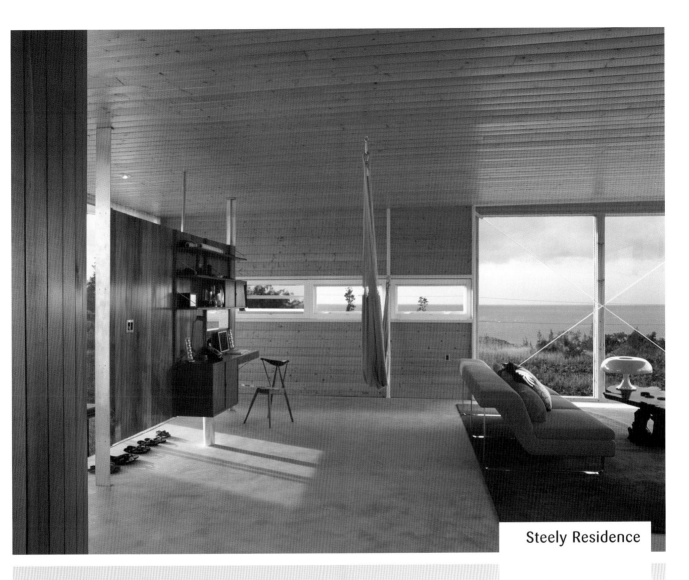

Located 20 miles from the active Kilauea volcano of Hawaii island, from which a plume of steam can be seen during the day where the lava meets the ocean and the glow of the caldera is reflected in the clouds by night, this house sits above the only black sand beach left on this side of the island. It was designed for and by the architect and his painter wife.

Architect: Craig Steely
Location: Hawaii, HI, United States
Date of construction: 2002
Photography: JD Peterson

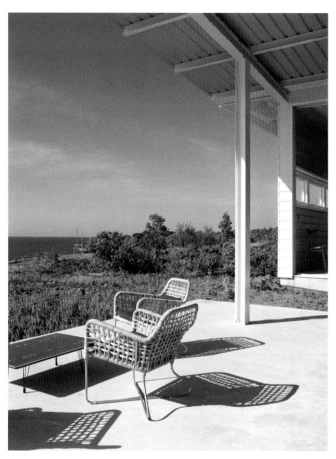

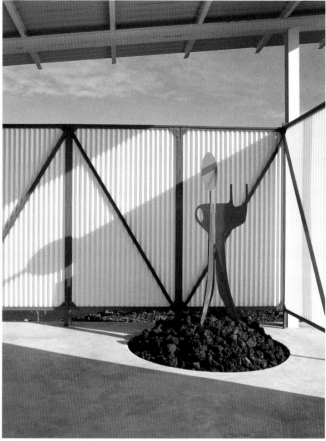

A cantilevered concrete pad and cistern elevate the house six feet above the untouched lava, so as to have the least possible effect on the landscape.

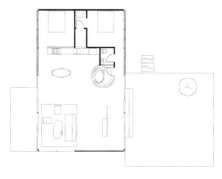

Ground Floor

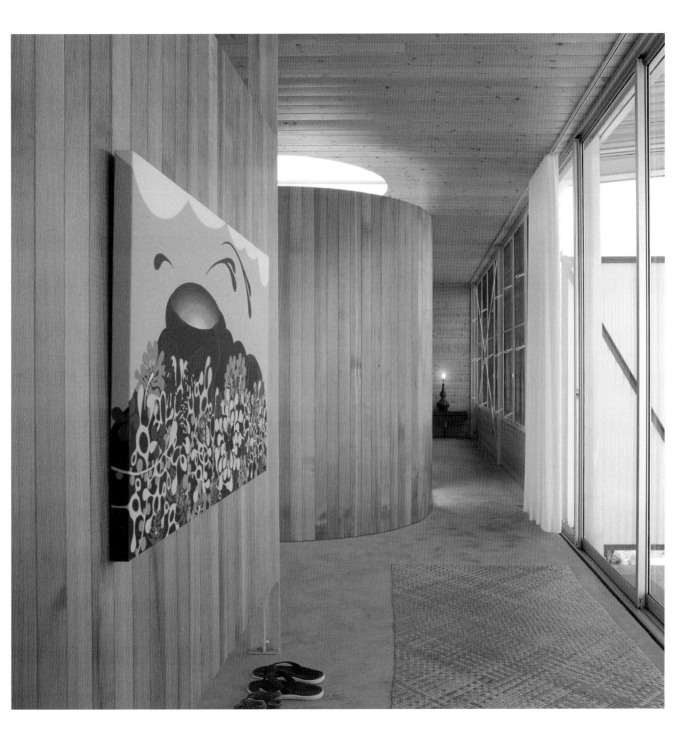

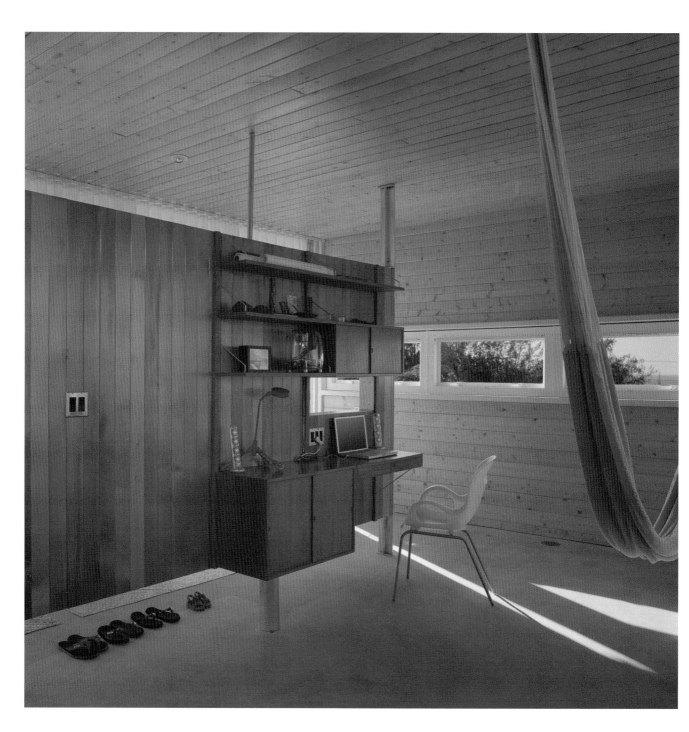

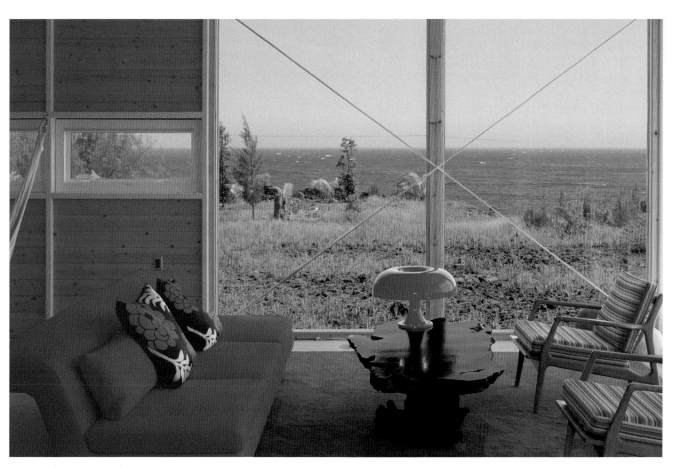

Being situated in such a natural and sensitive environment, a green approach to building was considered a must. All water used inside the house and in the garden is caught on the gull-wing roof and stored in the concrete cistern.

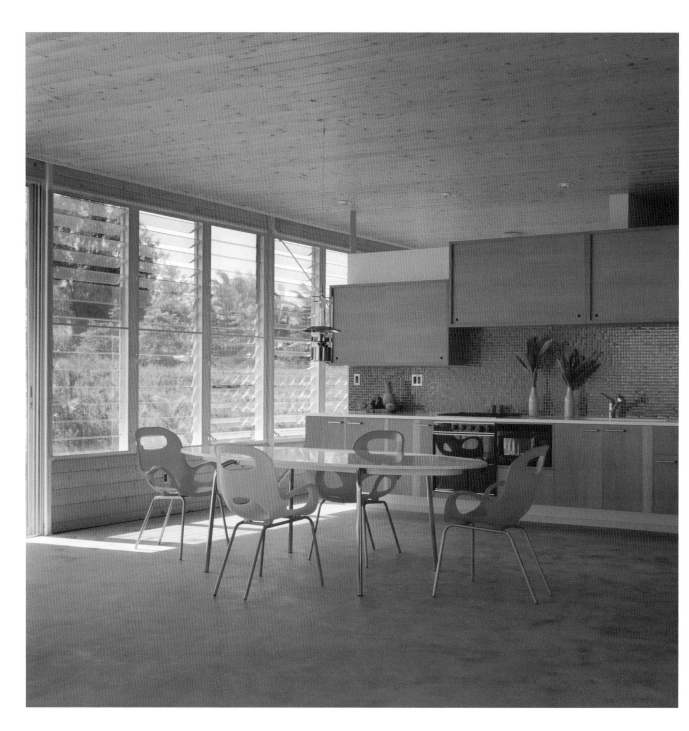

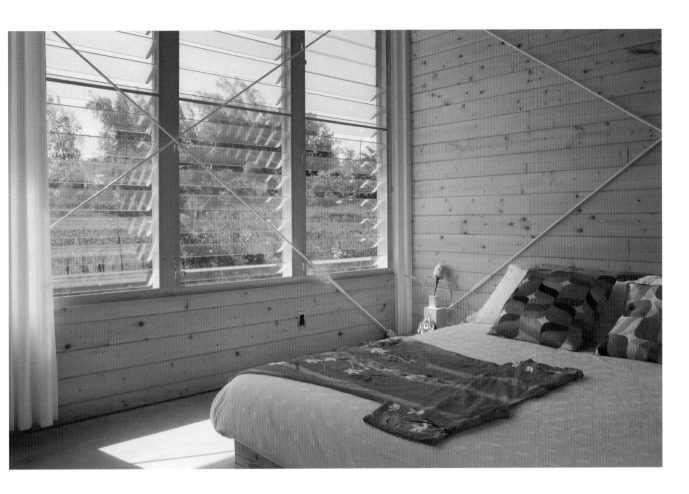

The house adjusts to the climate by means of curtains, screens, and louvers that control light, air circulation, and privacy.

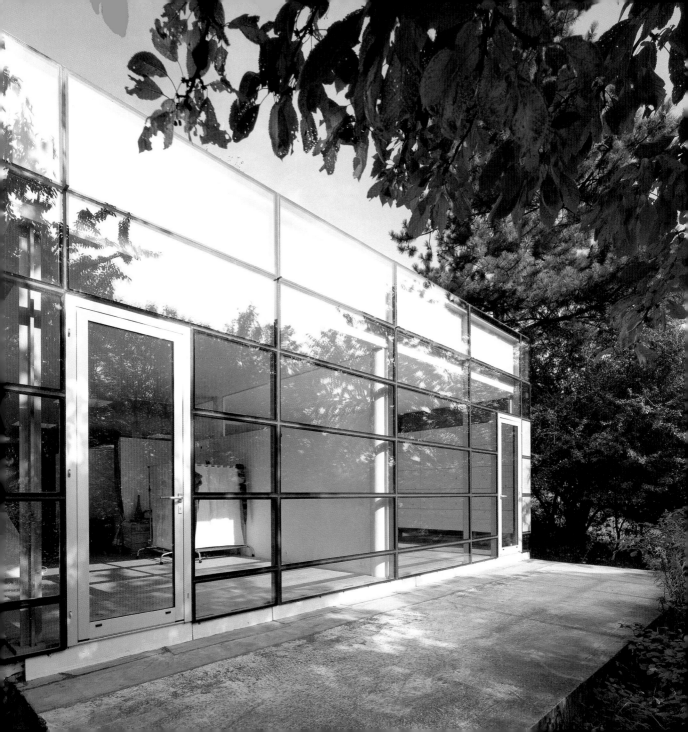

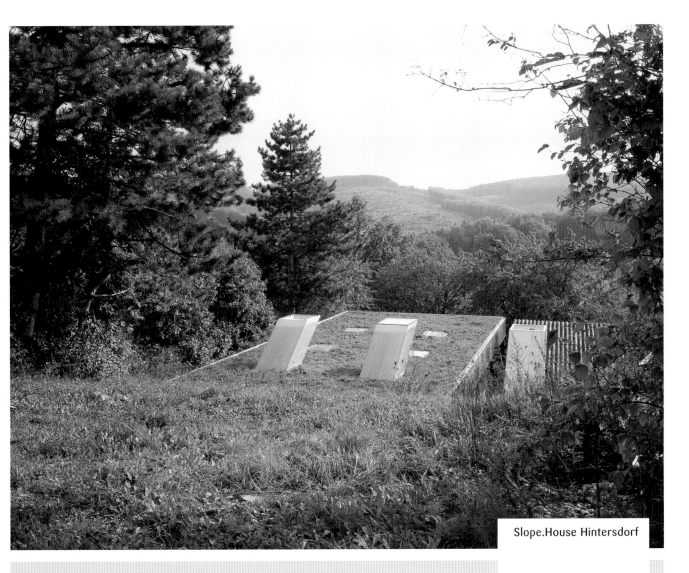

The challenge of this project was to create a home and office in a protected area with minimal visual impact while making the most of the setting's physical features. Using the natural slope of the land, the project was conceived as an underground structure with few exterior surfaces and maximum heat retention.

Architect: lichtblau.wagner
architekten
Location: Hintersdorf, Austria
Date of construction: 2002
Photography: Bruno Klomfar

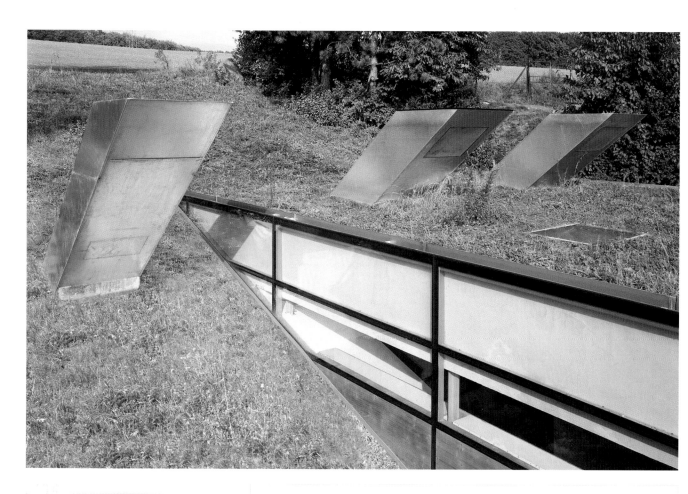

The roof becomes an
extension of the high
part of the land, almost
completely camouflaging
the building and providing
a highly efficient means
of thermal isolation.

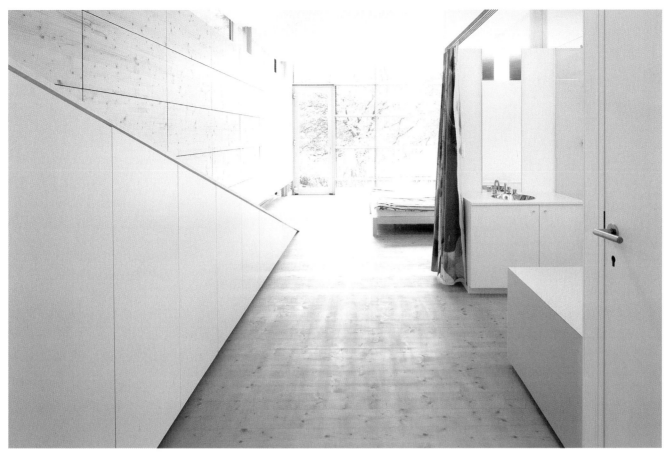

The bedrooms sit below ground and are illuminated by inclined conduits that capture the sunlight from different angles.

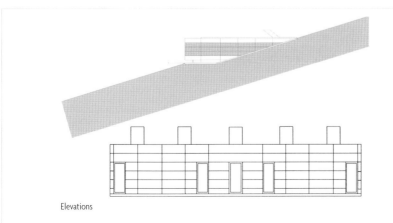

Elevations

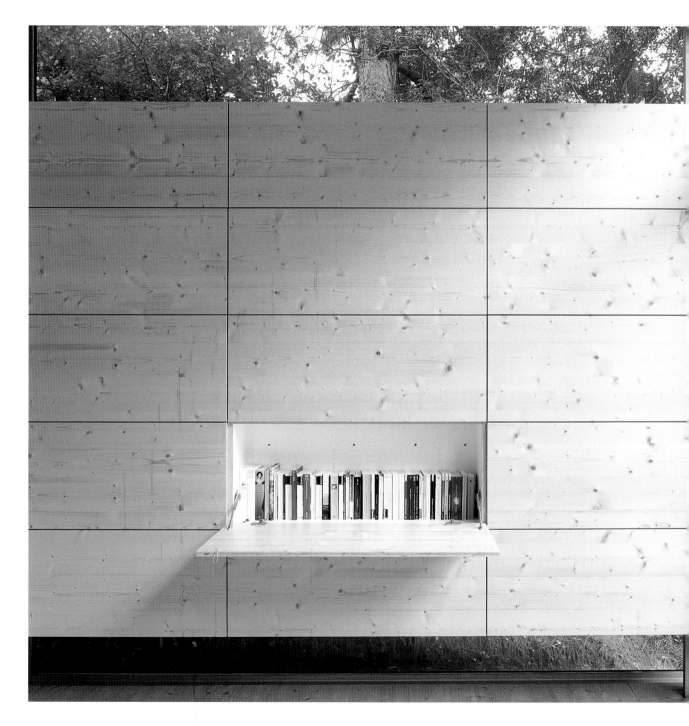

All the interior finishes are wood, and many components made of prefabricated pieces were assembled by the owners themselves.

Section

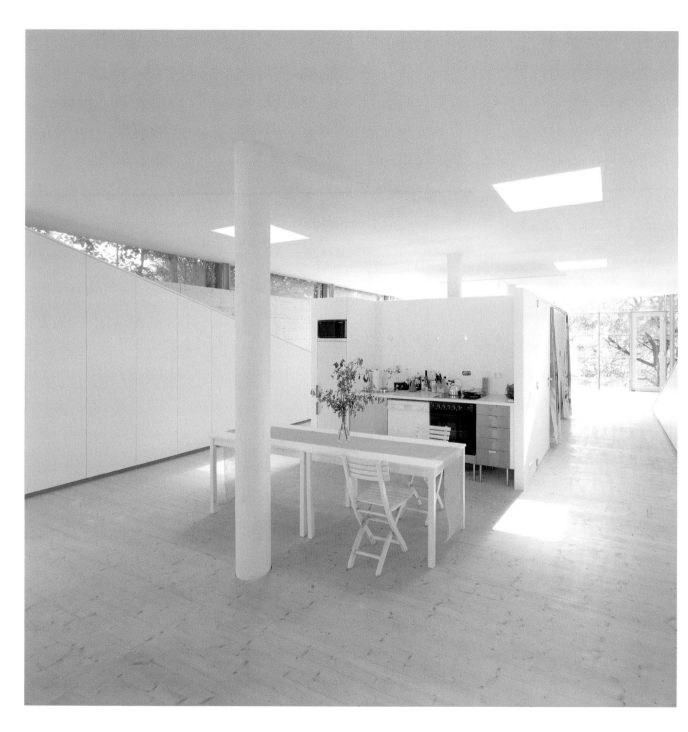

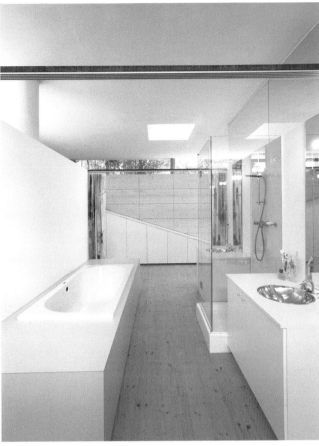

The central service core enables a flexible room distribution in which the bedrooms and living areas can be divided as required.

To optimize storage space, cabinets were built into the interior dividers and along the length of the lateral walls.

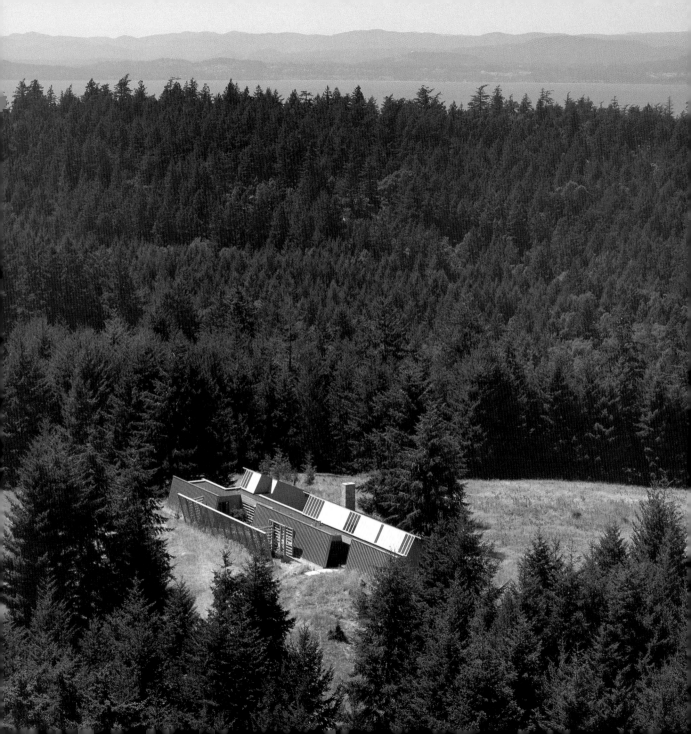

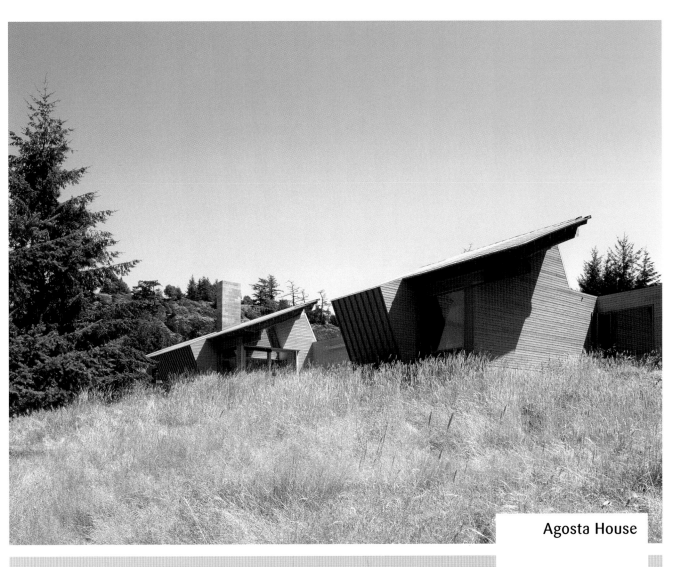

Agosta House

Created for a Manhattan couple as a country home, this house sits on a meadow atop a hill flanked on three sides by trees and on the northwest side with a panoramic view of the valleys and the islands of British Columbia. The project plan included an office and a small garden protected from the local wildlife.

Architect: Patkau Architects
Location: San Juan Island, WA,
United States
Date of construction: 2000
Photography: James Dow

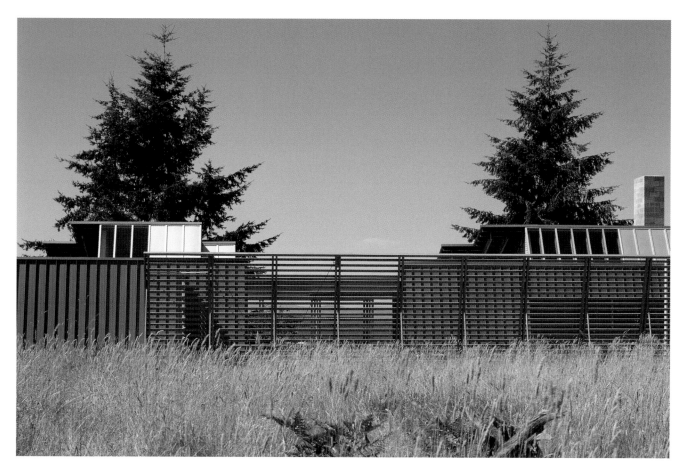

The dialogue between interior and
exterior is constant and reflected
in many ways: the roof overhangs; the
large openings; the placement of
the elements, which creates small
patios; and the exterior latticework,
which protects the garden.

Reflected Ceiling Plan

Ground Floor

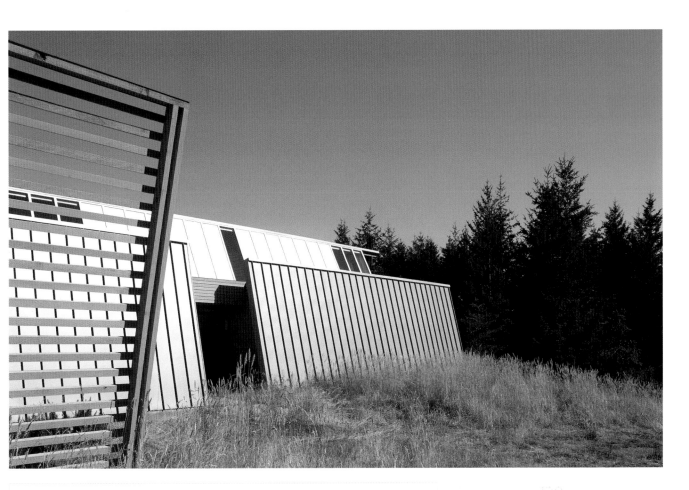

The structure mimics the subtle but continuous slope of the land by playing with inclined walls and roofs.

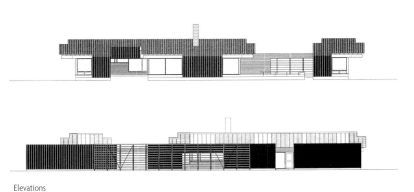

Elevations

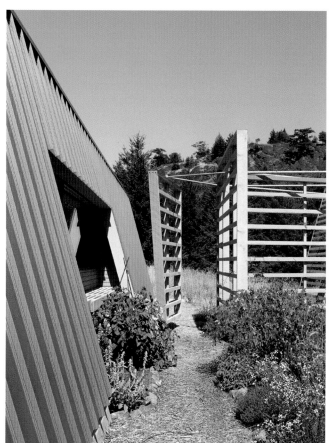
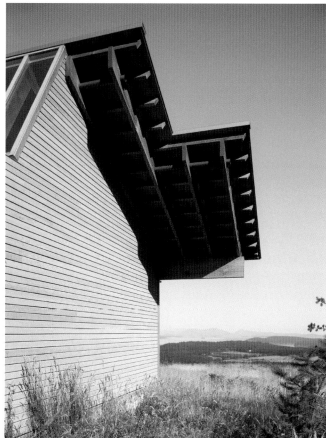

The exterior is finished mainly
with galvanized steel sheets,
which protect the structure not
only from the elements but also
from the danger of forest fires.

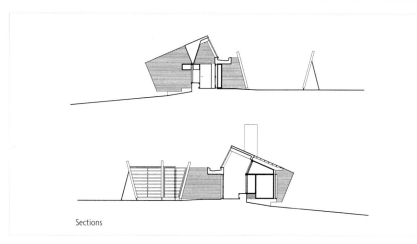

Sections

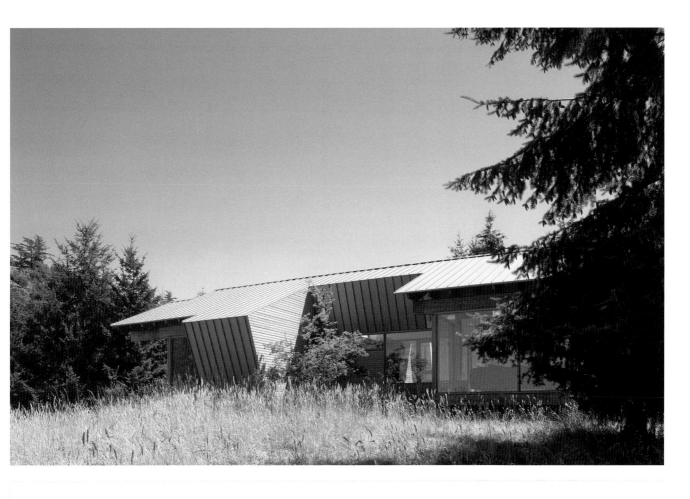

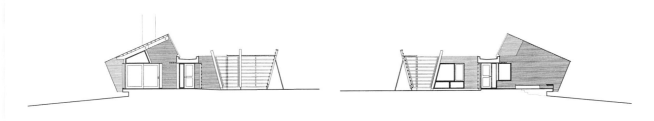

Sections

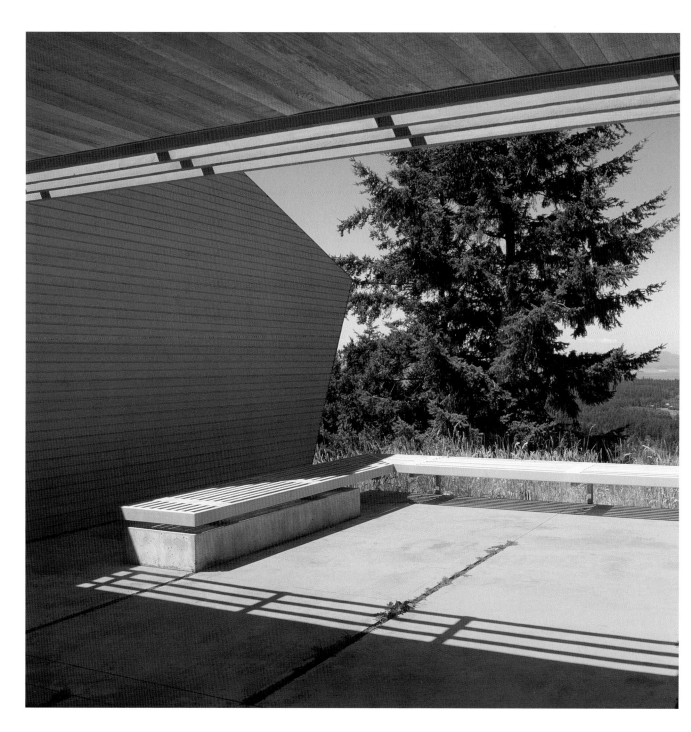

Galvanized steel sheets, the framework of unfinished wood, and the glass wall produce different layers that provide glimpses of the panorama on the opposite side of the house, creating a feeling of lightness.

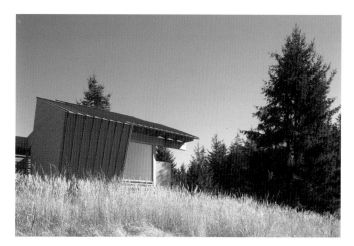

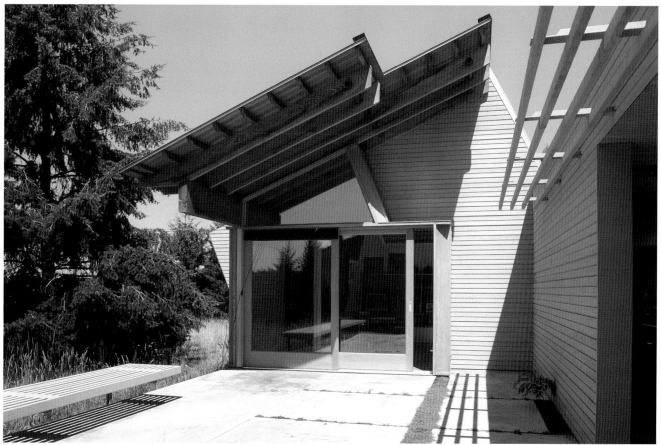

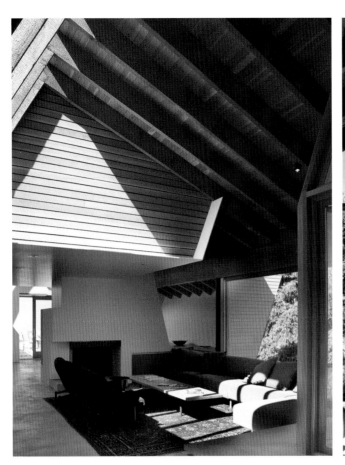
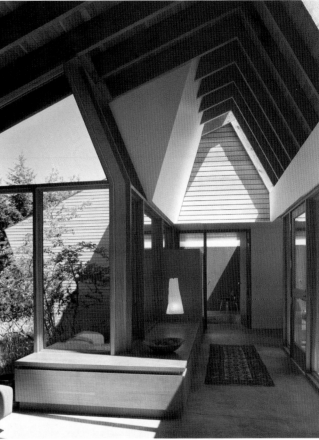

130

The elements left open to view and
the materials used –predominantly
wood– create an interior setting that
is contemporary yet reminiscent of
traditional structures throughout the
United States.

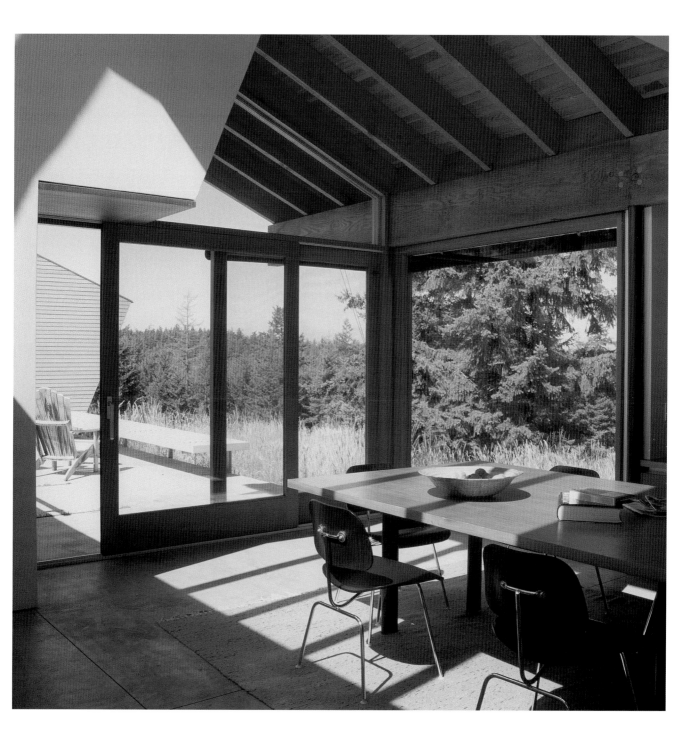

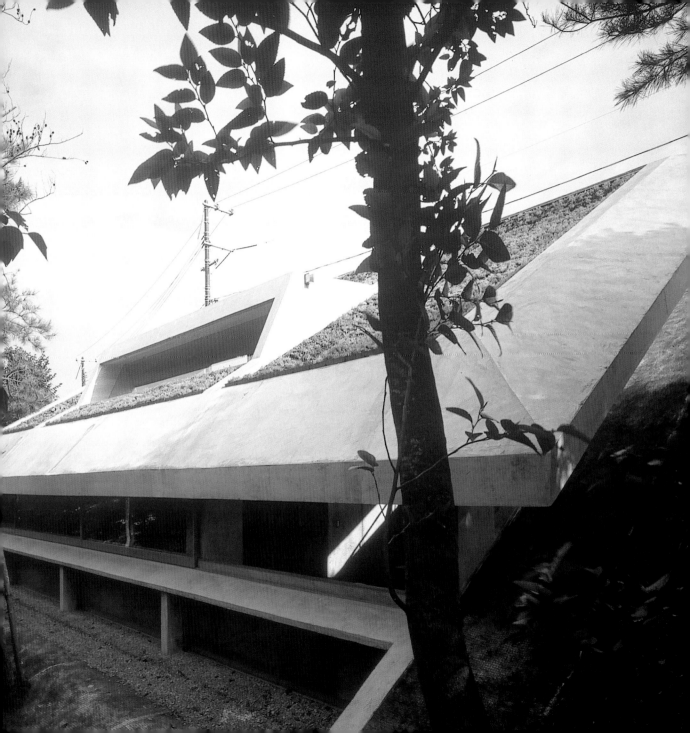

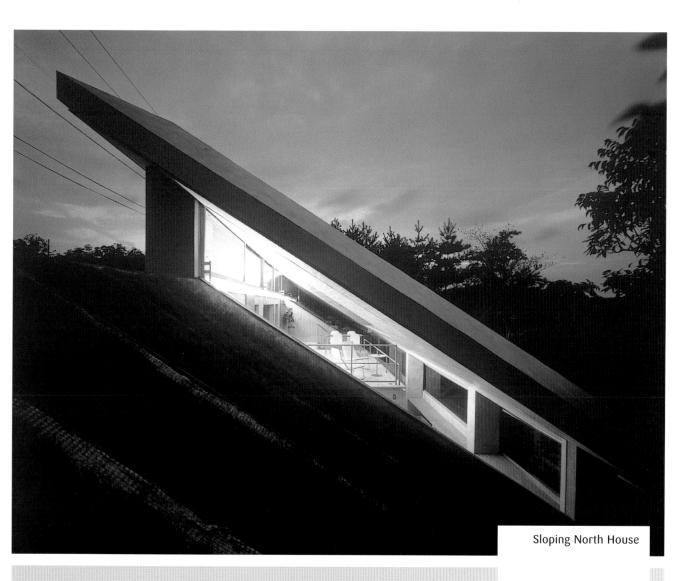

Sloping North House

Sloping North House in Yamaguchi, Japan, is an environmentally sensitive solution to an impossible site: a steep, north-facing mountainside. The semi-underground living area takes advantage of passive cooling in the summer and, with a roof that extends slightly above the hilltop, the warmth of winter's low-angled sun rays.

Architect: Sambuichi Architects
Location: Yamaguchi, Japan
Date of construction: 2002
Photography: Tomohiro Sakashita

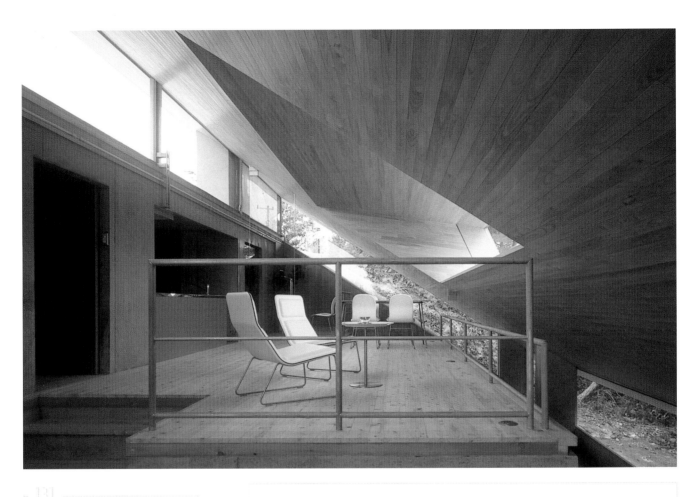

Without relying on energy-saving technology, the house is intended to capture, preserve, and recycle energy through its design. Its angled position is calculated to offer constant warmth in winter and shade from the high summer sun.

Ground Floor

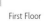

First Floor

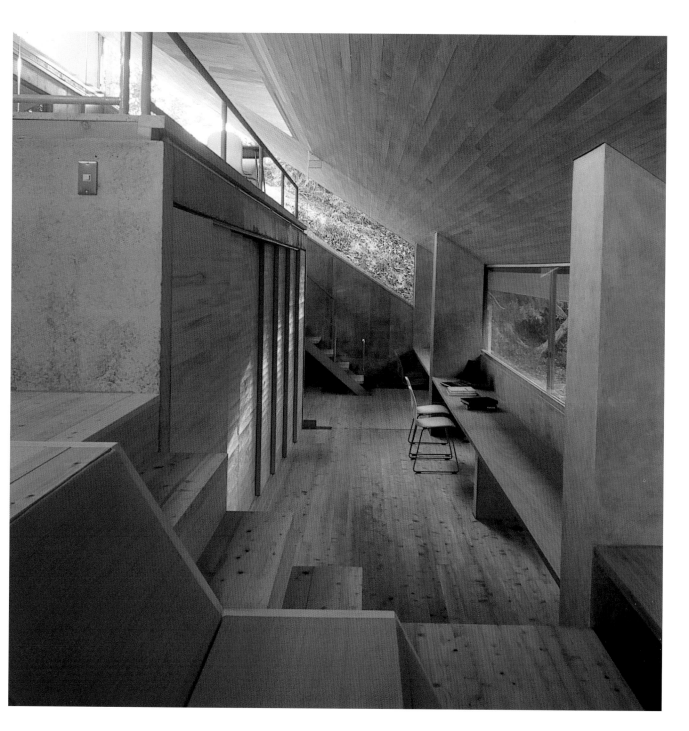

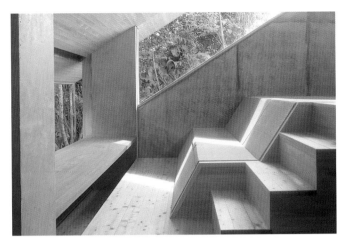

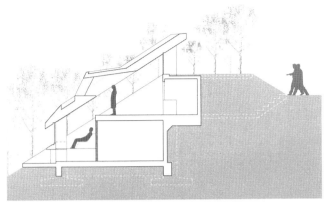

Section

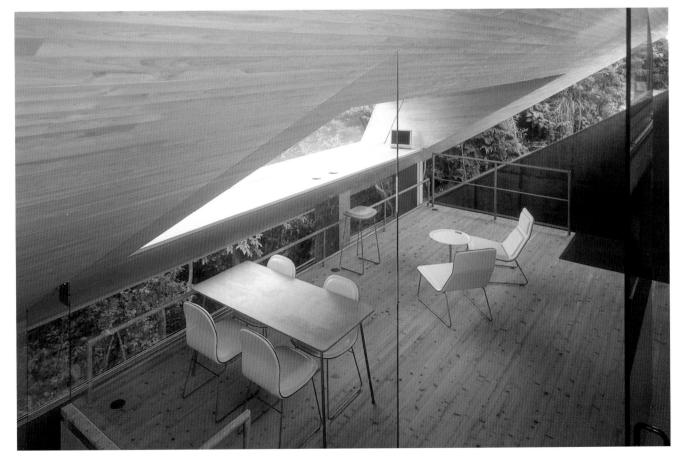

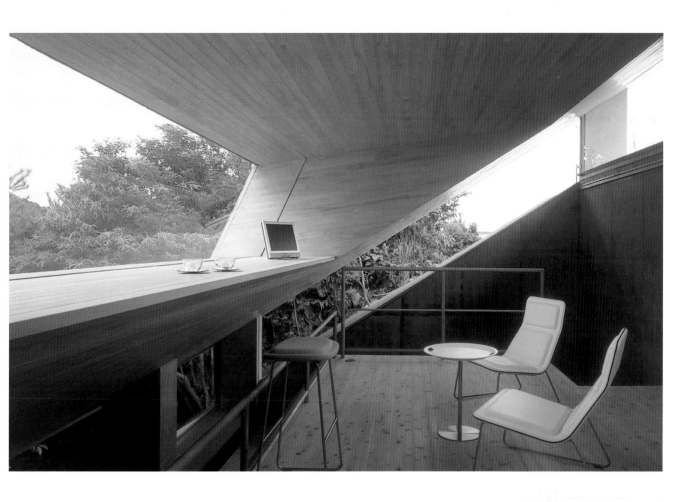

Due to its orientation, a large aperture toward the north provides a view over the sunlit mountains without the need for window shades.

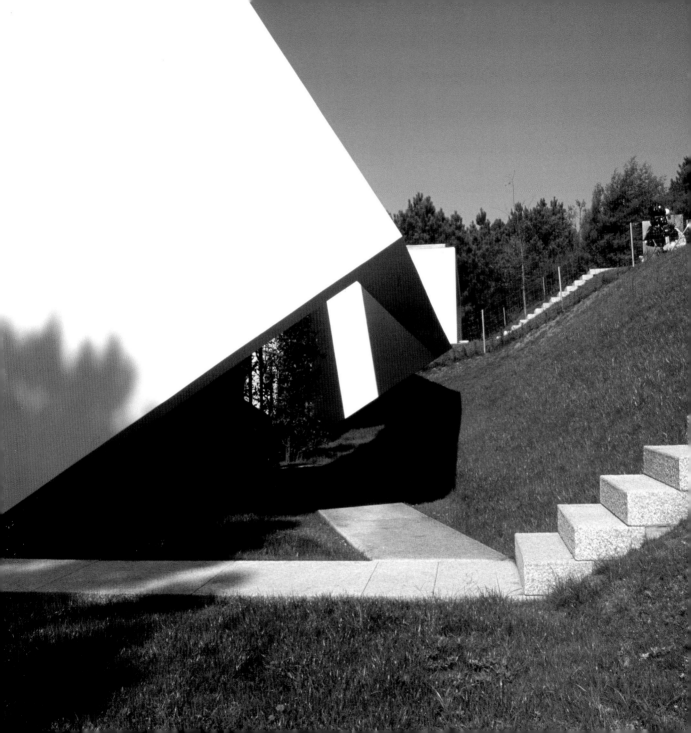

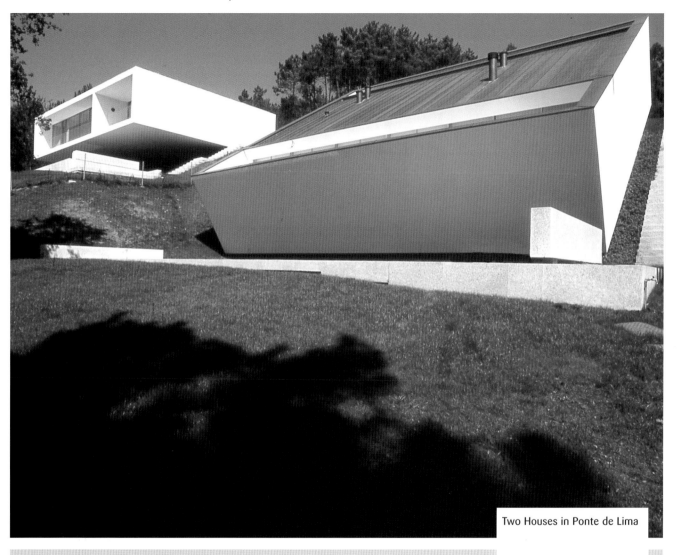

Two Houses in Ponte de Lima

These two houses seem to have been dug into the landscape, forming a dynamic composition of geometric lines and angled surfaces that challenge the conventional aspects of contemporary architecture. Sitting on a steep hill, the houses are designed to be integrated with nature and maintain a constant architectural dialogue.

Architect: Eduardo Souto de Moura
Location: Ponte de Lima, Portugal
Date of construction: 2002
Photography: Luís Ferreira Alves

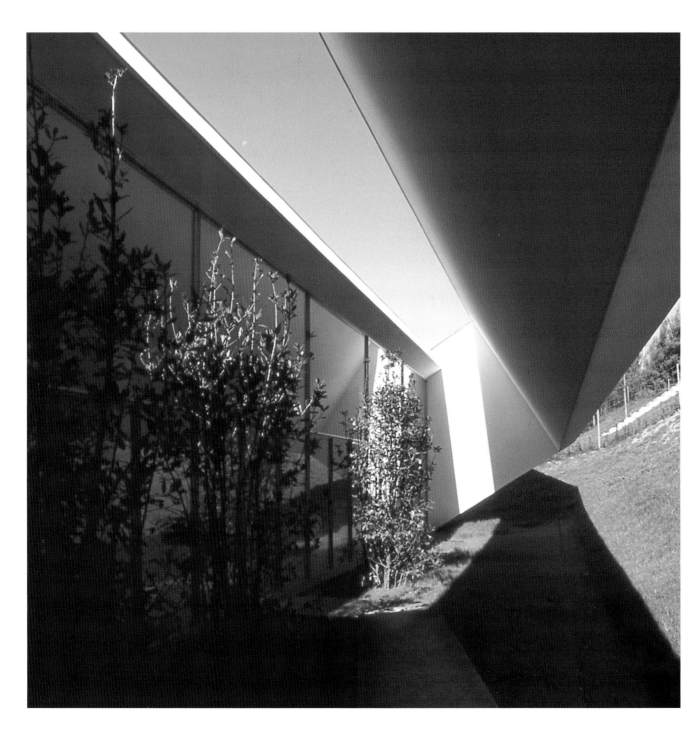

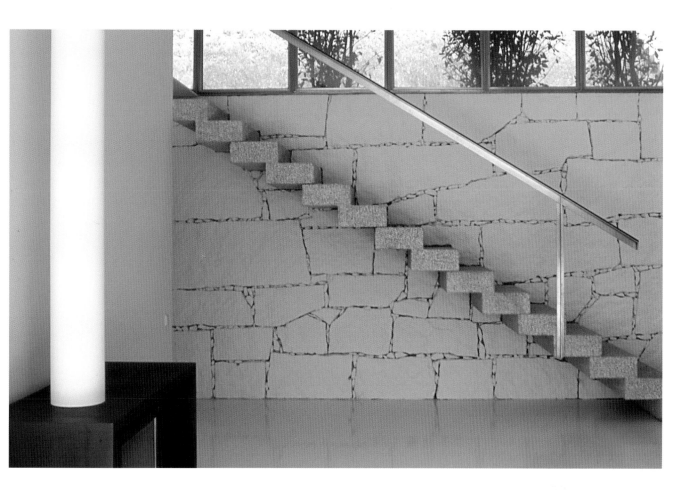

The sloping structure that envelops the leveled interior spaces allows views toward the exterior and creates a shaded exterior patio.

Elevations

Ground Floor First Floor

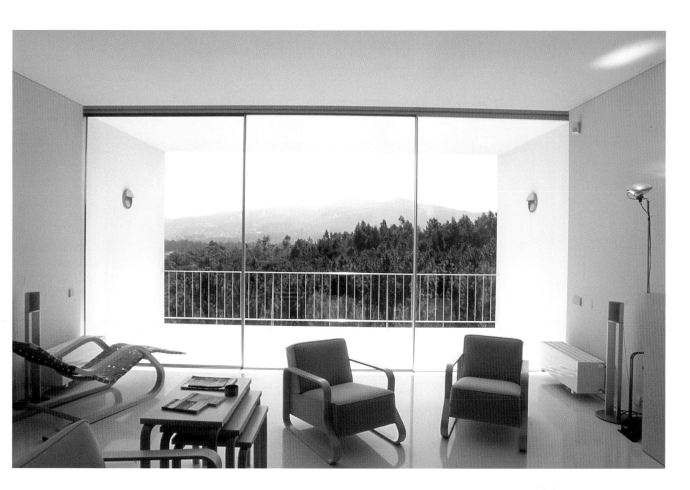

The interiors are finished in
a seamless neutral shade,
maximizing the luminosity
gained through glass doors
and skylights.

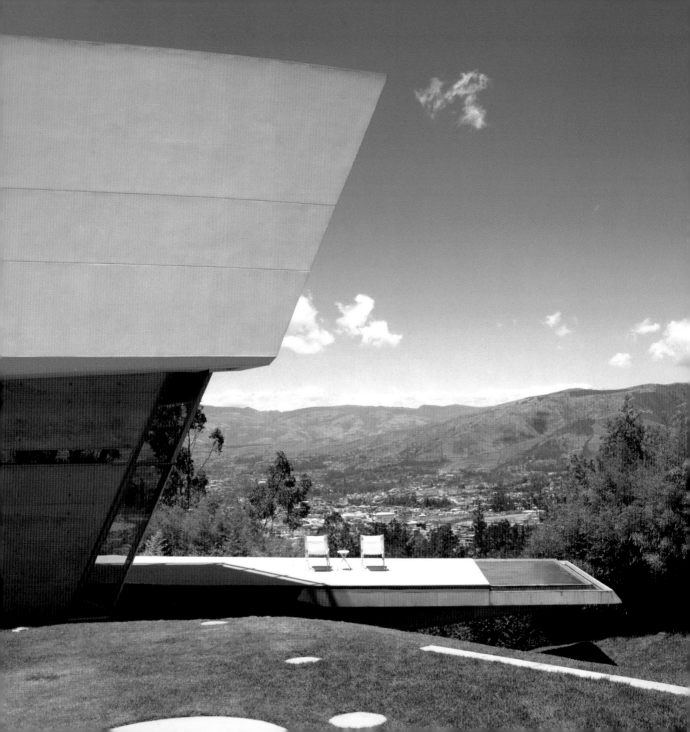

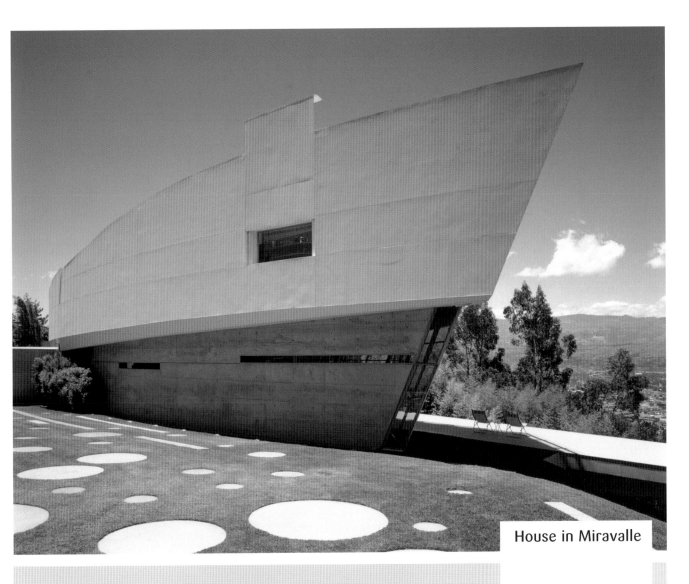

House in Miravalle

The main challenge of this project was designing a house that would take full advantage of the many views and maintain the privacy of its occupants while blending in with the surrounding environment. Facing the Andes mountains, the house was adapted to the site's mountainous terrain and endowed with a curved, angled structural wall.

Architect: Wood + Zapata
Location: Miravalle, Ecuador
Date of construction: 2002
Photography: Undine Pröhl

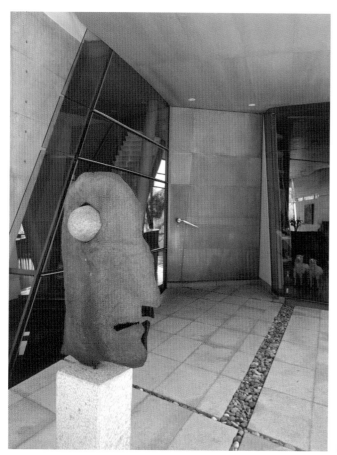

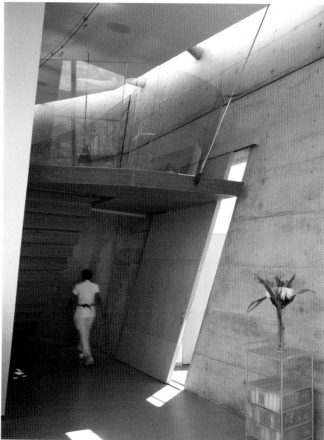

The two main wings of the building form
a large angle, allowing them to take in
most of the views and create a feeling
of proximity. Concrete, glass, and wood
are the main building materials.

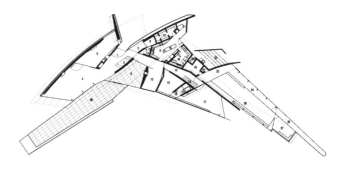

Ground Floor

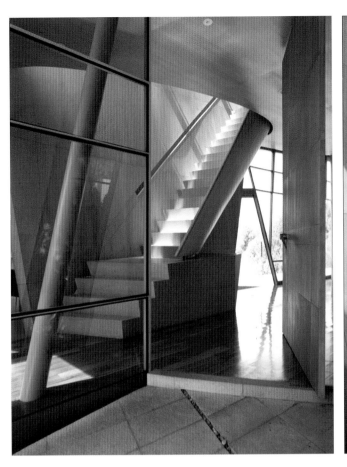

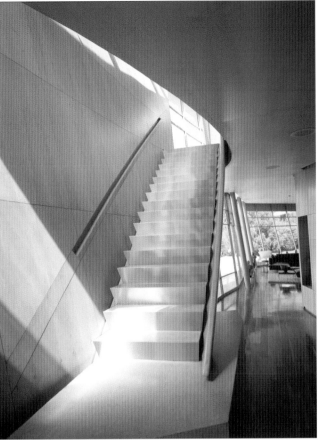

The combination of geometric angles and curved lines produces a dynamic relationship between the materials and levels that make up the house.

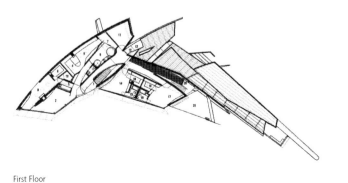

First Floor

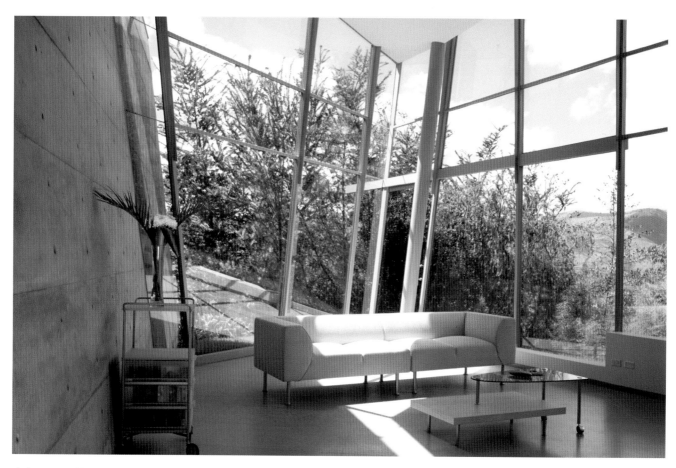

The living room and the bedroom
features ample views of the mountains
through fully glazed walls supported
by a metal-frame structure.

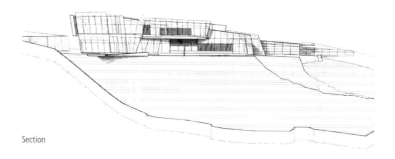

Section

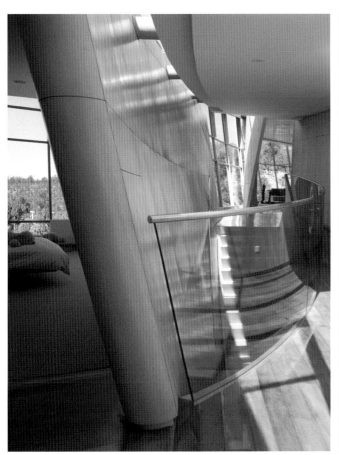
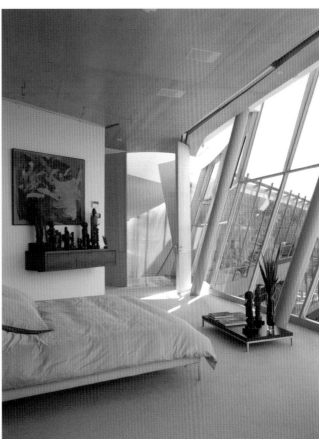

Elevations

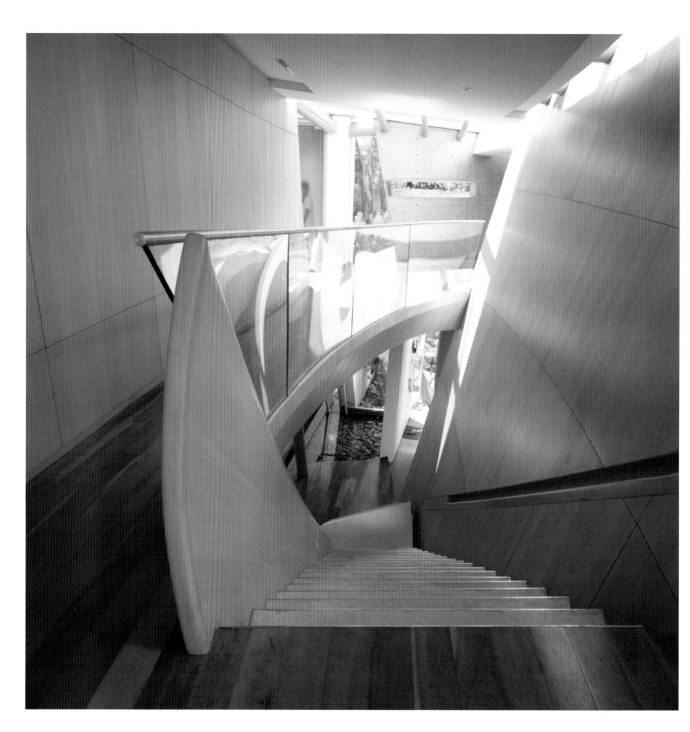

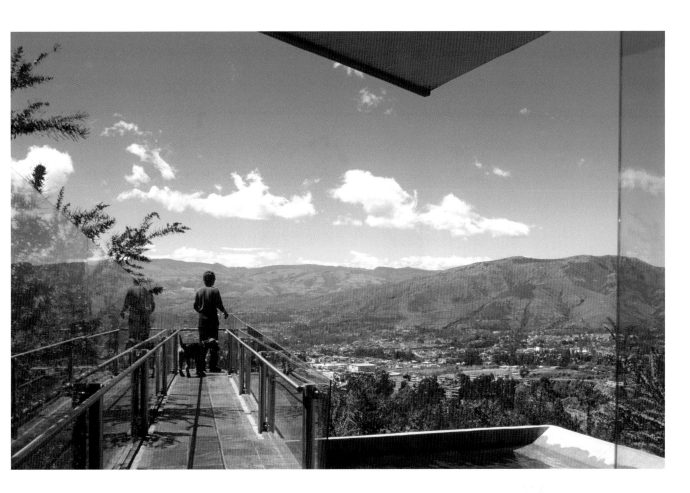

A stone passage flanking
the pool extends to
form a glass balcony and
private overlook.

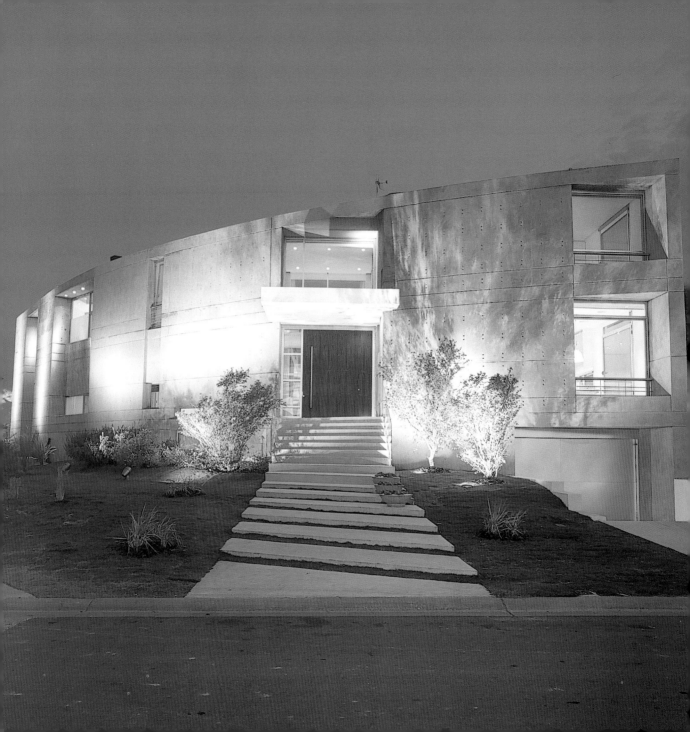

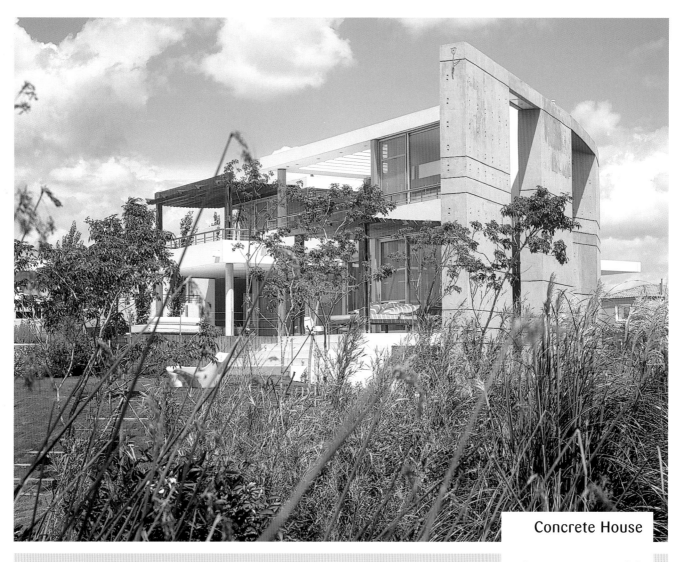

Concrete House

This country house for a young family adopts an original form composed of three sides, one of which is curved and embraces the house to orient the view away from the street and toward the lake. The solid, curved concrete wall contrasts with a fully glazed façade that opens up to a pool terrace and lake beyond.

Architect: Barrionuevo-Sierchuk
Arquitectas
Location: Buenos Aires,
Argentina
Date of construction: 2004
Photography: Adela Aldama

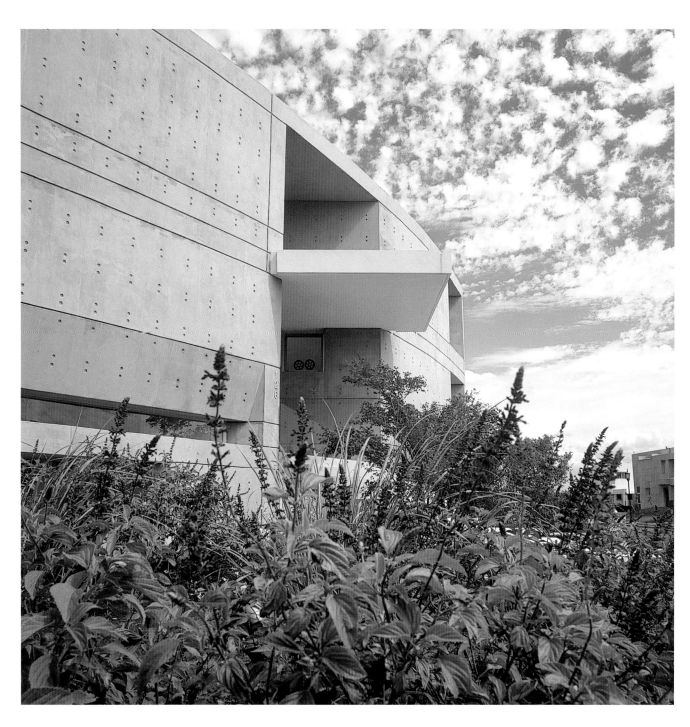

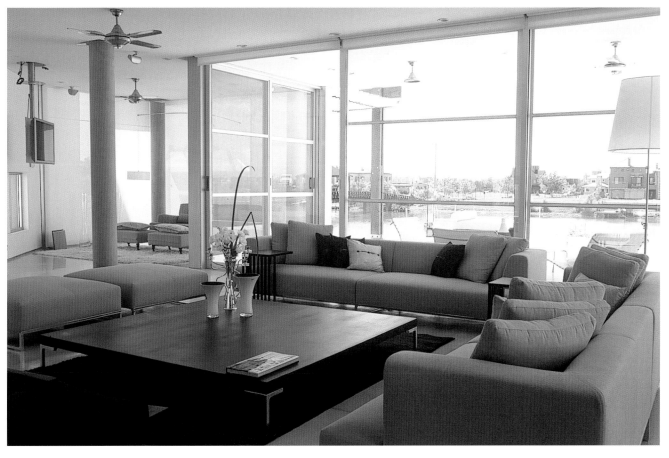

The floors, crafted on site out of granite mosaic, extend out to the terrace and into the pool. This synthesis of materials is matched by the neutral color scheme that characterizes the interiors.

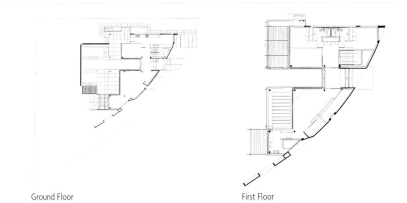

Ground Floor

First Floor

The vertical space was maximized by creating a horizontal window and leaving the upper space free for storage purposes.

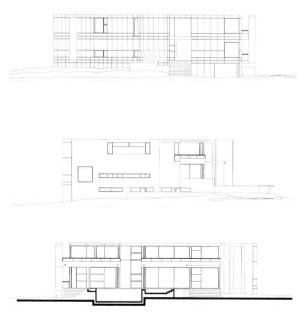

Elevations

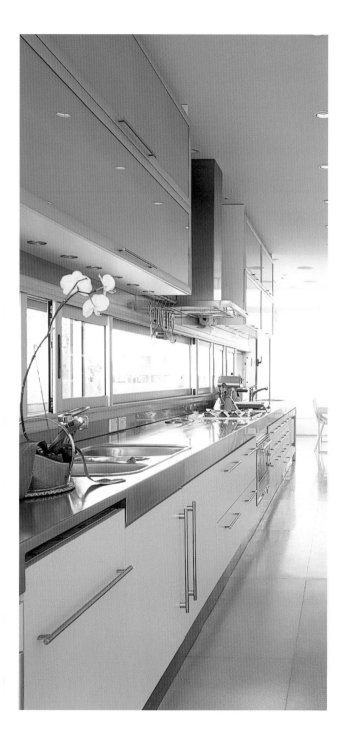

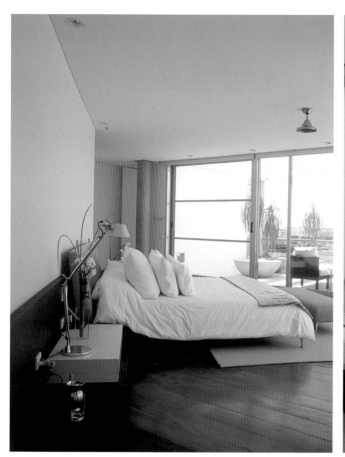

A hanging mirror allows the fully glazed bathroom wall to remain untouched, while clear basins emphasize the effect of transparency.

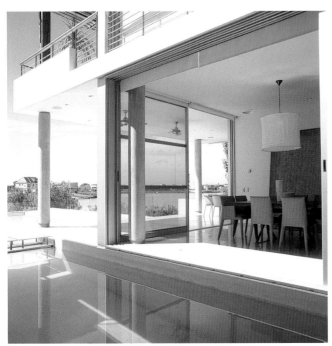
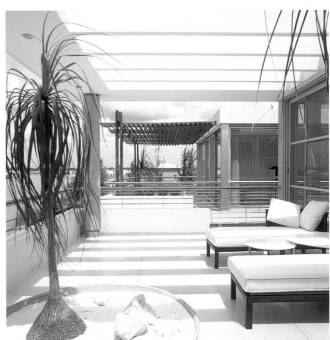
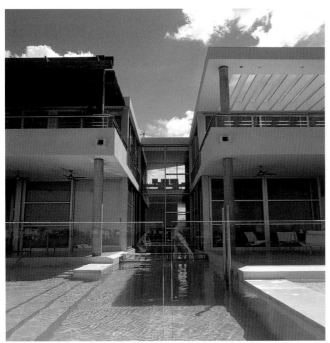
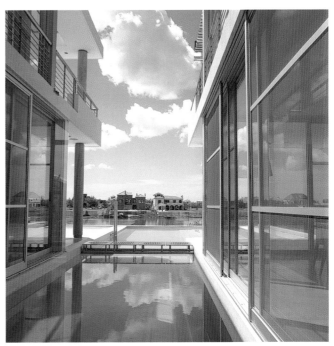

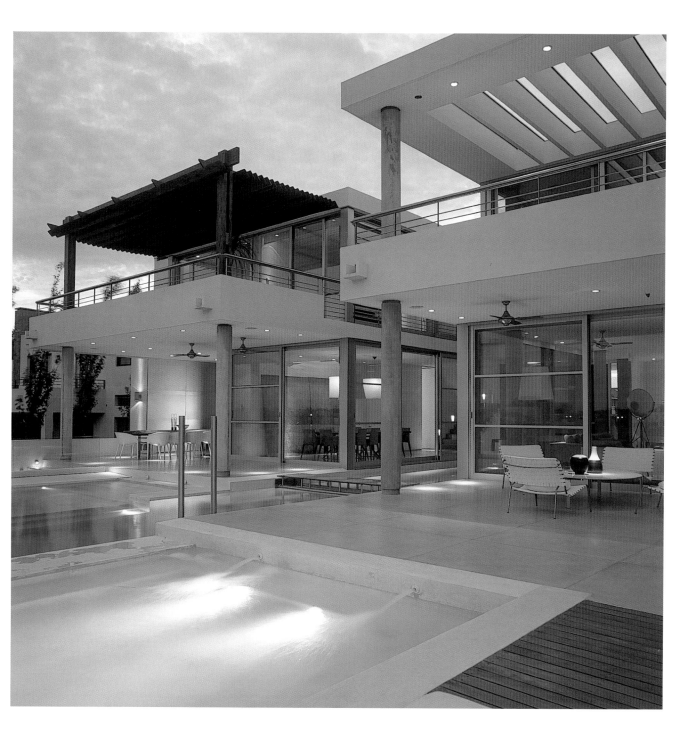

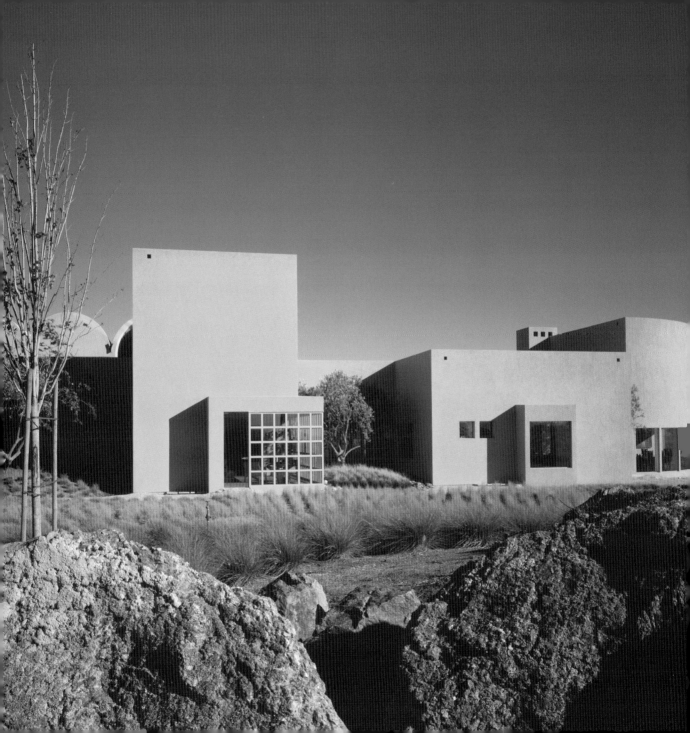

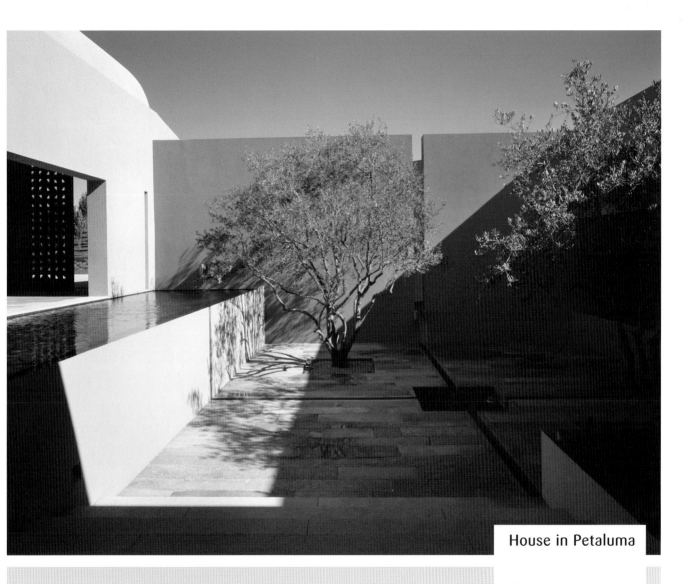

House in Petaluma

Concealed from the winding road of olive trees and flowers that leads to it, this house is located on a hilltop above the valley of Petaluma. Past a 20-foot-high and 56-foot-long barrel vault and open courtyard, the interior living space reveals the breathtaking view over the valley.

Architect: Legorreta + Legorreta
Location: Petaluma, CA, United States
Date of construction: 2004
Photography: Lourdes Legorreta

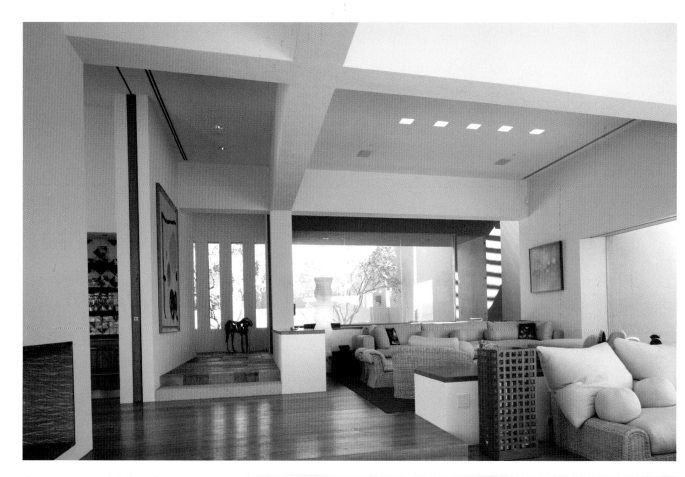

The exterior structures are bathed in vivid colors that contrast with the neutral interior, adding to the sensory experience already provided by the landscape.

Site Plan

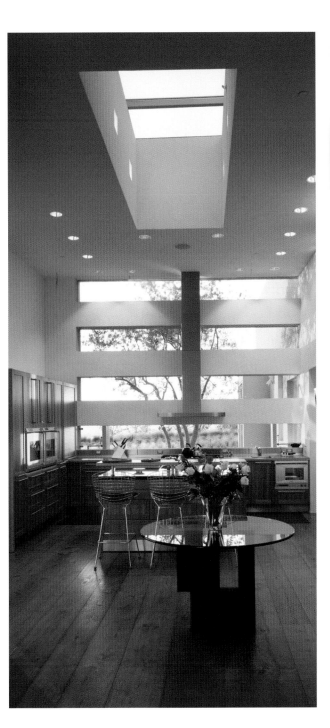

A pair of sliding doors divides the living area from the kitchen and dining room, offering the possibility of joining or separating the two zones.

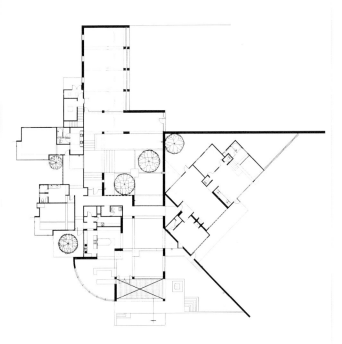

Ground Floor

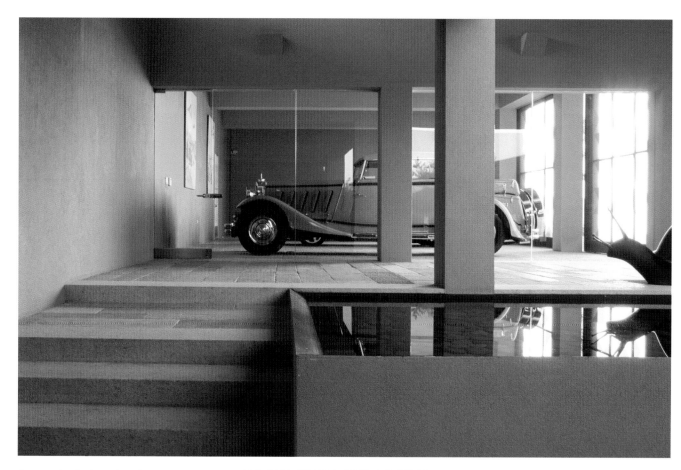

A garage enclosed in glass can be used to exhibit collector's items such as this antique car.

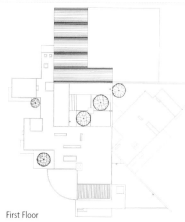

First Floor

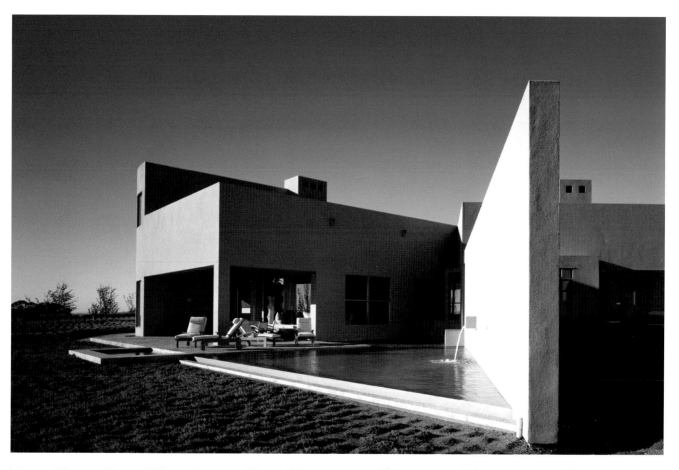

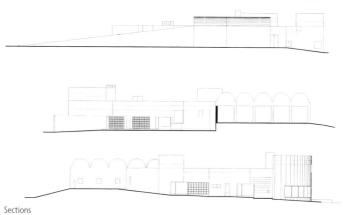

Sections

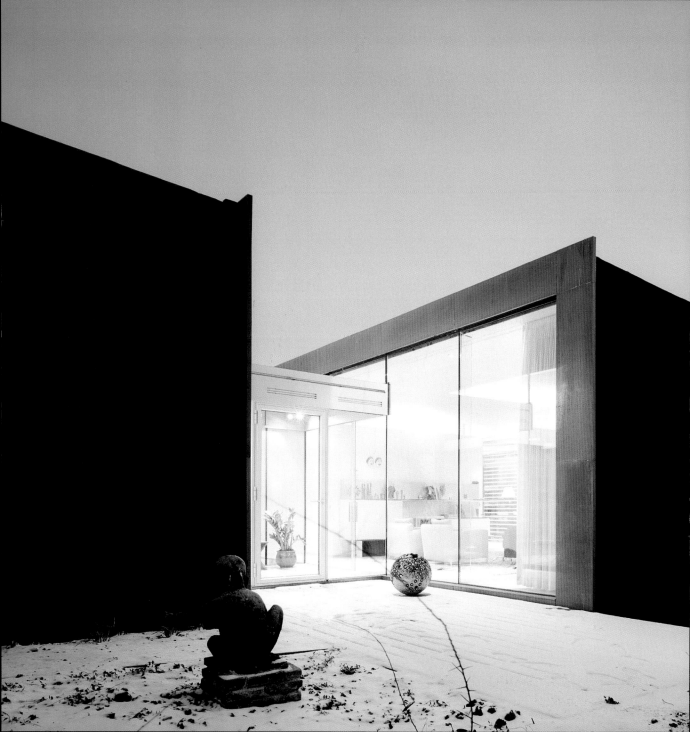

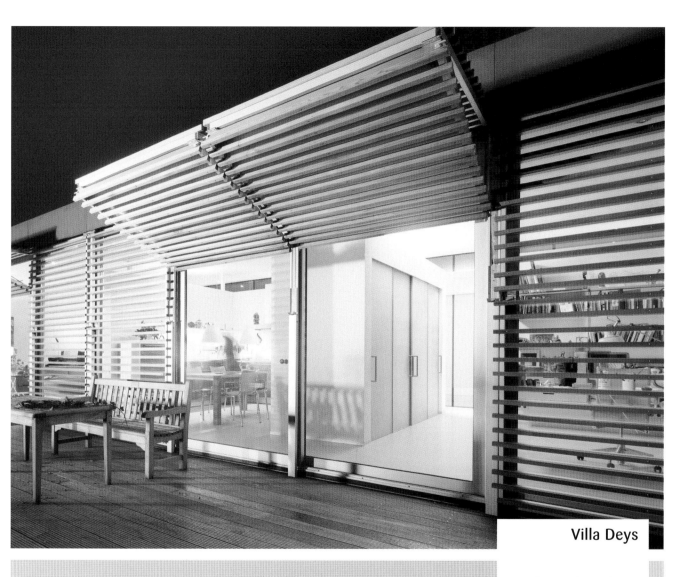

Villa Deys

This villa, located around the outer marshes of the Rhine, was designed for a middle-aged couple as a practical house in which to live independently as long as possible. Fully integrated with the natural surrounding, the plan emphasizes technical features that allow the inhabitants to be self-supporting for as long as they can.

Architect: Achitectenbureau
Paul de Ruiter
Location: Rhenen, Netherlands
Date of construction: 2002
Photography: Rien van Rijthoven

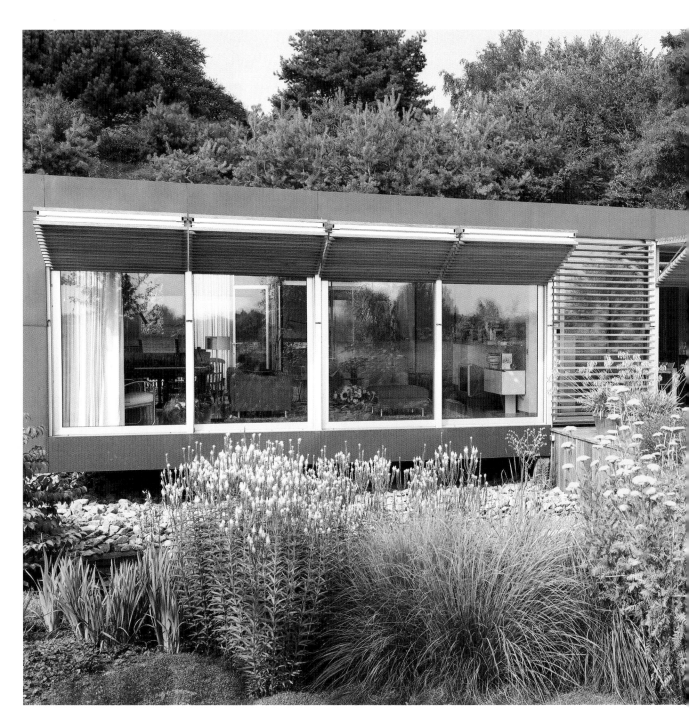

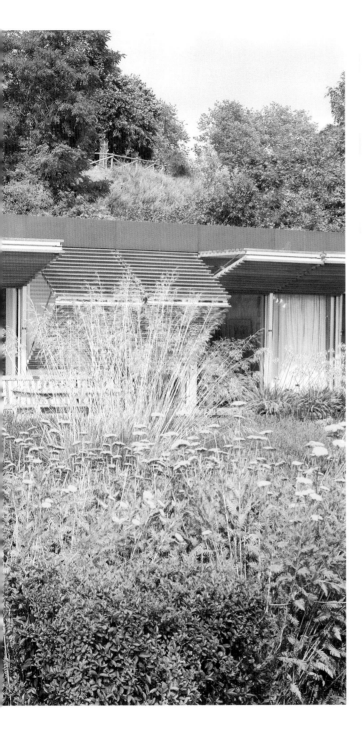

Instead of ordinary doors, the architects installed electronic sliding doors activated by a remote control that also opens and closes the curtains, front door, and sunscreens. The whole building is free of thresholds to facilitate movement and accommodate wheelchairs if needed.

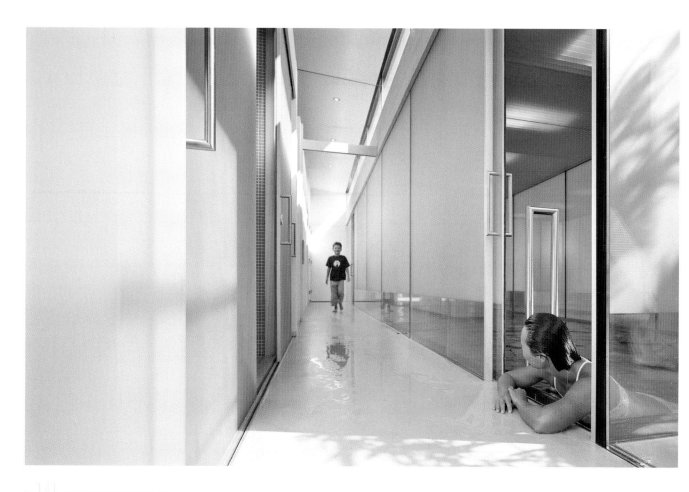

The indoor pool, installed as a means of exercise for the tenants, was made fairly shallow and is maintained at a constant warm temperature. Contained within sandblasted glass walls, a transparent lower perimeter allows swimmers to see the exterior from inside the pool.

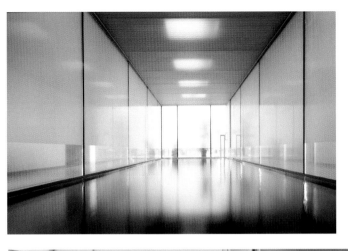

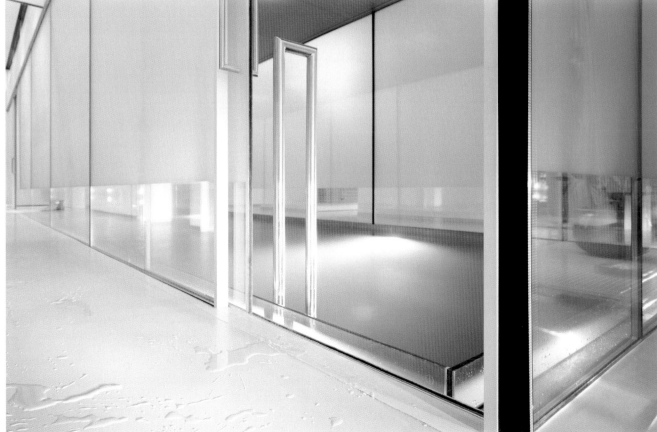

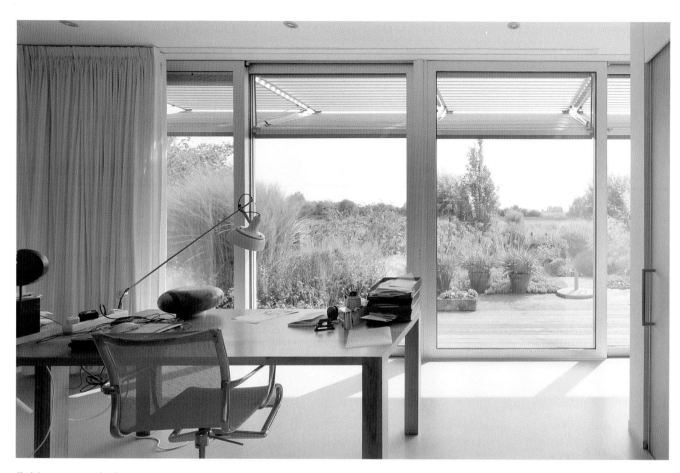

The lights are programmed so that different light switches serve different purposes, such as reading, relaxing, or having dinner.

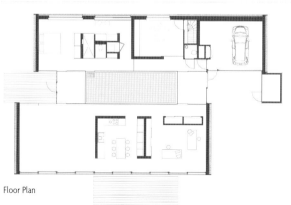

Floor Plan

Sections

Elevations

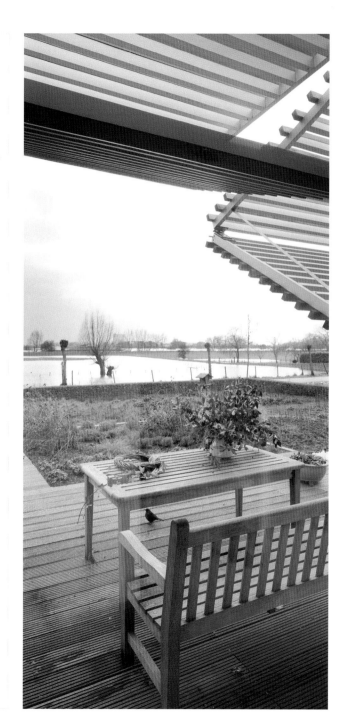

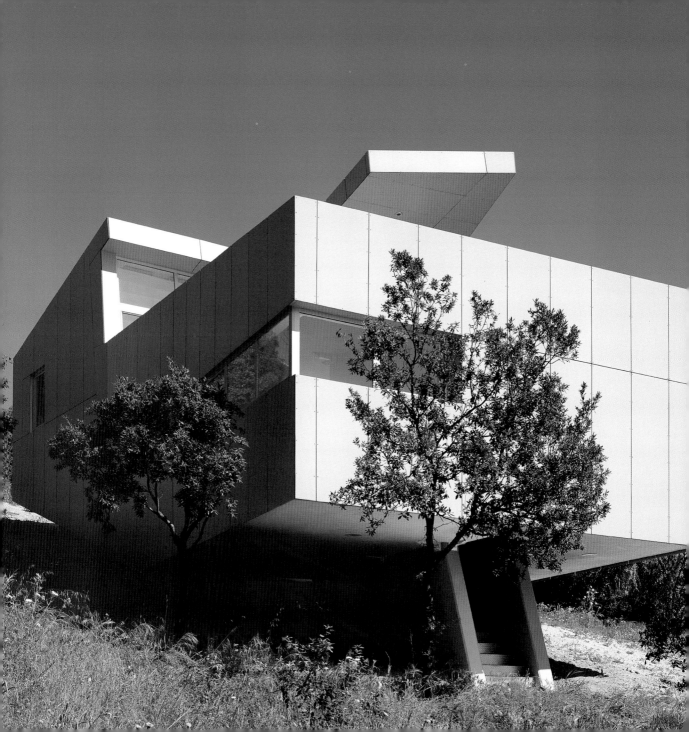

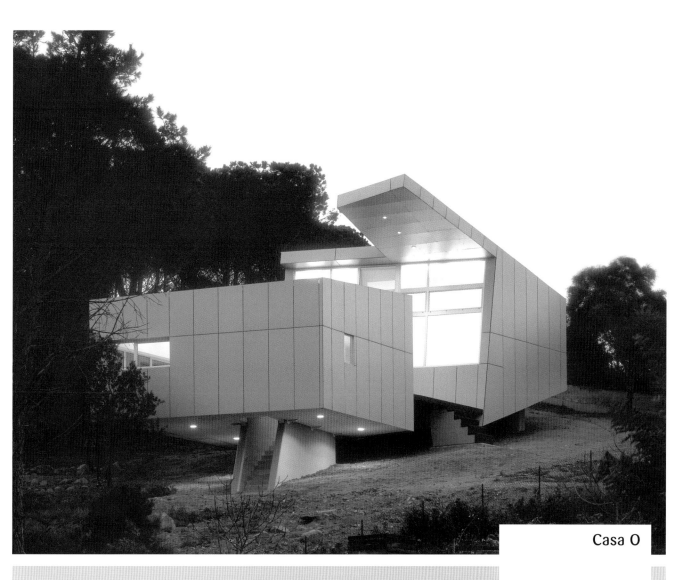

Casa O

Architect: Fabrizio Leoni
Architettura
Location: Sardinia, Italy
Date of construction: 2004
Photography: Dessì & Monari

Surrounded by open land, hills, and fields, this house in Sardinia, designed
for a small family, establishes a close relationship to the topography through
orientation, form, and material. The structure is expressed as a massive rock
wrapped in an exterior film that orient and frames different views from
inside the house.

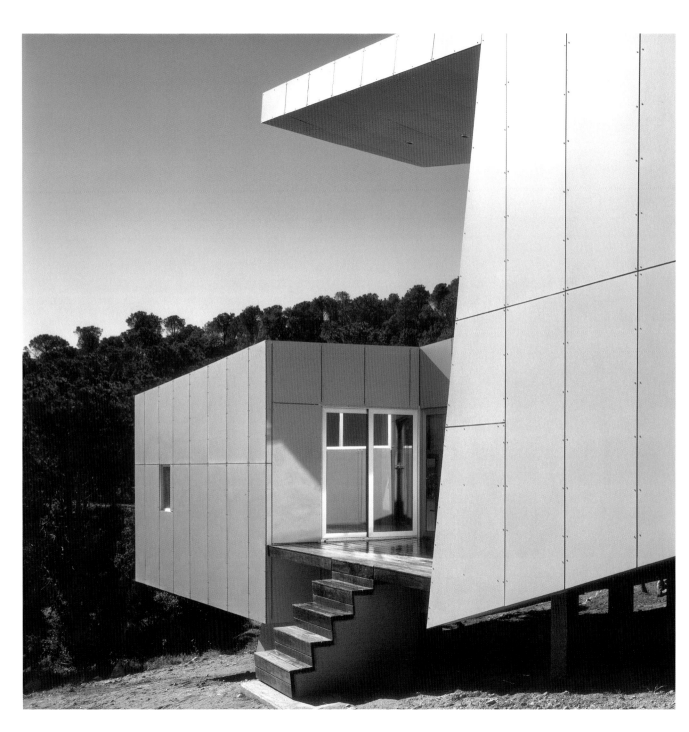

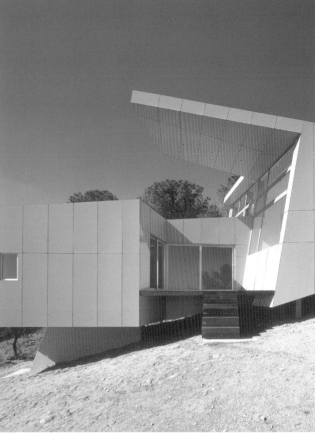

The configuration of the house incorporates a semiprivate interior patio that offers an exterior space oriented toward the morning sun. A cantilevered roof provides shade both to the exterior terrace and to the interior spaces.

Site Plan

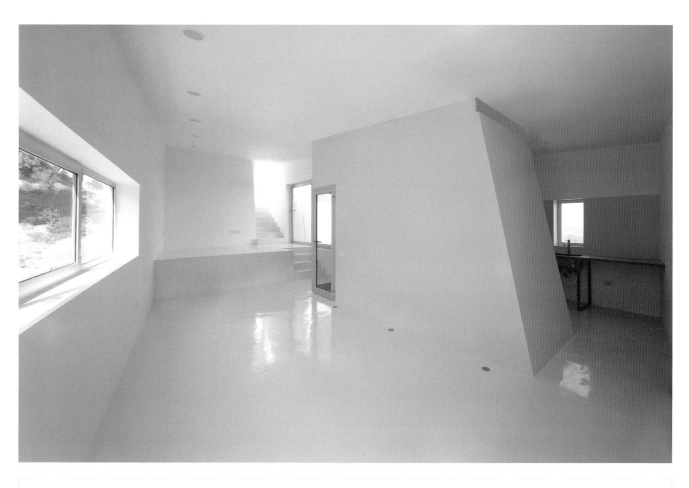

Ground Floor

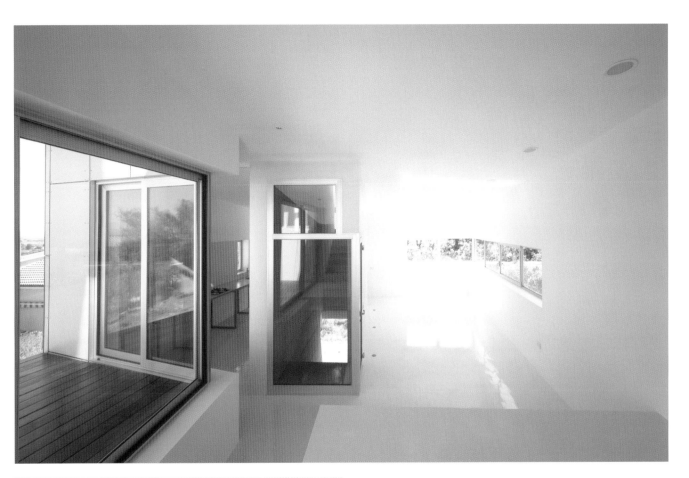

A stairwell can be used as a partition to separate different areas; in this house, a dividing wall containing the staircase serves as a partition between the living area and the kitchen.

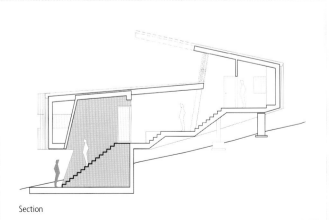

Section

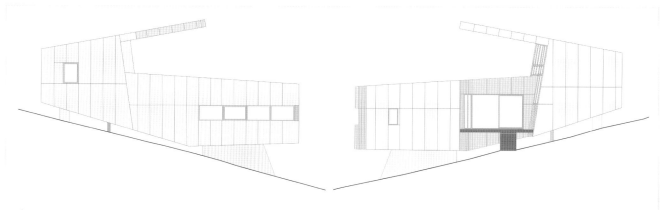

Elevations

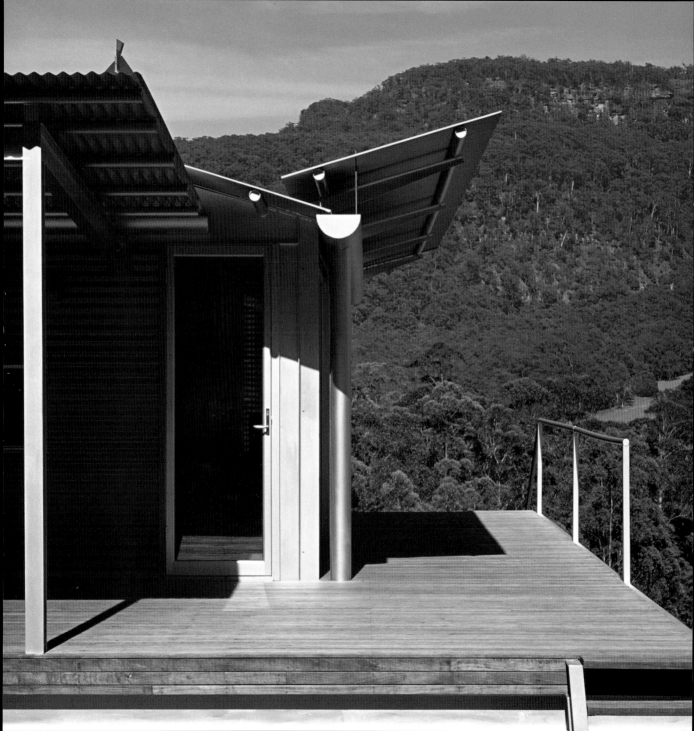

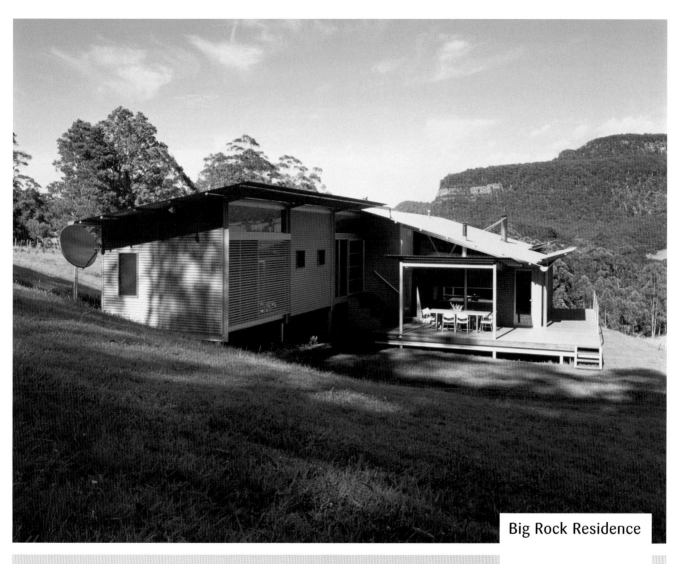

Big Rock Residence

Conceived as a full-time residence in the country, this lightweight, steel-clad house perched high on a steeply sloping site responds to the harsh and rugged landscape with a robust steel-frame construction comprising the two rectangular pavilions that hover above the fall of the land.

Architect: Edward Szewczyk + Associates
Location: Kangaroo Valley, Australia
Date of construction: 2004
Photography: Michael Saggus

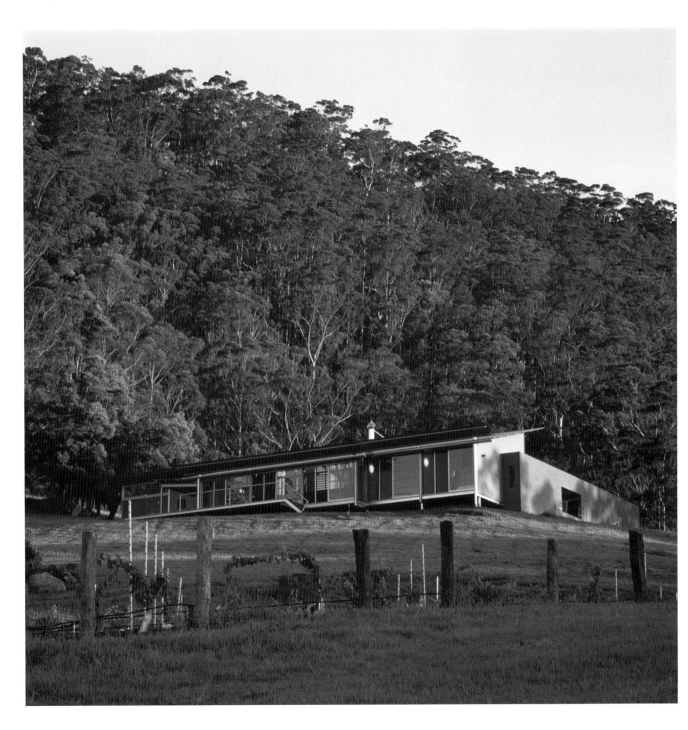

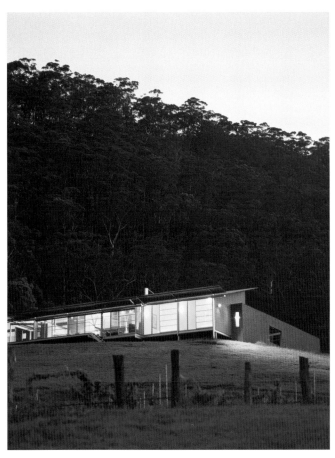

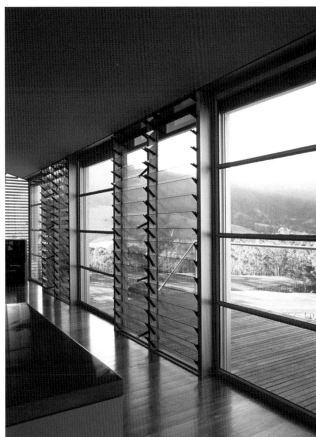

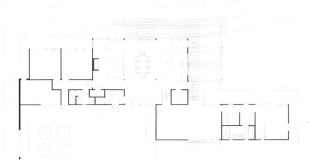

Floor Plan

Section

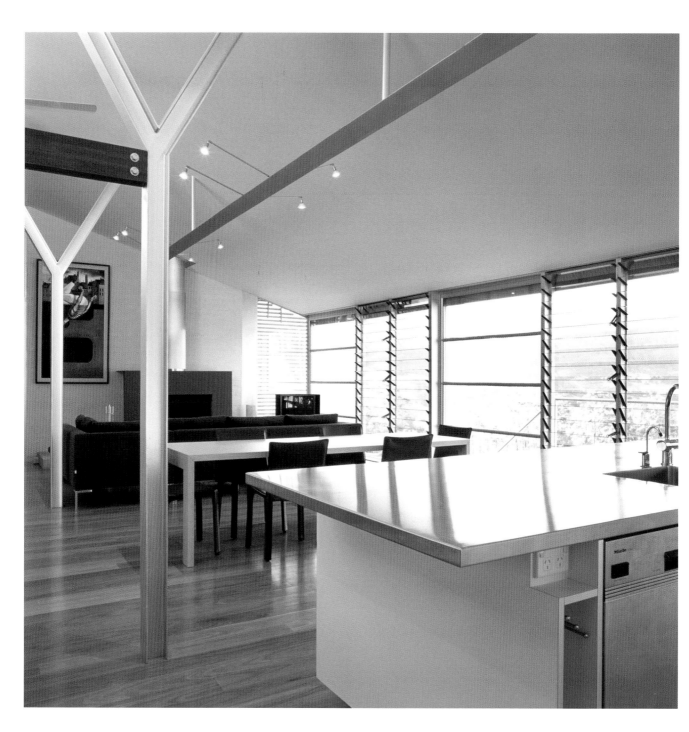

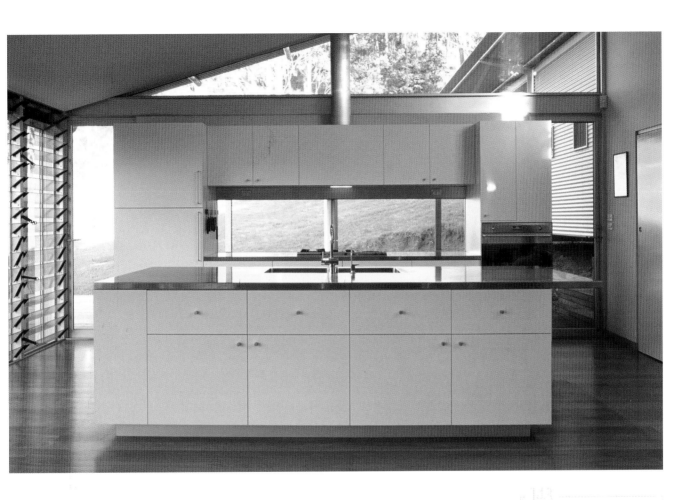

To allow free air movement
around the building and
increase transparency,
the northern veranda
roofs are detached from
the main roof.

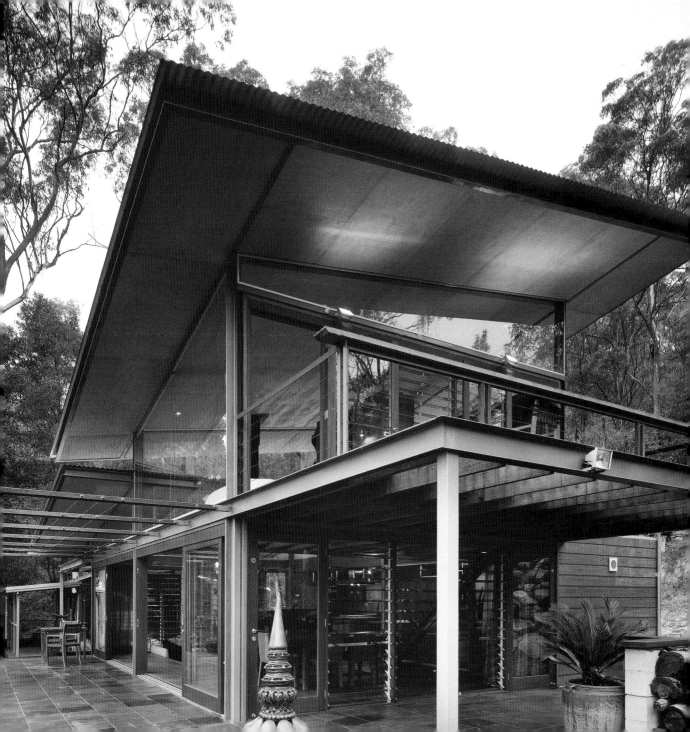

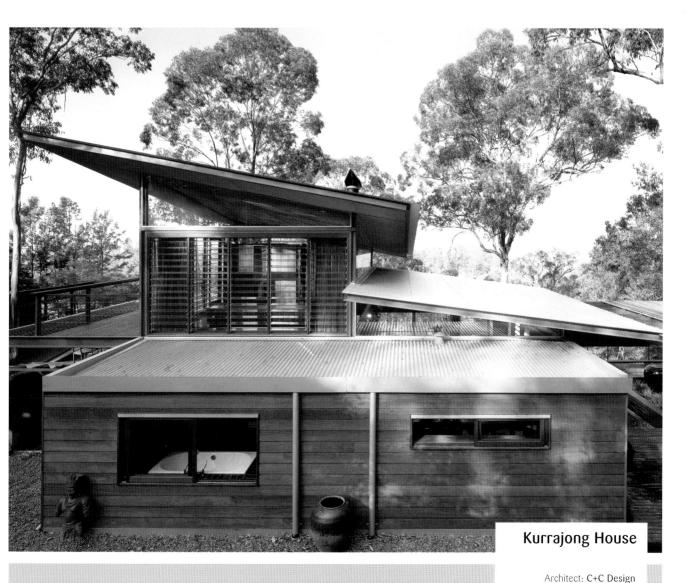

Kurrajong House

Architect: C+C Design
Construct
Location: Bowen Mountain,
Australia
Date of construction: 2003
Photography: Murray Fredericks

Nestled in the dense bushland of Bowen Mountain, the existing timber slab hut was transformed into a single-story contemporary home, acknowledging the inherent qualities of the traditional construction methods and local materials typical of this area of the country.

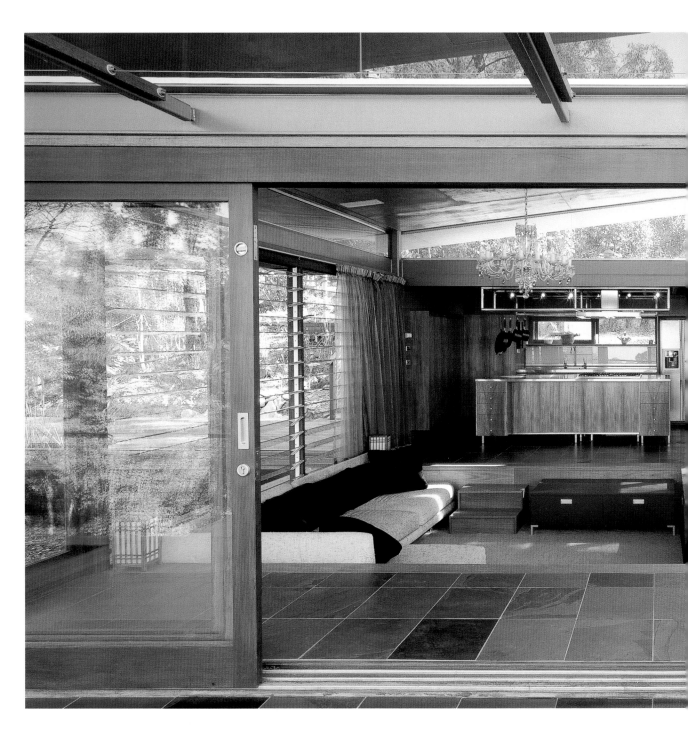

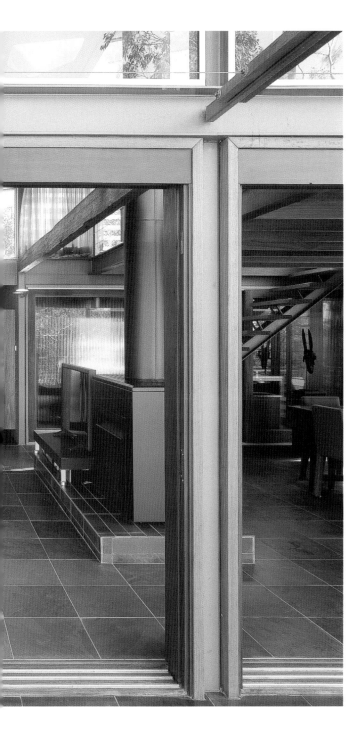

The living area was dug into the main space, creating an intimate zone within the open-plan living, kitchen, and dining area.

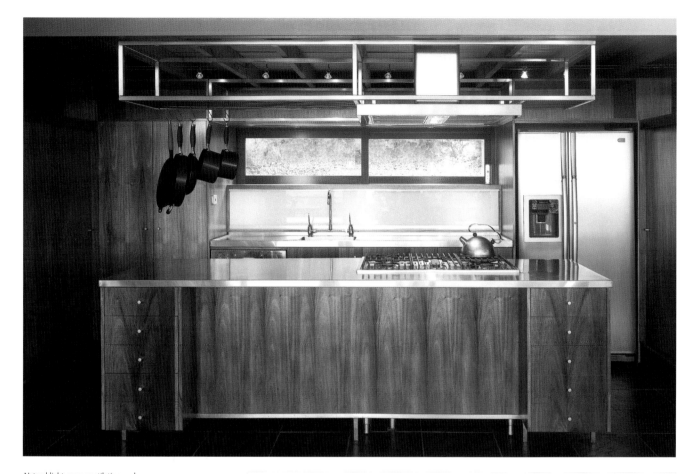

Natural light, cross-ventilation, and passive solar heating and cooling principles allow the occupants a high level of comfort all year round at a significantly low cost.

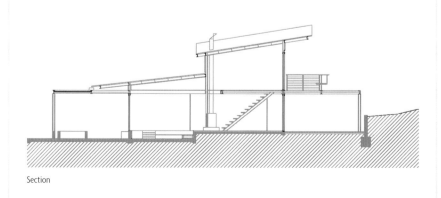

Section

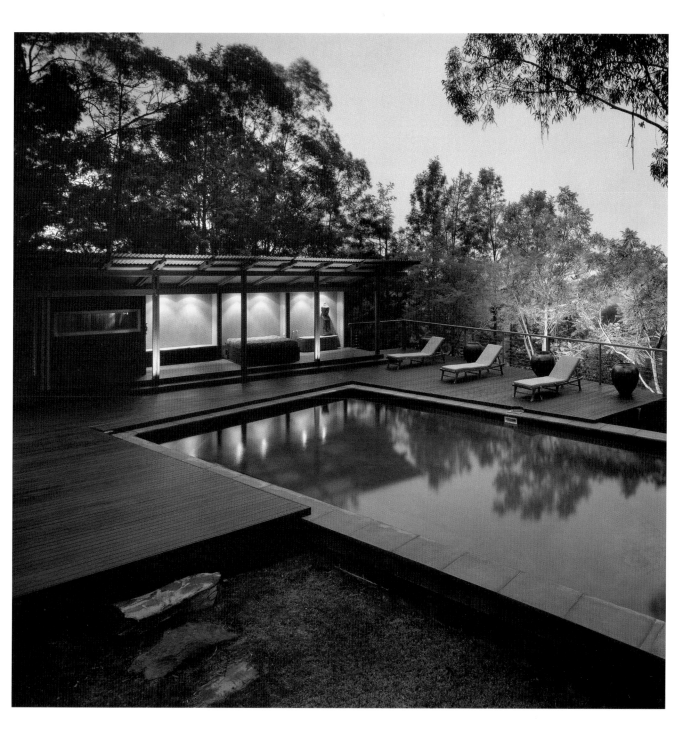

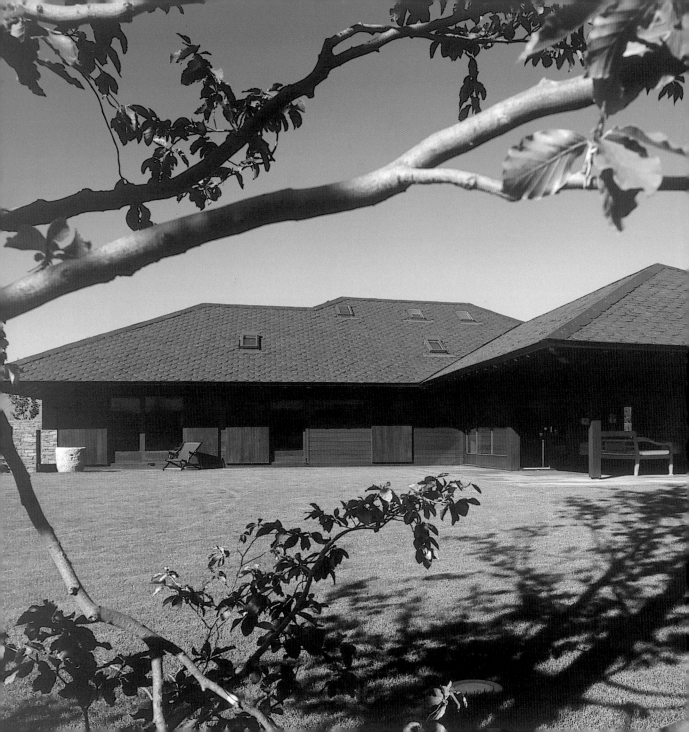

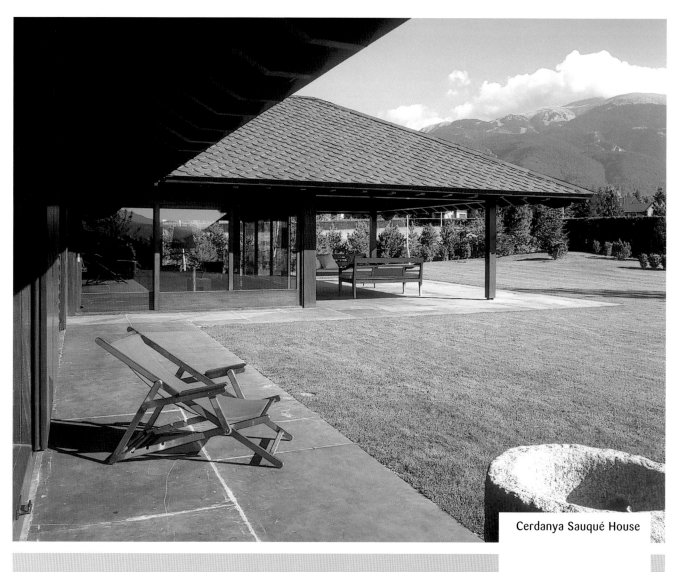

Cerdanya Sauqué House

Located on an exclusive site in the Pyrenees mountains, this house mixes contemporary and rustic esthetics through the combination of modern materials like stainless steel with others such as aged wood and traditional wooden beams.

Interior design: Fatima Vilaseca
Location: Cerdanya, Spain
Date of construction: 2004
Photography: Jordi Miralles

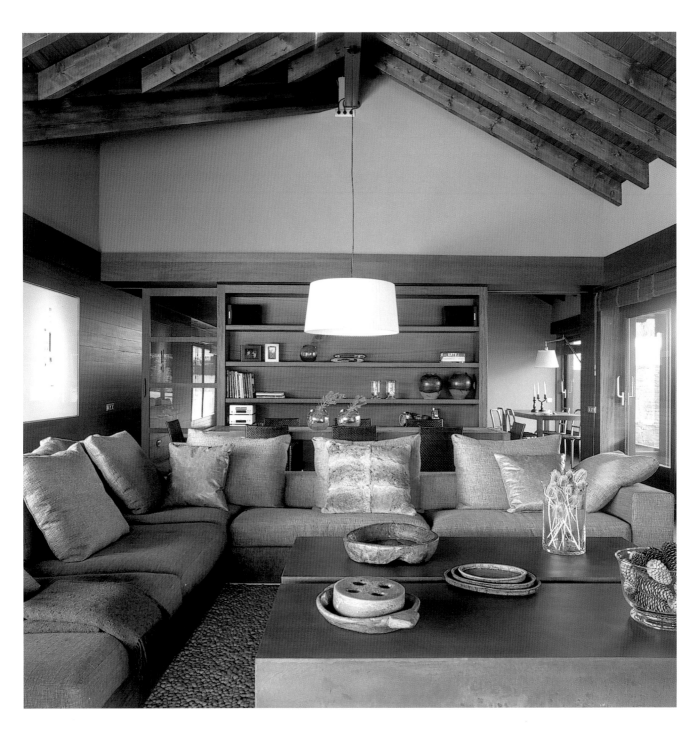

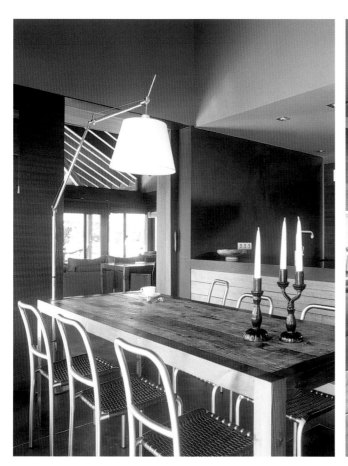
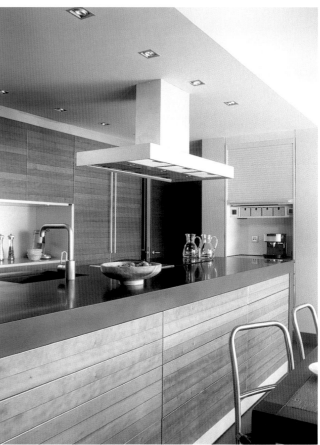

Modern light fixtures and
kitchen appliances add
a contemporary touch to
an otherwise rustic interior.

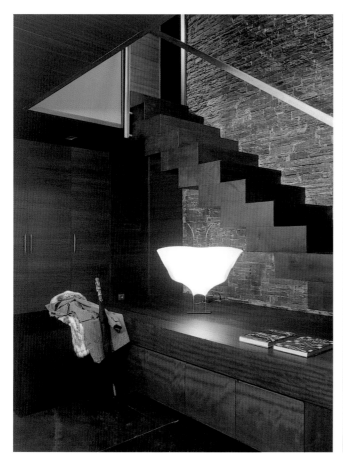
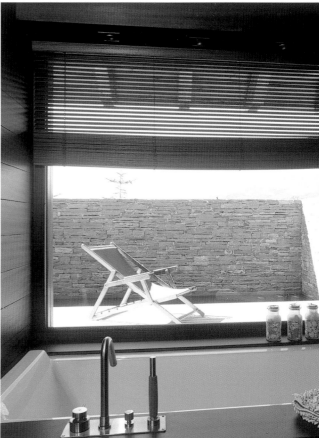

The stone wall that encloses the pool
terrace provides privacy to both
the patio and the bathroom, which
looks out onto the deck through
a large window.

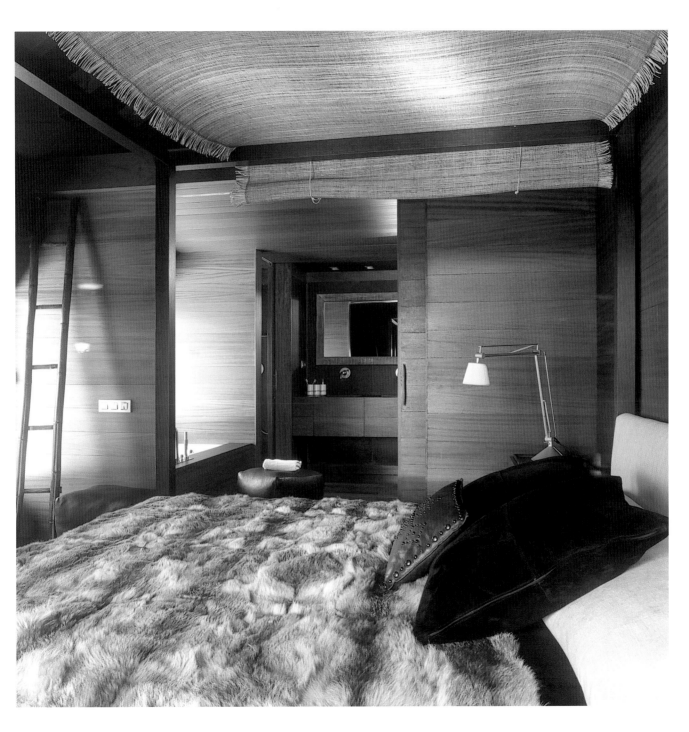

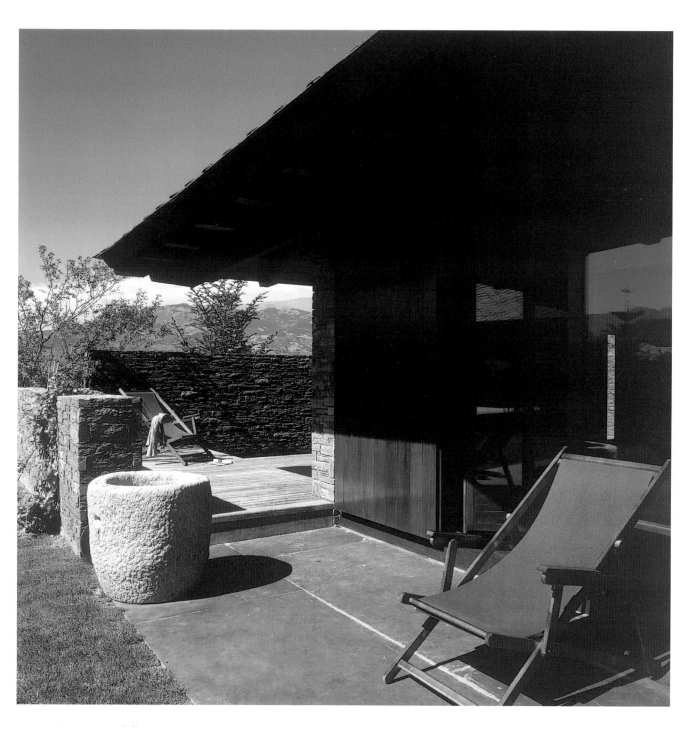

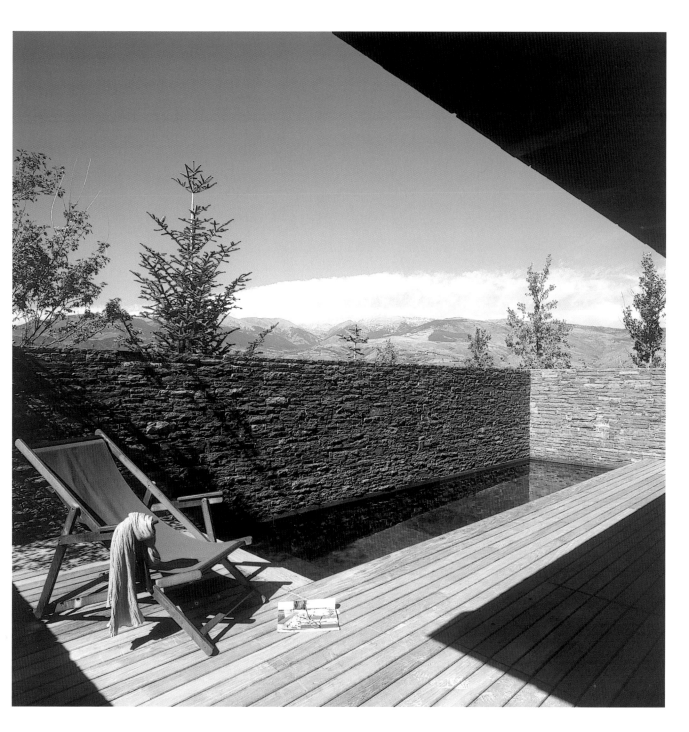

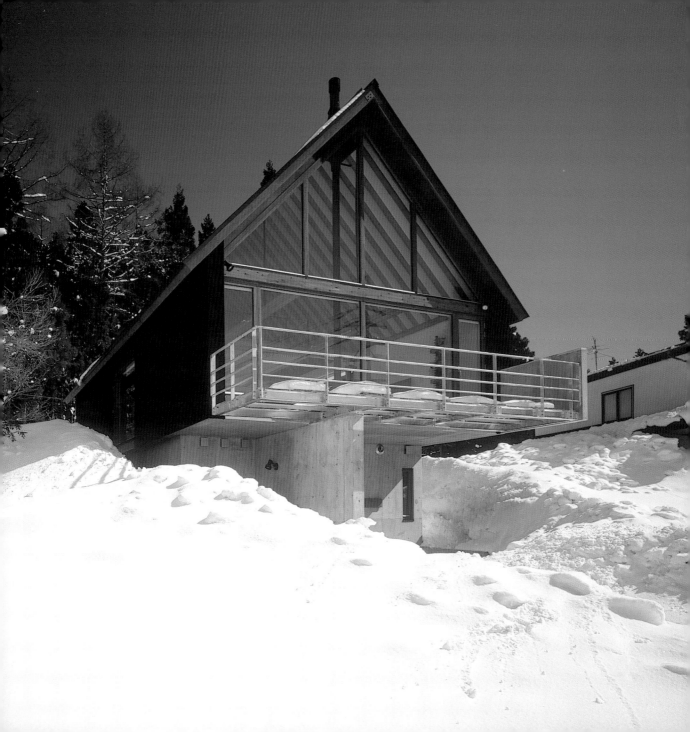

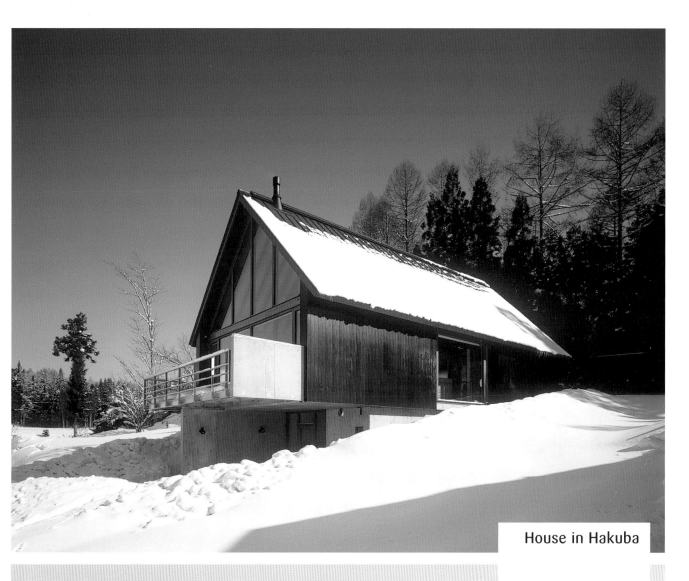

House in Hakuba

Mounted on a concrete plinth, this house in the snowy mountains of Hakuba looks out over the white landscape through a timber-framed façade beneath a pitched-roof structure. Not only does the plinth isolate the house from the snow-covered ground, but it also elevates it to enable a splendid view over the mountain.

Architect: Satoshi Kuwahara
Location: Hakaba, Japan
Date of construction: 2004
Photography: Nacása & Partners

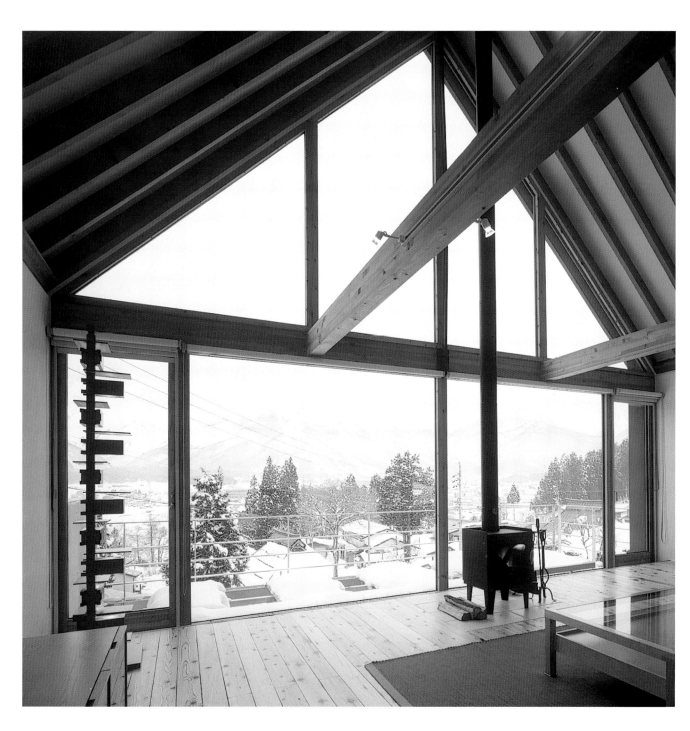

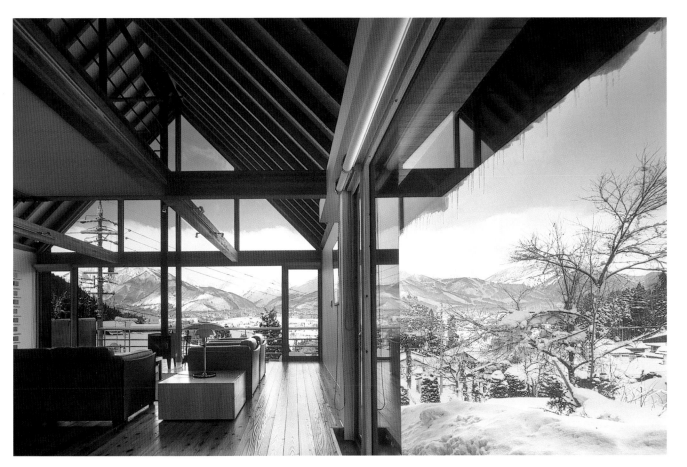

A sculptural cast-iron furnace serves as a decorative object within the living area.

Plan

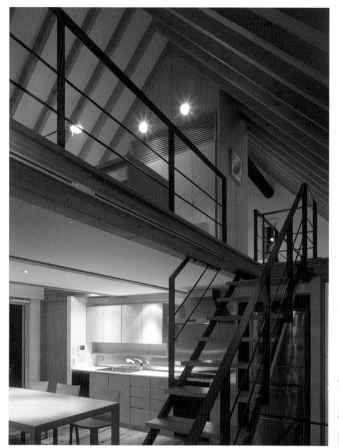

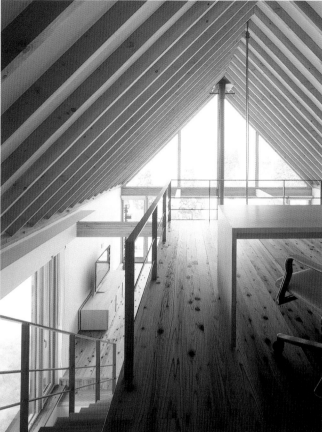

The extensive height of the ceiling was created to house a mezzanine level with a bedroom and office space.

Ground Floor

First Floor

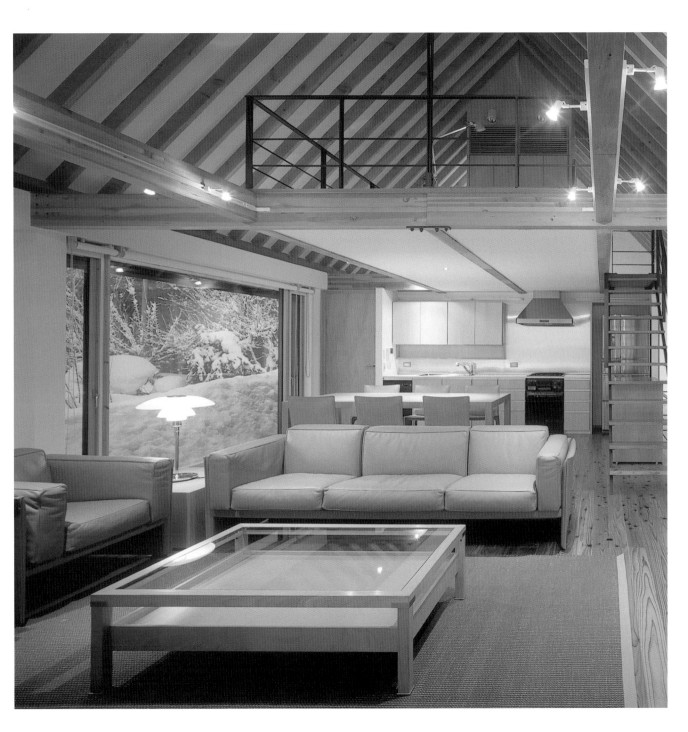

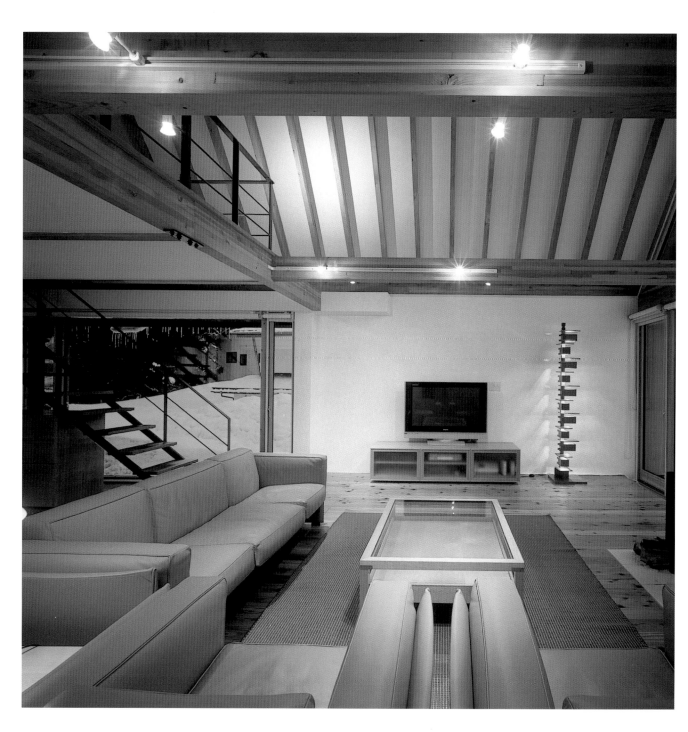

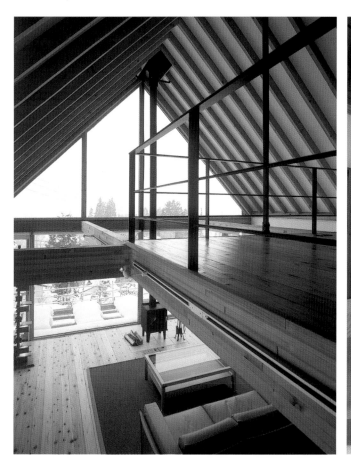

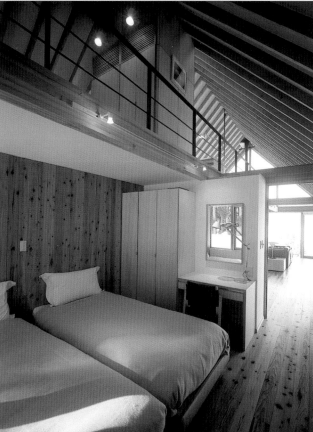

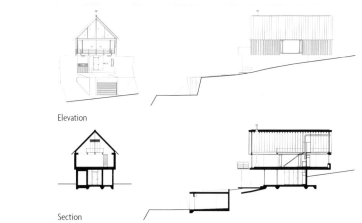

Elevation

Section

The lower level inludes an
extra bedroom at the rear
of the house that
incorporates a small
working area and closet.

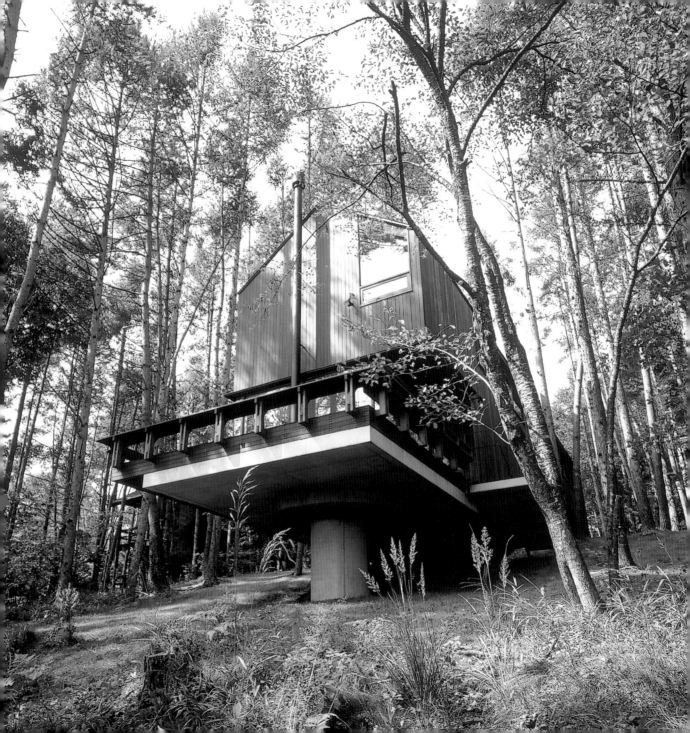

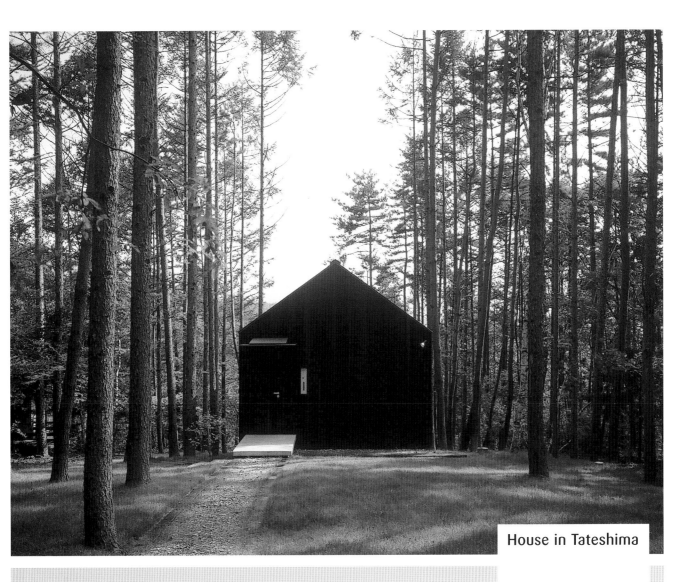

House in Tateshima

The sloping terrain of a dense forest in Japan was chosen to project this house from the ground and up through the trees to provide a stunning view of the lush landscape. A discreet stone path leads to the back side of the house, which reveals the panoramic view through full-lenght glass walls in the living area.

Architect: Ken Yokogawa
Location: Tateshima, Japan
Date of construction: 2004
Photography: Nacása & Partners

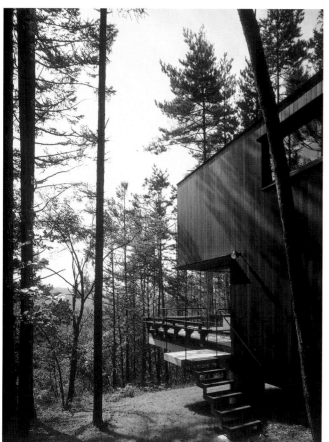
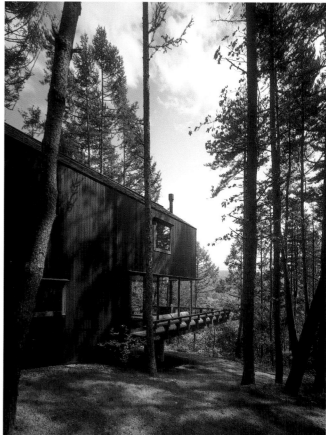

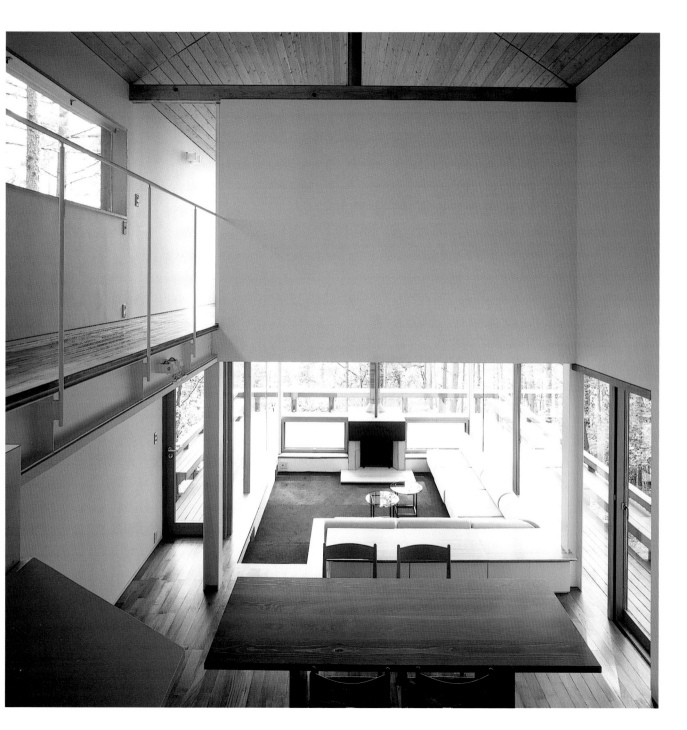

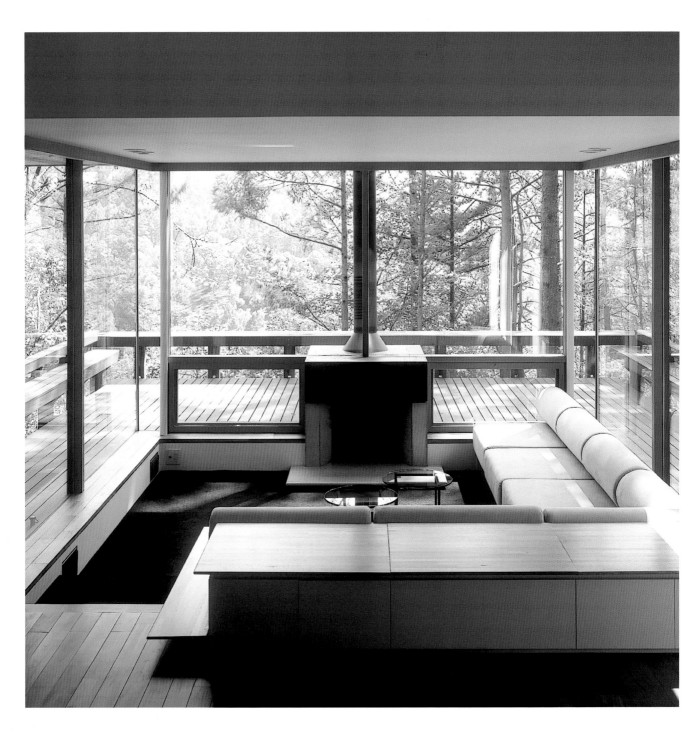

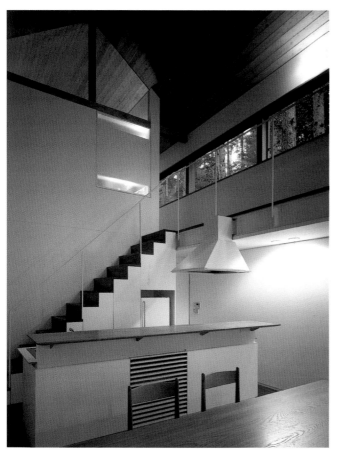

147

The staircase that leads to
the rooms on the upper
level doubles as storage
units for the kitchen area.

House in Tateshima **579**

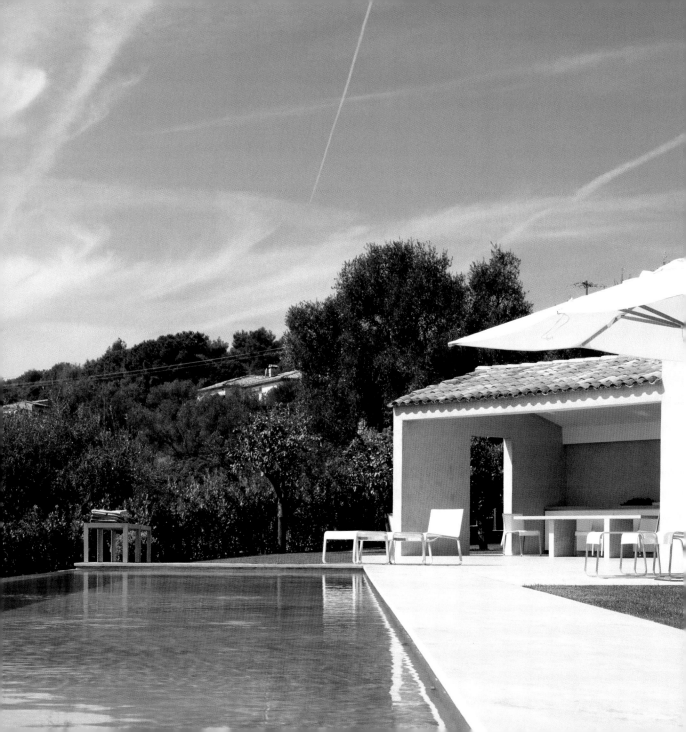

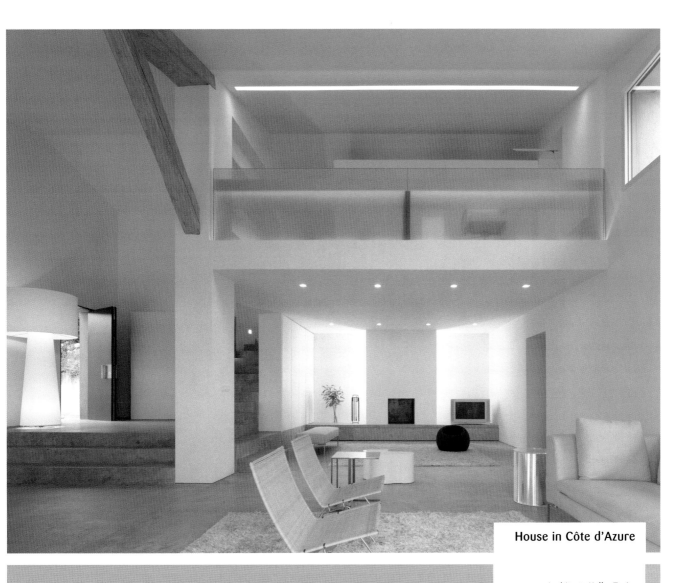

House in Côte d'Azure

Resting on a green hillside in the Côte d'Azur, this 3,450-square-foot holiday home, belonging to a New York-based creative director of one of the leading advertising agencies, combines a relaxed atmosphere with precise detailing, resulting in an elegant, tranquil, and comfortable retreat.

Architect: KallosTurin
Location: Côte d'Azure, France
Date of construction: 2003
Photography: Dennis Gilbert/VIEW

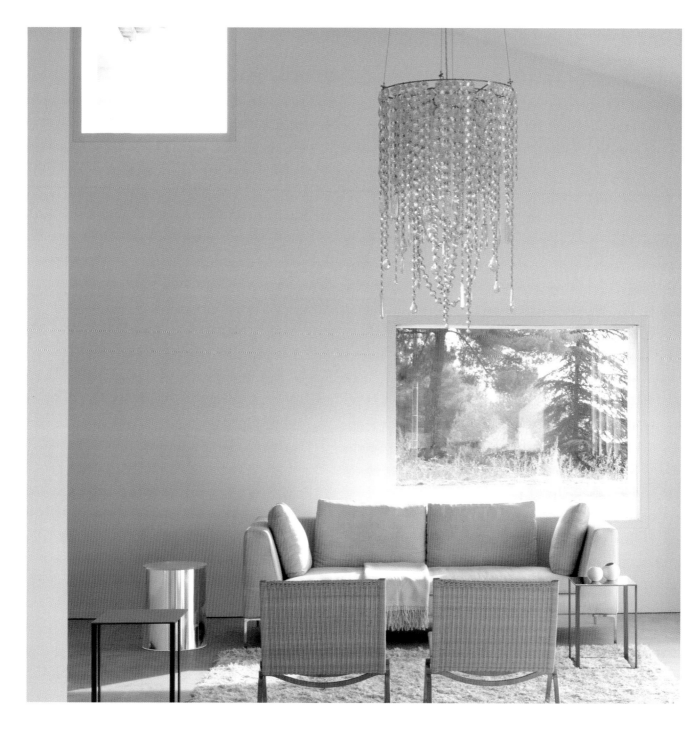

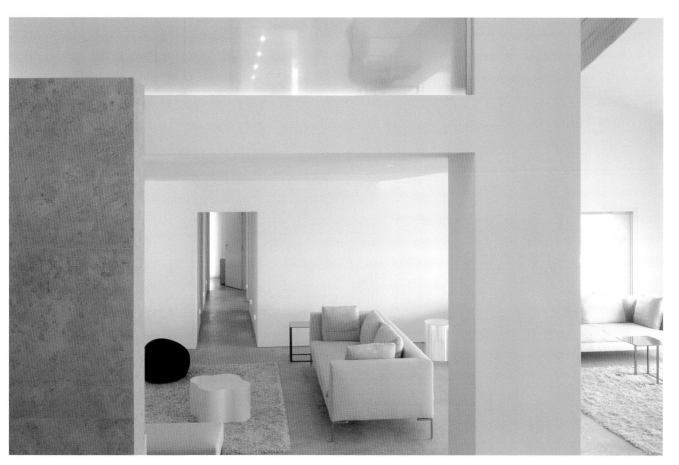

The architects selected a muted, neutral palette to emphasize the tranquil nature of the place. Materials were limited to limestone, oak, white corian, and white lacquer.

The client's office was situated on a mezzanine level overlooking the living area. The living room has deep, stone-clad drawers which store children's toys when they are not in use.

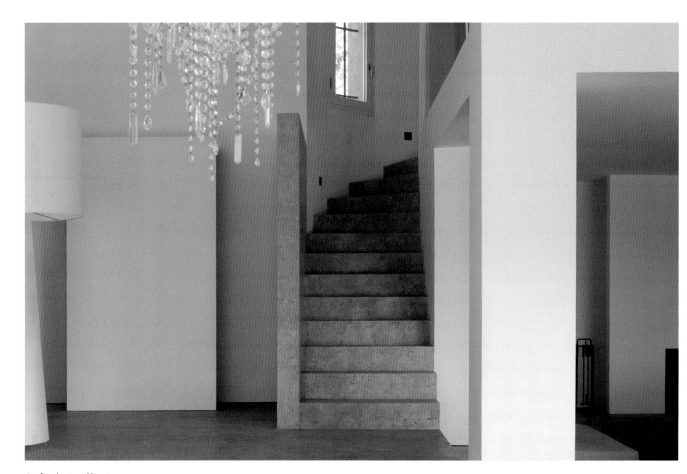

A soft amber-toned limestone was
handled in a monolithic way on
the floors, stairs, counters and
benches throughout the spaces to
create a sense of continuity.

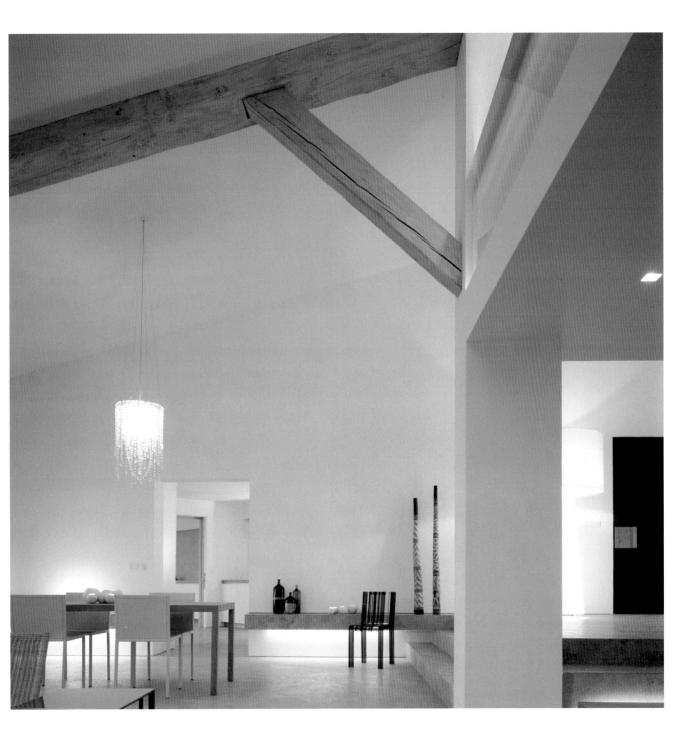

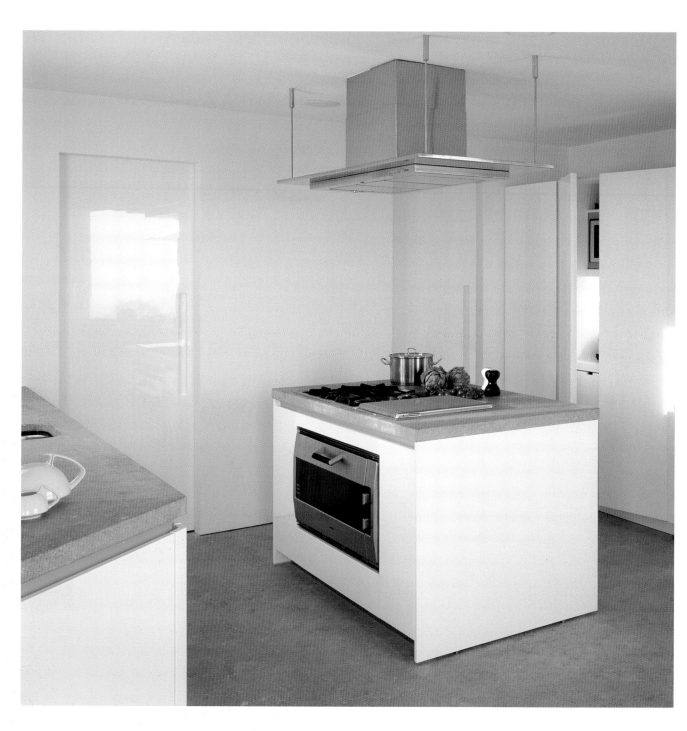

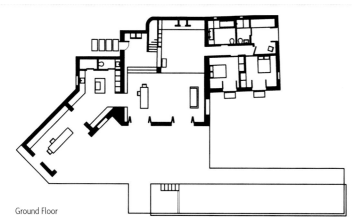

Ground Floor

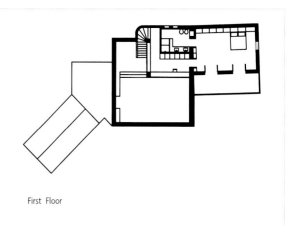

First Floor

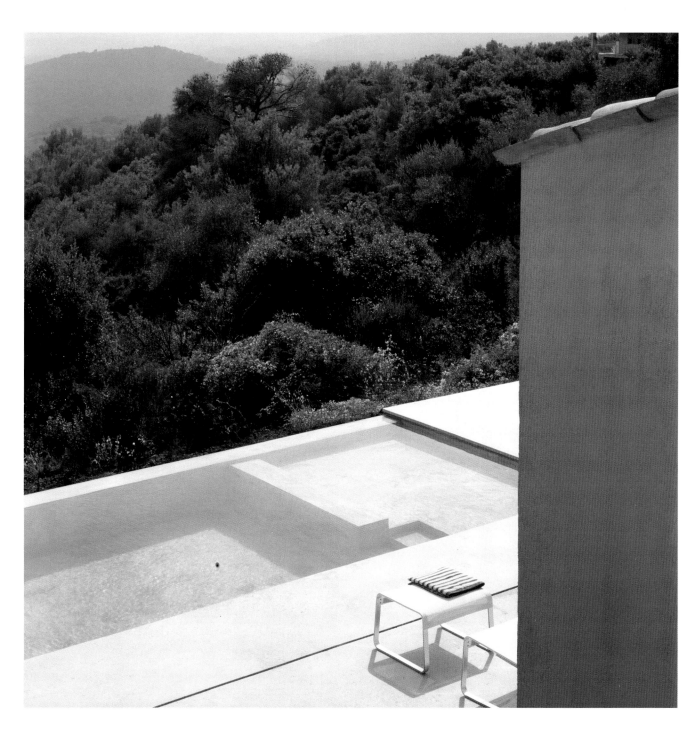

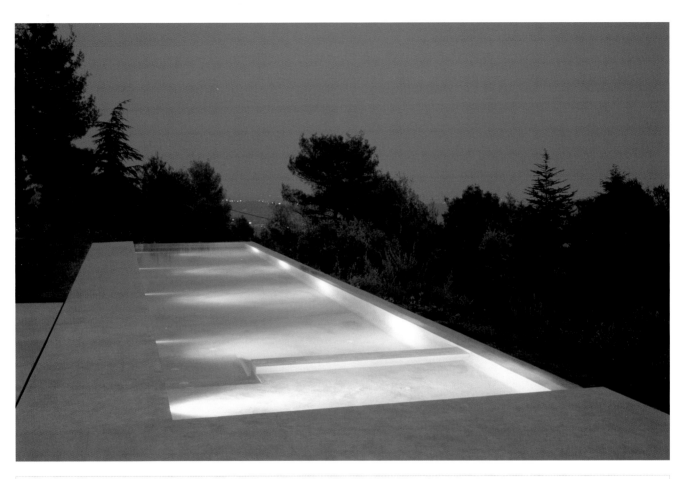

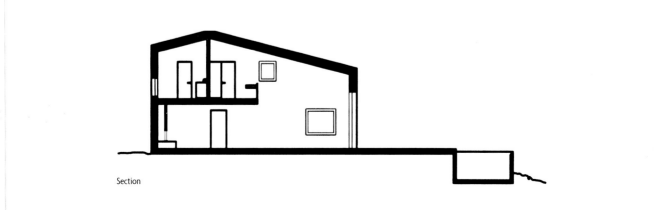

Section

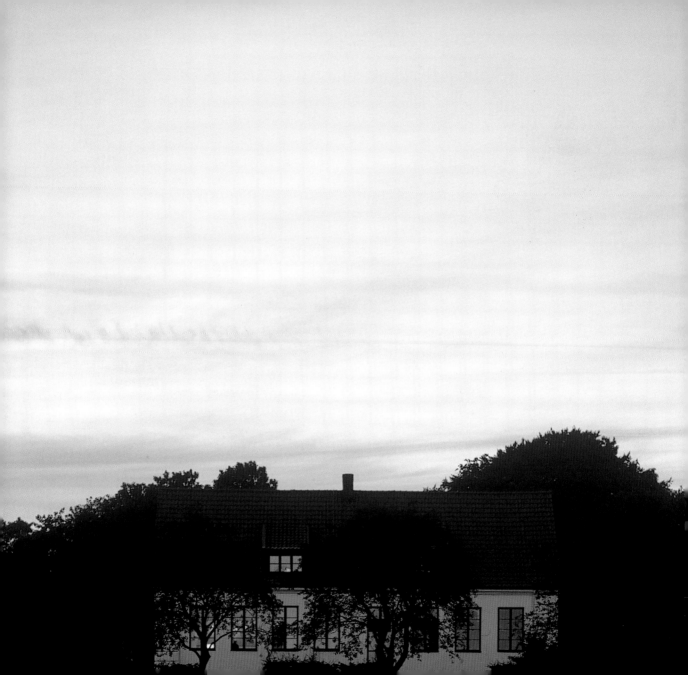

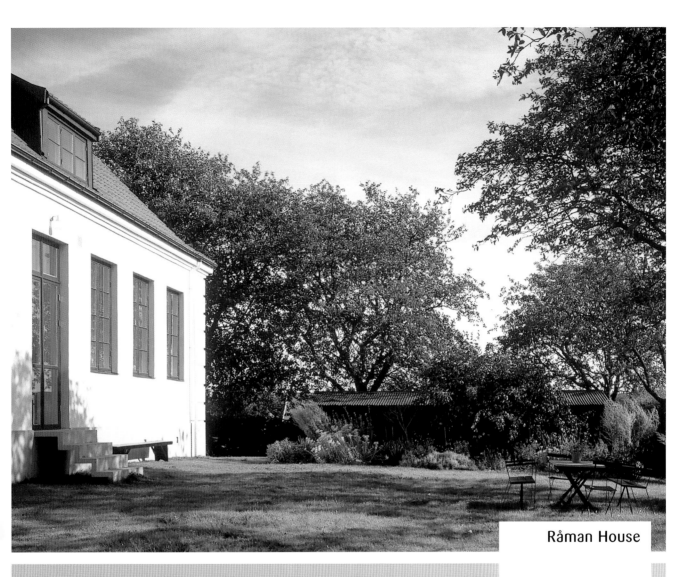

Råman House

Originally a typical old Swedish country school building, this structure was converted into a country house for a professor and designer of glass and ceramics and her artist husband. The former classrooms made for a generous kitchen, dining areas and studio space, while the upstairs contains the master and guest bedrooms.

Architect: Claesson Koivisto Rune Arkitektkontor
Location: Baldringe, Sweden
Date of construction: 2000
Photography: Patrik Engquist

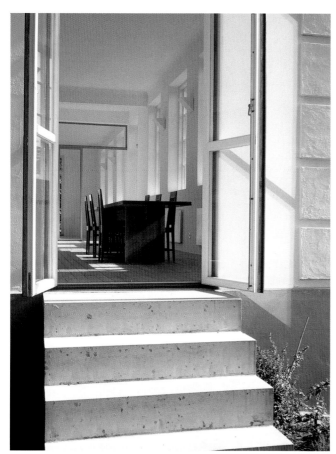
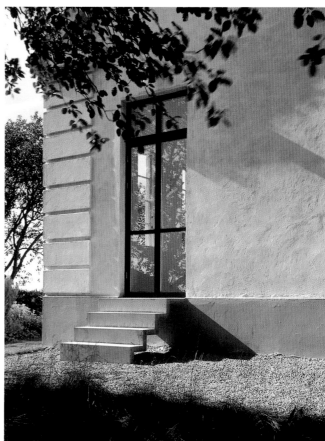
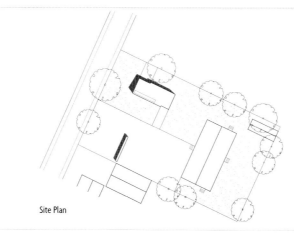

Site Plan

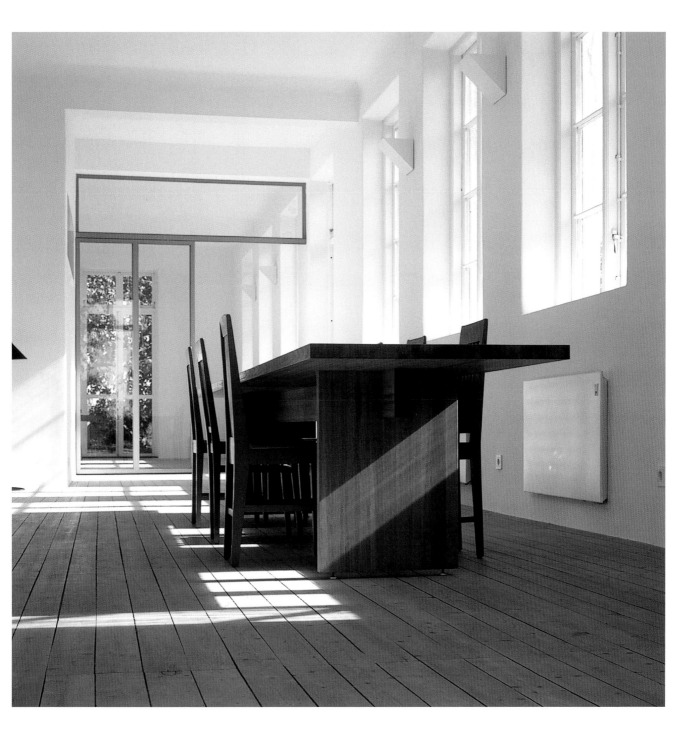

Mismatched chairs and
furnishings can result
in an original and
unrestrained style.
The floors are made
of bleached
and white-oiled pine.

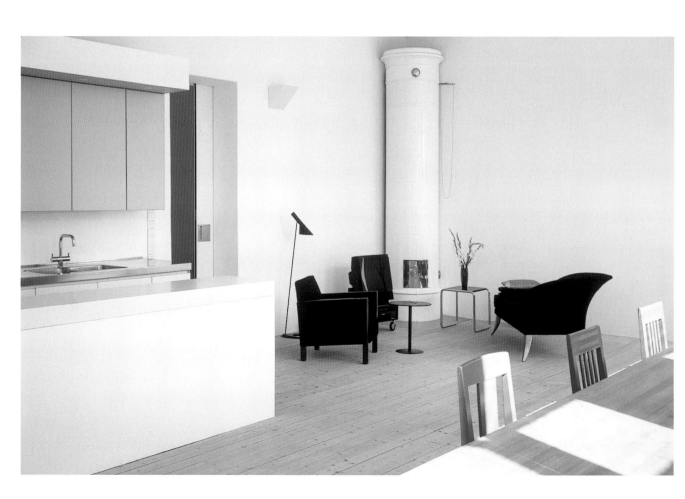

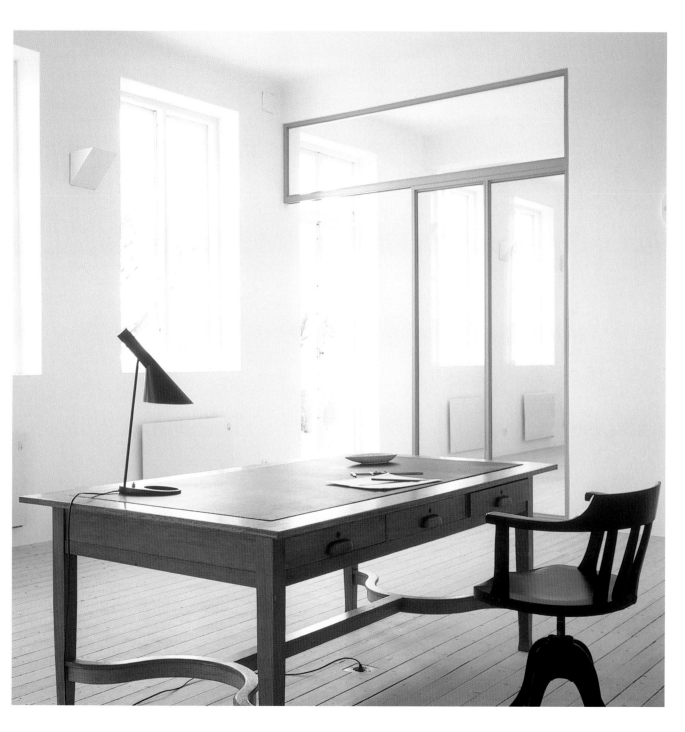

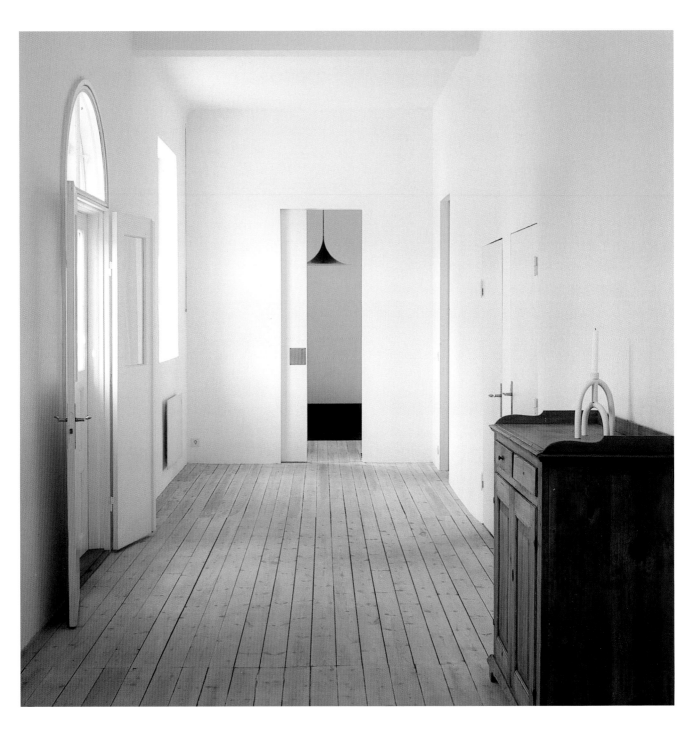

150

A bedroom with large
proportions can be
dramatized by positioning
the bed in the center,
and using the wall space
for shelves, window
seats, or closet space.

Ground Floor

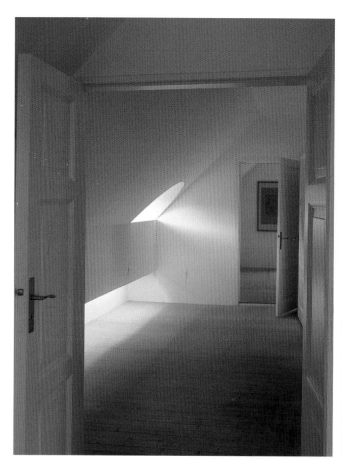

A long, artificially lit niche above the floor lights up the hallway between the two bedrooms.

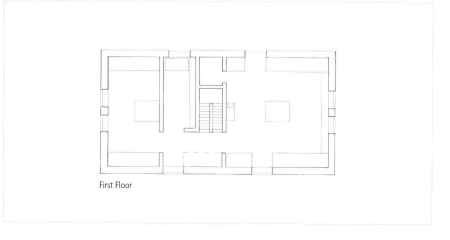

First Floor

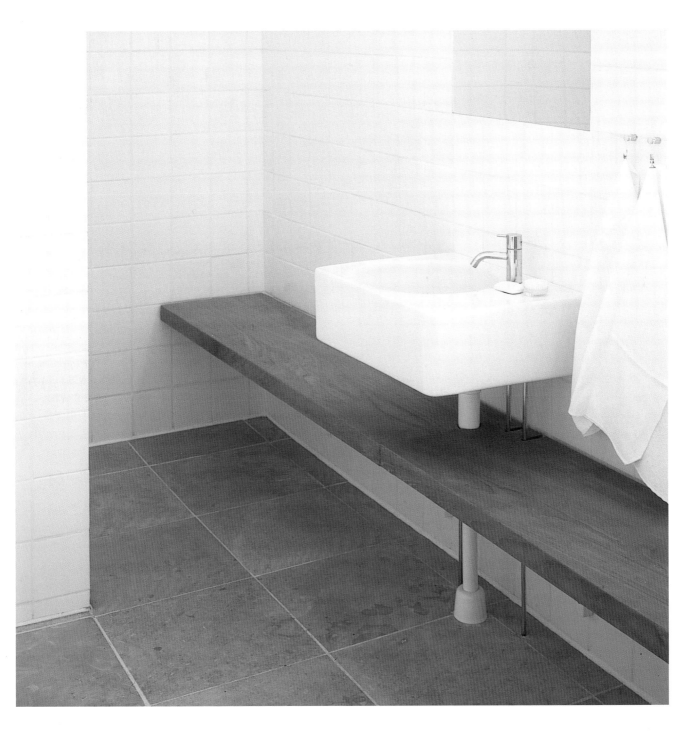